Showing Off!

D1595620

ALSO AVAILABLE FROM BLOOMSBURY

The Curatorial, edited by Jean-Paul Martinon
Key Terms in Philosophy of Art, Tiger C. Roholt
Phenomenologies of Art and Vision, Paul Crowther

Showing Off!

A philosophy of image

JORELLA ANDREWS

BLOOMSBURY

LONDON • NEW DELHI • NEW YORK • SYDNEY

Bloomsbury Academic

An imprint of Bloomsbury Publishing Plc

50 Bedford Square	1385 Broadway
London	New York
WC1B 3DP	NY 10018
UK	USA

www.bloomsbury.com

Bloomsbury is a registered trade mark of Bloomsbury Publishing Plc

First published 2014

© Jorella Andrews, 2014

Jorella Andrews has asserted her right under the Copyright, Designs and Patents Act, 1988, to be identified as Author of this work.

All rights reserved. No part of this publication may be reproduced or transmitted in any form or by any means, electronic or mechanical, including photocopying, recording, or any information storage or retrieval system, without prior permission in writing from the publishers.

No responsibility for loss caused to any individual or organization acting on or refraining from action as a result of the material in this publication can be accepted by Bloomsbury Academic or the author.

British Library Cataloguing-in-Publication Data
A catalogue record for this book is available from the British Library.

ISBN: HB: 978-1-4725-3179-7
PB: 978-1-4725-2662-5
ePDF: 978-1-4725-3304-3
ePub: 978-1-4725-3409-5

Library of Congress Cataloging-in-Publication Data
A catalog record for this book is available from the British Library.

Typeset by Newgen Knowledge Works (P) Ltd., Chennai, India
Printed and bound in India

Contents

Acknowledgements

This book was a long time in the writing! Heartfelt gratitude goes to my family, friends and colleagues for their enduring support and encouragement, with special thanks to Anna Andrews van de Laak, Ludi Andrews, Gavin Butt, Donna Kehoe, Jean-Paul Martinon, Angela Nicholls, Irit Rogoff, Diana Stephenson and my editors at Bloomsbury, Liza Thompson and Rachel Eisenhauer. I also thank Carolyn Lefley and Liz Johnson-Artur for allowing me to include their photographic works in this book.

Image credits

Text credits

I thank the publishers of the following works for granting me permission to reproduce substantial extracts for the purposes of analysis and discussion:

Phenomenology of Perception by Maurice Merleau-Ponty. Translated from the French *Phénomenologie de la perception* by Colin Smith. English translation © 1962, Routledge and Kegan Paul Ltd. Reproduced by permission of Taylor and Francis Books UK.

Sense and Non-Sense by Maurice Merleau-Ponty. Originally published in French as *Sens et non-sens*, © 1948 by Les Éditions Nagel. This translation is based upon the revised third edition, issued by Nagel in 1961. English translation © 1964 by Northwestern University Press. First published in 1964 by Northwestern University Press. All rights reserved.

The Primacy of Perception and Other Essays by Maurice Merleau-Ponty. *L'oil et l'esprit* © 1964 Éditions Gallimard. English translation © 1964 by Northwestern University Press.

The Visible and the Invisible by Maurice Merleau-Ponty. Originally published in French under the title *Le Visible et l'invisible*. © 1964 by Éditions Gallimard, Paris. English translation © 1968 by Northwestern University Press. First printing 1968. All rights reserved.

The Poetry of Michelangelo: An Annotated Translation by James M. Saslow, © 1993 by Yale University Press.

Selected English translation film subtitles of dialogue were also used from the following films: Raj Kapoor (dir), *Sangam* (India, 1964); Víctor Erice (dir), *The*

Quince Tree Sun (Spain, 1992); Moufida Tlatli (dir), *The Silences of the Palace* (Tunisia/France, 1994) © Moufida Tlatli.

Every effort has been made to trace the copyright holders but if any have been inadvertently overlooked, the publishers will be pleased to make the necessary arrangement at the first opportunity.

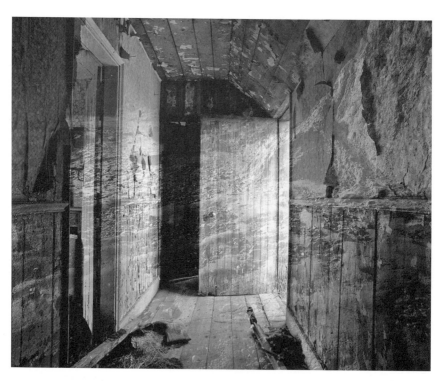

FIGURE 1 *Carolyn Lefley, 'Realm #3, Smoo Cave' from the series* Realm, *2009–12.* © *Carolyn Lefley. Reproduced with permission.*

Introduction: Trailer

In praise of *visual* paradigms

Why can even the most fleeting of visual phenomena have such overwhelming and ongoing power to shape our thoughts, feelings, sense of self and sense of the world? Why, at a given time or in a given place, might this or that particular image or visual experience have taken hold? An image or experience that others may have ignored or regarded as unremarkable? And why, as it seems actively to be unfolding itself to us, might we sense that it has relevance beyond our own personal circumstances?

Indian Lady (1997) is a silent, 30-second video loop by the Bangalore-based performance photographer, Pushpamala N. In it, the artist, in the guise of a coy, sari-clad woman, fleetingly enters, crosses and leaves a makeshift stage. Behind her is a roughly painted urban backdrop, a night scene with skyscrapers glittering on a distant shoreline. On the one hand, this backdrop looks like a generic image of an idealized and unobtainable modernity. But on the other hand, it is an accurate portrayal of Mumbai (or Bombay), India's financial, industrial and commercial capital – the richest city in South and Central Asia[1] – and famously home to Bollywood, one of the world's greatest dream factories.[2] While on stage, and addressing an audience we do not see, the woman performs an abbreviated, amateurish 'filmi'-style song-and-dance routine, and then she is gone. Only to reappear and disappear, again and again, in an endless and unvarying cycle – of what? Of appeal to, and retreat from, public scrutiny? Of ambition, and thwarted ambition, to express and impress?

At first sight, *Indian Lady* could be regarded as relatively inconsequential. It looks like a snippet of faded film footage that has become compelling because of how and where the artist has chosen to present it. Its short, repetitive structure, for instance, has the rhythm and impact of a commercial. And when it is screened in a gallery setting it is as a large-format wall projection that inevitably attracts attention due to its scale. Created when Pushpamala's work was beginning to be noticed in international art circles,

it has been exhibited in a variety of contexts: in 1997 it toured in India and Australia in connection with the exchange residency project 'Fire and Life'; in 2004 it was included in her solo show of photo and video performance work, also titled *Indian Lady*, at the Bose Pacia Gallery in New York; and in 2006 it was part of a group show of contemporary Indian art, *House Of Mirrors*, at London's Grosvenor Vadehra Gallery.

Then there is *Indian Lady*'s overt subject-matter which, again at first sight, might be assumed to have a relatively narrow appeal. Certainly, when the work is exhibited and discussed, its cultural specificities tend to be foregrounded – the questions it raises about 'Indianness' and gender, for instance. But the more often its recurring image-loop is watched, the more it breaks out of any sense of limitation we might initially impose upon it. Instead, with its motif of repeated entrances and exits onto and from that simple stage, it takes on the proportions of a pared-down epic. It is as if a whole life has been compressed into a few seconds and into one characteristic set of gestures. Not only that. Its simplified, schematic and, therefore, open construction leaves space for our intellectual and imaginative participation. Combined with the particularity of its content – *that* woman, *that* stage, *those* aspirations – it draws us in, in a quest to find out more, while challenging us with questions that are at once personal and philosophical. What would the iconography of *my* life look like if similarly distilled? What factors and forces would have made it so? What would it convey? How much room would there be for manoeuvre or transformation? And what could all of this teach me not only about the nature and risks of my own visible being but also about the visible world, of visibility, itself? These are all questions that lie at the heart of this book.

The point I am making is that the more this video-piece shows itself to us, the more we realize that the image-world into which it is repeatedly delving is a manifestation of the same world in which we are all embedded with varying degrees of awareness, effort, anxiety, pleasure and purpose. As it turns out, from whatever cultural perspectives we view it – and this includes the many different viewpoints and paradigms to be found within the Indian subcontinent itself – *Indian Lady* communicates widely and at a fundamental level. This implies that a detailed understanding of how its image-world operates will have a broad relevance. Indeed, its power to communicate to this extent seems to rest on (at least) two factors.

A profound desire

First, at the level of content, *Indian Lady* portrays a specific instance of an inherent human drive to express ourselves not, or so I argue, just at the level of speech but, fundamentally, at the level of visibility.[3] To be acknowledged – for better or worse – not only on the basis of our own claims about ourselves

but also above all for who, what, and how we *show ourselves* to be. Certainly this is one way in which *Indian Lady*'s status as a silent film could be interpreted. But, as Pushpamala's video suggests, this is a drive that can be difficult to embrace. This is partly because visual communication – showing rather than saying – despite often operating in highly codified and conventional ways in everyday life, has an intrinsically open-ended, even unruly, character which makes it vulnerable to untold, and often contradictory, levels of interpretation and misinterpretation. As cognitive scientist Donald Hoffman has put it, images, including retinal images (those which are 'cast on the light sensitive tissue at the back of the eyes'), are not only information rich but also offer 'countless possible interpretations'.[4] From a biological perspective, 'universal rules' are taken to guide the visual processing that is involved in constructing the world we see, a world characterized by depth, motion, surface colours and illumination. However, these rules are multiple, and the process of construction is multistaged.[5] We also know that there are aspects of our visual being – its forms, structures, patterns, colours – that will already have had an impact on others, viscerally and emotionally, perhaps positively, perhaps negatively, before we, or they, are conscious that this has occurred. This is because human self-showing never operates solely within the parameters of the individual human will. Rather, a whole host of visual and cultural phenomena are also always showing themselves through us. In addition, the self-showing world – or 'the appearing world', to use an expression drawn from the writing of the political philosopher Hannah Arendt[6] – incorporates non-human as well as human impulses and exchanges. This signals not only that the agency associated with self-showing resides within the visible world at large but also, therefore, that my use of the term 'self' in non-human contexts is not intended to be understood anthropomorphically. In any case, it is no surprise that attempting to show ourselves, whether within or outside of conventional or intended parameters, means becoming involved in processes over which we can have only tenuous control. Not only that. At the level of value, and as most small children quickly come to understand, it is also a drive generally identified with egotistical or empty exhibitionism. As such, it frequently elicits profound disapproval. Even in our contemporary image- and celebrity-focused cultures, in which ardent and now mainly digitally powered self-promotion is encouraged at all levels, the expression 'showing off' has negative inflections. As a consequence, contemporary society habitually encourages and exploits but also eventually punishes those who indulge in it. Within this process, positive qualities intrinsic to self-showing become obscured.

For many thinkers, the tension just described between image, expression and subjectivity is a defining modern and contemporary phenomenon. The art historian Hal Foster has focused precisely on this matter in his 2012 book,

The First Pop Age, which considers the ways in which, in his view, five (male) artists, Richard Hamilton, Roy Lichtenstein, Andy Warhol, Gerhard Richter and Ed Ruscha, reinvented the painted image in order to 'get the measure of' post-war media and consumer culture and social and political trends. Referring to what he sees as a new notion of humanity as *homo imago* (as opposed to other more established definitions such as the well-known humanist conception of man as a rational animal), Foster examines how the work of these artists articulated challenging shifts taking place regarding the status of mid-twentieth-century image-culture, *self*-image and subjectivity. For instance, he writes that:

> Often in Pop, especially as practiced by Warhol, people are regarded as a species of image and vice versa, with both people and images thus subject to the vicissitudes of the imaginary (which, in the Lacanian account, is a volatile realm where narcissistic impulses vie with aggressive ones). This view of a vexed relation between subject and image in Pop goes against the usual association of this art with the easy iconicity of media celebrities and brand-name products. On the contrary, Pop in general and Warhol in particular sometimes underscore the sheer difficulty of our status as *homo imago*, the great strain of achieving and sustaining coherent images of self and other at all.[7]

Foster treats the relationship between image and subject as complex and often, in the case of Warhol, as 'distressed', as wounded and wounding, and traumatic. In addition, he identifies what is often described as Pop's appearance of superficiality with its proposition that this was – and still is – an age in which 'subjectivity had surfaced into the world, with the psychological interiorities of bourgeois selfhood now confused with the everyday exteriorities of consumerist life'.[8] At issue, in other words, was a now very differently distributed sense of self. This understanding contrasts significantly with that of other commentators on modern and contemporary visual culture who have often taken the tensions between image, expression and subjectivity within modernity to signify not a shift in, but a degradation of, our humanity. Take, for instance, a classic late twentieth-century diagnosis by one of the most quoted but also one of the most difficult to position, theorists of visual and virtual culture, Jean Baudrillard. 'Everyone seeks their *look*', he wrote in a short essay, 'Transsexuality', which first appeared in 1990:

> Since it is no longer possible to base any claim on one's own existence, there is nothing for it but to perform an *appearing act* without concerning oneself with *being* – or even with *being seen*. So it is not: I exist, I am here! but rather: I am visible, I am an image – look! look! This is not even narcissism, merely an extraversion without depth, a sort of self-promoting

ingenuousness whereby everyone becomes a manager of their own appearance.[9]

At an immediate level there is much evidence to support Baudrillard's diagnosis. The management of image and self-image is an undeniably dominant contemporary compulsion. But is the apparently wholesale negativity of Baudrillard's claims inevitably justified? Are not other, or additional, perspectives also possible? In particular, how valid is the dualism, the fundamental irreconcilability, between image – or appearance – and existence that is embedded in his words? Certainly this is an opposition that I want to avoid. On the contrary, my aim is to examine the possibilities that emerge when image and existence are accepted as primordially intertwined. In this respect, then, I argue that Foster's *homo imago* is not in fact a recent phenomenon but one to which we have recently, and collectively, become particularly attuned. My aim is also to ask what happens when, as a consequence of this acceptance, self-showing and the associated idea of self-as-image are understood not only as operating far beyond the prosaic definitions that are conventionally associated with them but also as playing a crucial and enriching ethical role. For this reason, my commitment is to think with, and within, the visible, despite its many areas of tension. Furthermore, my primary form of research is to try and think in depth with particular visual works – works of visual art, moving image and design, mostly modern and contemporary but some from earlier periods – in which these matters are directly addressed, or exposed. Hence my use of *Indian Lady*, in this chapter and the next, as one of several ways into my project, for there is something compelling about the coy energy of Pushpamala's protagonist's appearing act, or rather her reappearing act, her repeated returns on stage. Her recurring performance embodies not only the difficulties and weaknesses associated with self-showing and an understanding of self-as-image, but also the contrary determination to fight back and lay claim to the visible. Indeed, from this perspective, it is no surprise that the sari she is wearing is emphatically red. In India, red is culturally symbolic of valour, as well as having associations with emotion, sexuality and fertility. Hence the red sari is traditionally worn by brides and by women at other auspicious occasions. When presenting my findings in *Showing Off* though, and in order to emphasize the multidimensional and often elusive character of the image-world, I have decided in this instance not to support my descriptions and discussions of works of art with illustrations. But I am accompanying my arguments with a self-standing series of photographs by two contemporary artists, Carolyn Lefley and Liz Johnson-Artur. These works, which I do not discuss, embody many of the important sensibilities at issue in this book – visually, viscerally, thematically and emotionally – and in doing so may provoke further layers of unarticulated thought.

The visible as irrepressibly inclusive

The second reason for *Indian Lady*'s power to communicate widely and deeply is because here two apparently paradoxical characteristics of visual communication interact with each other in a way that demands attention: on the one hand, its capacity to set at a distance, and, on the other hand, what I would like to describe as its fundamental inclusivity or hospitality. The visual is rightly described as a 'distance' sense. Not only because it is able to embrace that which is far off, bringing it into perceptual and conceptual range, but also because it can set the up-close world sufficiently at a distance to enable fresh perspectives to be taken upon it and upon our place within it. Although many thinkers have therefore described the distancing capacities of the visual as alienating and thus ethically problematic, on the contrary – and here is the paradox – it is for these very reasons that the visual world is also profoundly relational. For no matter how far off things look, or indeed how much they might differ or appear far removed one from the other, they all remain part of a diverse yet single visual continuity of which we are also a part. We are therefore enjoined not only to perceive but somehow also to think of them together, and this is an expansive activity. It makes our world bigger, while also embedding and involving us more profoundly in it. As we look at *Indian Lady* therefore, it becomes clear that we are not just being confronted with the intricacies of a scene that is somewhat unfamiliar or idiosyncratic. The work is also in the process of presenting us with an aspect of, and vantage point on, our own life-worlds and our own lives. In other words, it is like a mirror. Not a mirror understood in prosaic, or narcissistic, or idealizing terms though, and not as an instrument of representation narrowly understood, but as a device with the power to cause assumed distinctions (between self and other, here and there, etc.) to be perceived as less stable and more ambiguously distributed than we might ordinarily take them to be. A device, too, that helps us understand that whatever else we are, we are indeed also images, circulating among many others within an extensive image-world. As indicted earlier, this is a fact that need not be equated, as it often is, with a negative state of objectification or capture. Quite the contrary. As the twentieth-century phenomenologist Maurice Merleau-Ponty put it in his late essay 'Eye and Mind' of 1961, his own passionate elaboration on the generally unrecognized positive powers of the visual:

> Like all other technical objects, such as signs and tools, the mirror [and we might add the image-as-mirror] arises upon the open circuit [that goes] from seeing body to visible body. . . . The mirror's ghost lies outside my body, and by the same token my own body's 'invisibility' can invest the other bodies I see. Hence my body can assume segments derived from the

body of another, just as my substance passes into them; man is mirror for man. The mirror itself is the instrument of a universal magic that changes things into a spectacle, spectacles into things, myself into another, and another into myself.[10]

In its status as image, more specifically as moving image, *Indian Lady* is one such mirror, a form of common ground, in which, if we follow Merleau-Ponty's definition of it, the exchanges it enables are neither narrowly reciprocal nor narrowly imitative and thus closed. On the contrary, as we become immersed within its spatial, visual and material structures and follow its various references and associations, we find ourselves asking questions and making connections based on the understanding that duplication, displacement and situatedness are necessarily intertwined phenomena – I will strengthen this point by following several of *Indian Lady*'s associative itineraries in the next chapter. As such, we find ourselves participating in Merleau-Ponty's 'open circuit' and extending it. Indeed, later in this chapter, and throughout this book, I will focus more explicitly on how and why it is that the strongest possible connections between ourselves and others occur precisely by means of the affinities, differences and ambiguities just described.

A philosophy of image

It is precisely this issue of where images might take us (what circuits they might open up), and how they might change us that interests me – how particularly they might initiate us into an understanding of self-as-image that is neither paranoid nor exhibitionist. It is in this sense that I want to think about a philosophy of image – a notion that many thinkers, historically, have regarded as a contradiction in terms because, approaching the visual via a dualistic mindset, they have equated it with a realm of deception or dissimulation.

By 'philosophy of image' I do not mean a set of ideas about images, or about 'image', that might be applied to or imposed upon particular visual scenarios. At issue instead are those ideas and intuitions that are in the process of being activated by individual images, or by sets of images, themselves. In my case, from an experiential point of view, they were images and sets of images that seemed to have been less chosen *by* me, and more to have arranged themselves *before* me, for the purpose of challenging my thoughts and expectations with their own intrinsic logics and narratives. As such, and even though they included visuals drawn from advertising, their agency was qualitatively different to that of the so-called phatic or 'targeted image that forces you to look and holds your attention'[11] in its attempts to persuade – as generally occurs within contexts of modern high-speed, indeed

'instantaneous' mass communication. In this regard, Paul Virilio, whose abiding critical engagement is with the study of speed and its effects, has referred to 'certain signs, representations and logotypes. . . . Geometric brand images, initials, Hitler's swastika, Charlie Chaplin's silhouette, Magritte's blue bird or the red lips of Marilyn Monroe'[12] that are at once overwhelmingly personal and powerfully transsituational but leave no opportunity for interaction. Indeed, in his 1988 essay, 'A Topographical Amnesia', he described the phatic image as having a very particular structure and mode of appearance: 'not only [is it] a pure product of photographic and cinematic focusing', he wrote. 'More importantly it is the result of an ever brighter illumination, of the intensity of its definition, singling out only specific areas, the context mostly disappearing into a blur.'[13] 'During the first half of the twentieth century', he added,

> this kind of image immediately spread like wildfire in the service of political and financial totalitarian powers in acculturated countries, like North America, as well as in destructured countries like the Soviet Union and Germany, which were carved up after revolution and military defeat. In other words, in nations morally and intellectually in a state of least resistance.[14]

The types of coming-to-appearance to which I am referring, by contrast, are insistent but not instantaneously seductive or impositional. They do not operate according to the logics of those visual economies that seem specifically designed to rob us of agency and reduce or prohibit individuation – even if it is sometimes in the midst of precisely these economies that they come powerfully to light. On the whole they are quietly pervasive, and they generally take their time to reveal themselves. Certainly, while I was writing, the processes of activation were slow. In some cases, they were elicited from a prolonged involvement with and adjustment to the internal and associative trajectories of the images in question. In other instances, even if initial insight came in a flash, this was followed by the time-consuming task of making retrospective sense of what seemed to have occurred. The important point, though, is that here images are never experienced as passive entities. They are experienced as agents with ongoing power to address us (and therefore also to withdraw from us). Inevitably, what is learned is always at once concrete, specific *and* provisional.

Of course, this claim about images as agents is not an original insight. It has been explored by a number of twentieth-century and contemporary thinkers. The works of Merleau-Ponty and Roland Barthes (notably his intriguing final book, *Camera Lucida* of 1980) are just two well-known twentieth-century sources. More recent sources include the writing of Kaja Silverman and Vivian Sobchack – see for instance, Silverman's seminal book *World Spectators*

from 2000 (particularly the last chapter, titled 'The Language of Things') and Sobchack's earlier, Merleau-Pontean inspired reconceptualization of film, *The Address of the Eye* of 1991. And of course this conception of image as agent also has an ancient legacy, although one that was increasingly suppressed, dismissed or neglected as Western, and then global culture, became more and more enthralled by humanism and rationalism. For instance, it is powerfully embedded within much medieval religious imagery and within the ancient Orthodox Christian understanding of what it means to engage with religious icons in the context of worship. For here, the icon is not defined as a representation of divine realities to be looked at. On the contrary, it is an entity experienced as looking *at* the beholder, and, in this way, functioning as a perceptual doorway or, alternatively, as a vehicle, a mode of transportation, *into* the divine. It literally moves us. These, again, are themes to which I will return. But what I hope to contribute to these varied discussions, as already noted, is a focused exploration of the ethical implications of the image as a self-showing entity, and of self-showing itself in its many different modes and manifestations. At this stage, however, where this matter of a 'philosophy of image' is concerned, I want to amplify three points already introduced.

An ethical orientation

In the first place, I want to re-emphasize the fact that my basic orientation towards the visual is that it must be engaged with – with interest and energy – because it exists and we are a part of it. Not only is my approach, in this sense, provisual. In the second place, as already indicated, I also focus on the ethical potential of a specific and conventionally much disprized visual phenomenon: that of self-showing or showing off. Here, though – and as the following pages will elaborate – I understand self-showing at its most fundamental levels to operate in ways that are alternative to its conventional associations with exhibitionism or narcissism. In other words, my concern is not with self-showing or showing off as a problem – which of course it can be, and often is – but as an ontological as well as existential reality from which a particular ethics can be drawn. And here, an interrelated point is that within this provisual, phenomenologically informed context, I also present an affirmative notion of image and appearance, and thus also of self-as-image. This will be a particular theme of the book's second chapter, 'Appearance is everything'. But, given my earlier references to Baudrillard's perspectives in 'Transsexuality', one strategy will be to present a counterpoint to the debilitating 'look, look' mentality that Baudrillard seems to have associated with self-showing in that essay. In other words, I will try to determine how we can enjoy a grounded sense of self-as-image by detaching it, even if only provisionally, from a sense of needing to be seen and, by implication, needing

to be favourably judged. On the one hand, then, I will be trying to open up a sense of free space, or free play, between showing off and being seen. And on the other hand, again in counter-reference to Baudrillard's words, I will be challenging the dualistic distinction he presented in that work between being and appearance.

Clearly, by proposing a positive relationship between the visual and the ethical, and by trying to rethink the relationship between self-showing and being seen, and between appearance and being, my orientation in *Showing Off* goes against the grain of much recent thought. For in philosophy and art – and here we might include investigations of cultural difference, identity and post-identity politics, power relations and the politics of representation – not only are relationships between the visual and the ethical usually theorized in negative terms, the visual itself is also conventionally, and I would argue reductively, conceptualized not with a primary focus on self-showing or coming-to-appearance (or, as indicated, as an attempt to untangle the relationships between self-showing and being seen) but according to the dyadic logics of seeing and being seen. Here, agency and power are assumed to operate either on the side of those who see, or on the side of those who control the means by which people and things enter into visibility. These are regimes that Nicholas Mirzoeff – drawing on the late eighteenth and early nineteenth-century work of the military theorist Carl von Clausewitz and the historian Thomas Carlyle – has named 'visuality', defined as 'a specific technique of colonial and imperial practice, operating both at "home" and "abroad", by which power visualizes History to itself'. 'In so doing', he continues, 'it claims authority, above and beyond its ability to impose its will'.[15] It operates today, as in earlier times, as an authoritarian, and thus disempowering, often disenfranchising, military–industrial visualizing complex.[16] To cite him again:

> Visualization demonstrates authority which [in turn] produces [problematic forms of] consent. . . . Visuality is thus a regime of visualizations, not images, as conjured by the autocratic leader. . . . It is also the attribute of bureaucratic and structured regimes. . . . The visualization performed by autocracy is that moment envisaged by the French philosopher Jacques Rancière when the police say to us 'move on, there's nothing to see here'.[17]

Thus where I use the term 'visuality' in this book it will be in accordance with these meanings. It should be distinguished from references I will make to 'the visual', which is meant to be a broad term encompassing vision, visibility and self-showing, and to which I do not wish to attach any particular ethically inflected meaning.

For Mirzoeff, to return to him, the critical visuality studies he is advocating are also about claiming 'the right to look' at that which 'authority' wants to keep hidden, even, and especially, if one has no 'formal' right to do so. And, he adds, it is the right 'to be seen' to be looking.[18] At issue, here – and again, Mirzoeff's words are permeated with sensibilities drawn from the writing of Rancière – is the need to negotiate a different place from which to look, challenging not simply whether one can 'look' at this or that event but who may decide 'where that line falls'. In this way, his aim is that of 'putting authority in question'.[19]

Returning, in any case, to that notion of agency residing on the side of the one who sees, or the one who controls the means by which someone or something is seen, the assumption is that to be seen – when it occurs outside of these parameters of control – is to be at a disadvantage; hence, for instance, in her 1993 book, *Unmarked: The Politics of Performance*, contemporary theorist Peggy Phelan questioned an idea that was central, for a while, to activist practices of the 1970s and 1980s: that projects of political emancipation must be intertwined with, and are dependent on, processes of 'making oneself visible'.[20]

Acknowledgement of the vulnerability of visibility also underlies the realities of life lived within increasingly pervasive systems of imposed and self-imposed surveillance, as well as apparently confident public performances of visual self-display – in celebrity culture, for instance, and with the rise of the selfie – where such issues as the effective management of an individual's status and circulation as image within the image-world are invariably experienced as matters of ongoing anxiety as well as enjoyment.

In *Showing Off*, in contrast to these dominant anti-ocular accounts, I agree with the still relatively non-dominant perspectives offered by such thinkers as Silverman, Lawrence Blum, David Michael Levin, Edward Casey, Jacques Rancière, and others,[21] that visibility need not be avoided or denigrated as always problematically subject to the oppressive or mastering gaze of self and others. Furthermore, I want to insist that an equation of visibility with vulnerability need not be regarded as a weakness. Nonetheless, with my focus on self-showing, my orientation also contrasts with these differently inflected, positive accounts of the relationship between visuality and the ethical. Broadly speaking, through their careful and nuanced explorations of the nature and scope of the visual, these theorists have reconceptualized this relationship by extending our understanding of the nature and character of sight, and by elaborating an ethics founded on the practice of non-oppressive, that is, generous, responsive and accountable, ways of seeing. This broad approach is also significant because it challenges the sufficiency of the traditional ethical imperatives of rationalist principle, impartiality, and the sufficiency of externally derived rules and codes held to be universally and

generally applicable. Rules, codes and principles are all very well. But as Blum insists, citing the earlier work of Iris Murdoch – her novels as well as her philosophical writing – the ethical life demands that our attention is above all directed towards 'the important role of *moral perception* in the moral life'.[22] He continues:

> How do agents come to perceive situations in the way they do? How does a situation come to have a particular character *for* a particular moral agent? What is the relation between our moral-perceptual capacities and other psychological capacities essential to the moral life? These questions have drawn scant attention in contemporary ethical theory.[23] Moral philosophy's customary focus on action-guiding rules and principles, on choice and decision, on universality and impartiality, and on obligation and right action have masked the importance of moral perception to a full and adequate account of moral agency. Yet although an agent may reason well in moral situations, uphold the strictest standards of impartiality for testing her maxims and moral principles, and be adept at deliberation, unless she perceives moral situations as moral situations, and unless she perceives their moral character accurately, her moral principles and skill at deliberation may be for naught. In fact, one of the most important moral differences between people is between those who miss and see various moral features of situations, confronting them.[24]

Importantly, too – this is a theme I will develop later – by focusing on ethical modes of seeing these thinkers also treat as ethically productive certain of the supposed weaknesses that classical philosophy has often associated with our perceptual, and particularly visual, modes of immersion in the world. These 'weaknesses' are interlinked with the personal nature of perception, with its entanglement in specificities, its associations with emotion and its susceptibility to deception.

To repeat, then, there are many affinities between the perspectives I present in *Showing Off* and the work of the provisual theorists at issue here. But there is also a prominent difference. For in the work of those provisual theorists, visuality is again approached according to those dyadic logics of seeing/being seen referred to above. By contrast, I want to ask what happens to our understanding of visibility when that third term that I have already foregrounded, 'self-showing', is brought into play. As such, the proposition I would like to present is that the proper site of generosity and agency within any visual encounter is located not on the side of sight but rather within the vulnerabilities and the agency intrinsic to the self-showing world of which

we ourselves are inextricably a part. In other words (and bearing in mind that not only humans but also things and situations show themselves), I argue for an ethics that is grounded in our capacity to inhabit both the risks and the possibilities of our own visible being.

Of course this is a claim that I need to test. Therefore, particularly, but not exclusively, in the chapter titled 'Image wars', various 'worst-case' scenarios are brought into play where the condition of visibility is concerned. This includes scenarios relating to those bodies that are conventionally taken to be disadvantaged or disprized within dominant visual regimes and that are, indeed, frequently subjectively experienced as such.[25] Here, for instance, the work of Merleau-Ponty's contemporaries Jean-Paul Sartre, Simone de Beauvoir and Frantz Fanon are important points of reference, as are the ways in which their critiques have been taken up subsequently by writers and visual practitioners. A more recent, seminal work which has a bearing on my work in this regard – I will refer to it briefly later on in this book – is of course Ariela Azoulay's *The Civil Contract of Photography*.

Phenomenological perspectives

My second introductory point concerns the fact that my emphasis on self-showing is derived from phenomenology, where it has always been a central theme. Martin Heidegger's ontological work, for instance, from the early *Being and Time* of 1927 onwards, consistently examined which conditions within culture facilitated, and which prevented, what he called the coming to presence of whatever presents itself – note the not necessarily human-centred orientations that are indicated here. Merleau-Ponty, in his *Phenomenology of Perception* of 1945, defined seeing as the entrance into 'a universe of beings which *display themselves*'.[26] Furthermore, he insisted that vision itself, as an activity that stylizes, be understood as a form of display. Later, in *The Life of the Mind* of 1978, as Silverman reminded her readers in *World Spectators*, Hannah Arendt defined the world as that which '"intends toward being seen" and aspires or moves toward appearance'.[27] Crucially, she located this intentionally even in what might be called 'brute materiality'.[28] And more recently the French philosopher and theologian Jean-Luc Marion has rearticulated such phenomena in terms of 'givenness', which he regards as having ontological status.[29]

It was, however, the work of Merleau-Ponty that originally inspired *Showing Off* and remains its main philosophical source.[30] The starting point was an easily overlooked statement embedded in the *Phenomenology*, a startling, counter-intuitively positive account of the relationship between vision, violence and the ethical that challenged, in advance, the anti-ocular

positions that were formulated by post-Merleau-Pontean thinkers working later on in the twentieth century:

> Perception . . . asserts more things than it grasps: when I say that I see the ash-tray over there, I suppose as completed an unfolding of experience which could go on *ad infinitum*, and I commit a whole perceptual future. Similarly, when I say that I know and like someone, I aim, beyond his qualities, at an inexhaustible ground which may one day shatter the image that I have formed of him. This is the price for there being things and 'other people' for us, not as the result of some illusion, but as the result of a violent act which is perception itself.[31]

Although Merleau-Ponty's ideas, here, were admittedly tied to an exploration of the workings of perception rather than self-showing per se, it seemed to me that the trajectory that was steadily being opened up was precisely in the direction of the latter.[32] Again, I return to this in 'Image wars', in the section titled 'A productive violence'. Since Merleau-Ponty's thought has such an important, ongoing role in this book, and in order to undergird the position I have just indicated, arguably two specific remarks are worth making.

The first concerns Merleau-Ponty's resolutely embodied, non-dualistic understanding of the relationship between visuality and thought, and its philosophical implications. The philosophical foundations for his non-dualistic thought were already persuasively set out in his first book, *The Structure of Behaviour* of 1942, and in the *Phenomenology*. For in these works, drawing not only on the writing of such phenomenological forerunners as Husserl and Heidegger but also on current research in the human and cognitive sciences, he developed an existential phenomenology that both challenged and provided viable alternatives to what were then the two dominant modes of philosophical thought in France: rationalism and positivism. This search for alternatives always unfolded within the context of his in-depth explorations not only of existing ideas to which he felt attuned but also those with which he disagreed. For instance, although he ardently disavowed rationalism, during this period and throughout his career one of his most important interlocutors was the 'father' of rationalism, René Descartes, whose works he read and reread. Likewise, although he rejected scientific adherence to strict notions of causality and to what he called 'the objectivist prejudice', he consistently developed his thought with regard for, and with reference to, developments that were occurring within the sciences. This orientation of indebtedness to diverse philosophical and scientific sources impacted on his engagement with perception and visuality and shaped his understanding of the visual field as both constructive and responsive, inventive and receptive in character. Also notable about his orientation as a whole was an approach

to the philosophical, the political and the ethical that disavowed absolutism and remained always open to reconfiguration – while also always refusing to opt for an easy relativism. As he put it in his inaugural lecture at the Collège de France in 1952:

The philosopher is marked by the distinguishing trait that he possesses *inseparably* the taste for evidence and the feeling for ambiguity. When he limits himself to accepting ambiguity, it is called equivocation. But among the great it becomes a theme; it contributes to establishing certitudes rather than menacing them. Therefore it is necessary to distinguish good and bad ambiguity.[33]

At the same time, 'Even those who have desired to work out a completely positive philosophy have been philosophers only to the extent that, at the same time, they have refused the right to install themselves in absolute knowledge.'[34]

Thus, commentators are correct in saying that although, as noted, Merleau-Ponty's writing engaged consistently with political and ethical questions, he nonetheless did not attempt to formulate a politics or an ethics as such. This orientation has a bearing on Merleau-Ponty's understanding of the visual and its relation to the discovery of truth. For instance, as I will discuss in greater detail in the second chapter of *Showing Off*, 'Appearance is everything', Merleau-Ponty insisted that because visuality is a fundamentally intercorporeal, thus always situated and mediated phenomenon, it is one in which processes of distortion and misrepresentation have unavoidable but important roles to play in our quests to engage with facticity. As he put it in his essay 'The Primacy of Perception': 'It is not accidental for the object to be given to me in a "deformed" way, from the point of view [*place*] which I occupy. That is the price of its being "real".'[35] Here again purported weaknesses of the visual are presented as paradoxical strengths.

The second remark I want to make about Merleau-Ponty's project concerns the way in which he consistently made the experiences of visual artists paradigmatic for his thought. Of particular interest were the ways in which painters engaged with the world perceptually, and, from this experience, were able to break out of already established perceptual and pictorial conventions to discover new communicative and conceptual models. In 'Eye and Mind', for instance, he cites artists' descriptions of the experiential shifts that take place as they go about creating their work. Thus he refers to the ways in which, in practice, the roles between painters and the visible frequently come to be reversed such that 'painters have said that things look at them'.[36] Of interest to him are emerging scenarios in which 'it becomes impossible to distinguish between what sees and what

is seen, what paints and what is painted'[37] – situations in which, importantly, a distributed sense of agency becomes apparent, that is, a sense of agency that is not limited to human will and action. Likewise, the work of art at its best 'mixes up all our categories in laying out its oneric universe of carnal essences, of effective likenesses, of mute meanings'.[38] It is this which gives it its expanded, revelatory rather than representational character. In 'Eye and Mind' he described this work with which painters par excellence were involved with the highest degrees of awareness as 'the labor of vision'[39] and, elsewhere, as the result of an 'inspired exegesis'.[40]

Given Merleau-Ponty's focus on generativity, however, it is significant – and for some, puzzling – that, at the time of writing, his attention was focused on artists who, by then, might have been regarded as somewhat outmoded. His artist par excellence was Paul Cézanne, and his focus was largely on painters working in the figurative tradition. Indeed, René Magritte, in a letter written in 1962 to the philosopher Alphonse de Waelhens, was dismissive of Merleau-Ponty's artistic choices: 'The only kind of painting Merleau-Ponty deals with', he wrote, 'is a variety of serious but futile divertissements of value only to well-intentioned humbugs'.[41] Certainly, Merleau-Ponty had little to say about artists involved in various forms of conceptual practice – Merleau-Ponty was, after all, a younger contemporary of Marcel Duchamp – or about artists working with photography or the moving image. Nonetheless, as I will show, his phenomenological observations have a powerful bearing on visual works of all kinds. This is because the 'labor of vision' with which his painters were involved, far from being exceptional, elucidated the (albeit often overlooked) visual structures of the world at large. In fact, in 'Eye and Mind' he emphasized this point by insisting that the paradoxical reflexive interactions that are so often at the heart of the artistic process are also *prefigured* at a pre-human level through the operations of that ordinary device – referred to earlier – that most of us use every day: the mirror. No wonder, then, that these objects have held a long fascination for artists. 'More completely than lights, shadows, and reflections', he wrote in the lead-in to the mirror-passage cited earlier, 'the mirror image anticipates, within things, the labor of vision'.[42] In *Showing Off*, I follow Merleau-Ponty in making the experiences, and also the work, of artists paradigmatic. This brings me to the third and final matter that I wanted to expand upon concerning the conception of 'philosophy of image' that is at issue in this book. It has a particular bearing on my methodology.

An ideographic approach

In *Showing Off*, I take a highly particularized (or ideographic) approach towards generating certain non-conventional perspectives on the nature, workings

and impact of the self-showing world. At issue are not only the ways in which I foreground art and the particularities of specific art works when constructing my arguments but also the idiosyncratic and perhaps apparently arbitrary nature of the various visual and other references that I bring into play.

This fact might raise more general questions about the philosophical validity of my discussions. This is why I opened this chapter with an initial attempt at anticipating and addressing such concerns and why I also drew on Merleau-Ponty's thought within that context. Now I would like to expand on this by turning, specifically, to the paradoxical but philosophically crucial relationship he articulated in his writing between two key concepts: particularity and universality, the latter being a concept that he insisted on retaining albeit in a redefined form. This time, I turn to a section of his 1952 essay 'Indirect Language and the Voices of Silence' in which he addresses the question of why, when we live in the midst of such diversity, we speak collectively nonetheless of being involved in 'a' world and in 'a' history[43] – a question that I will also address, in depth, in the book's final chapter, 'Sacred Conversations'. As indicated by the essay's title, this question, and the essay more broadly, was to a large degree provoked by a then recently published work, *The Voices of Silence* of 1951, an encyclopedic study of world art, past and present, written by Merleau-Ponty's contemporary, the art critic, writer, explorer and statesman André Malraux.[44] Merleau-Ponty particularly responded to a perspective on art that he found somewhat surprising, namely, Malraux's claim that the extreme stylistic fragmentation characteristic of modern art was a threat to collective understanding and cultural cohesiveness because the commonalities required for interpersonal communication had been made unavailable. Merleau-Ponty began by stating that Malraux had, in general, made a good analysis of the 'objectivist' or representational prejudice with respect to language or expression which 'is challenged by modern art and literature'.[45] But he then suggested that:

> perhaps he [Malraux] has not measured the depth to which the prejudice is rooted. Perhaps he has too swiftly abandoned the domain of the visible world. Perhaps it is this concession which has led him, contrary to what is to be seen, to define modern painting as a return to subjectivity – to the 'incomparable monster' – and to bury it in a secret life outside the world. His analysis needs to be re-examined.[46]

And indeed Merleau-Ponty went on to express the alternate and apparently paradoxical view that the 'problem' presented by modern painting was in fact the inverse, that of 'knowing how one can communicate without the help of a pre-established Nature which all men's senses open upon, the problem of knowing how we are grafted to the universal by that which is most our

own'.[47] In other words, what Merleau-Ponty saw to be affirmed here was the robustness of communication and the reality that genuine, that is, open and exploratory communication, is always fired by the attractions and obscurities of difference. A shared world is possible *because of* and not despite the individual nature of our perspectives and communications. Our connections are strongest where individual functioning displays the highest degree of idiosyncrasy.

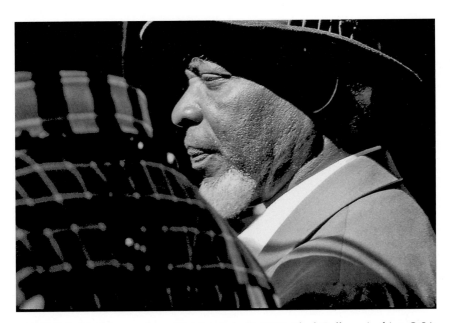

FIGURE 2 *Liz Johnson-Artur, 'Brixton Splash', 2013, Black Balloon Archive.* © *Liz Johnson-Artur. Reproduced with permission. http://lizjohnson-artur.blogspot.co.uk*

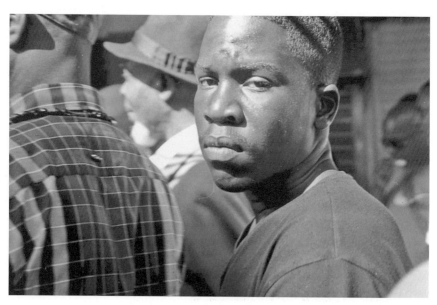

FIGURE 3 *Liz Johnson-Artur, 'Brixton Splash', 2013, Black Balloon Archive. © Liz Johnson-Artur. Reproduced with permission. http://lizjohnson-artur.blogspot.co.uk*

1

Would the film of your life . . .?

Image-world inclinations

We enter upon a stage which we did not design and we find ourselves part of an action that was not of our making.

ALASDAIR MACINTYRE[1]

In this chapter – and before more directly addressing self-showing itself in the rest of this book – I begin my investigation of the contemporary image-world by delving into three circuits of meaning within Pushpamala N's *Indian Lady* that I think highlight important image-world tendencies. It is often against, and always in relation to these tendencies that contemporary attempts at self-showing, and the ethics connected with them, must unfold.

Backstories

My initial description of *Indian Lady* was focused on its overt subject-matter: a sari-clad woman performing a Bollywood-style dance routine, coyly and amateurishly on a makeshift stage. This short scene was presented by the artist in the format of a repeating video loop; it might go on ad infinitum. Early on I also interpreted the work as a possible cycle of 'appeal to, and retreat from, public scrutiny' or of 'ambition, and thwarted ambition, to express and impress' – issues to which I will return later on in this chapter. But I also wrote that the energy and insistence of those repeated returns on stage embodied a determination to 'lay claim to the visible' despite the many difficulties and weaknesses that are associated with it. These difficulties and weaknesses include our sense that much of the visible realm operates outside of our direct control, even outside of our conscious awareness. Nonetheless, unless we

intervene, it shapes who and how we are, and how we are perceived by others. Therefore, the first circuit of meaning I want to follow concerns the many circumstances or backdrops against which our lives inevitably figure and in relation to which they are invariably judged. Or, turning to the writing of American moral philosopher Alasdair MacIntyre, and in order to underline the unfolding, temporal character of these lived backdrops, the *narratives* that shape our lives. These backdrops and narratives, I would add, have the immediate appearance of being highly coded, predictable and overdetermined. But, if identified – they are often so normalized that they have become near imperceptible – if entered into and diagnosed from a lived, and not just an intellectual perspective, they inevitably open up and out. In any case, they compose the entangled and contradictory realm in which we are entrenched, *and* in which all manner of self-showing agencies, our own and those of the world, may be discovered.

In his 1981 book *After Virtue*, MacIntyre insisted that it was only through this lens of narrative that investigations of identity and agency, topics that were being much debated during this period, could be adequately pursued. Defining mankind as 'essentially a story-telling animal'[2] in our actions and practices as well as our fictions, he also underlined that:

> we are never more (and sometimes less) than the co-authors of our own narratives. Only in fantasy do we live what story we please. In life, as both Aristotle and Engels noted, we are always under certain constraints. We enter upon a stage which we did not design and we find ourselves part of an action that was not of our making.[3]

For this reason, he insisted, 'I can only answer the question "What am I to do?" if I can answer the prior question "Of what story or stories do I find myself a part?"'[4] The ethical importance and impact of this question is clear. In addition, we need to understand that just as we tend to put ourselves centre-stage, even in those stories of which we have only limited awareness and control, so we are likely, at best, to be only on the periphery of other people's stories. 'In my drama . . . I am Hamlet or Iago or at least the swineherd who may yet become a prince, but to you I am only A Gentleman or at best Second Murderer.'[5]

Like MacIntyre's *After Virtue*, but communicating through visual rather than word-based means, *Indian Lady* is an early example of how Pushpamala's work in general brings into focus the complex, sometimes enabling but often profoundly undermining stories, agendas and practices that surround individual and collective life. The fact that *Indian Lady* is a silent film underlines the largely non-explicit ways in which those narratives become embedded in us, and we in them. In this respect her work is

diagnostic, but the strongly visual character of her interventions opens up suggestive rather than explicit routes into otherwise difficult to access territory. In addition, and as discussed in the previous chapter, these are indirect routes that also loop back into our own situations as viewers. Positioned slightly off guard by the work's capacity to direct our attention 'elsewhere', we find ourselves better able to consider the backstories and backdrops that shape and possibly also constrain our own lives. What are our imputed roles within those stories, and what alternative roles might we want, or need, to play?

Indian Lady's ability to reposition us in this way is largely because of the literal way in which it repeatedly pushes its own background into the foreground. For the more we watch its image-loops, the more we realize that it is not only the woman's performance but also the backdrop against which she performs that is important. In fact, the woman is on stage for only half of the video's short duration. The rest of the time – a few seconds at the beginning of the image-loop and considerably longer in its final part – it is the backdrop's painted city scene that fills the screen, its surface disturbed into ripples and billows as the woman, having exited the stage, now passes behind it from left to right. Then, as she pulls it aside somewhat in order to reappear on stage, we catch a glimpse of a third scene a little further back: what looks like a small portion of wall and two closed doors. In other words, the video reveals details of the everyday spaces and structures that surround and inform that performance on stage. Questions of staging, and of figure–ground relationships, are reinvestigated in much of Pushpamala's later work. The encyclopedic photo-performance project, *Native Women of South India: Manners & Customs* (2000–4), made collaboratively with the artist Clare Arni, is a case in point.[6]

As indicated in the previous chapter, *Indian Lady*'s painted cityscape could be interpreted as a generic image of an idealized modernity, and as an aspirational image. To those in the know, however, it is also a recognizable representation of the Mumbai skyline. In fact, the backdrop image was sourced in a standard Mumbai postcard. Therefore, and given its visual prominence within the video, it is a small step for viewers of *Indian Lady* to interpret the video as dealing not only with the performance of an individual life but also with its embeddedness within conditions, aspirations and contradictions associated with the life and times of Mumbai, and of India more broadly, during a period when both city and nation were carving out places for themselves within a modern global economy and its increasingly globalized mass cultures.[7] Here, extremes of wealth and poverty, esteem and misery exist side by side. This is partly due to the possibilities and problems associated with scale. During the 1990s, Mumbai's already large population grew to above the 10-million mark, bringing it to megacity status. A decade

or so later, it was among the world's top ten such cities[8] and in 2009 it was named an Alpha World City, that is, a city identified as having key global financial and commercial significance. It is now home to some of the world's wealthiest inhabitants and, as noted, it is where the most glamorous and the most escapist branch of India's film industry is located. But as Pushpamala herself has put it – she lived and worked in Mumbai during the late 1980s – the city's harsh urban realities of wretchedness and hypocrisy and its long association with the convention of the 'wicked metropolis' are undeniable.[9] This remains the case. According to a 2006 report – the most up-to-date report I was able to find – slum dwellers make up a staggering 54 per cent of Mumbai's population.[10] In addition, India, with a huge percentage of its population living below the poverty line,[11] finds itself positioned amidst the paradoxes of escalating globalization and privatization as one of the world's biggest providers of cheap, but technologically advanced outsourced industrial and post-industrial labour.

But this is not all. Since India's post-war Independence, and despite its status as the world's largest democracy, the nation has been plagued by sectarian violence. Indeed, on 12 March 1993 (just four years before Pushpamala produced *Indian Lady*), Mumbai, which has been a site of ongoing Hindu–Muslim violence since 1947, was torn apart by bomb blasts that left at least 250 people dead and around 1,100 injured. Bouts of sectarian violence in the city some months earlier had resulted in the death of around 900 people. Arguably, therefore, it is difficult when watching *Indian Lady*'s shaking and billowing urban backdrop not to be reminded of what were, in 1997, still open wounds. Indeed, it was in order to engage with these urgent issues as proactively and powerfully as possible, and to take a stance against sectarianism as a prevailing cultural attitude in favour of new forms of liberal secularism and cultural critique, that Pushpamala's artistic project – and that of several other contemporary Indian artists – evolved as it did during the mid-1990s, conceptually, formally and methodologically.

Also of note, of course, is that the contradictions and instabilities just described also characterize the workings of *Indian Lady*'s most overt reference: Bollywood. Bollywood is perhaps the most influential cultural backdrop to life in India and in the Indian diaspora and an industry so prolific that already by the 1970s India had overtaken the United States as the world's biggest producer of films. Since the turn of the twenty-first century, Bollywood, and Bollywood aesthetics, have circulated around the globe as a prominent, although by no means mainstream, brand.[12] This is despite the fact that Bollywood and its productions have frequently been described as second-rate when compared to Hollywood standards. In his 2006 book *Brand Bollywood*, for instance, the journalist Derek Bose described these productions as content-weak, upholding 'a tradition of film-making replete with mindless songs and dances,

star-crossed lovers, ostentatious celebrations of glamour and spectacle, lost and found brothers, convenient coincidences and happy endings'.[13] They have also been described by others as narrative-weak in a Western (Aristotelian) sense. As film theorists Rajesh Devraj and Edo Bouman put it in the introduction to their 2010 book *The Art of Bollywood*:

> Bollywood has given birth to a famously hybrid form of cinema that mashes together Indian and foreign influences. For Western viewers accustomed to their own traditions of storytelling, the Bollywood narrative often seems a mere device to present extravagant song-and-dance routines, high-strung emotion, comic interludes, fights, and a host of other elements. This kind of film is commonly known in India as the *masala* film, after the Hindi word for a spicy mix.[14]

Interestingly, as another film scholar, Ravi Vasudevan, has pointed out, a plausible reason for this may be due in part to Bollywood's pre-cinematic links with the popular Parsi tradition in theatre. Vasudevan writes that although the Parsi community in India, which had migrated from Persia centuries earlier, were 'an entrepreneurial group which developed close ties with colonial enterprise' and were therefore regarded as figures of modernization, Parsi theatre 'from the mid-nineteenth century displayed a number of linkages with pre-modern narrative and performance traditions' and was characterized, among other things, by 'a universe driven by a repetitive dynamic, rather than one governed by a transformative, conflict resolving logic'.[15] This repetitive dynamic is of course also the overriding logic of Pushpamala's piece.

In addition, Bollywood film-making is known for the often chaotic administrative and financial arrangements that underpin (or in many cases fail to underpin) it, making it vulnerable not only to inefficiency but also to exploitation, including financial and other entanglements with India's criminal underworld. This was in part exacerbated by the fact that up until 2001 the Indian government had consistently refused to assign Bollywood legal status as an industry. Thus, until recently, Bollywood producers were unable to secure support and security from tax and other governmentally approved benefits.[16] Furthermore, although, as indicated, a great number of films are made each year, it nonetheless remains the case to date that, partly due to low ticket pricing, the Indian film industry consistently generates a relatively small share of the global market where film revenue is concerned.

Returning to *Indian Lady*, then, it is also to this complicated cultural, economic and political world that the video refers, a world broader by far than that of the enclosed performance space that is more immediately presented to us. The referential richness of the video opens up still further, though, if

the backdrop's physical production and materiality are also considered. For Pushpamala reports that the backdrop was created by a hoarding painter whom she had employed to enlarge a postcard-sized representation of the city onto a large piece of cloth. This is significant. By incorporating this transaction into the rationale of the video-piece, she drew particular attention to the place and power of a commercial art form that has little or no contemporary impact in the West but which, still in 1997, and until digital methods began to take over at the start of the twenty-first century, had exceptional ideological force in India. As she has put it, in India hoarding painters 'design everything . . . from public arches, temple architecture and ashram complexes to film sets and TV series, theatre backdrops, festival tableaus and political cuts outs'.[17] Thus, they are continuously defining contemporary Indian culture 'with their weird, kitschy, eclectic mix of images . . . creating a strange continuum between dream, commerce, reality and exploitation'.[18] With remarkable throwaway precision, therefore, *Indian Lady* can now also be seen to be calling all of this into play.

Hoarding paintings also return us to Bollywood. Until recently, they were one of the primary means of promoting Bollywood films within urban and public space. Such enormously sized handmade works could promote these films via images created at a vast scale not easily achievable using pre-digital photographic techniques. (Beyond a certain size, for instance, unmanipulated photographic images of this kind would look distorted.) In addition, since each hoarding painting was individually produced in one or other of the numerous workshops located across India, it also allowed for a highly customized promotional approach to be taken. It enabled a given film, distributed nationally, to be advertised differently in different locations; hoarding painters would draw from a film's eclectic content those aspects of it – the romance, perhaps, or the violence, or the comedy, or this or that film star – that would most appeal to the preferences of particular regional audiences, thus boosting ticket sales in a nation where, as Devraj and Bouman have put it:

Bollywood has colonized . . . popular culture thoroughly. For decades, filmi music was the only pop music in India, and the music industry condescendingly referred to non-film releases as 'private albums'. Other arts were also pushed to the margins, and, today, Hindi cinema's influence can be seen everywhere, from television, fashion, and advertising to the very language of the streets. Its images pervade the visual culture of the subcontinent, leaving their mark on religious prints and street signs alike. They dominate public spaces everywhere – Bollywood produces publicity images on a scale that has transformed the urban environment in India, turning entire cities into galleries for its giant displays.[19]

The rationale for Devraj and Bouman's book is to examine these popular art forms, works that have been given very little critical attention by scholars, in order to understand more about the workings of Bollywood and of its hold on public imagination. But, in a different way, *Indian Lady* was already doing the same thing in 1997. It was highlighting aspects of the ideological constructions surrounding an individual life and an apparently simple performance. The inclusion of the hoarding painter's work within a scene otherwise unfolding within what looks like an ordinary, enclosed space of display, underlines the way in which this intensely image-saturated urban environment plays a dominant, but often unnoticed – because naturalized – role, locking subjects into repeating cycles of escape into the realms of archaic fantasy. Again, what this does is direct us to consider our own different but not dissimilar situations in this respect.

Past–present

The second 'circuit' I want to discuss is provoked by a quality that imbues not only the painted backdrop just discussed but also the video's own surface texture and colour: fadedness. Although Pushpamala's video-work was filmed in the last years of the twentieth century, it resembles a snippet of low-resolution archive footage. Pretending to record an unaccomplished attempt at amateur dramatics, or part of a long-forgotten talent show, it seems to take us back in time to a scene that is at once aspirational and out of date, behind the times, and unable to catch up. This sense of disparity is highlighted by the juxtaposition of the woman's enactment of tradition with the backdrop behind her, which seems to downgrade her performance in two ways. First, by means of contrast, through the backdrop's schematic reference to the new and glamorous (the high-rise Mumbai skyline). And second, by means of congruence, through its hand-painted shabbiness. But this is a tension that we can all recognize. More often than not, it seems, our lives play out against a backdrop – certainly a media backdrop, although there are many others – that seems configured to minimize who we are and what we have by highlighting our and their insufficiencies. Returning to *Indian Lady* and its broader contexts, this is also a tension associated by some theorists with the self-perception of once colonized nations, such as India, certainly within their early post-colonial eras. As Vasudevan put it in *The Melodramatic Public* (citing Matsushiro Yoshimoto's essay 'Melodrama, Postmodernism and Japanese Cinema'), post-colonial nation states emerging after World War Two were consistently animated by 'a sense of lack . . . a sense that we are always going to be unable to catch up with those who were the original creators of modernity'.[20] But a question we must surely ask as we view *Indian Lady*, from our vantage point in the present (here is another way of responding to that

shaking and billowing backdrop), is to what degree modernity's well-rehearsed narratives of progress might not themselves now be outmoded? And to what degree, so long as those modernist myths are adopted and internalized in a wholesale manner in developing nations, they prevent other, differently productive models from coming into circulation, locally and globally?

But as well as referencing outmodedness, fadedness in *Indian Lady*, and in Pushpamala's work more generally, also points to her ongoing concern with *pastness* as a cultural and social force within the present. Here, a point of focus is on the workings of pastness ossified into powerful stereotypes, including those that are promoted by popular culture, and their impact on the lives of women in particular, which brings us back to *Indian Lady*'s sustained and multilayered engagement with Bollywood and its legacies.

Indian Lady's quality of fadedness – the somewhat shabby, hand-coloured appearance not only of the painted backdrop depicted within it but also of the video's own surface – is like a humble approximation of Technicolour. By these means *Indian Lady*'s general referencing of Bollywood traditions and aesthetics becomes historically specific. As film theorist M. Madhava Prasad has put it, her work recalls 'Hindi movies of the 1960s',[21] a period in Indian film-making significant for a number of important transitions, some at the level of meaning and value, and others of a technical nature at the level of production. The latter included the widespread transition from black-and-white to colour filming, and an aesthetic shift that would see Indian commercial films become increasingly, indeed exceptionally spectacular and extravagant. These were phenomena which were much in evidence in the film that Prasad particularly references in this regard: the actor, director and producer Raj Kapoor's first colour film, *Sangam*, from 1964, which was notable for its pioneering use of Technicolour as well as for its location shoots abroad – in France, Italy and Switzerland – its memorable score and numerous songs, composed by the prolific duo Shanker Jaikishan, and its considerable length. The film was a hit when it was released, and is still considered a classic today. As I will show, within the context of our broad discussions of the contemporary image-world and its challenges, Prasad's association of *Indian Lady* with *Sangam* is worth pursuing. In the first place, Pushpamala's video is directing our attention to a film that was created in a historical and cultural context in which questions of tradition and stereotype, and how best to navigate them, were being struggled over in a new way. In the second place, I will argue that an analysis of *Sangam*, its melodramatic aspects notwithstanding, reveals a treatise on the ethics of honest self-disclosure or self-showing. Moreover, its most important insights address and challenge popular Western assumptions about ethics, identity and community.

As carriers of innovation *and* conveyors of tradition, Indian commercial films from the 1960s were often ambiguously positioned with respect to

India's own cultural past. As remains the case in Bollywood today, films such as *Sangam*, while set in the present, habitually drew on traditional narratives, typologies and morals derived from the ancient epic traditions of the *Mahabharata* and the *Ramayana*. The latter, for instance, centres on the exploits of Lord Rama, an avatar of the god Vishnu, who has come to earth to defend the righteous against the unrighteous. It tells of his journeys while in exile and focuses, among other things, on his quest to rescue his wife, Sita, an avatar of the goddess Lakshmi, from the clutches of his demonic opponent, the violent, materialistic and egotistical Ravana. In so doing, the Ramayana elaborates on the duties of right relationship and presents character ideals such as the ideal father, brother, wife, ruler and servant. In this way it sets out the concept of dharma, a complex term that is rooted in a notion of natural as well as cosmic and ethical order, and examines the relationship between adherence to dharmic principles – which might be expressed as doing the right thing, at the right time, in the right way, for the right reasons – and freedom. *Sangam*, which is the highly dramatized and emotive tale of an ill-fated love triangle, engages with these traditions in two ways. First, through its plot, the issue that is most obviously played out is an ethical one about the relative claims of friendship over romantic love. Also of note, though, is the sense that, from this traditional perspective, the three-way relationship at the core of the film's narrative must indicate an adharmic or disordered situation which must in some way be resolved. To a degree, though, in *Sangam*, and certainly for Pushpamala, the point at which dharmic ideals turn into damaging cultural stereotypes may not always be easy to discern. Second, the film's title, *Sangam*, or *Confluence*, refers to one of the most sacred sites in India for the ritual washing away of sin, the Triveni Sangam in Allahabad, formerly known as Prayag or Prayag Raj. A mythic place of cosmic reconciliation, and, in the *Ramayana*, a location visited by Rama during his travels, here, three great rivers meet. Two are physical rivers, the muddy Ganges and the clear, blue Yamuna. The third is the invisible Saraswati, which is believed to well up to join them from underneath the ground. At the end of *Sangam*, in case there is any doubt, the film's three main characters – I will return to them shortly – are overtly identified with these three rivers.

In *Sangam*, however, and in films like it, these traditional values were typically played out against a complex historical, cultural and political backdrop. They were produced during a period when India was trying to break away from the impact of its long colonial past – many Indian films since the 1930s had had a strong focus on questions of Indian identity in which, inevitably, the exploration of traditional values played an important role. But in the 1960s, this was also a nation clearly seduced by Western consumer culture, and attempting to participate in a burgeoning global economy largely orchestrated

by the successors of its old colonial masters. Indeed, in India during this period, film – which from the early twentieth century quickly became, and remains, India's most popular, pervasive and influential form of entertainment – was an important site for working through dilemmas of this kind.[22] As indicated, for instance, one filmic development increasingly dominant during the 1960s was the practice of on-location shooting abroad, which provided escapist settings in which these competing values – East versus West, traditional versus modern and consumerist – could be juxtaposed. Thus, this was a post-colonial moment in which Indian film-making and the Indian mindset more broadly were beginning to reopen to the rest of the world. Film sequences of the period, set in foreign locales, are often described by commentators as functioning for their audiences much like tantalizing travel brochures. But they often also presented scenes in which traditional Indian cultural and ethical mores could be voyeuristically suspended and virtuously supported at the same time. Admittedly, as evidenced by the tagline through which *Sangam* was promoted – 'Ageless as Asia, Exciting as Europe' – here benign and indulgent rather than censorious attitudes towards exotic Western values were being forged.[23] In general, though, if I may cite Devraj and Bouman one last time:

> [T]he 1960's belonged to a generation that saw the new consumerist culture of the West as glamorous and cosmopolitan. However, despite its faithful replication of trendy Western fashions and bouffant hairdos, the 1960's film retains an ambivalence about Western culture. . . . Movies . . . offered the Indian audience a glimpse of denied pleasures: tours of the sights in swinging London or fashionable Beirut, with occasional voyeuristic detours into nightclubs and casinos. Yet . . . any direct engagement with the corrupting influence of the West was ruled out. Filmmakers sermonized piously about the superiority of the ancient East, even while their cameras sidled up to all those shameless blondes and looked up their skirts.[24]

Even in films from the 1960s set entirely in India, their eclectic content often unfolded in glamorous environments displaying the latest luxury items (furniture, cars and clothes), thus promoting the kinds of ultra-wealthy, cosmopolitan lifestyles for which Mumbai itself is known today – to reiterate a point made earlier, despite the still endemic poverty of what is now one of the most populated cities in the world, Mumbai is also listed by *Forbes* among the top-ten cities for billionaires. And of course – ironically – during the mid-1960s and into the 1970s, just as Bollywood films were offering their audiences tantalizing views into the West, and, directly or indirectly, promoting such values as mass and hyper consumerism, so in the wider world, particularly

through the then-emerging hippie movements in the United States and Europe, increasingly influential grassroots subcultures were attempting to challenge precisely those materialistic values, often by embracing suitably abridged or adapted versions of Hindu-based spirituality.

Importantly, though, by making references of this period in Bollywood's evolution, and to Bollywood conventions and values more broadly, Pushpamala's aim was not to be nostalgic, or just to produce a piece of cultural history. As Prasad, again, has put it, although *Indian Lady* is 'set in the past . . . the past is present here not only as a signified of the narrative but as an assemblage of signifiers: the past of genres, photographic and cinematic'.[25] As indicated, one aim was to interrogate the ongoing impact of these 'signifieds' and 'signifiers' in relation to female identity, paying particular attention to the ways in which traditional stereotypes and various conflicts between tradition and modernity are played out here. For this reason, *Indian Lady* is often described by the artist and others as a distilled critique of the way in which popular cinema, and popular culture more generally, reproduces and upholds 'antiquated perceptions of women', with women idealized to the degree to which they figure as guardians of tradition.[26] Within this context, the video's cycles of repetition are taken to emphasize both the pervasiveness and the underlying emptiness of this commerce in gender stereotyping. And yet, looking at her work, it is difficult to describe it as having an emphatically oppositional character in this regard. Indeed, if we recall that Pushpamala is a performance photographer and that she *herself* is the Indian lady cavorting on stage, it becomes clear that her art practice is neither one of just duplicating stereotypical representations, nor of rejecting them outright, but of inhabiting them, even animating or reanimating them. In this way, it seems to me, the stereotype itself, consistently and rightly theorized as having such an overwhelmingly powerful negative social and cultural force, is presented not only as that which we fear due to its reductiveness but also as that which we frequently love for exactly the same reason, since it provides us with a clearly defined protective screen behind which we can hide, and in relation to which we can pretend to express ourselves. As the political journalist Walter Lippmann wrote, long ago, in his classic 1922 book *Public Opinion*, in a chapter devoted to an analysis of the stereotype and its role in creating falsifying pseudo-environments:

> A pattern of stereotypes is not neutral. It is not merely a way of substituting order for the great blooming, buzzing confusion of reality. It is not merely a short cut. It is all these things and something more. It is the guarantee of our self-respect; it is the projection upon the world of our own sense of our own value, our own position and our own rights. The stereotypes are, therefore, highly charged with the feelings that are attached to them. They

are the fortress of our tradition, and behind its defenses we can continue to feel ourselves safe in the position we occupy.[27]

Arguably, and although certainly irrational, this sense of willing accommodation can even be applied to stereotypes we would define as negative, and through which we are in turn negatively defined. Ones that, far from adopting, we should dismiss as repellent. But perhaps this is not surprising. As Lippmann put it a little later on in the same chapter, the stereotype is an obstacle to reason and, I would add, also to the proper functioning of perception understood in its broadest and most challenging sense. 'Its hallmark', he writes, 'is that it precedes the use of reason'.[28] It 'is a form of perception' that:

> imposes a certain character on the data of our senses before the data reaches the intelligence. . . . There is nothing so obdurate to education or to criticism as the stereotype. It stamps itself upon the evidence in the very act of securing the evidence.[29]

It is this well-defended, falsifying and thus dangerous, but nonetheless seductive realm of the stereotypical that Pushpamala inhabits and enacts, fleshing it out in her carefully considered, and knowing way – and yet with a light touch. But because she does so, something of its deeply embedded and apparently autonomous force is transformed into a matter of transaction and choice. And in this respect the power of the stereotype begins to be subverted. Thus, as with all good art, in this way the work upon which we are focused, *Indian Lady*, quietly breaks through that fortress referred to above, making us look at that which, for a mix of personal and culturally informed reasons, we are conditioned at once to accept and ignore. But what are the particular stereotypes that Pushpamala is trying to address here? And what of their broader relevance where the challenges of self-showing in general are concerned?

Although Prasad does not make this point in his essay on Pushpamala's work, given the thematic content of *Indian Lady*, a good sense of the issues she is trying to address can be gained by putting *Indian Lady* in conversation with *Sangam* and by taking particular note of *Sangam*'s treatment of *its* female protagonist within that broader context of a narrative exploration of love and friendship. By way of introduction, however, it is worth underlining that this exploration is one that cannot but remain relatively open to interpretation – like *Indian Lady*, *Sangam* has a discursive character that also accords with the discursiveness of India's epic texts themselves. For as the scholar Vijay Mishra has noted, these epics are 'marked by generic capaciousness and lack of closure'.[30] They are 'foundational texts that get endlessly rewritten,

though not necessarily endorsed. They are critiqued, their values challenged, their structures destabilized, even parodied, but they remain foundational nevertheless'.[31]

In *Sangam*, as in Pushpamala's *Indian Lady*, the leading female character, the alluring Radha – played by Vyjayanthimala, with whom Kapoor had begun an affair in real life – both is, and is not, the focus of this film. She is the focus in that she is the one whom the male protagonists, the wealthy, high-caste Gopal, played by Rajendra Kumar, and his poorer best friend Sunder, played by Kapoor himself, have loved since childhood. As quickly becomes apparent, though, the dominant theme throughout seems to be the intense friendship between Gopal and Sunder, its eventual fate, and the casualties it leaves in its wake. From this perspective, the female character could be seen as little more than a stage upon which that relationship between, and the desires of, the two men are played out. In the words of Mishra, in *Sangam*, as in other films by Kapoor, 'men desire, women are only desired or, as Laura Mulvey pointed out, the filmic apparatus simply forecloses women's desire'.[32]

Sangam's storyline may be divided into two parts. The first part establishes the intertwining relationships between the film's three characters. It establishes that while both Sunder and Gopal love Radha, Radha loves only Gopal. It establishes that while Sunder, the extrovert, is consistently and unashamedly vocal about his feelings, the introverted Gopal keeps his feelings of love hidden from both of them. And it establishes Sunder's absolute determination to win Radha's love against all odds. These odds are that Gopal is better marriage material, both responsible and respectable, and of course, that he is loved by Radha. In contrast, at the beginning of the film, Sunder is characterized as a personable if somewhat irritating joker and wastrel. Then, realizing he must make something of his life, he joins the Indian Air Force and sometime later is presumed to have been killed while on a dangerous mission. Gopal is shocked and saddened, but finally feels free to express *his* feelings of love to Radha, and they prepare to marry. In true melodramatic style, however, just days before the wedding, Sunder makes a heroic return. Without hesitation, Gopal again suppresses his love and, with what appears to be his wholehearted approval, it is Sunder who marries an apparently compliant Radha.

The second part of the film – *Sangam* lasts almost 4 hours – starts with the honeymoon of Sunder and Radha. This scene, a long, multipart sequence, is the one that is filmed in Europe. It is also notable for the shift that has occurred in Radha's apparent feelings for Sunder. Without any clear explanation of how this has occurred, she now seems to be in love with him. However, towards the end of the honeymoon and upon their return to India, the marriage is soon put under pressure because, unaware of Gopal's love for Radha, unaware of what had passed between Gopal and Radha while he was presumed dead, and ignoring Gopal's and Radha's consistent reluctance to

meet, Sunder keeps insisting that all three spend time together. Then Sunder discovers an unsigned love letter addressed to Radha. It had been written by Gopal during the time of their engagement and Radha had kept it, but Sunder believes that Radha is betraying him with an unknown third party. Grabbing his revolver, he interrogates Radha relentlessly, determined to find and kill her lover. Sunder torments her with endless interrogations. Finally, first Radha, and then, quite independently Sunder, go to Gopal's home to find solace, and it is here that the truth is finally revealed. Shaken, Sunder insists that he will leave the marriage so that Gopal and Radha can finally be together – despite Radha's protests to the contrary. Now married, she wishes to remain so. But Sunder refuses to acknowledge her wishes. And so, finally, in order to honour Radha – at last, perhaps, someone is listening? – Gopal takes Sunder's gun and shoots himself. Dying, he instructs Sunder to 'restore Radha to her heaven. . . . The true meeting is between Ganga and Yamuna, and for this to happen Saraswati must drown.'[33] The film ends with Gopal's funeral, presumably at the site of the Triveni Sangam.

According to one commentator, this ending should best be regarded as nihilistic:

> Saraswati represents 'intelligence, consciousness, cosmic knowledge, creativity, education, enlightenment, music, the arts, and power' and I wonder if Raj Kapoor the director, through the death of Gopal, has not wanted to allude to the destruction of all these civilisational values which were dying in our sophisticated world, where desire reigns supreme.[34]

But if it is viewed from the perspective of our discussions of self-showing and its relationship to the ethical, and of the ways in which such self-showing may be hindered, we see that Gopal is by no means blameless. This becomes especially apparent if, returning to the film's unfolding plot, we consider two questions.

Why, in the first place, *did* Radha end up marrying Sunder? At first sight, because Gopal chose to sacrifice his love for Radha in favour of his friendship for Sunder – Gopal is, here, the embodiment of the traditional hero-renouncer, the romantic figure who loses the one he loves. But in actuality it occurs for at least three intertwined reasons. In each of these Gopal plays a part. First, it occurs because Radha is embedded in a set of relationships in which she is never properly seen or heard, nor are her wishes taken into account. Early on, for instance, Sunder admits knowing that she loves not him but Gopal, but this only makes him more determined to pursue her. Worse, when Sunder is in the Air Force, Gopal, in his role as Sunder's self-sacrificing friend, purposefully misrepresents Radha's feelings to Sunder, leading him to believe that she has, after all, now come to love him. Sunder is ecstatic. But

the film also points to a deeper problem: that of Radha's general immersion, as a woman, in an environment that is culturally and naturally predisposed to block her attempts at genuine self-showing. It is an environment that is dominated by precisely those 'antiquated' and problematically gendered perceptions of women that Pushpamala's work specifically highlights and seeks to disrupt. The power and pervasiveness of this environment seems to me to be emphasized by the fact that throughout most of *Sangam* all of Radha's attempts to communicate her true feelings towards the two men are thwarted, not only by one or other conventional demand but also at a more elemental or uncontrollable level due to happenstance, interruption, misunderstanding or twist of fate. As I will show, however (and in contrast to Mishra's evaluation referred to earlier), Radha is no victim and, like Pushpamala's Indian Lady, rather than withdraw, she continues in her efforts to declare who she is – or who she has decided to be – and how she feels. As I see it, she is the one who finally emerges from the film as its most radical, and most radically free character. But more of that later.

A second reason, arguably, for Radha's marriage to Sunder making sense within the overall logic of *Sangam* is that even before Sunder has transformed from wastrel to war hero, he too had long been in the grip of a powerful cultural force. A powerful cultural stereotype, in fact: the figure of the conqueror whom nothing, not even death, can stop. From the very beginning of the film, when Sunder, Radha and Gopal are children, he is already absolutely single-minded with respect to eventually winning Radha for himself. This single-mindedness of his is exacerbated by his extreme extroversion, an extroversion which, instead of orientating him towards others, makes him impervious to them and horribly unreflective. In this sense, Sunder is both likeable and lethal. He is honest and open, but his honesty and openness are so impositional that they seem to leave no space for others to reveal themselves.

A third reason why the narrative unfolds as it does – and perhaps the most pertinent one where *Showing Off* is concerned – is revealed at the end of the film, during its final moment of truth. It is rooted in Gopal's equation of friendship with sacrifice, this time at the expense of honest self-showing. This makes him, too, insensitive to the needs and desires of others, and, indeed, dangerous. After all, as Sunder himself points out during their confrontation, it has now become clear that their lifelong relationship has been based largely on dissimulation. In the sequence in which each man is offering to renounce his love for Radha for the sake of the other, Gopal challenges Sunder to shoot him. 'Bravo Gopal!' is Sunder's ironic response:

Another sacrifice! Standing in your tall tower throwing alms to a beggar. But I am not a beggar. I'm your friend. I was, but you didn't understand. If you had, none of this would have happened. If you'd let me look into your

heart, if you'd let the fire burst out of your heart, three lives would not have been consumed by its flames.

And so, finally, back to Radha, and to the second set of questions I wanted to ask. What happened to her upon her marriage to Sunder, and why did she want to remain married to him? What happened, first of all, is that upon her marriage Radha immediately took on a new persona. She became the embodiment of the idealized dutiful wife. To begin with, arguably, she may have inhabited this role reluctantly, as something she felt forced into and reduced by. But during the honeymoon, and certainly by the end of the film when she insists that she wants to remain married to Sunder, her position is clear: 'Marriage', she says to Sunder, again in that final confrontation, 'is a duty one must nurture and I've nurtured it. Love may suffer, weep, smolder, but duty is a rock, not wax, and I'm not wax either.' With these words, therefore, she delivers an unexpected perspective on what most modern women would (in many contexts, quite rightly) regard as a negative trope, a constraining stereotype. In this way too, I think, she presents an added dimension to the ethical issue at the heart of the film: the nature and relative merits of friendship over romantic love. In *Sangam*, friendship wins out. But, as indicated, it is not the sacrificial friendship between the two men that provides the truly productive model. Rather, I would argue, it is in Radha's attitude towards Sunder that the most consistently powerful model of friendship exists, for two reasons. First, their relationship is built on honesty. Neither has lied about their feelings for the other and, as Sunder has made clear, at root it is honesty, not sacrifice, that provides the foundation for friendship – the courage to show another person what is in your heart. It is only in such a context that sacrificial love can have any meaning.

A second reason for validating Radha's friendship for Sunder above that of Gopal and Sunder is that Radha's impulse throughout is to invest everything she has into honouring, or as she puts it, nurturing reality over sentiment. As a result, after marriage, she does not allow the duty to which she refers, and her new role as a dutiful wife, to degenerate into something dry and bitter. Instead, she actively allows duty to transform into something empowering, even desirable. Therefore, if at one level, Radha might be regarded as the epitome of the stereotypical, dutiful wife, at a deeper level her experience challenges us to question and perhaps redefine our own understanding of duty, a notion that, in the West today, tends to be associated with personal diminishment or constraint. We are forced to ask whether an unsentimental commitment to duty really is an outmoded value, or whether, if successfully navigated, it might be radical and regenerative. Furthermore, we are asked to consider whether there is not a moment when a confluence *must* occur between desire (romantic love), honesty and duty if any relationship worth

its name is to survive. Perhaps, then – certainly for the sake of argument and with an eye on the realities of everyday experience – sentimental models that idolize romantic love above all else are the ones worth regarding as reductive, restrictive and outmoded since, on their own terms, they cannot provide the resources needed to pass the test of time? Perhaps Radha did not get what she wanted but got something better? Certainly, this is what the film's title, and its conclusion, indicate. Certainly, too, Radha has changed, seemingly for the better.

So much more could be thought and written about Radha. Particularly about the various ways in which the realms of ideals and of stereotypes negotiate their way through her, and the ways in which she, in turn, negotiates her way through them, in the first place by inhabiting them. In *Sangam*, of particular significance in this regard is that long honeymoon sequence – filmed, as noted, in several romantic sites in Europe. For not only is this the place and time in the film where Radha begins actively to nurture duty, interestingly it is also where, precisely through the figure of Radha, ideas about the modern, the Western, the non-traditional and the transgressive are most overtly processed. Key here is her flirtatious performance of Western sexuality – in the couple's hotel suite in Paris, and for the eyes of her apparently scandalized husband only – in the form of an impromptu burlesque. In this sense, therefore, there is a direct correlation between Radha's life strategy and Pushpamala's broad artist methodology which, as noted, is that of a performer identifying, inhabiting, testing and transforming circumstances that at first sight may seem profoundly undermining, even non-negotiable.

Stage fright (near-future technologies of showing and self-showing)

If *Indian Lady*'s combination of references and look – that quality of fadedness already discussed at length – evokes the past, it also points towards what were, in 1997, the emerging-present and near-future. This is the third circuit I want to pursue, and it operates on several levels.

Clearly, in terms of its depiction of an everyday, amateurish desire to perform in public, *Indian Lady* embodies the same sensibilities that were driving the escalation in popularity, during this period, of the now globally franchised television talent shows that are of such great appeal because they combine the apparent discovery, polishing and packaging of new talent with the spectacle of competition and elimination – a theme to which I will return. Perhaps less obviously but more interestingly, it also anticipates the impact of emerging technological developments within communication culture, namely, the visual aspirations, anxieties and often casual, do-it-yourself aesthetics that have been accompanying the mass availability of affordable, compact,

digital imaging and dissemination technologies since the mid- to late 1990s. During this period (which included the dot-com boom and its spectacular crash in 2001), new avenues for visual expression became widespread. The multimedia capacities of already popular weblogs increased, the personal and domestic use of webcams and webcam sites escalated, and with the release of web 2.0 in 2003 came Facebook in 2004, and a range of new participatory video and image sharing sites, including Flickr, also in 2004, YouTube a year later in 2005 and more recently, of course, Tumblr, Instagram, Snapchat, and so forth. But most notable was the emergence of the camera phone, first marketed in Japan in 2000, which meant that everyday communication via mobile technology – for those with access to it – was becoming not only increasingly common but also increasingly visual. Today, with in-phone cameras standard on most mobile devices, this flexible facility for creating, archiving and literally carrying a shareable image-repertoire around with us is a more or less normalized aspect of everyday life in the world's technologically developed regions. Nonetheless, despite the fact that rapid advancements in terms of pixel concentration, screen size and quality, and memory size have made these devices capable of taking, processing, storing, displaying and disseminating increasingly high-resolution photographs and videos, these technologies are still typically associated with forms of communication that are spontaneous, instinctive, opportunistic and 'unstaged': a kind of image-making that is about capturing fleeting impressions and passing attractions, and creating forms of documentation that may have no more than the most temporary or even disregarded of existences. This sensibility, repeatedly expressed and exploited by cultural producers from advertisers to artists, has also often been emphasized by mobile-phone marketers themselves, through their own strategic use of an apparently lo-res aesthetic within their advertisements. Perhaps nowhere most evocatively than in an early photo-messaging commercial produced for the service provider Orange: video-artist Chris Cunningham's stylishly deranged *Muck About* from 2002.

Cunningham's 40-second film is a compilation of apparently impromptu, snapped scenes of urban night life, transformed into an extraordinary sequence of blurred and strangely suspended images. Moving steadily from left to right, we see anonymous people doing everyday things: someone is interrupted while in the bathroom; some men, and then a couple of dogs, are hanging out on a plot of waste ground; a crowd of people are clubbing; groups of people are eating in a busy café, a man and woman are caught kissing, and the woman looks up in alarm. The video ends by panning along an urban street. The simultaneously provisional and arresting visual aesthetics (in fact, the director has used specialized cinematic techniques to make this ad), overtly undermine the film's voiceover in which a young, female, American, voice drawls conventional instructions for creating perfectly composed and

focused photographs perhaps from an old-fashioned photography manual. As she reads, her voice is intermingled with a discordant but compelling soundtrack – the beginning of *Barry 7's Contraption* by Add N to (X) – that imports a somewhat jarring, somewhat mechanical, and yet hypnotic sense of momentum into the imagery:

> When taking a photograph, make sure that your subject is ready . . . and that they are arranged in a suitably formal manner. This can be difficult with members of the animal kingdom. Avoid blurring by keeping movement to a minimum. Follow these simple rules and you'll end up with photographs you'll treasure for a lifetime.

Right at the end, the tone and tempo of the female voice changes. It becomes active and animated: 'Go on, muck about with free photo-messaging.' The message is clear. By promoting the mobile phone's evolution into a much more visually orientated device, the service provider was also declaring that this technology offers users the opportunity to participate – on their own terms – in the creation of new, deregularized and personal photographic aesthetics. Here, in other words, the commercial's lo-res aesthetics are associated not with the old, but with the new and experimental. As discussed earlier though, images are always multivalent in their meanings and affects. Also immediately apparent in Cunningham's film is the fact that layered into this atmosphere of implied agency is an atmosphere that is distinctly oppressive. At issue here is not that most of its depictions take the form of night scenes, but rather the way in which a *film noir* sensibility is evoked throughout. That is, the commercial's championing of a low-key, self-created image-world characterized by autonomy, freedom and lightness of touch is inserted into a world that is dark, and in which ordinary people who are simply socializing, or being intimate, are clearly also in a position of intensified exposure. Either they are being captured photographically without, apparently, ever being aware of it or they are brought to a point of rude awakening at the moment of capture. Thus in visual terms, and in a world where the photographer is as likely also to be the photographed, a message about new forms of enablement and ownership of the image-world is also undermined – most overtly near the commercial's end, in that startled look of the woman who, from the depths of a passionate embrace, realizes that she has been surreptitiously pictured. Once registered, this threatening sensation retroactively permeates the rest of the film. In fact, a sense of capture is emphasized throughout by the repeated affects of frozenness that are part of its visual aesthetics. In any case, there is a definite sense of power-shift with the film's casual, throwaway aesthetics and apparently participatory ethos now intertwined with an aesthetics of exposé. In this way, almost in prophetic

mode, the ad seems to pick up on and communicate undercurrents we now know are associated with the new technological facilitation of image-making and sharing. Arguably, too, in this case, these undercurrents are associated neither with anonymous, institutionalized practices of surveillance on the one hand, nor with 'sousveillance' (literally, watching from below) and inverse surveillance on the other, in which, aided by today's personal mobile devices, traditional, one-sided, top-down, institutionally driven forms of surveillance are made reciprocal and put under pressure. Indeed, much has been made of the increasingly prominent cultural and political role of amateur mobile-phone footage as a source of evidence gathering, reportage and critique. We all know that some of the most compelling, and influential, contemporary news images are grainy, gritty, shaky images of this kind. Rather, what seems to be portrayed in *Muck About* is an atmosphere of voyeuristic intrusion, a one-sided game of image-capture that is directed not, as with the paparazzi, at known individuals, but rather at one's peers, in their off-moments of leisure or privacy. This feeling of intrusion is intensified at certain points in Cunningham's film, when there are shifts from an outdoor to an indoor space, that is, from spaces that are normally read as public to those that are normally understood as communal yet private.

But this is not all. The content and aesthetics of Cunningham's short film also evoke further dimensions of what it means for images to be 'taken'. Certainly the world in which this technology circulates is one characterized by the exchange – and, behind the scenes, the ever-increasing commercial value – of personal data, including visual data. The legalities keep evolving, but for a long time, unless precautions were taken, the default position on sites such as Facebook, which users think of as offering them personal space, was that photographs or videos, once posted, were automatically placed under license to the service provider to be collected or used, royalty-free, as desired. In addition, again depending on users' privacy settings and those of their friends, personal imagery may be available for use or manipulation by the online users through the simple device of 'copy' or 'save image', or by capturing and disseminating screenshots. It is also worth remembering the unsavoury nature of the project from which Facebook was birthed – an anonymous, misogynistic ratings site which was advocating what would become a highly problematic aspect of Facebook and other social media sites, namely, their roles within cyberbullying cultures. Within these contexts, to repeat, private moments can become subject to unanticipated distribution to, and use by others. Thus the world of online image sharing and networking is one in which we often find a literal and confusing mixing-up of categories between private and public, between what is and what is not our own.[35] Often this is not felt to be a particular problem. Many see it as a positive phenomenon. In any case, this is not a world to be engaged with naively.

The problematics of viewer power

As with all technological and commercial developments, these, occurring around the turn of the twenty-first century, have brought considerable positive and negative social, cultural and personal transformation into play. Certainly they intensified certain trends in visual self-expression and image-based social interaction, and provided new venues for their circulation. As a consequence, the dynamics of the global image-world, online and otherwise, underwent adjustment, with individuals within mass culture being increasingly reframed less as consumers and more as producers or co-producers of image and self-image. As already discussed, this is a phenomenon that has been cultivated and often exploited by professional mass-market image-producers, promoters and distributors: not only advertisers, broadcasters and film-makers but also those working in the areas of marketing, public relations and talent management. A case in point, by way of illustration, is the repurposing and rebranding of television, a traditional 'push' medium, along user-centric lines. Quite apart from changes with respect to delivery (such as on demand services) there has also been an intensified focus on reality television in its many forms, on user generated content and participatory journalism, and on other types of viewer involvement.[36]

In principle, this shift (or apparent shift) towards an increasingly personal, participatory and democratized image-world promises scope for an outpouring of diversity in terms of the image types and styles being made and shown worldwide. It offers, or should offer, scope for an enhanced sense of personal freedom and agency of expression. All of which may be regarded as vital for their capacity to surprise and to enlarge our expectations about the kind of world we live in. But, recalling the tentative on-stage enactments of Pushpamala's Indian Lady in front of her undepicted audience on the one hand, and the strong atmosphere of what I called voyeuristic intrusion in Cunningham's piece on the other, it is far from inevitable that this will be the case. That is, the broader conditions of production and reception surrounding these technologized, public-facing and often interactive scenarios have the capability to exert considerable constraint, narrowing rather than expanding creative and expressive possibilities. For instance, time and again and again, the norm is for viewer power (the power of sight) to predominate over the power of image-making and over individuated modes of self-showing. As with contemporary forms of technologized self-expression, these modes of viewer involvement are generally presented as democratized and participatory in their ethos. Take, for instance, the role of the viewer in the televised elimination shows already mentioned, and in the proliferating online ratings sites and ratings facilities within sites. In many instances, however – perhaps in most – these activities have a generally impoverishing

role where the contemporary image-world, and everyday image-making or image-projection are concerned.

Unless challenged, at least four mass viewer-related factors have a confining effect within the image-world. First is the fact that in these contexts, seeing and judging tend to be conflated, conceptually and temporally, creating evaluation loops that are not easily interrupted or diverted along alternative routes. At issue here is not so much that the image-world is a world evaluated in terms of likes and dislikes, or competitively, in terms of winners and losers, but that such judgements tend to be made too quickly, without adequate forethought, and often in ways that may well be inappropriate or inadequate to the given data. For this reason, as indicated in the previous chapter, one of the things I try to do in *Showing Off* is to look for instances within the self-showing world where being visible – where self-showing – may be experienced as distinguishable from being judged.

Second, the values informing these judgements are generally preconditioned in ways that make the visual world more, not less, narrowly defined and appreciated. Arguably, an explanation for this may be found in the long-standing idea that central to the modern image-world, and indeed to modernity itself, is a conflict between two values, originality on the one hand, and a limited but easily consumable conception of excellence on the other. Of course, originality and excellence per se are not intrinsically opposed. But at certain formative cultural moments they have been treated as such, with the value of excellence exerting a conservative and constraining force against the new and different. Accompanying this idea is the further claim that in situations of mass appeal or popular consensus it is the value of excellence thus understood that wins out. In other words, mass viewers tend to value that which is the 'best of' an already existent category over attempts at opening up unfamiliar territory. This at least was the argument presented by the unknown author or authors of 'Art and Originality', a short editorial published in the *New York Times* more than 130 years ago on 24 July 1881, in which wide-ranging and enduring image-world issues were raised.[37] The article was focused on the modern development of art during America's so-called Gilded Age (its period of post-Civil War, post-Reconstruction boom from about 1870 to 1890), and on the impact of American public taste on art-buying and art-making. The editorial began by observing a disparity with respect to the reception of modern art between the critics who were 'almost always on the side of novelty and originality' and 'the buying and admiring public' who seemed to have 'a horror' of it. 'What class of pictures are [sic] most bought in the United States?' we are asked. 'Undoubtedly the Parisian pictures of the kind that are thoroughly safe as being within the limits of orthodoxy in art' is the reply – it is the 'excellent, unimaginative' work of European academic

painters such as Meissonier that is preferred over the experiments of Millet, Corot, Courbet and Manet:

> It is Meissonier or Bouguereau or Verboeckhoven that makes the average American part with his well-earned thousands, not painters of original thought, inventive artists, sculptors who startle and delight the ateliers with brilliant innovations. Of the former, the merits are very great, but these do not lie in the direction of originality.[38]

As noted, the issue here is not with excellence per se. Rather, it is with the fact that popularist valuations based on a narrow conception of excellence operate not only within the bounds of the already known but also within the realm of the naturalized and thus unquestioned. It is by these means, therefore, that a deadening conformity and, within that context, a relentless, self-conscious competitiveness are generated, and the otherwise potentially unruly image-world is presented as if controlled and contained. This also sheds light on an otherwise inexplicable counter-phenomenon within modern, critical or 'advanced' art, namely, the practice of creating or exhibiting art using strategies that reject accepted standards of artistic or curatorial excellence. The aim here is not to please, but to challenge. Here, of course the interpretative and disseminating role of the art critic is crucial in either obstructing or assisting such artistic phenomena.

There is also, of course, the other side of the story – the reality that visual and other content that is produced for mass consumption either tends to appeal to already proven mass taste or works hard to cultivate mass taste along certain already determined routes. Regarding the latter strategy, a project by the contemporary artist Carey Young is instructive. *Colour Guide*, from 2004, was an installation at Stockholm's Index Contemporary Art Foundation. At first sight, it looks like a purely aesthetic work: like a large-scale, modernist stained glass window, its luminous grid of colours filtering the daylight entering the gallery from outside. But the documentation accompanying the piece tells a more complex story. The installation was provoked by an email sent by Corbis, Bill Gates' powerful, commercial image-library and photographic agency, to one of its photographers. The photographer had then forwarded the email to the artist who included it in the installation. As reported by Young on her website, the email was significant because it explained 'the company's "colour guide", a set of colours that should be used within any photographs shot by freelance photographers working for them, since these colours will apparently be more attractive to the mass market in the near future'. In her installation, therefore, Young covered the existing gallery window with coloured vinyl squares that replicated the Corbis colour guide so that it became the viewers' sole source of illumination.[39]

A second art project, by American-based Russian émigré artists Vitaly Komar and Alex Melamid, is also illuminating since it was concerned, precisely, with the identification of mass sensibilities where art is concerned. In 1994, the artists used a professional market research company in order to discover the preferences of the American public when it came to paintings. When interviewed, Melamid claimed that the project, which was a development of earlier initiatives, had been carried out with the intention of getting 'in touch with the people of the United States of America: somehow to penetrate their brains, to understand their wishes – to be a real part of this society, of which we're partially part, partially not'.[40]

Other motivating factors (and here we must take into account the strong sense of feigned earnestness with which Komar and Melamid often approach their work) were urgent questions about the contemporary role of art within society at large: 'We're in kind of a dead end, the whole society. There's a crisis of ideas in art, which is felt by many, many people. Not only in art; in social thinking, in politics.'[41] And again:

> [W]e really don't know where to go, and what our next step has to be. Artists now – I cannot speak for all, but I have talked to many artists who feel this way – we have lost even our belief that we are the minority which knows. We believed ten years ago, twenty years ago, that we knew the secret. Now we have lost this belief'.[42]

The idea was that by polling the American public, ways forward might be found in all of these areas. Linked to this, finally, was the expressed desire to produce art that could be defined as being of and for the people, and not just for an elite group.

The initial, American, poll resulted in an exhibition of paintings, *America's Most Wanted and America's Least Wanted*, created by the artists on the basis of the data gathered, and shown at the Alternative Museum in New York under the title 'People's Choice'. The outcomes are also available online.[43] The project was carried out under the auspices of the Dia Art Foundation in New York and, significantly, was sponsored by Chase Manhattan Bank. The polling process was then extended to 13 other countries (in chronological order, the artists listed: France, Turkey, Iceland, Russia, Denmark, China, Kenya, Finland, Portugal, Holland, Ukraine, Italy and Germany) and, between November 1995 and March 1997, to web users. The survey questions differed slightly from country to country. Somewhat to Komar and Melamid's surprise, the results of the polls, with the clear exceptions of the web user category, Holland, and to an extent Italy, were all remarkably similar: there was a clear consensus for undulating landscapes, showing a predominance of blue (generally lakeside views), and inhabited by people. Even in the US poll, the

artists found that those surveyed seemed to share the same preferences, regardless of class or race, although Melamid did observe that the taste for blue diminished 'with income and with education'.[44] Certainly, though, 1990's American popular taste in painting did not seem to have changed significantly from that of the 1880s, as reported earlier. But was this due to a fundamental conservatism or predictability on the part of the nonetheless diverse groups of people surveyed? Was it because there was a too limited range and availability of experimental art within mainstream society which in turn limited appreciation of it? Or was the problem with the poll itself – particularly with the closed, either/or questions it was asking – and with the system of polling as a dominant approach, within democracies, of trying (or of being seen to be trying) to discover what the majority of people want? For the Dia's director, Michael Govan, further questions also came to the fore. As he put it in his introduction to *Most Wanted Paintings on the Web*:

> In an age where opinion polls and market research invade almost every aspect of our 'democratic/consumer' society (with the notable exception of art), Komar and Melamid's project poses relevant questions that an art-interested public, and society in general often fail to ask: What would art look like if it were to please the greatest number of people? Or conversely: What kind of culture is produced by a society that lives and governs itself by opinion polls?[45]

In 2012, the *Most Wanted* project was featured in the third episode of the UK broadcaster Channel 4's series *What Makes a Masterpiece*, which asked to what degree aesthetic phenomena and preferences might be due to neurological factors. Here, the project was used, reductively it seemed, to support a causal argument that there are neurologically embedded, universal rules governing these preferences, and that great art may simply be that which is best able to discover, follow or manipulate those rules. Likewise, art itself was presented as that which is valuable to the degree that it is liked, and not to the degree to which it might challenge our tastes, our preferences and, indeed, our prejudices.

A third issue of concern, regarding contemporary mass viewer-related power and its impact, has to do with the generally anonymous and non-reciprocal nature of mass evaluation. For anonymity of this kind has unaccountability built into it and in many instances it may therefore be predisposed towards a lack of generosity. Indeed, here, the image-world maintains its momentum, its fascination and, in many instances, its economic viability, by being relentlessly judgemental, even punitive. Expression and reception are pitted against each other, frequently to the advantage of the latter.

This in turn affects the nature of everyday image production. For, fourth, since judging viewers are themselves the increasingly habitual creators of image and self-image, loops of conformity are invariably activated. When in image-making mode, they find themselves relentlessly anticipating how their productions will be seen and judged by others. Thus, while it is true that adopting the position of a viewer of one's own work has an important role to play in the creative process, the danger here is not only that seeing and judging, as discussed earlier, but also that seeing, judging and making can become continuously and unproductively conflated.

Today, the sense that we are continually evaluating others, and continually under evaluation ourselves, is pervasive at all levels. The media world – but not only the media world – goes all out, it seems, to consolidate this atmosphere of pressure by continually promoting a baseline of exclusive and carefully controlled visuality. Looking back, this message was perhaps nowhere as succinct and effective as in two high-profile advertisements, *Would the film of your life go straight to video?* and *Shine and Rise*, that were part of a 2003 billboard campaign launched in the United Kingdom by the *Economist*. These ads were themselves part of what has been described as one of the longest running and most admired poster advertising campaigns of recent times,[46] a campaign that was central to the rebranding of the *Economist* in 1987 under the creative direction of the London-based agency Abbott Mead Vickers BBDO. Throughout this ongoing campaign, which is managed in a participatory, open-entry fashion, with all agency employees invited to contribute ideas, both its look and its message have remained more or less consistent. In the main, a text-based approach is taken using the font and colour scheme of the *Economist*'s already well-known white-on-red logo,[47] optimizing it in order to dart out pithy, emotive messages focused on the enduring strategic power of market intelligence, and promoting a notion of success based on one-upmanship.

Although the messages communicated in *Would the film of your life go straight to video?* and *Shine and Rise* were expressed verbally, these slogans were notable for the powerful visual themes that they evoked. With *Would the film of your life go straight to video?* this message was assisted by the fact that its billboard format also recalled the proportions of cinematic widescreen. The tone of *Would the film of your life go straight to video?* was intended to undermine, sowing seeds of self-doubt and discontent. *Shine and Rise* seemed more aspirational. But by simply reversing the colloquialism 'rise and shine', it insisted upon a very particular causal relationship between the quality of a person's visual presence in the world and his or her capacity to excel in life. And so in each case the message was the same: successfully manage your status and circulation as image within the image-world, or else. The barely veiled sense of threat and dread associated with being perceived

as second-rate was unmistakable, and this was fortuitously reinforced by the *Economist*'s evocative, trademark colour scheme. A further point is also worth making. The slogan 'Shine and Rise' not only reversed a well-known saying within the English language, more profoundly it also reversed the biblical proclamation – dating from the eighth century BCE – on which that saying was based. (It is worth underlining that, as with the *Ramayana* and *Mahabharata* in the Indian subcontinent, biblical allusions and values are so embedded into the languages of the West that even in the most secular of circumstances – even if, as in the *Economist* advertisement, they are turned upside down – they continue to function as a significant cultural backdrop. Even where Judaism and Christianity are overtly objected to, they remain a formidable point of reference.) The biblical words at issue here, from the book of Isaiah, are worth citing for the non-egocentric perspectives on self-showing that they convey. Significantly, they do not concern the self-aggrandizement of specific men or women, but rather the now non-dominant conception of the glory of God flashing, shimmering, anointing, and transforming a literal/ metaphorical place, Jerusalem, made desolate under long years of colonial rule by the Assyrians and Babylonians, into a refuge, a home, not only for the Jews but also for people from all nations. 'Arise, shine, for your light has come, and the glory of the Lord rises upon you', declares the prophet Isaiah to the devastated city.

> See, darkness covers the earth and thick darkness is over the peoples, but the Lord rises upon you and his glory appears over you. Nations will come to your light, and kings to the brightness of your dawn. Lift up your eyes and look about you: All assemble and come to you; your sons come from afar, and your daughters are carried on the arm. Then you will look and be radiant, your heart will throb and swell with joy.[48]

The biblical pronouncement is focused on enlargement, inclusiveness and hospitality. By contrast, *Shine and Rise*, and the *Economist* campaign in general, though witty, pithy, memorable and impressive, are all about exclusivity and elitism. And it has worked. According to calculations made by the Economist Group, the newspaper's circulation doubled between 1984 (before the redesign took place) and 1992. But the question that is of course central to the broad theme of self-showing is how the ethos of this campaign, irrespective of its success – the fundamental way in which the newspaper is showcased – sits alongside the paper's stated ethos. The *Economist*'s publishers highlight its reliability and impartiality. It is 'a weekly international news and business publication, offering clear reporting, commentary and analysis on world current affairs, business, finance, science and technology, culture, society, media and the arts'.[49] Directed towards a high-end readership,

and now the Economist Group's flagship publication, it was first established in London in 1843 with the aim of promoting what its founder, a Scottish hat maker called James Wilson, saw to be the civilizing and moralizing as well as economic values of free trade.[50] The newspaper's ethos was also predicated upon a strong rationalist principle, and it still claims to foreground three key values: independence, objectivity (conveyed by a voice that is anonymous and collective[51]) and topicality.[52]

Clearly, the *Economist*'s highly emotive advertising strategy goes against the newspaper's stated rationalism, embodied in Wilson's assertion that 'reason is given to us to sit in judgment over the dictates of our feelings'.[53] Its promotion of one-upmanship also sits uncomfortably alongside what apologists for free trade take to be its inherently cooperative character, and its support of a system in which each contributor is supposedly enabled to capitalize on that which it is best placed to produce. It seems, rather, to affirm the critics of the system who claim that a real-world end-product of free trade is that it supports the status quo where the spread of wealth is concerned, keeping those on top firmly in place.

Thus, the *Economist* campaign holds together two apparently contradictory demands. On the one hand, there is the requirement to increase the popularity of the publication, to extend its reach by appealing to ever wider audiences. And indeed, when I first saw *Would the film of your life go straight to video?* it was not in an appropriately up-market, urban location but looming over the weed-ridden, broken-stoned exit of a suburban railway station. Likewise, my first glimpse of *Shine and Rise* was from the window of a bus as it negotiated a busy but run-down south-east London shopping street. But on the other hand, the rationale of its campaign is to preach exclusivity and elitism. The fact that it navigates these two demands successfully lies in its capacity to exploit the tension between them, by offering and withholding the secrets of success, making them attainable and unattainable at the same time.

The light that blinds

According to the contemporary Dutch art critic Camiel van Winkel, the world we live in today is a 'regime of visibility' which 'cuts across all cultural and social registers, from top to bottom, from centre to periphery' and is characterized by a 'permanent pressure' to visualize, to expand and enhance sites and occasions for visualization.[54] Driving this compulsion, he claims, is our perception that the world, which has long been defined as oversaturated with images, actually suffers from a paucity of images, a 'visual shortage'.[55]

Enlarging on van Winkel's claim, we could characterize this paucity in at least three further ways. The first, already discussed, has to do with the restricted, rather than expanded image-repertoire that continues to dominate, despite the fact that image production, display and dissemination have all become increasingly democratized and participatory. The second, only alluded to earlier, concerns the reality that still only around a third of the global population has access to the digital technologies and infrastructures undergirding this participatory turn. According to market research from June 2012, for instance, the internet was still inaccessible to 65.7 per cent of the world's population.[56] My aim here is not to idealize the realm of digital communications, or to suggest that without it, life is necessarily impoverished. But I am interested in the implications of this data. What then of the relationship between the 34.3 who do have access – based predominantly in Asia, Europe and the Americas – and those who do not? That is, those whose presence within the digitized image-world, if and as it occurs, is entirely at the level of representation? In addition, what implications for questions of identity, diversity and agency will accompany the arrival or expansion of digital technologies and infrastructures in currently excluded or low penetration territories? To what degree will the conditions for entrance and participation, not to mention the ethics surrounding them, be overdetermined by already established visual and other communicative protocols, leading again to conformity?

There is also a third condition of paucity that I would like to bring into play. This concerns not merely the images or the modes of visual being and expression that are refused entrance into the image-world at large – so to speak – but also those that are systematically taken out of circulation. These are issues that have long dominated the work of Chilean-born artist, photographer and film-maker Alfredo Jaar. One of his most important projects from the 1990s, *The Rwanda Project*, was provoked by the fact that, despite the scale of the atrocities taking place in Rwanda in 1994, the genocide was barely registering within global news and current affairs coverage. The question was why not? And the challenge Jaar set himself was to go to Rwanda and to produce images, inevitably relating to the horror taking place, but that people would nonetheless look at, register and respond to. His strategy, upon arrival, was not to produce disaster photographs of the kind we might expect from a photo-journalist, but beautiful images, mainly portraits of Rwandans, often looking directly at the camera. Furthermore, his approach to disseminating these works, to staging and displaying them, was theatrical and, in his own words, seductive.

I'm not afraid of seduction. . . . Because I deal with information that most of us would rather ignore, I need to use certain seduction devices like theatre or mise-en-scène. My view is that if you present it in a less

seductive way most people would not even approach it. . . . Some people are outraged that these mise-en-scènes can be so beautiful while dealing with such horrific subjects, such marginalized subjects. Well, my answer has always been that these subjects deserve to be recognized as valid subjects and as worthy of research and of representation. Why is a subject like the tree in eighteenth century landscape painting worth more research and resources than the Rwandan genocide? It is my way of dignifying the subject in dedicating all the resources available in order to represent certain realities, or to create new realities from an existing reality. The mise-en-scène should dignify my subjects and contextualise properly the issues I am focusing on.[57]

Later, in *The Lament of the Images* of 2002 – exhibited that year at *Documenta XI*, Kassel, curated by Okwei Enwezor, as well as in the Galerie Lelong in New York – Jaar underscored his critical position by creating a photograph-free (but not non-visual) two-part installation. Viewers entered a darkened room in which three small backlit text panels – white words on black – documented three important instances of image-absence within the field of global current affairs. The first, with the header 'Cape Town, South Africa, February 11, 1990', reflected on the news coverage of Nelson Mandela's release from his long incarceration on Robben Island. It started by describing the images that *were* taken and then broadcast live around the world, images that showed 'a man squinting into the light as if blinded'. This was followed by a brief resumé of Mandela's incarceration, and of the labour he and his inmates were forced to carry out in the island's limestone quarry, ending with an account of a photograph that therefore could not be taken: 'There are no photographs', we read, 'that show Nelson Mandela weeping on the day he was released from prison. It is said that the blinding light from the lime had taken away his ability to cry'.

The second text, with the header 'Pennsylvania, U.S.A., April 15, 2001' was provoked by a *New York Times* article Jaar had read telling of the purchase by Corbis – the organization already referred to as the subject of Young's 2004 installation – of millions of images from other international agencies, including, in 1995, the Bettmann and UPI (United Press International) archive, which holds some of the most significant images of the twentieth century. These photographs, we are told, were to be buried for safekeeping in an old limestone mine in Pennsylvania now known as the Iron Mountain National Storage Site, with the intention that, over time, digital scans would be made and sold. This text piece ends with the words: 'At present, Gates owns the rights to show (or bury) an estimated 65 million images.'

The third and final text piece had the heading 'Kabul, Afghanistan, October 7, 2001'. It reported that, before the instigation of American airstrikes on

Afghanistan following 9/11, the US Defense Department bought the rights to all commercially produced satellite images of the region, resulting in 'an effective whiteout of the operation, preventing western media from seeing the effects of the bombing, and eliminating the possibility of independent verification or refutation of government claims. News organizations in the US and Europe were reduced to using archive images to accompany their reports.'[58]

Viewers of these texts then progressed along a short dark corridor into another room where they themselves were suddenly confronted with a cinema-screen-sized block of blinding light. The associations were of course multiple and sobering. As Jaar himself put it:

> We are living today in a paradoxical situation. There has never been so much access to information and images. Our landscape is saturated by images. But at the same time, we never have had so much control of images by private corporations and governments. I wanted to speculate about this situation. *Lament of the Images* is a modest philosophical essay on our relationship to images today.[59]

The politics of coming-to-appearance

When asked whether he was still confident in the power of images, Jaar replied that he believed images 'are more necessary than ever'. 'But', he continued,

> I also believe that the political and corporate landscape of our times is full of control mechanisms that will not allow certain images to exist in their proper context. As artists are producers of meaning, we need to contextualise images properly. We must create a framework for their political efficacy. And the space of culture is probably the last free space remaining where this can be done.[60]

There is, then, an image-politics and a politics of display. For as Jaar puts it here, and as Pushpamala's work also demonstrates, at issue are not just the many images that remain uncreated or otherwise unavailable to sight. Also at issue is how the images that do exist are staged and shown – the forms of mediation to which they are subject, the ways in which they are formatted, and the rhetorics that characterize and surround them. This is, of course, a point that has also been made forcibly by Jacques Rancière and lies at the heart of his discussions of what he has called the 'distribution of the sensible'.[61] By this he means the ways in which societies assign what may

be seen and what remains unseen, what can be said and what cannot, what can be heard and what remains inaudible. It also refers to the alliances that are set up between different kinds of information or content, and the ways in which they are characteristically communicated. As Rancière put it in a 2010 interview published in *Art Review*:

> What is important for me is to shift from the question 'is it possible to make this or that image' to the question 'what does it imply, more generally, about the distribution of the sensible, how people are located in a certain universe, in a certain interrelation of words and images?'[62]

By way of explication he referred to Godard's joke 'that epic is for the Israelis and documentary is for the Palestinians. The idea that there are certain situations where only reality can be taken into account – there is no place for fiction.'[63]

Returning to themes opened up earlier on in this chapter, there is also a politics of the *self* on show, of which we will be examining different dimensions throughout this book. This is a politics with a long and varied history, incorporating the many debates about representation and self-representation, identity and, more recently, post-identity that have been important in modern and contemporary counter-cultural, or activist, art projects around the globe. Indeed, returning a final time to the work of Pushpamala N, we see that as well as exploring image-politics with a particular, but not exclusive emphasis on the conditions surrounding women in the Indian subcontinent, her work – including her working methods – also connects with the ways in which image-politics have played out more broadly within the histories and theories of twentieth-century and contemporary activist art.

There was an initial intensification of such art practices during the 1960s and 1970s. This was, of course, the star-struck, media-conscious era that prompted Andy Warhol to claim that 'In the future everyone will be famous for fifteen minutes.' It was also an era marked by the proliferation of mass non-conformist and freedom movements. In the art world, this was paradigmatically expressed in the German artist Joseph Beuys' participatory, anti-consumerist ideal that 'Everyone is an artist.' It was also demonstrated through the impact on art of second wave feminism, civil rights activism and protest – particularly, in the United States, against the Vietnam War (1955–75), which was so extensively and strategically mediatized via the then-newest forms of visual mass communication (television) that it came to be known as the first 'television' or 'living room' war. In other words, it was an era in which, for many visual practitioners, dilemmas about visual expression and exposure, and about remote viewing and personal responsibility, were uppermost. As

is often pointed out, this issue was forcefully, and literally, brought home at the time in Martha Rosler's series of photographic collage-works about the Vietnam War: *Bringing the War Home: House Beautiful*, 1967–72, in which American domestic interiors and media images of the horrors of the war were juxtaposed, as was, of course, actually the case in everyday life.

But although these artists were often conveying political messages loudly and clearly, it was not just content, but choice of medium – the *how*, as much as the what and why of communication – that was vital. The underlying idea was that political power was not only intimately connected to, and reliant upon, questions of representation but also upon modes of *presentation*. The medium, as Marshall McLuhan famously put it, was the message. Or, as Jaar later put it, the challenge was to create the contexts and frameworks needed to ensure the political efficacy of a given image. As such, artists often chose to work with materials and formats associated with mass communication in order to also illuminate and deconstruct their modes of operating and persuading. Photography gained a renewed importance, and much has been written about the impact, particularly for politicized and activist art practices, of the first battery-powered, thus portable, videotape recorder, the Sony portapak, that was launched in 1967. The work that was produced using these media was often an extraordinary mix of the personal and the political, with artists turning the still or moving image camera on themselves and on their environments, especially the media-scapes in which they were immersed. Questions were continually raised about the rhetorics of reportage, advertising and other forms of mass communication, and the degree to which spaces for individual political agency remained a possibility. To my mind, one of the best exhibitions to engage with these issues was *Broadcast*. Curated by Irene Hofmann, and co-organized by ICI, New York, and the Contemporary Museum, Baltimore, it was on show at MOCAD (Museum of Contemporary Art, Detroit) – where I saw it – from 12 September to 28 December 2008. It focused on selected artists working between 1966 to 2007, namely, Dara Birnbaum, Chris Burden (i.e. *TV Hijack* from 1972), Gregory Green, Doug Hall, Chip Lord and Jody Procter, Christian Jankowski, Iñigo Manglano-Ovalle, neuroTransmitter, Antonio Muntadas, Nam June Paik, the guerrilla television group TVTV (Top Value Television) – their documentary *Four More Years* from 1972, which presented counter-coverage of Nixon's presidential campaign – and Siebren Versteeg.[64]

Within this context of media shift, in which artist-activists were increasingly making use of mass media, arguably it also became easier for individuals and communities that had habitually been spoken-for, marginalized or ignored within dominant culture to express themselves and their concerns. But, as is clear from Pushpamala's *Indian Lady*, for instance, while part of the initial struggle to communicate must be to create appropriate sites, platforms

and languages for self-expression and self-definition, this is by no means sufficient. To be on stage, to be a focus for attention, does not mean that you will be seen or heard on your own terms. There are other conditions of perception and reception at issue, including the fact that relationships between expression and reception, between self-showing and being seen, can never be guaranteed to be reciprocal no matter how apparently unmediated they might be. In each case, one is performing to, and will be judged by 'one knows not who'. For McLuhan and others, the possibilities opened up by the proliferation of new electronic media – first radio and film, but particularly television; McLuhan died before the mass availability of the internet became a reality – were of extraordinary importance:

> Electric speed in bringing all social and political functions together in a sudden implosion has heightened human awareness of responsibility to an intense degree. It is this implosive factor that alters the position of the Negro [sic], the teenager, and some other groups. They can no longer be contained, in the political sense of limited association. They are now involved in our lives, as we in theirs, thanks to the electric media. This is the Age of Anxiety for the reason of the electric implosion that compels commitment and participation, quite regardless of any 'point of view'.[65]

At so many levels McLuhan was correct. But one of several factors that his statement, here, did not anticipate or address were the debilitating effects of the oversaturation of images and information that this same electronic revolution would produce: the ways in which the senses might be incapacitated and led astray, following Virilio, due to the ongoing and unexamined impact of optical and other such technological devices.[66]

Pushpamala's body of work is interestingly located within these debates about the impact and effects of changing, indeed escalating media-streams. And, given her strong political stance, her own feminist concerns, her commitment to performance and her engagements not only with image but also with modes of communication, her work relates to various broad legacies of politicized art-making. Particularly, given that her performance projects are focused on masquerade, they may be seen to have an especial affinity with the less obviously proselytizing, more deadpan, and better known work of Cindy Sherman, produced from the 1980s into the present. But what distinguishes and individuates Pushpamala's work are a certain lightness of touch, a fleetness of foot, a reckless playfulness and fearlessness. Her work testifies to the fact that she is not intimidated by the fast flowing and often constraining information and image-worlds in which she is immersed. This is evident not only from *Indian Lady* and *The Ethnographic Project* but also from early photo-romances such as *Phantom*

Lady or Kismet of 1996–8, from *Dard-E-Dil* (*The Anguished Heart*) of 2002 and from current, ongoing work such as *Avega: The Passion*, which evokes themes from the *Ramayana*. For rather than become utterly incorporated into these stereotypical image-worlds, rather than seeming to disappear into them (as, arguably, Sherman often seemed to do in her early *Film Stills*), Pushpamala's involvement is much more volatile. Far from being erased by the stereotypes to which she relates, she activates them so that they become a kind of playground in which experimentation, negotiation and enjoyment intertwine. She refuses a position of victimhood. She takes, and makes, her own way through. How apt that in her early work, *Phantom Lady or Kismet*, she made use of costume and characterization to reference and re-enact Indian cinema's screen heroine of the 1930s and 1940s, Fearless Nadia. Fearless Nadia was in fact the extraordinary Australian-born actress and stunt woman Mary Ann Evans, who had moved with her father to Bombay in 1913 at the age of 5. Another woman, then, who knew how to take the self-showing world by storm.

2

Appearance is everything

Entranced

To see is to enter a universe of beings which display themselves.

With startling economy, these words from Merleau-Ponty's *Phenomenology of Perception* present a fresh, powerful, but as yet little debated redefinition of vision and the visual. Considered purely on their own terms, decontextualized for now, a sequence of 12 words, two features stand out. The first is that sight is associated with the activity of entering, thus of approaching, of drawing near and being drawn in – in a way that might require some degree of self-relinquishment on the part of the seer. As such, Merleau-Ponty calls into question that truism about vision that has been made with increasing insistence from the mid-twentieth century onwards, namely, that sight fundamentally '*sets* at a distance, and *maintains* the distance' [my emphasis] – here I am citing a 1978 interview with the influential feminist writer and psychoanalyst Luce Irigaray, who had risen to prominence in the 1970s with the publication of two important books, *Speculum of the Other Woman* in 1974 and *This Sex Which Is Not One* in 1977.[2] Merleau-Ponty's words also challenge the associated idea that vision inevitably works in the world as an ethically problematic, because predominantly alienating force, an idea, again, so recurrent in the most respected twentieth-century and contemporary theorizations of vision that it has become normative. Take, for instance, the well-known perspectives offered by Merleau-Ponty's contemporaries Jean-Paul Sartre and Jacques Lacan, and by those who would broadly follow the intellectual trajectories they had marked out – Michel Foucault, Irigaray and, more recently, Peggy Phelan, to name but a few – in which, on the whole,

to see is to dominate. And in which to *be seen* is to risk objectification and estrangement, and to be made vulnerable. This is, of course, an understanding of vision and visibility that has also frequently been conceptualized through the notion of 'the Gaze', defined by Jacques Lacan, following Sartre, as a phenomenon that is experienced as all the more powerful and imposing because it is problematically diffused, unlocalizable, and thus difficult to address. In fact, in *The Four Fundamental Concepts of Psycho-Analysis* published in 1973 but first developed in lecture-form in 1964, Lacan defined it not as 'a seen gaze, but a gaze imagined by me in the field of the Other'.[3] A phenomenon, moreover, that is taken to induce a variety of symptoms, such as shame, or a sense of sustained oppression, or, in many instances, a counter-response of aggression, narcissism or exhibitionism. One too, according to Irigaray, where invidious gender and sexual differences are played out, since 'investment in the look is not as privileged in women as in men'.[4] This theme was perhaps most famously developed in a text referred to in passing in the previous chapter, film theorist Laura Mulvey's classic 1975 exploration of the gendered dynamics of seeing and being seen within cinematic space, 'Visual Pleasure and Narrative Cinema'.[5] As noted in the introduction to this book, this sense of sight – and of the visual more broadly – as alienating and tied up with the intention to dominate, is also central to recent explorations of visuality and visualization.

Given this ongoing trend towards the problematization of vision and visuality within so much twentieth-century and contemporary critical thought, it is not surprising that 'anti-ocular' theorists of lived experience have been searching for an ethics rooted in a purportedly non-visual elsewhere. For instance – to turn to just one such project – the philosopher Wolfgang Welsch is one of several thinkers who, for many years, has consistently resisted the supposed overprivileging of the visual in dominant culture, by arguing that auditive practices provide more productive routes to knowledge, understanding and the ethical. In *Undoing Aesthetics*, first published in German in 1993, he wrote that:

> Philosophy . . . which was traditionally a discipline for the assertion of visual primacy, has become an insistent critic of visual dominance in the twentieth century. The two most important thinkers of the first half of this century, Heidegger and Wittgenstein, identified the visual orientation as being the *proton pseudos*[6] of the history of occidental thought and brought to bear elements of hearing in opposition to this.[7]

He continues:

> The transition from philosophy of consciousness to the paradigm of communication, such as has taken place in recent decades in various

European and American schools of thought, means in every case a transition from the traditional favouring of vision to a new emphasis on hearing.[8]

By contrast, while recognizing that various difficulties and dangers are indeed associated with the visual, Merleau-Ponty's approach has always been marked by the determination to engage productively with the reality that to 'have a body' – that is, to be an inextricable part of the material world – is 'to be looked at' and 'to be *visible*'.[9] The distinction that Merleau-Ponty makes between these two visual phenomena leads me to my next point.

A second feature, an innovative one, is also in evidence in Merleau-Ponty's assertion that 'to see is to enter a universe of beings which *display themselves*'. Admittedly, as his words demonstrate, he begins with sight. But the world he describes sight as entering is explicitly *not* a world of things seen, *not* a world colonized by, or subjected to, sight. Instead, we are presented with a different trajectory, in which one form of agency – that of seeing – transitions into another – that of self-showing. And the implication is that this self-showing world is the prior reality; that seeing, too, first and foremost, is an act of expression and self-exposure.

Merleau-Ponty's words, therefore, break out of that traditional seeing/being-seen dyad according to which the visual tends to be conceptualized. And in so doing, they also upset the usual ways in which power relations within the visible are understood. To repeat, in Merleau-Ponty's account, agency within the spheres of the visual is no longer primarily invested in the one who sees. Nor is sight coupled oppositionally with the perceived passivity or vulnerability of being seen. At issue is not a world replete with so-called objects of perception but a self-showing or appearing world of which we who see are an irreducible part. Not only because we too are visible entities but also, as noted in the introduction to *Showing Off*, because vision itself is an activity that stylizes, and must be understood as a form of display. For these combined reasons, his words mark a paradigm shift, offering an understanding of the relationship between the visual and the ethical in which, to repeat, ethical agency is fundamentally located on the side of self-showing. It is not surprising, then, that throughout his career, a career committed to reconceptualizing and restaging the parameters of philosophy according to the exigencies of *lived* experience and urgencies, he insisted that it is within this perceptually available world that philosophy must be rooted if it is to be viable. For in Merleau-Ponty's view, no matter how well formulated or internally cohesive a philosophical system might be, if it is unsituated and ahistorical in character – that is, if it is incapable of witnessing the many unanticipated instances and modes of self-showing that occur in everyday life – it will be ineffectual at the level of everyday life. And, as with classical philosophy, so

with the piecemeal, laboratory-based researches that are prioritized by the human sciences. The latter, by too radically abstracting themselves from the complexities of lived existence, fail adequately to illuminate them. As he put it in the *Phenomenology*, then, with respect to philosophy:

> The first philosophical act would appear to be to return to the world of actual experience which is prior to the objective world, since it is in it that we shall be able to grasp the theoretical basis no less than the limits of that objective world, restore to things their concrete physiognomy, to organisms their individual ways of dealing with the world, and to subjectivity its inherence in history. Our task will be, moreover, to rediscover phenomena, the layer of living experience through which other people and things are first given to us, the system 'Self-others-things' as it comes into being; to re-awaken perception and foil its trick of allowing us to forget it as a fact and as perception in the interest of the object which it presents to us and of the rational tradition to which it gives rise.[10]

In his last, unfinished work, *The Visible and the Invisible*, Merleau-Ponty repeated this point. His words, again worth citing at some length, are differently inflected here. They are more evocative, opaque and (productively) unresolved than in his earlier writing. But he makes the same fundamental demands of philosophy. In fact, he expands upon them. 'If it is true that as soon as philosophy declares itself to be reflection or coincidence it prejudges what it will find', he writes:

> [T]hen once again it must recommence everything, reject the instruments reflection and intuition had provided themselves, and install itself in a locus where they have not yet been distinguished, in experiences that have not yet been 'worked over', that offer us all at once, pell-mell, both 'subject' and 'object', both existence and essence, and hence give philosophy resources to redefine them. Seeing, speaking, even thinking (with certain reservations, for as soon as we distinguish thought from speaking absolutely we are already in the order of reflection), are experiences of this kind, both irrecusable and enigmatic. They have a name in all languages, but a name which in all of them also conveys significations in tufts, thickets of proper meanings and figurative meanings, so that, unlike those of science, not one of these names clarifies by attributing to what is named a circumscribed signification. Rather, they are the repeated index, the insistent reminder of a mystery as familiar as it is unexplained, of a light which, illuminating the rest, remains at its source in obscurity. If we could rediscover within the exercise of seeing and speaking some of the living references that assign them such a destiny in a language, perhaps they would teach us how to

form our new instruments, and first of all to understand our research, our interrogation, themselves.[11]

At first sight, the world described in *The Visible and the Invisible* appears very different to that opened up in the *Phenomenology*. In the *Phenomenology* the focus, tone and vocabulary are robust and we are directed towards experiences that are specific and situated. At issue are not so-called objects in general. Instead, actuality and singularity are key with respect to where things are located and how they function in the world. The perceptual realm described in *The Visible and the Invisible*, by contrast, is full of ambiguities and intertwinings. There are references to mystery and obscurity. What is given in each case, though, is the same world from inverse perspectives. The *Phenomenology*'s reference to a realm of experience that is 'prior to the objective world' is analogous to *The Visible and the Invisible*'s field of 'living references' that have not yet been 'worked over'. And as it turns out, in the *Phenomenology* it is the very robustness and specificity of actual experience that also makes it somewhat elusive, impossible to systematize within tidy, pre-existing models of thought. As in *The Visible and the Invisible*, it is a world where illumination and obscurity go hand in hand. Therefore, if we are to engage with this world justly, we must become entangled within it (or, more accurately, recognize that we are already entangled within it) and, he adds, be willing to lose our way – an instance of that sense of self-relinquishment referred to earlier coming into play. But this does not mean that the self-showing world is without structure or coherence. To repeat: 'If we could rediscover within the exercise of seeing and speaking some of the living references that assign them such a destiny in a language, perhaps *they would teach us how to form our new instruments*, and first of all to understand our research, our interrogation, themselves.' At issue is that this 'teaching' is not immediately apparent to us, and can only become so from within that place of reimmersion and fresh involvement. Hence, Merleau-Ponty's commitment to phenomenology. For – and here he cites the 'father' of phenomenology, Edmund Husserl – phenomenology is both attentive and dialogic in nature, involving a process of 'infinite meditation, and, in so far as it remains faithful to its intention, never knowing where it is going'.[12] Therefore, phenomenology is good at helping us access insights that do not simply reiterate what we already (think we) know and expect. As he puts it in the final paragraph of the *Phenomenology*'s 'Preface', phenomenology is 'a disclosure of the world [that] rests on itself, or rather provides its own foundation. All cognitions', he continues, 'are sustained by a "ground" of postulates and finally by our communication with the world as primary embodiment of rationality. Philosophy, as radical reflection', he continues, 'dispenses in principle with this resource'.[13] Therefore, the 'unfinished nature of phenomenology and the

inchoative atmosphere which has surrounded it are not to be taken as a sign of failure, they were inevitable because phenomenology's task was to reveal the mystery of the world and of reason'.[14] Hence too, Merleau-Ponty's insistence, in both the *Phenomenology* and *The Visible and the Invisible*, that philosophy is a project that must be started over repeatedly. Certainly, as Sartre would later put it, this was the place where, as a philosopher, Merleau-Ponty was 'always digging'.[15]

Structures of appearance

Phenomenological spaces of self-presencing are multisensorial. But in the work of some phenomenological thinkers, the visual characteristics of these spaces have been strategically underplayed at times. As already noted, for Heidegger – in 'What Is Thinking?' for instance – there is a distinct turn to and elevation of the aural. This is also the case in some of Arendt's political writing. Indeed, in *The Human Condition* of 1958, when discussing the necessity of public 'spaces of appearance' for the possibility of (democratic) political agency, appearance, here, is primarily associated with the disclosures of speech or discourse. My argument here, with respect to speech, is not that it is somehow unimportant, but that it is of value only to the degree that it is properly responsive to the appearing world, directing us towards this world, and not, as is arguably so often the case, away from it: speech as dissimulation, deflection and concealment – a theme to which I will return in the next section of this chapter. For Merleau-Ponty, the visually inflected aspects of self-presencing remained fundamental, as did the necessity of conceptualizing sight, language, thought and action together. The latter conceptualization is evident in the text just cited from *The Visible and the Invisible* where both seeing and speaking were presented less as clearly distinguishable, individual acts of interrogation or expression, and more as highly receptive, multidimensional communicative zones in which a great many discoveries are yet to be made about what it might mean to perceive, to investigate and to learn. An emphasis on the visual in relation to other perceptual modes, as well as in and of itself, was also evident during the 1950s when, in the context of an increasingly influential linguistic turn then taking place within philosophy, Merleau-Ponty was writing in a more focused way about language and communication. In the *Phenomenology* he had already posited that it is not just through their content but particularly through their non-verbal modulations that spoken words express our embodied styles or modes of situating ourselves in and perceiving the world. Later, in his 1952 essay 'Indirect Language and the Voices of Silence', he characterized the nature and effects of these non-verbal modulations by turning to what we

would normally define as a purely visual phenomenon: colour. Crucially, this referencing of colour was not metaphorical; it was not just a matter of rhetorics, intended to make the visceral and emotive aspects of verbal expression more vivid. Rather, Merleau-Ponty was pointing to a layer of correspondence he took to exist between the verbal and the visual where words exist in the same way that colours do: 'what if, hidden in empirical language', he wrote, 'there is a second-order language in which signs once again lead the vague life of colors?'[16] This implies that he was making the visual paradigmatic for language as well as drawing attention to the primordially or pre-linguistically communicative nature of the visual world. These are points worth stressing: within post-Merleau-Pontean critical contexts characterized either by anti-ocularism, or by a tendency to conceptualize the visual according to linguistic models, some theorists have tried to 'rehabilitate' Merleau-Ponty by claiming that his attention to language during this period was evidence of a burgeoning anti-visual orientation in his own thought too.[17] Given his overall philosophical output though, such a view is unjustified and obscures what is, arguably, one of the most important distinguishing features of his thought, and a consistent strength of his phenomenological project. At this stage, therefore, it is worth returning to the words with which we began: 'to see is to enter a universe of beings which *display themselves*', and to consider them in the more immediate contexts of the portion of the *Phenomenology* in which they are to be found.

Object-horizon

Merleau-Ponty's words appear in Part One of the *Phenomenology* which is titled 'The Body', specifically in its first chapter, 'Experience and Objective Thought: The Problem of the Body'. Functioning as a preface, this chapter takes up and recontextualizes themes already addressed in the *Phenomenology*'s substantial four-chaptered 'Introduction'. These are, predominantly, Merleau-Ponty's insistence on the philosophical and methodological limitations of empiricism and idealism, as against the non-dualistic conceptions of perception, thought, world and body – or body-subject – that he proposes. A particular point of connection between the 'Introduction' and this preface, and a key theme in the fourth chapter of the 'Introduction', 'The Phenomenal Field', was his argument, against empiricism, for a rich understanding of sense experience. One that 'is still to be found in Romantic usage, for example in Herder', in which 'we are given not "dead" qualities, but active ones'.[18] Here too, as elsewhere, it is clear from his choice of language and examples that he prioritizes vision for its particular ability to attune itself to this active understanding of sensation. This agency and vitality of the world of sensation as it is made available to

the body-subject and, particularly, to sight, is developed in the portion of the text with which we are concerned. Here, embedded within a discussion of the object-horizon structure of visibility, various dimensions of the nature of sight and the structures of self-showing are opened up. In his words:

> To see an object is either to have it on the fringe of the visual field and be able to concentrate on it, or else respond to this summons by actually concentrating on it. When I do concentrate my eyes on it, I become anchored in it, but this coming to rest of the gaze is merely a modality of its movement: I continue inside one object the exploration which earlier hovered over them all, and in one movement I close up the landscape and open the object.[19]

'The two operations', he continues,

> do not fortuitously coincide: it is not the contingent aspects of my bodily make-up, for example the retinal structure, which force me to see my surroundings vaguely if I want to see the object clearly. Even if I knew nothing of rods and cones, I should realize that it is necessary to put the surroundings in abeyance the better to see the object, and to lose in background what one gains in focal figure, because to look at the object is to plunge oneself into it, and because objects form a system in which one cannot show itself without concealing others.[20]

Nonetheless,

> The object-horizon structure, or the perspective, is no obstacle to me when I want to see the object: for just as it is the means whereby objects are distinguished from each other, it is also the means by which they are disclosed. To see is to enter a universe of beings which *display themselves*, and they would not do this if they could not be hidden behind each other or behind me. In other words: to look at an object is to inhabit it, and from this habitation to grasp all things in terms of the aspect which they present to it.[21]

In all of these passages, experiences of sight and phenomena of self-showing are constantly juxtaposed. Where sight is concerned, the first thing of note is how active and engaged it is. It is constantly on the move, and when it does come to rest, here or there, this is preparatory to a further, differently focused and differently articulated entrance into other aspects of the visible. Indeed, in these texts, the participatory and, we might add, curiosity-driven qualities of seeing as entering already discussed are amplified.

Merleau-Ponty's language is emotive in this regard. For instance, he describes sight – when it is focused and attentive – as a process through which we become *anchored* in the world. Later, as one of *plunging* into that to which we attend. The latter description in particular – plunging – also implies risk and exhilaration. Paradoxically, then, to attend closely to something does not immediately or inevitably lead to a broad experience of certainty or stability. On the contrary, to a greater or lesser extent, it inaugurates a certain loss of one's bearings, pleasurable or unpleasurable, and a need for readjustment. Thus both descriptions – seeing as becoming anchored and seeing as plunging – convey a conception of sight that renders those who see at once more involved and less in control than we might, in some instances, like to be. In any case, the contrast between this perspective on vision and those associated with still dominant, contemporary anti-ocular sensibilities could not be more apparent. To return to Welsch, by way of example, in a second essay published in *Undoing Aesthetics* – 'Aesthetics Beyond Aesthetics' – vision is defined as 'individualistic', 'emotionless', 'pure' and 'uninvolved'.[22] But Merleau-Ponty's own prolonged explorations, here and elsewhere – particularly his investigations of the visual procedures and testimonies of the artists he admired – led him to very different conclusions about its fundamental character and scope. Nonetheless, bearing in mind Welsch's descriptors, an important point must be made. To claim, with Merleau-Ponty, that sight is not only an active but also a responsive activity, to insist that it is *not* fundamentally 'individualistic', 'emotionless', 'pure' and 'uninvolved', means that what it delivers cannot be a world that is constructed on my terms or according to my preferences.

Necessary unfamiliarities

Until I adjust to it, the self-showing world that I am continually invited to enter, will – or *should* – be experienced to some degree as remote and unaccommodating. Take, for example, Merleau-Ponty's discomfiting descriptions – in his essay 'Cézanne's Doubt' also from 1945 – of the visible worlds that many of Cézanne's paintings opened up. Moreover, Merleau-Ponty argues that, for a host of practical reasons, it is vital that the everyday, lived world be experienced in precisely this way too.

> We live in the midst of man-made objects, among tools, in houses, streets, cities, and most of the time we see them only through the human actions which put them to use. We become used to thinking that all of this exists necessarily and unshakeably. Cézanne's painting suspends these habits of thought and reveals the base of inhuman nature upon which man has installed himself.[23]

This is why, he continues:

> Cézanne's people are strange, as if viewed by a creature of another species. Nature itself is stripped of the attributes which make it ready for animistic communions: there is no wind in the landscape, no movement on the Lac d'Annecy; the frozen objects hesitate at the beginning of the world. It is an unfamiliar world in which one is uncomfortable and which forbids all human effusiveness.[24]

For Merleau-Ponty, to repeat, this atmosphere of strangeness and suspension in Cézanne's work is important: at least temporarily it halts the prosaic or circumscribed ways in which we habitually see, conceptualize and narrate the world and our relationship to it. Drawing on a more technologized metaphor, it is as if a pause button has been pressed, and an opportunity provided not only to look and to think again but also to become differently involved. The alien character of these paintings also indicates that human subjectivity is not their central reference point. We discover that here the world is precisely *not* laid out for easy visual consumption. It seems to be operating on its terms, not ours. Indeed, one of the main reasons Merleau-Ponty continually returns to the paintings of Cézanne is because of their powerful capacity to present him with this sense of the visual world as a kind of agent, as 'for us an in itself'. Not only in the manner just described – through those depictions of strange people and frozen landscapes – but also through the compositional and material components of painting itself, particularly, returning to an earlier theme, his use of colour. Comparing Cézanne with the Impressionists, Merleau-Ponty writes that whereas the Impressionists' palette and application of colour produced effects in which objects lost their substance, 'the composition of Cézanne's palette leads one to suppose that he had another aim':[25]

> Instead of the seven colors of the spectrum, one finds eighteen colors – six reds, five yellows, three blues, three greens, and black. The use of warm colors and black show that Cézanne wants to represent the object, to find it again behind the atmosphere. Likewise he does not break up the tone; rather, he replaces this technique with graduated colors, a progression of chromatic nuances across the object, a modulation of colors which stays close to the object's form and to the light it receives.[26]

In Cézanne's work, Merleau-Ponty continues, the object is no longer 'covered by reflections and lost in its relationship to the atmosphere and to other objects; it seems subtly illuminated from within, light emanates from it, and the result is an impression of solidity and material substance'.[27]

The emphasis, in other words, is not, as with Impressionism, on sight understood primarily as a process in which the human visual apparatus transforms sensations received as bits of data into meaningful images. Instead, as noted earlier, the focus is on those processes of self-showing into which sight, properly understood, is already incorporated. And key here, to repeat, is the capacity of colour, or a certain use of colour, to create a strong sense of a world that emanates agency, that 'seems subtly illuminated from within' as Merleau-Ponty put it, and, from this basis, can both resist and act upon us. This is especially significant given that, following Galileo and Descartes in the seventeenth century, and the empiricist philosopher John Locke in the eighteenth, colours have come to be defined as 'secondary qualities', that is, as qualities that do not in fact belong to real objects, but represent instead certain 'powers' in us to produce ideas – of redness, or greenness, and so on.[28]

Three further characteristics of the self-showing world are also revealed as important. Here again, this world is shown not, ultimately, to be in the service of human beings, projects and projections. The first characteristic may initially sit uncomfortably with Merleau-Ponty's descriptions, earlier, of the paradigmatic, but apparently immobile visible worlds depicted in Cézanne's paintings. For like sight, the self-showing world is also intensely active and motile, although the speeds at which this activity and this motility occur may vary dramatically. Whether fast or slow, however, at issue is a dynamic system in which openings and closings, disclosure and hiddenness, and degrees of illumination and obscurity modify, challenge, but also serve one another. These factors, and their effects, are again brought to focus for Merleau-Ponty in Cézanne's paintings: Cézanne, he writes, 'did not want to separate the stable things which we see' – here he is referring to our everyday, or prosaic ways of seeing – 'and the shifting way in which they appear; he wanted to depict matter as it takes on form, the birth of order through spontaneous organization'.[29] Later, in 'Eye and Mind' he wrote that, well before the emergence of cubism – understood as an image-making strategy that overtly shattered the supposedly settled sense of placement, containment and orderliness generally associated with the dominant pictorial model of linear perspective – Cézanne already knew that 'the external form, the envelope, is secondary and derived'.[30] In the experiments Cézanne carried out during the middle period of his working life, wrote Merleau-Ponty, he 'came to find that inside this space, a box or container too large for them, the things began to move, color against color; they began to modulate in instability'.[31] This brings me to a second characteristic of the self-showing world, namely, its complex relationship to one of the most dominant structures through which it is given to be seen: linear perspective.

We might regard Cézanne's project as one in which linear perspective, first coherently formulated in Leon Battista Alberti's *De Pictura* (*On Painting*) of 1435, is being dismantled before our eyes. And that Cézanne is exchanging this model, according to which we have long been taught to construct both our pictorial worlds and our view of reality, for one that is less determined but more perceptually and psychologically accurate. Merleau-Ponty seemed to be suggesting as much when he wrote in 'Cézanne's Doubt' that by 'remaining faithful to the phenomena in his investigations of perspective, Cézanne discovered what recent psychologists have come to formulate: the lived perspective, that which we actually perceive, is not a geometric or a photographic one'.[32]

But in the text from the contemporaneous *Phenomenology* that we have been discussing at length, where Merleau-Ponty equates sight with the entrance into 'a universe of beings which *display themselves*', it is clear that he grounds this capacity for self-display in what he calls 'the object-horizon structure, or the perspective'[33] through which things are both distinguished from each other, and disclosed. This suggests a more complex relationship to linear perspective than an outright rejection of it. It suggests – or so I will argue – that the deeper significance of Cézanne's work is that it exemplifies several facts that the mathematical coherence of linear perspective may initially obscure. For instance, that linear perspective is not a purely artificial system devised in isolation from, or idealized opposition to lived reality. Indeed, Alberti was emphatic in *On Painting* that it was the product of what, today, we would describe as a rich, interdisciplinary exploration of the visual. One that brought together theory – more specifically, a range of theories drawn from mathematics, geometry and the study of optics – and practice – specifically ancient Greek and Roman as well as then-contemporary painting and sculpture, including Alberti's own. This is why Alberti explains in *On Painting* that although the book begins with a discussion of relevant mathematical themes, he wants his readers to accept his ideas 'as the product not of a pure mathematician but only of a painter'.[34] The painter being one who 'strives to represent only the things that are seen' and for whom, therefore, methodologically, the imitation of Nature, and the synthesis of its most beautiful aspects, is key.[35] Indeed, arguably, there is a direct relationship between the rigour of linear perspective's infrastructure and its capacity to create space not only for the display of remarkable visual detail and diversity but also for in-depth, accurate and animated explorations of the varied positional, proportional and other relationships that exist between these elements. The best works produced according to its logics testify to this.

The third claim I want to make with respect to the self-showing world also manifests itself in the visual structures and 'reality effects' of linear perspective. Namely, that as an aid to the detailed imitation of nature, that

is, of appearances, it inevitably reproduces the always incomplete character of the visual world. For here, as Merleau-Ponty put it, 'objects form a system in which one cannot show itself without concealing others'.[36] Put differently, the ever-modulating self-showing world can be seen only if it is seen in part. Paradoxically, therefore, whether in everyday life, or by means of the representational devices of linear perspective, we are presented with a world in which there is, at once, not only much more to see than we might ordinarily think is the case, but also much less. And one that tries to teach us, simultaneously, to do both.

These propositions regarding linear perspective within a broader discussion of self-showing are worth considering in more detail with reference to specific visual works. First, because, like vision itself, linear perspective tends to be treated in predominantly reductive, even negative terms by modern and contemporary theorists. Secondly, because the logics of linear perspective – despite the critiques and challenges offered by modern art and philosophy – continue to dominate everyday life everywhere, principally through the global proliferation of the photographic in its various forms. And thirdly – this is a theme I will develop more fully later on – due to its multilayered 'reality effects' and, therefore, its power to make both truth and lies convincing.

The first work of art to which I would like to turn, unsurprisingly, is by Cézanne. It is one of his many depictions of Mont Sainte-Victoire, a well-known landmark near to Aix-en-Provence, Cézanne's place of birth and death, and a town to which he repeatedly returned throughout his life.[37] Painted, in oil on canvas, in about 1887, this work was exhibited at the Société des Amis des Arts at Aix, a society of amateur artists, almost a decade later, in 1895. There, it was seen and admired by the poet Joachim Gasquet, so much so that Cézanne presented the painting to him. In the 1920s it was purchased by the art collector Samuel Courtauld, and has been in the collection of London's Courtauld Gallery since 1934.[38] Although it is a work that Merleau-Ponty probably did not have the opportunity to study face to face, it demonstrates aspects of Cézanne's approach that were of particular importance to him.

A redeployment of linear perspective

The Courtauld *Mont Sainte-Victoire* has been much discussed by art historians and could be described as an iconic work. Produced when the new photographic modes of seeing and showing were also in the ascendency, it is conventionally regarded as one of the several paradigmatic works of early modern art that questioned the classical ideals and assumptions of perspectival stability and scale that photography also in fact affirmed, and proposed alternative, often visually demanding paradigms for picturing the

world and our relationship to it. But linear perspective does play a role in this painting.

Painted from a high vantage point, the Courtauld *Mont Sainte-Victoire*, with its fragmented foreground of close-up portions of tree trunk and branches, depicts the valley of the river Arc, a grid-work of fields, fences and foliage with scattered buildings, a distant railway bridge, and, still further back, the centrally positioned mountain itself. The scene seems to recede rapidly, even precipitously, from foreground to background, not only directly towards the mountain peak on the horizon straight ahead but also, due to Cézanne's deployment of two-point linear perspective, to two implied vanishing points positioned well outside of the picture frame, to the far left and far right. In this way, a strong panoramic sense is created in which a more or less clearly focused, painted view of the landscape is encompassed by the strange presence of unpainted, peripheral and virtual views of the scene. As such, the painting establishes a non-oppositional relationship between what we might prosaically call the visible and the invisible. Indeed, visible and invisible are presented as intertwined, with the latter seemingly generated by or from the former. This sense of spatiality is supported by Cézanne's use of colour. Depth and distance are enhanced by the contrast he creates between the stronger greens and ochres used in the foreground, and the softer, more recessive pinks and blues of the mountain further back. It is also supported by additional compositional means. For instance, moving to the upper third of the work in which the sky is depicted we discover that it is partially obscured by the large, sweeping, branches of those partially visible foreground trees. Seen, as noted, as if in close-up, these branches form a kind of filigree through which we are encouraged to look. Conversely, though, as has often been remarked, it is also the case that the mountain peak, the painting's most distant point, feels much closer than it should, closer, certainly, than its actual location about 8 miles away from where Cézanne had positioned himself to depict the scene. This apparent contraction of space, contradicting yet coexisting with that atmosphere of depth and breadth just described, was achieved in three ways. First, returning to those branches in the upper portion of the work, there is the flattening effect of their patterned arrangement on the canvas. Secondly, there is the curved branch seen on the right that exactly follows the curve of the distant mountain range, thereby creating a sense of sudden spatial equivalence between a line we would otherwise interpret as being far off and another that we would otherwise interpret as nearby. Thirdly, and most powerfully, the focal point of the painting is dominated by a point of visible – but physically impossible – exchange, in which the lowest branch of the foreground tree on the left seems to bend down and stretch across the miles as if to touch that distant, central peak. This sense of destabilization in which the far off enters into the foreground and vice versa

was again reinforced by colour, but by a use of colour that reverses that other system of depth-inducing effects described earlier. Although the foreground foliage – like the foliage further back – is of a strong green, the branches and the tree trunk to the left are painted in the same subtle tones as the far away mountain. Here, then, colour sets up relationships and rhythms that operate independently from, and undermine, the spatial logics that it actively supports elsewhere. Taken together, therefore, the effects of line and colour in this painting are at once strong, earthy and quietly anarchic. A world has been assembled – or rather appears still to be assembling itself – in which forms seem to be stacked on top of, and behind, one another in a way that can suddenly shift from the archaically robust to the provisional, and back again. All in all, therefore, the scene and our own visual experience of it are in a constant state of renegotiation. And here the renegotiation of time as well as space is at issue. For what we are given to see in the Courtauld *Mont Sainte-Victoire* is a world of nature that is also a living–working landscape, and has been since Roman times. As we look, layers of history and habit that have been shaped by human need and resourcefulness, by agriculture, industry and technology – the Bibémus quarry was nearby, as were new reservoirs that had been built during the nineteenth century, one, the Barrage Zola, by Émile Zola's engineer father – intersect with a much longer, older and slower story of geological transformation. This leads to a further point, namely that, as near meets far, as actual meets virtual, as the grid-work of fields transitions into a fretwork of branches and back again, and – mainly through the patchy, physical application of colour to canvas – as the coherence of linear perspective gives way to a patchwork of physical marks and vice versa, we find ourselves reflecting not only on what is given to us to be seen but also on how it comes to appearance. Specifically, due to Cézanne's markedly material way of working, and in a manner made possible only within the logics of the visible, we become attuned to the manner in which the landscape starts to open up, layer by layer, object by object, colour by colour – that is, not merely through what is depicted but by more finely tuned forms of self-showing at the level of form, colour and composition. As such, Cézanne's painting at once presents a scene of spatial, material and durational presence – as with conventional paintings constructed according to the logics of linear perspective we are presented with a space that we can imagine entering, not just with our eyes, but with our bodies. But it is also a scene animated by a pulsing sense of expansion and contraction; it is a painted structure, relating to an actual geographic location, that seems to exemplify the conception of seeing as entering and to exercise our sight in the art of seeing both further away than before, and closer by.

The kinds of juxtapositions and destablizations that I have been describing are often specifically associated with the novelty and impact

of Cézanne's compositions on subsequent developments in modern art, particularly, of course, cubism. We might argue that these juxtapositions and destabilizations are the result of Cézanne's importation of a pictorial system external to that of linear perspective. More specifically his adoption of an aesthetic of juxtaposition, or what the art historian Lucy Lippard, writing in the 1960s, would call a collage aesthetic, whose 'shock tactics' have been overtly used by modern artists to challenge habituated ways of picturing, viewing and interpreting the world at large, and to activate radical new forms of visual engagement. But it is also possible to argue, as I have already been doing, that Cézanne's approach does not so much undermine or negate the logics of linear perspective as excavate its paradoxical nature. It is true that linear perspective's mathematical or geometrical character, and its habitual recourse to the logic of the grid, easily create impressions of pristine, well-ordered worlds without hiding places. But phenomenologically speaking, what is actually presented, by precisely these means, is *not* the image of a world that exists, 'necessarily and unshakeably'[39] (i.e. a rationalized or idealized conception of the world), but a fact that the mathematical coherence of linear perspective may tend to obscure: namely, that its 'reality effect' is tied to its faithful reproduction of the always *incomplete* character of the visual world:

> What prohibits me from treating my perception as an intellectual act is that an intellectual act would grasp the object either as possible or as necessary. But in perception it is 'real'; it is given as the infinite sum of an indefinite series of perspectival views in each of which the object is given but in none of which it is given exhaustively. It is not accidental for the object to be given to me in a 'deformed' way, from the point of view [*place*] which I occupy. That is the price of its being 'real'.[40]

Cézanne's composition, therefore, makes visible what linear perspective as a system tries to keep secret: that its world is not in fact that of the closed circuit but an open one. Indeed, it is worth noting that a particular marker of openness and incompleteness in Cézanne's *Mont Sainte-Victoire*, the almost touching of the near and the far, and the quivering gap that this produces, is an animating device found in many of the most famous Western illusionistic paintings. There is a correspondence between Cézanne's almost-touching branch and mountain peak, for instance, in the almost-touching hands of God and Adam in Michelangelo's fresco for the Sistene Chapel ceiling. And in the almost-touching hands of Mary and Joseph in Raphael's 1504 *Marriage of the Virgin*, a virtuoso application of linear perspective, this time with a central vanishing point, to a scene of figures positioned in a Renaissance cityscape. Without the framework provided by linear perspective these effects would lose their power.

This idea, that the structure of appearance produced by linear perspective is an open rather than closed system, is worth pushing still further. Linear perspective is often described as a system that works – that is not only convincing but also reassuring – because, by means of single point perspective, it establishes a clearly defined and directed viewing position or, by means of two-point perspective, a clearly mapped out movement between two points on the horizon, by which the unfolding scene can be mastered. In this way, it is therefore taken to have introduced and reinforced in viewers a sense of being ideally positioned before a world that unfolds itself for them alone. Here again, though, the Courtauld *Mont Sainte-Victoire*, and Cézanne's modes of picturing more generally, seem to intervene less by challenging the logics and effects of linear perspective and more by mining and demonstrating the complexity and plasticity that are intrinsic to this system. The point I want to make here, therefore, is that the visual set-ups associated with linear perspective as they are activated by Cézanne are powerful at one level for the ways in which they pull, stretch or extend our own seeing so that we become aware of the back- and mid-ground as well as foreground, the peripheral as well as the centrally positioned; the out of focus as well as the in-focus, the 'invisible' as well as that which seems to have been marked out as particularly or pointedly 'visible' within a given scenario – that to which our eyes seem most forcefully to be pulled. This is a point I made earlier. Also evident at another level, paradoxically, is the reality that, through linear perspective's capacity to deliver a world to us in such a precisely situated manner, it also promises that an indefinite number of other, equally precise and situated vantage points may be taken upon the scene. Or rather, we discover that vantage points that are not our own are also mapped out in these images – just as they are also, in fact, mapped out within all of the ordinary visual scenarios in which we find ourselves. Indeed, what is crucial about the expanded, complex, layered modes of self-showing and of seeing at issue in Cézanne's painting is the degree to which we are able to extend them into the realms of everyday life. Indeed, this expanded understanding – which includes vantage points occupied by human and by non-human entities – and those moments in which we can suddenly become profoundly aware of them were issues that Merleau-Ponty was particularly attentive to. In the *Phenomenology*, for instance, when writing about an ordinary environment – that of his study, perhaps – he opened it up not only according to his own perspectives, needs and actions but also as a place that was animated, through and through, by networks of object-to-object 'viewpoints' and exchanges:

> When I look at the lamp on my table, I attribute to it not only the qualities visible from where I am, but also those which the chimney, the walls, the table can 'see'; but back of my lamp is nothing but the face which it 'shows' to the chimney.[41]

As already indicated, for Merleau-Ponty, Cézanne's work was exemplary because it pushed the faithfulness to phenomena already central to the Albertian project in ways that drew attention to the agency of the non-human as well as the human world. Indeed, despite the classical focus on the human and humanistic that was central to Renaissance values and scholarship, there is a strong sense that this was also an important theme in Alberti's *On Painting*. Here he writes about the necessity of depicting animation not only within the realm of human action and interaction – the depiction of emotion, for instance, through the physical placement and movements of the human body – but also within the realms of the non-human.

> Now I must speak of the way in which inanimate things move, since I believe all the movements I mentioned are necessary in painting also in relation to them. The movement of hair and manes and branches and leaves and clothing are very pleasing when represented in painting. I should like all the seven movements I spoke of to appear in hair. Let it twist around as if to tie itself in a knot, and wave upwards in the air like flames, let it weave beneath other hair and sometimes lift on one side and another.[42]

To repeat, then, what Cézanne's painting seems to exemplify, through its use of linear perspective and various distortions of it, is the potency of this system, usually defined as highly rationalized and realistic, to enable flexible and imaginative entrances into a given scenario. As noted, this includes the capacity to imagine and identify with modes of entering and engaging that are not only between us and things, but also between the depicted things themselves. What is amplified, again, is seeing as entering, as motile and exploratory, and as a process of beginning to look with eyes that are not our own. With this comes a strong sense, in pictorial form, of the definition of sight that is the theme of this chapter, that is, of sight that is in the service of a phenomenon that is prior to it, namely, self-showing.

These points about the agency of self-showing, and about the impact of linear perspective in this regard, are worth taking still further. In particular I want to dwell on the need – the urgent need, arguably – for the complex understandings of the visual opened up by a work such as Cézanne's *Mont Sainte-Victoire* to be normalized within everyday life. What does this mean, and how can this be achieved? To this end, I will turn to a second iconic work – of sculpture, this time – again much discussed by twentieth-century and contemporary art historians. The work in question is *Prairie* made in 1967 by the British sculptor Anthony Caro, who – due to the remarkable transitions that occurred in his work from 1959 and into the early 1960s – has been described as one of only a few artists to have succeeded in 'redefining the standards by which art [and notably sculpture] is judged'.[43]

In 1959, Caro was making traditional, in the sense of monolithic, figurative sculptures. Nonetheless, already evidenced in the purposefully lumpen, roughly textured, and not yet fully formed quality of pieces such as *Man Taking Off His Shirt*, *Woman Waking Up* and *A Woman's Body* was a quest to try and find new parameters for sculpture, to push it as far as it could go, using relentless experimentation at a material and compositional level. Indeed, in their unformedness, these figurative works have themselves often been described as full of yearning: the body as it experienced from the inside, striving to break out of its confines, to find definition and release. By 1960, though, following a study trip to the United States in 1959, everything had changed, methodologically, materially and visually, with the creation of his first non-figurative work, *Twenty-four Hours*. Assembled from found pieces of flat, shaped steel, painted dark brown and black – all new departures – the only potential link with his earlier sculptures was the rawness of its surface texture. Of particular note in the context of our discussions, however, are the factors that enabled this change to come about. For despite the important influence on Caro of both Henry Moore (for whom he worked between 1951 and 1953) and David Smith who had begun working with welded steel several years earlier than Caro – *Twenty-four Hours*, and the developments that followed, have a lineage that is more deeply rooted in the languages and methods of painting than in sculpture, that is, in pictorial language, and, particularly, a language informed, once again, by the infrastructures and dynamics of linear perspective. One manifestation of this is found in *Twenty-four Hours'* layered construction with its elements arranged in such a way as to create a strong, layered sense – more articulate from some angles than others – of foreground, mid-ground and background. Indeed, of influence on Caro in this regard was his meeting and evolving friendship with the colour field painter Kenneth Noland. While Caro was in the United States, Noland was exhibiting his circle paintings and the relationship between one of these paintings, *Half* from 1959, and the construction of *Twenty-four Hours* is clear, the latter being, in effect, a transposition of the pictorial logics of Noland's piece into sculptural form. What this transposition also brought with it, despite that look of ragged darkness at the level of materiality, was a new feeling of openness, of forms relating across space, and therefore of lightness. These emergent features of openness and lightness, and the creation of structures that have been described as non-sculptural, as if drawn in space, became distinguishing features of the large-scale, multipart welded and bolted steel, or steel and aluminium works for which Caro is best known, and of which *Early One Morning* (1962) and the later *Prairie* are paradigmatic examples. These works were also, of course, literally painted, in a single, bright, saturated colour that unified the various elements from which they had been constructed, and optically intensified that sense of lightness. Thus, despite their scale, as

Caro himself noted, works such as *Early One Morning* – the starting point of which was, in fact, an upright structure that resembled a simplified canvas-on-easel form – were non-monolithic. At a formal and perceptual level, and in contrast to the experience of viewing traditional sculpture, we are invited to enter Caro's environments optically, to look *through* as well as *at* them, just as with two-dimensional works constructed according to the logics of linear perspective. In addition, these are works whose elements unfold in space – Caro himself saw correlations with the temporalities of music and dance – placing emphasis on the horizontal rather than, as is the norm with traditional sculpture, the vertical. Arguably, this emphasis on the horizontal was yet again indebted to painting, in part to developments in mid-twentieth-century painting with which Caro would have been familiar, notably Jackson Pollock's practice of painting on canvases laid out on the floor rather than suspended vertically on walls or easels. But also referenced are the horizontality, groundedness and illusion of depth that were the distinguishing features of two-dimensional works produced following the devices of linear perspective. Indeed, this notion, that Caro's works may be regarded as participants in, and negotiators of, the logics of linear perspective seems convincing when we consider, for instance, his use not only of girders, I- and T-beams but also of semi-transparent mesh panels, in the construction of such works as *Aroma* (1966), *The Window* (1966–7) and *Source* (1967). Although Caro regarded this use of mesh 'as analogous to the presence of glass in a skyscraper',[44] and although his spatial explorations have been specifically associated with a 'growing engagement with concerns which had hitherto been the exclusive domain of architecture',[45] there is an unmistakable sense that they also make visual references to Alberti's veil (the grid-like device he described in *On Painting* as a vital aid to achieving perspectival accuracy), and to Alberti's equation of the surface of a painting with a window to be looked through. Furthermore, in *Prairie*, which was also made during this period, the open infrastructure and unstable aspects of linear perspective discussed earlier seem to be laid bare in a particularly powerful way. Thus, *Prairie* makes for an interesting counterpart to, and development of, the Courtauld *Mont Sainte-Victoire*, not only prosaically – the work's title evokes the landscape, although it refers, in fact, to the commercial paint colour covering all of its surfaces – but also at a more complex, compositional level. As Alex Potts has put it in *The Sculptural Imagination*:

> It is undeniable that Caro's best sculpture keeps driving one to view it in different ways, close to and further away, from above and to one side, none of which quite offers a sense of wholeness, but produces instead a somewhat baffling concatenation of different, unresolved and unstable

apprehensions of what the work is. *Prairie*, for example, might be envisaged as a flattened horizontal yellow expanse, but the consistency of such a perception is frustrated by the impossibility of positioning oneself so as to be able to survey the whole work from above. Standing back to view it in its entirety, one sees it more and more in profile, as a structure raised from the ground. The cutting upward thrust of the vertical metal plate set a little to one side from the main body of the work also throws into disarray any settled sense of horizontality.[46]

This instability is apparent even when the sculpture is presented in a carefully framed photographic form, as in Potts's book. The 'almost perversely precarious and structurally ambiguous supporting structure of obliquely tilted metal sheets', he writes, has a complexity that 'plays havoc with any sense one might have of some clear layering in horizontal planes or some neatly articulated tension between horizontal and vertical'.[47]

Here, then, the space of self-showing is such that seeing as entering is experienced as perceptually demanding; the scene is not set up to easily accommodate us. But a work such as *Prairie* also indicates a movement in the opposite direction. Crucial – and now, at last, I progress to the fourth broad point I wanted to make about the workings and effects of linear perspective and of the self-showing world – is the degree to which the complex object-horizon structures of a work such as *Prairie*, its intertwinings of appearance and concealment, and its instability, actively affect the everyday, physical space of its viewers; it does so in a way that not even Cézanne's destabilizing paintings could achieve. A factor here, of course – already evidenced in Caro's 1959 figurative piece *A Woman's Body* – is their relinquishment of the sculptural equivalent to the picture frame, namely, the plinth that serves to separate the world of the artwork from that of the viewer. And yet – perhaps due to the bold and singular colouration of Caro's sprawling sculptures – they always also maintain a sense of their own internal coherence; they remain somewhat contained within a space and time of their own, as if their worlds and ours exist side by side but do not coincide. This makes sense. At a time when many artists were trying to erode what they defined as an elitist and artificial barrier between art and life, Caro, by contrast, insisted that 'Sculpture's space and our space are not the same . . . *separation* is the secret of sculpture's function as art'.[48] Not surprisingly, therefore, his works from the 1960s have often been described (again using biblical terminology) as in the world but not of it.

Like Caro's large and colourful sculptures, the self-showing world and aspects of our own condition as self-showing beings *can* be attention grabbing. Certainly that is how the activity of showing off is usually

understood. Nonetheless, as is clear from our engagements with Cézanne's paintings or with a work such as Caro's *Prairie* – circumscribing such acts of self-display is the fact that the visible world at large does not generally *insist* on being seen. It exists predominantly 'at the fringe of the visual field' or in a dormant state. It offers itself to sight, but this is an offer that may or may not be taken up. Unlike the speaking or sounding world from which it is difficult to find respite, the self-showing world can be more easily rebuffed. It is for such reasons that the visible world has been theorized as being at the mercy of sight and thus problematically vulnerable, and why those arguing for a provisual ethics have tended to locate ethical agency first and foremost on the side of sight.

And yet the visual, even at its most peripheral and understated, continues to have a powerful presence. As Merleau-Ponty has argued, to turn away from something, to ignore or evade it, means that we must, in the first instance, have acknowledged it. More than that, since, as I am claiming, agency resides not just on the sight of sight but, more fundamentally, on the side of self-showing, sooner or later, despite our attempts at evasion, that which shows itself will eventually be seen. Even when these solicitations are unpleasant – and they often are – the sooner we attend to them the better. This was a point starkly made by Merleau-Ponty in his remarkable essay 'The War Has Taken Place', and in turning to this essay we shift, perhaps rather suddenly, from the world of art to that of international politics and warfare, where the same fundamental themes about the priority and agency of the self-showing world are also at issue.

Face to face

Dated June 1945, 'The War Has Taken Place' was published 4 months later in the first issue of *Les Temps Modernes*, the journal that Jean-Paul Sartre founded with Merleau-Ponty, Simone de Beauvoir, and others, and of which Merleau-Ponty was political editor until his resignation in January 1953.[49] In it – and in a way that provides rare insight into the more overtly personal aspects of Merleau-Ponty's character and life experience – he considered the causes and consequences of France's inadequate responses to the political situation prior to the outbreak of World War Two and France's subsequent occupation by German forces. Here, according to Merleau-Ponty, was a self-showing reality that no one wanted to see. In fact, he described it as one which neither he, nor his countrymen, were philosophically or ethically predisposed to see. His opening reference is to the unwillingness of even the most politically aware in pre-war France to face the facts of mounting German military aggression, and he associated this failure, this blindness and apathy, with the dominance of an intellectual context (an 'optimistic

philosophy') that made it almost impossible to acknowledge present realities. As he put it:

Events kept making it less and less probable that peace could be maintained. How could we have waited so long to decide to go to war? It is no longer comprehensible that certain of us accepted Munich as a chance to test German good will. The reason was that we were not guided by the facts. We had secretly resolved to know nothing of violence and unhappiness as elements of history because we were living in a country too happy and too weak to envisage them.[50]

'We knew that concentration camps existed', he continued, 'that the Jews were being persecuted, but these certainties belonged to the world of thought. We were not as yet living face to face with cruelty and death: we had not as yet been given the choice of submitting to them or confronting them.'[51]

Of especial significance here is Merleau-Ponty's distinction between two scenarios. On the one hand, there were the dangers and choices connected with 'living face to face' with actuality. On the other hand, there was the deactivating consolation of becoming immersed instead in the 'certainties' that 'belonged to the world of thought' – the abstract, universalizing certainties that had been the stated objectives of the philosophical and scientific traditions in which Merleau-Ponty and his compatriots, including 'generations of socialist professors had been trained'.[52]

The practical and ethical discoveries Merleau-Ponty had made while writing 'The War Has Taken Place' would take root. He would live up to his conviction that the self-showing world, whatever its context of appearance, should take precedence over the world of ideas and ideals, despite its personal cost – it resulted in a break in his relationship with Sartre, and his resignation as political editor of Les Temps Modernes.[53] As noted by Hubert and Patricia Allen Dreyfus, the translators of Merleau-Ponty's compilation of essays from this period titled Sense and Non-Sense, in his essay 'Faith and Good Faith' of 1946, he had written that 'man's value does not lie in . . . an unquestioned faith. Instead, it consists of a higher awareness of . . . when it is reasonable to take things on trust and the moment when questioning is in order.'[54] This value was one that Merleau-Ponty felt compelled to apply to his relationship to Communism when a series of facts became apparent, principally that 'there were Russian concentration camps', and that 'the North Koreans had started the war in Korea', therefore, the reality that 'Stalin too could be imperialistic'.[55]

As Sartre was at last 'learning there was history', Merleau-Ponty was becoming increasingly aware of its complexity. . . . [By 1952] Merleau-Ponty and Sartre were temporally and temperamentally out of phase with

each other. Merleau-Ponty was always a step beyond Sartre. Moreover, as Sartre himself put it, 'I was always more dogmatic; he was more *nuancé.*' At a time when Merleau-Ponty had become disillusioned with Communism, Sartre chose increasing activism and Communist sympathy – simply as an absurd act of will. Or so it seemed to Merleau-Ponty, who found just the opposite meaning in day-to-day political events.[56]

Appearance, dissimulation and truth

We must not, therefore, wonder whether we really perceive a world, we must instead say: the world is what we perceive.

MERLEAU-PONTY[57]

Within phenomenological contexts, appearance is everything. This means that an important task facing phenomenological thinkers is to address the relationship between appearance and truth. This was an issue that Merleau-Ponty directly addressed on numerous occasions. Take, for instance, the words just cited from the 'Preface' to the *Phenomenology* where two points are of particular note. First, with respect to his use of the term 'wonder', he is engaging with a long-standing philosophical puzzle associated with representational theories of perception in their various modes. This is the idea that to see is never directly to perceive objects in the world. Rather, it is to perceive mental representations, or images, of them that are produced due to the interaction of sense data derived from objects (what John Locke and others referred to as 'qualities') and our own perceptual – and some would add psychological – apparatuses. Some thinkers believed that there was parity between the world itself and our mental representations of it. Others – Locke, for instance – believed that although, due to the powers of primary qualities, mental representations bear degrees of resemblance to actual things, the pictures we form of the world are nonetheless radically different from the world as it actually is. At an extreme, representational theories of vision go so far as to cast doubt on the very existence of a world of objects at all. But such a destination point in thinking is one that Merleau-Ponty disregarded since it fails to illuminate the complexities of lived experience with which he believed philosophy should above all be concerned, and where a rather different understanding of truth is disclosed:

> In more general terms we must not wonder whether our self-evident truths are real truths, or whether, through some perversity inherent in our minds, that which is self-evident for us might not be illusory in relation to some truth in itself. For in so far as we talk about illusion, it is because we have identified illusions, and have done so solely in the light of some perception which at the same time gave assurance of its own truth.[58]

It is true that Merleau-Ponty, and phenomenology more broadly, could in this way be accused of sidestepping a crucial philosophical conundrum. But what is being proposed is that, for irreducibly embodied and therefore always situated beings such as ourselves, certain questions – about the nature and operations of the noumenal realm, for instance – should be acknowledged as unresolvable. Instead – and this is the second point I wanted to make at this stage – our philosophical attention is better turned to the many questions we *can* investigate productively since they are rooted in what Merleau-Ponty referred to as 'the self-evidence of perception', and in what I would like to restage as the self-evidence of appearances.

> We are in the realm of truth and it is 'the experience of truth' which is self-evident. To seek the essence of perception is to declare that perception is, not presumed true, but defined as access to the truth. . . . The self-evidence of perception is not adequate thought or apodeictic self-evidence. The world is not what I think, but what I live through. I am open to the world, I have no doubt that I am in communication with it, but I do not possess it; it is inexhaustible.[59]

Thus Merleau-Ponty asks us to exchange unproductive wondering for immersion in what he calls the 'mystery of the world and of reason';[60] he sees it as phenomenology's task to uncover this perceptually available realm, predominantly by paying attention to appearances which, as already indicated, he takes to be intercorporeal phenomena in which we, as seers and as self-showers, are always already implicated.[61] To reiterate, then, his broad approach to the philosophical is predicated upon a positive understanding of the relationship between visual phenomena and realm of truth. This was true throughout his career. It is likely, for instance, that *The Visible and the Invisible* may, at one time, have had the working title of *The Origins of Truth*.[62] Indeed, a reference from *The Visible and the Invisible* is worth citing now. As before, there is a sense that here the position already presented in the *Phenomenology* is being rearticulated, but from another side. That is, more emphatically from within the appearing world with its ambiguities and openness. The context is Merleau-Ponty's description of interrogation as a process in which sense and non-sense, and illusion and disillusionment, impinge upon each other and alter our understanding of that which we are seeking to know. 'Belief and incredulity', he wrote, are

> so closely bound up that we always find the one in the other, and in particular a germ of non-truth in the truth: the certitude I have of being connected up with the world by my look always promises me a pseudo-world of phantasms if I let it wander.[63]

Here again, though, the intimation is not that our interrogations of the visual world can never be regarded as veridical, but rather that truth is never a finite concept. Therefore, the pursuit of understanding is an activity that is shot through with what Merleau-Ponty called perceptual faith:

> [W]hen an illusion dissipates, when an appearance suddenly breaks up, it is always for the profit of a new appearance which takes up again for its own account the ontological function of the first. I thought I saw on the sands a piece of wood polished by the sea, and *it was* a clayey rock. The breakup and the destruction of the first appearance do not authorize me to define henceforth the 'real' as a simple probable. . . . The dis-illusion is the loss of one evidence only because it is the acquisition of *another evidence*. . . . What I can conclude from these disillusions or deceptions, therefore, is that perhaps 'reality' does not belong definitively to any particular perception, that in this sense it lies *always further on*; but this does not authorize me to break or ignore the bond that joins them one after the other to the real, a bond that cannot be broken with the one without first having been established with the following . . . what each perception, even if false, verifies, is the belongingness of each experience to the same world, their equal power to manifest it, as *possibilities of the same world*.[64]

The challenge is to remain open to revelation and to adjust our positions accordingly. Insofar as we ourselves are embodied, temporal beings, truth, like the image itself, must be regarded as a phenomenon that unfolds. What is clear, in any case – returning to the earlier theme of seeing as entering – is that truth is ascertained by pursuing, not turning away from the visible.

This also means that Merleau-Ponty's understanding of the visual and its relation to knowledge and truth must be considered in the light of another conventional position that I have not yet mentioned. This is the view advanced by those thinkers for whom the supposed distancing capacities of vision are regarded not as a weakness, as discussed earlier, but as a particular strength, making it better placed than the other senses to deliver a world of truth to us, dispassionately and accurately.[65] For these thinkers, sight is valued precisely because it purportedly tends towards a state of disembodiment, disinterestedness and autonomy, having the capacity, somehow, to leave the seer, and his or her particularities and prejudices behind. An example of this is the notion of the impartial eyewitness which, in its human and technological variants, remains central to modern systems of verification (to observational science, to surveillance and criminal justice procedures, and to processes of documentation and reportage). As I will show, the problem here, from a Merleau-Pontean perspective, is less with the notion of impartiality

(a variant of this is also central to Merleau-Ponty's thought) but with the assumption that it is from a position of bodily or material disconnection from persons, places, things and events that impartiality is achieved and truth approached.

And as it turns out, these Merleau-Pontean reservations have found support from contemporary research in the field of criminal justice. For it appears, from analyses of eyewitness identification procedures – procedures that remain crucial with respect to investigating and prosecuting crimes but are often proven to be unreliable[66] – that the most trustworthy eye witnesses are those who generally exhibit high extraversion (among other factors), that is, are highly sociable, and thus have a strong sense of interest in, and connection with the world around them.[67]

A literary excursion into dangerous territory

Questions of appearance and truth in relation to self-showing have not only been matters of recent concern. Thus I will now turn to an illuminating eighteenth-century English literary source, *The Pupil of Pleasure. By Courtney Melmoth*. First published in 1776, *The Pupil of Pleasure* is a tale of multiple seduction written by the poet, novelist and ex-clergyman, Samuel Jackson Pratt. Then still in his twenties, he was already a successful writer, and would become well known as the author of numerous comic novels that were intended to provide social and cultural commentary as well as to entertain. 'Courtney Melmoth' was Pratt's pseudonym. Indeed, it was his stage name; having left the Church after embarking on a scandalous love affair and 'sham marriage', he was, for a time, an unsuccessful actor. His 'marriage', which would never be formalized, would cause considerable damage to his reputation with the reading public; his 'wife', however, who was known as Mrs Charlotte Melmoth and had taken to the stage with him, went on to enjoy success as an actress in Britain, followed by fame in America.[68] *The Pupil of Pleasure* is useful for two reasons. First, it is a morality tale – a sensationalist morality tale which was met with censure upon its publication – that explicitly considers relationships between appearance and the ethical, focused as it is on questions of visual comportment, seeing and seeming, disclosure and revelation. Secondly, according to the *Oxford English Dictionary*, it is in this work that the earliest recorded use of the expression 'to show off' is to be found. Indeed, three different inflections of this term are presented, the third of which has especial affinities with the argument for an ethics of self-showing that I am putting forward in this book.

The Pupil of Pleasure was written during a period in Western European intellectual history that has frequently been described as explicitly valorizing the visual, and conflating visual paradigms with epistemological and

educational ones. This was manifest in the empirical sciences, for instance, where emphasis was placed on the visual dimensions of data collection, experimentation and demonstration. These included the often dramatically orchestrated and spectacular public showings of new scientific discoveries that had become a form of popular entertainment. The best-known visual representation of such a demonstration is arguably Joseph Wright of Derby's *An Experiment on a Bird in the Air Pump* of 1768, which is part of the National Gallery, London's collection. Set in a domestic environment, it shows a travelling lecturer–demonstrator presenting various experiments relating to the study of pneumatics to the avidly attentive members of a household. The painting's own sense of the spectacular is heightened by the fact that the experiment referred to in the title involves a creature, a bird, shown at the point of near death, fluttering desperately in a vacuum jar as it serves science. This focus on the visual, and on the idea of the spectacle, was also evident in other areas of cultural life. Another well-known, and somewhat earlier example, for instance, was the invention, in 1711, of the new *Spectator* newspaper's 'Mr Spectator', a popular, imaginary figure of unassuming character, and a member of the fictional 'Spectator Club', whose role it was to unobtrusively observe the habits and foibles of his fellow citizens and then comment on them.[69] Significantly, a stated aim of the *Spectator* was to popularize questions of philosophy, ethics and morality, bringing them 'out of closets and libraries, schools and colleges, to dwell in clubs and assemblies, at tea-tables and coffee-houses' and to do so in a way that again sought to intertwine knowledge and entertainment – to 'enliven morality with wit, and to temper wit with morality'.[70] *The Pupil of Pleasure* had a broadly similar ethos. Specifically, it was a satirical response to a controversial collection of private letters that had recently been published. The letters in question, most of which were dated from 1746 to 1754, were written by the British parliamentarian Philip Dormer Stanhope, the Fourth Earl of Chesterfield to his illegitimate or 'natural' son, also called Philip Stanhope. Brought into the public realm in 1774, when both the author and the recipient of the letters were dead, by Chesterfield's widow, *Lord Chesterfield's Letters to His Son* could be described as a father's idiosyncratic attempt to educate his son in the ways of the world and on how to succeed within it. In this context, he introduced what he called his 'system'. This placed emphasis on the 'art of pleasing' through the cultivation of 'the Graces' – namely charm, refinement, propriety, and so on – and on the capacity to gain mastery over other people by means of flattery, dissimulation and the discovery, then exploitation, of human weakness. Not surprisingly, the published letters were greeted with considerable criticism, even outrage. According to Samuel Johnson, the prolific man of letters and social commentator who was the contemporary of both Chesterfield and Pratt, Chesterfield's letters taught 'the morals of

a whore, and the manners of a dancing master'.[71] And, as Virginia Woolf remarked much later, in 1930, in her own essay on Chesterfield's letters, they raised controversy again in the Victorian age, when an edited version was made available. Woolf's appraisal was more measured than Johnson's. She commented on the shift in the letters from an early discussion of the Virtues, or Cardinal Virtues, of prudence, justice, fortitude and temperance to an ever greater emphasis on the Graces which, she writes, 'assume tremendous proportions' – they 'dominate the life of man in this world. Their service cannot for an instant be neglected'.[72] Her critique is focused more on the emptiness or flimsiness of his position than on its evils, describing integrity – that is, 'belief in something' – and the observation of the Graces as incompatible.[73] Tellingly, too, particularly with respect to my arguments in *Showing Off*, she observes that the fundamental problem with Chesterfield's system is that 'All value depends on somebody else's opinion.'[74] In other words, here, the one who shows him or herself – no matter how great a dissimulator or manipulator – is always at the mercy of the one who sees. She continues: 'For it is the essence of this philosophy that things have no independent existence, but live only in the eyes of other people.'[75] Arguably, although Pratt, like Johnson, is a critic, he also tries, I think, to present a measured critique of the Chesterfield letters. In the novel, we learn from one of his characters that the Earl 'did but point at the benefits of duplicity in a private letter, at least not by his *consent* made public'.[76] Another of Pratt's characters observes that Pratt's main character, Sedley – I introduce him below – pillaged the volume for the pernicious, and rejects the instructive.[77]

Following Chesterfield's literary model, *The Pupil of Pleasure*, which was published in two volumes, is composed entirely of letters written and received by the book's main characters. This device of letter writing is particularly apt, since it enables these characters to speak for themselves, rather than be spoken for. Central are the letters exchanged by the book's (anti-)hero Philip Sedley and his friend, James Thornton. From these, we learn that Sedley – handsome, young, a man of breeding, charm and taste – has gone to spend the summer in the spa town of Buxton, a then-fashionable English resort. His express aim is to put Chesterfield's system of deception fully into practice, in the manner of conducting an experiment. In his own words, he will make himself 'the living comment, upon the dead text'.[78] Thus, he will embark upon a practice of *lived philosophy*. He will enact a set of precepts, and, in the Enlightenment spirit of experimentation, will test their validity using Buxton and its social scene as his laboratory. Significantly, one of the virtues of a lived philosophy, even one such as this which may justly be described as abhorrent, is that it *can* be tested.

Sedley's 'Chesterfieldean' approach (a neologism coined by Thornton) is systematic and holistic since in order to meet with success he must

deceive all of Buxton society. This society's collective and unreservedly high regard of him will be vital. At the same time, his deceptions must also be specifically targeted and tested and to this end he picks out three women as his principal victims – after all, as he put it in a letter to Thornton, women are 'a sex that was born for our amusement'.[79] But not just any women will do:

> In is beneath a *gentleman*, to beat round the bagnio's, or criticise the brothel. Leave *such* to the appetites of apprentices, whose vulgar palates can digest any-thing. . . . The constitution of a man of fashion, demands, in these cases, the utmost circumspection: the *wife*, the *virgin* and the FRIEND, only, promise this *blissful security*.[80]

The gender dynamics cannot be ignored. Indeed, at first sight, the gender politics of visual display, of seeing and being seen as set out in Mulvey's writing on cinematic space might be mapped onto this eighteenth-century context of spectators and spectacles, manipulators and manipulated. Again, at first sight, Buxton operates like a protocinematic space of display, a space of leisure and entertainment separated from everyday life with its rules and obligations in which normally accepted notions of social responsibility and a sense of repercussion for one's actions are suspended. But this site of superficiality and dissimulation is at the same time a revelatory site, since it also provides the setting for Pratt's rich, threefolded exposition on the ethical implications of showing off to which I will turn shortly. Before that, a broad account of *The Pupil of Pleasure*'s plot is necessary.

The first of Sedley's victims (the 'wife') is Harriet Homespun, a young, pregnant woman who is holidaying in Buxton with her unprepossessing but affectionate clergyman husband, Horace. 'Since the first moment I cast my eye upon the bewitching HARRIET', Sedley writes to Thornton:

> I marked her for my own; and *she* hath since been the *grand* point of all my insinuation and ingenuity. Not a single article hath been neglected that could touch her imagination, move her heart, and catch her *favourite weaknesses*. I paid court to her fancy, to her feelings, to her foibles. Constant attendance has done the business I thought it would.[81]

As the novel progresses, Sedley succeeds in turning Harriet's affections away from her husband. He seduces her, and at one point even inculcates *her* in Chesterfield's arts of dissimulation in order that she might better deceive Horace. In fact, he lends her his annotated copy of Chesterfield's letters. Harriet, on her part, falls so desperately in love with Sedley that she is determined to abandon her marriage and reputation for him. Evidence

of Sedley's success is recorded in Harriet's letter to her friend Mrs La Motte:

> But alas! My CHARLOTTE, the scene is changed. I have been several days in a place of politeness, where HORACE is the most awkward of the circle. My eyes are now open to his imperfections – I *see* them, I *feel*, them, I *detest* them.[82]

Mrs La Motte's reply is filled with alarm, and she notes, accurately, that Harriet has become blind to her husband's many virtues. Harriet's next revelation marks the shift from dissatisfaction with her husband to a renewed relationship with him based on dissimulation. Guided by Sedley, she interprets these in virtuous as well as in self-serving terms:

> [T]hough I do not find any greater degree of tenderness for HORACE, yet, as I know how to make him happy, by merely suppressing those sentiments in his disfavour, which can do *me no service* to discover, I feel the sweets of *disguising the truth* upon some occasions. I have restored HORACE to perfect serenity, and I as sincerely thank Mr SEDLEY, for taking me to task.[83]

By the end of the novel, Harriet and her unborn child will have met their death as a consequence of her embroilment in Sedley's experiment.

The other women Sedley has targeted will be more fortunate. They are sisters. One ('the friend') is Fanny Mortimer, another young married woman. She is suffering from consumption, and is in Buxton with her family in order to recover her health. From various pieces of correspondence including a letter from Fanny to Sedley, it transpires that they are already more than acquaintances. Indeed, we learn that she had been the victim of an earlier attempt by Sedley to test Chesterfield's system, this time in the resort of Scarborough. There, unbeknown to her family, Fanny, then unmarried, had succumbed to Sedley's charms, finally to be rejected by him. There too, as part of the overall deception, Sedley had become intimate with Fanny's family, including her father, Sir Henry Delmore, who is pleased to become reacquainted with him in Buxton. Sedley's third intended victim is Fanny's unwed sister Delia (the 'virgin'). Like her father, Delia is aware neither of Sedley's previous relationship with Fanny, nor therefore of his delinquency.

In *The Pupil of Pleasure*, as already indicated, Sedley's written reports of his encounters with these three women are interspersed with letters written and received by Sedley's victims. In the letters between Sedley and Thornton, Sedley is candid as to his intentions and motivations. Adopting

the persona and methods of the scientific experimenter, he reports on his actions and their various outcomes. As the narrative unfolds, Thornton becomes increasingly appalled. He tries to dissuade Sedley from continuing, eventually stating that he will break communication with him. From the correspondence between the three women and their friends, we learn how each is differently entangled in Sedley's schemes, and how they respond. As these flows of correspondence proceed, various doubts about Sedley are gradually expressed. As with Thornton to Sedley, and Mrs La Motte to Harriet, the correspondents represent undeceived common sense, and attempt to guide and warn. But, like the readers of Pratt's novel, they are witnesses at a remove in terms of space and time, and therefore cannot directly or immediately intervene, a factor that adds considerable tension to the developing narrative. Finally, though, Mrs La Motte receives hard evidence of Sedley's tyranny (she finds that annotated copy of Chesterfield's letters among the now dead Harriet's possessions) and, through this and other disclosures, Sedley's downfall is unavoidable. Thus, the overall lesson of this book is that no matter how overwhelmingly powerful dissimulation may seem, the truth always, eventually, shows itself. Indeed, it suggests that, however much we ourselves may wish to dissimulate, there is, deeply buried in us, a drive towards truthfulness that is very difficult to suppress. Not merely passively, or inadvertently but also actively – or so the novel suggests – we always leave behind evidence of what we have done.

Volume One of *The Pupil of Pleasure*, then, records the rise of Sedley as he puts Chesterfield's system into practice. It is within this context that two of the three inflections of the expression 'showing (or *shewing*) off' are presented. Volume Two charts his fall. Here, too, via Delia Delmore's letters to her friend, Lady Lucy Saxby, in which she recounts her father Sir Henry Delmore's approach to educating his children, a third, ethically productive inflection to the idea of showing off is presented. As such, Henry Delmore's fatherly advice provides an emphatic, but as I will show not entirely oppositional, counter-narrative to the advice given by the Earl of Chesterfield to his son. In the end, Pratt's novel is redemptive where Sedley is concerned. He does, finally, and genuinely, repent, although he is not allowed to live with what he's done. Fanny Mortimer's husband kills him.

In Volume One of *The Pupil of Pleasure*, as noted, the expression 'to show off' occurs twice in the context of Sedley's experimentations with Chesterfield's system. In each case, dissimulation is involved, specifically the intent 'to adapt the character and conversation to the company'[84] while hiding one's own personality. As Sedley put it:

Are not heat, cold, luxury, abstinence, gravity, gaiety, ceremony, easiness, learning, trifling, business, and pleasure, modes which, according to my

Preceptor's advice, I am able to take, lay aside, or change occasionally, with as much ease as I would take and lay aside my hat.[85]

Here, then, the theme of masquerade or play-acting – already opened up in earlier chapters of *Showing Off* – explicitly arises; it continues to play an important role in Pratt's novel.

Sedley first refers to showing off with reference to a scene taking place in the 'private' context of the boarding house where he and a small group of other guests are staying. That is, it occurs in a context where all, except Sedley, are relatively off guard and relaxed; they do not think of themselves as being on show and under observation, as they would when out in public. Writing of his time shared with these guests, principally meal times, Sedley reports to Thornton that:

> At first, I said no more than just to shew my breeding, and inclination to be happy in their society. I let them shew off *themselves* as much as possible, that I might accurately learn their tempers, before I ventured to attack them. This is one of the very first elementary principles of my system.[86]

Here, Sedley is actively creating an environment that has every appearance of being hospitable and generous. His unassuming behaviour is such that, if it were to be described, it would be taken to be profoundly ethical. There is nothing to indicate that Sedley's performances are not what they seem, although we, as readers of his letters to Thornton, already know otherwise. With respect to the showing off that Sedley is invidiously encouraging, two things are of note. First, this is showing off as we would ordinarily or conventionally understand it. He is quietly inciting the others to flaunt their appearance, accomplishments, possessions, ideas, beliefs, concerns and activities. He is emboldening them to be excessively attention-seeking, and, through flattery, to become disproportionately self-satisfied. The connotations are all negative. Secondly, showing off is encouraged by Sedley for diagnostic purposes. From the way in which the people around him show off, he is able to ascertain what are likely to be their main areas of vulnerability, first to flattery and then to more overtly instrumental deceptions.

In Chesterfield's terms, Sedley is engaging in the unobtrusive art of 'unobserved observation', namely, 'a quickness of attention . . . the art of seeing all the people in the room without appearing to look *critically.*'[87] This is taken to be both crucial for success and justified since, as Sedley puts it: 'Is there not, according to that Oracle, pretty nearly the same degree of deception in every character; and are we not to turn all this hypocrisy to *our* advantage even when we *seem* to think every body *honest?*'[88] Unobserved observation and its attendant manipulation of others is, nonetheless, an

activity requiring a good deal of discipline. In a letter to Thornton, Sedley identifies the skills and risks at issue. With respect to his relationship with Harriet, for instance, he writes that although her 'passions are ardent, and I have sufficiently set them afloat' he must 'take care to guard against working up' his own passions. He continues:

> All the power of conquering dissimulation is over, when once DESIRE seizes the helm from the cautious hand of cool and deliberate REASON. . . . I must keep *myself* collected, and never strike, till I have fully thrown everybody about me off *their* guard, and till I can, then, gratify, conquer, triumph, and enjoy in full security.[89]

In any case, the 'hieroglyphics' of the heart must be kept undecipherable.[90]

When the expression 'to show off' occurs the second time, it is now Sedley's own carefully controlled and contrived, or stage-managed, self-showing that is at issue. The context has also changed since, for the first time in Buxton, he is operating in a broader, and more formal social setting. 'I have appeared in public', writes Sedley. As such, he is now in a space in which he can expect, himself, to become an object of scrutiny and judgement:

> I dined this day at the ordinary.[91] *Ordinary* indeed! such a room full of emptiness I never beheld: citizens apeing the men of mode, women of sallow countenances, and frippery fops. . . . However, as even blockheads are worth gaining, and their hearts worth misleading; as they have all foibles to flatter, and weaknesses that may be for our interest to work upon; I began to shew off, and brought the whole company over, as my admirers. I practised all the charming conversation-rules of DORMER, with as much facility as if I had been their author. . . . I looked every person whom I addressed *full in the face*. I dressed my countenance in softness, and gave the *douçeur* to all my motions.[92]

I have already described the outcomes of these two modes of showing off within the unfolding narrative of Pratt's novel.

Showing off in its third inflection occurs, as noted, in a letter written by Delia to Lady Lucy Saxby, in praise of her father as an educator of his children 'Every moment in the day', she writes, 'affords some fresh and beautiful instance of my noble father's wisdom and affection'.[93] It is this third usage, incidentally, that the *Oxford English Dictionary* cites in its presentation of the cultural and linguistic history of 'showing off' as a term. Delia's words are worth citing at length: 'Actuated by motives so singularly noble', she writes:

> Sir HENRY, at a proper crisis, makes each of his children, in some sort, independent – that is, my dear, he allots to each of us such a share of fortune in our own hands as is sufficient to the display and shew-off of

the natural disposition. He esteems it necessary to know the operation of the temper, when it has power to play; this – says he – is *not* to be known by the common mode of contracting, but of extending: it is impossible to discover any natural propensity, until opportunity gives liberty to all the little passions of the stripling, and indulgence gives way to unshackled inclination. Educated under such advantages, and the finer polishes of the school given by a father so venerable and superior; the youthful independent will not turn his honours, and the precious deposit entrusted to him, to abuse; and, if he does, even then there are many ways which Sir HENRY has discovered to turn his deviating conduct into the proper channel.[94]

Showing off, as it is presented here, is very close to showing off as it was encouraged in others by Sedley. Again, it is intended for diagnostic purposes but in order to test and refine the character, not destroy it. And again there is an element of surreptitiousness, even dissimulation involved, in that this testing of the character occurs in an atmosphere that is emphatically not disciplinary or even overtly educational or formative, but quite the opposite. It occurs in a space – analogous to that of Buxton, in fact – that is characterized by greater than usual laxity. Such a space is taken to be the best showcase of character. But what Lord Delmore does, and Sedley does not do, is designate or design a safe arena for those acts of self-display, given that they could prove to be humiliating or open to exploitation. To repeat, Delmore's position is a counterpoint to Sedley's and, thus, also to Chesterfield's. It is characterized by vital differences in terms of attitude and intent, but it also displays much that is in common.

This is also the case where that matter of dissimulation is concerned. For here, dissimulation is not presented as that which must on all counts be avoided as unethical. Rather it must be recognized as potentially dangerous, and thus used only with a clear conscience.

The very corner-stone of a great character is a clear conscience: if you feel well, you will act well: and if you do not, all the talents in the world will only serve to torment you. Never wear a mask before your motives, but when it is absolutely necessary to the felicity of life, such as deceiving, or rather bewitching, the unprincipled into virtue: some tempers cannot bear the plain Truth; she is too awful for them; be it then, in such particular cases, your parts to lead them to her temple by the most pleasing paths.[95]

Lord Delmore's further advice about the externalities of appearance and action, as recorded by his daughter, are illuminating.

I have no objection to your adorning yourselves with all the attractions of exterior, such I mean as are reflected upon the character from dignity

of manner, persuasion of voice, splendor of address, and elegance of air: 'Where virtue is, these are most virtuous.'

'They will act like magic', he continues,

> and make the innocence both of your sentiment, and example, perfectly irresistible; and I beseech you to exert them in the cause of that truth and sobriety of heart I have recommended. Make use of them to conciliate differences, to inspirit society, to embellish conversation, to soften the harshness of dispute, to animate attention; to please, to instruct, to entertain. To all these purposes they will be excellent, and ornamental. But beware of what a licentious and artful indulgence of them may possibly lead to – beware of DUPLICITY; of *that* duplicity, which, so accoutered – its destructive sword sheathed in politeness – its heart shielded by the impenetrable mail of gilded hypocrisy, – is equal to the siege of a city, and might do more real *mischief* than all the efforts of a legion of avowed villanies.[96]

Which brings me to a second feature of Delmore's encouragement of showing off as a means of diagnosing and shaping character, in which a very particular understanding of the nature of discernment is implied. First of all, discernment is rooted in a non-paranoid acknowledgement that we may well be deceived by what is initially given to us. Indeed, he has much to say about the terrible nature of the dissimulations to which we may be exposed and which, he says, 'cannot be detected, even at noon-day'.[97] In this regard, making an undeclared but overt reference to Chesterfield:

> Of all earthly things, therefore, most detest, what is most to be dreaded, the system of a well-bred, high-polished, elegant deceiver; no eye can see him; no understanding detect him; no policy escape him. He comes in the form of a Seraph, and those who are themselves honest, cannot imagine that he is a Syren.[98]

Here, Delmore is discoursing against the very condition of which, at this stage of the story, he is unwittingly also the victim. There is, however, a second aspect to discernment as he understands and practises it. For here, discernment is not associated with a type of sight or insight that attempts to see beyond or behind appearances. Rather it is concerned to look into, and follow the motions of those appearances with particular care. In other words, it is based on the understanding that appearances, and the truth of appearances, unfold, and that in time the truth always gives itself away. Indeed, in *The Pupil of Pleasure*, Sedley is seen to have outed himself in

several ways. This is something that Thornton had predicted: 'There is a moment, my dear, dissipated SEDLEY, in which, though thou wert to wear the mask of a forty years success, thou must perforce lay it aside, and appear in all the nakedness of Nature.'[99]

Therefore, to be discerning is to expect such revelations or disillusions to occur, and to be prepared for them by engaging with the world of appearances slowly and with a degree of reticence. Discernment, to repeat, is not a case of looking 'beneath' the surface. Rather, there is no 'beneath'. It is always on the surface, in the realm of appearances, that the truth gives itself. Arendt, citing Merleau-Ponty, made precisely this claim in *The Life of the Mind*:

> The everyday common-sense world, which neither the scientist nor the philosopher ever eludes, knows error as well as illusion. Yet no elimination of errors or dispelling of illusions can arrive at a region beyond appearance. 'For when an illusion dissipates, when an appearance suddenly breaks up, it is always for the profit of a new appearance which takes up again for its own account the ontological function of the first.[100]

Hitsuda's curtains and the complexities of surface

[I]t does not follow that all appearances are mere semblances. Semblances are possible only in the midst of appearances; they presuppose appearance as error presupposes truth. Error is the price we pay for truth, and semblance is the price we pay for the wonders of appearance. Error and semblance are closely connected phenomena; they correspond with each other.

HANNAH ARENDT[101]

It is by looking, it is still with my eyes, that I arrive at the true thing.

MAURICE MERLEAU-PONTY[102]

An insight to be drawn from *The Pupil of Pleasure* is that the realms of appearance and surface are complex in part because they consist of a texture of 'deceptive similarities'. This was an expression used by the multifaceted writer, philosopher, historian of science and one-time surrealist, Roger Caillois within a context rather different to the one we have just been discussing. The project with which Caillois was urgently concerned was to find viable ways of resolving the intellectually fragmented character of scientific investigation. He sought to do this by creating new, internally cohesive lines of communication across scientific fields and modes of classification.[103] He argued, however, that this could not be accomplished

by looking back to pre-modern models, that is, not, by retreating to the 'superficial analogies' characteristic of medieval thinking:

> [S]cience freed herself from these when she set up our present system of knowledge, which is methodical, subject to controls and capable of improvement.

> From this point of view the dreams of the medieval philosophers and of the learned men of the Renaissance represent a lure all the more dangerous because, responding to an ever-present need of the soul, today held vigorously in check, they seemed to offer a quick and fascinating answer to those attracted in advance by the plausibility of their propositions.[104]

'The tables of concordance in which a Paracelsus arranged natural phenomena are no longer acceptable', he insisted, 'any more than is the analogous science, essentially visual, of which Leonardo dreamed, drawing a head of hair like a river, a mountain like a draped cloth'.[105]

His solution, however, was once again not to reject the notion of visual lines of correspondence, but to search for other forms or manifestations of it. This is evident from his writing in *The Mask of Medusa*, which was first published in 1960 – despite the fact that he describes the nature of this search – this 'diagonal science' – using conventional concepts like 'penetrating beyond' and 'uncovering'. In his words:

> The advancement of knowledge is partly brought about by penetrating beyond superficial resemblances to uncover the deeper relationships between things, which, though less obvious, may be more important and significant. In the eighteenth century, books were published in which animals were classified according to the number of their legs, so that the lizard found itself alongside the mouse, zoologically speaking. Today, the former is put in the same family as the snake, which has no legs but which, like the lizard, lays eggs and is covered with scales.[106]

To seek to understand the physical and phenomenal world, then, is to become involved in a field riddled with 'countless traps' into which the scientist could become ensnared, traps all the more difficult to identify because, as Caillois put it, these traps, these deceptive similarities, 'are not just shams or sketchy resemblances. They are genuine likenesses which, in the end, are found to be of less significance than certain others. It is true', he continued, 'that in common with the mammals they are not, the lizard and the tortoise have four legs, and the bat, which is not a bird, has wings'.[107] And of course what is described here as a scientific problem is of more general concern for all of us. How often are we misled in our individual and collective attempts to make sense of the social, cultural and political situations that surround us

because we have analysed, classified and made decisions about them on the basis of similarly genuine, but deceptive similarities? How often have we run into difficulties because we have unprofitably prioritized one set of likenesses over another? To cite Caillois again:

> The secret of classification, then, is to pick out the key characteristics which different creatures have in common. The similarities which are ignored are not, strictly speaking false; but they fit into classifications which would, sooner or later, end in difficulties and inconsistencies.[108]

Caillois notes, however, that those features that have come to be regarded as subsidiary or have been disregarded (those features that are not brought into play for the purposes of classification)

> may become important once more. If, for instance, I want to study the action of wings, it is clear that I must take into account bats, birds and butterflies, in fact all winged creatures, whatever the reasons which led to their being classified in different families – invertebrate Lepidoptera, vertebrate birds, etc.[109]

Thus, advancement depends on our ability to ascertain which modes of classification are most appropriate within a given set of circumstances or intentions. And arguably this is one of the particular attributes of artistic activity, which is often deeply immersed in making and communicating re-evaluations of this kind. We saw this in previous chapter in the work of Pushpamala N; we have just seen it in the work of Cézanne, Caro and Pratt. Therefore, in order to examine the complexities of appearance further I turn to a work of contemporary art, a power print mounted on Plexiglas, made by the Japanese artist Tamami Hitsuda in 2001, the entire surface of which depicts a glowing and glimmering, digitally layered section of flowing pinkish-red curtain. An image, in other words, that could be described as an icon of superficiality but which nonetheless conveys at least three dimensions of surface complexity. But before describing and discussing it, a related point about the nature of my access to and engagement with this work is worth making. Although this work by Hitsuda has been exhibited – in 2003, for instance, as part of her one-person exhibition 'The Place Without Name' at the Tomio Koyama Gallery, Tokyo – my own and only access to it has been electronic. Not only that. Although the image seems to have existed on the internet for a while as an untitled digital file, to my knowledge the image, which I was able to download as a jpeg, now no longer seems to be visibly available. The Tomio Koyama Gallery website does however include installation shots of the exhibition. As it turns out, it was part of a series of visually similar works all of which are titled *Fibbing*. Unsurprisingly, as with all of Hitsuda's art, it deals with the allure

of illusion and artifice within the arts, and with relationships between fact and fantasy. In any case, with this point about access I want to underscore the crucial interrelationship between surface and interface. To engage with questions of surface is also to engage with questions of interface, thus with the dynamics of actual and possible connections between bodies and beings, systems, concepts, situations, disciplines and practices.

An electronic reproduction, then, of an image by the Japanese artist Tamami Hitsuda, almost perfectly square in format. It shows a cropped, salmon red, digitally assembled view of shimmering curtain. Its multitude of supple folds float, blow and drop in three flounced layers, from the top of the work to the bottom. At a certain point, the lowest of these layers seems to dematerialize, and then rematerialize, into an edge of cloud-like white. The image, as noted, is almost all curtain. But at the top of the piece there are intermittent hints of dark blue sky or screen or wall and, at the bottom, what looks like a stretch of dark red floor. And so the attractions of the work are at least twofold. First, there is the inevitable suspense that drawn curtains provoke, and second, there is the desire that is aroused to pull them apart and discover what lies behind. And here there is a connection with showmanship – indeed, both of these themes (the desire to pull aside and look behind, and the idea of art-making as a kind of performance) inevitably recall one of the history of illusionistic art's myths of origination, one for which we have written testimony but no visual evidence since no works by the artists in question survive. It is Pliny the Elder's account, in his *Natural History*, of a competition between two Ephesian artists of the fifth century BCE, Zeuxis and Parrhasius, to ascertain who was the greater illusionist.[110] The winner was not Zeuxis, who, having swept aside the curtain that concealed his work from view, revealed painted grapes so luscious that birds swooped down and tried to eat them. Rather, it was Parrhasius, who had simply painted a curtain which Zeuxis then asked him to pull aside. Parrhasius did not win primarily because of his skill. He won because he was able to exploit the significance, or rather, the visual insignificance, of the object he had painted – that curtain – within its broader cultural and psychological context. He understood that it operated as a symbol of concealment and thus as an irresistible signal to look behind. This brings me to the first aspect of surface complexity that I think Hitsuda's image engages with: the simple fact that surfaces are often difficult to see. Not because they are invisible, but, as discussed, because habits of thought and practice predispose us to want to see behind or beyond them. In the case of Hitsuda's image, there is in addition the difficulty of looking at surfaces that are shiny: that of the curtain itself as depicted in the image; for viewers of the physical artwork, also that of its Plexiglas surface; and in my case as a web-viewer, the additional glare of the computer screen interface. In

some of Hitsuda's other photographs in this series (*Fibbing 1*, and *Fibbing 2*, from 2002, for instance) attention was further deflected by fluffy artificial clouds hovering in front of the expansive curtain, as if in our space, thus transforming the curtain into a backdrop.

Nonetheless, Hitsuda's curtains, with their look and scale, their lusciousness, and their qualities of enfoldedness, constantly draw us to those surfaces that we might otherwise tend to ignore. And, as they gain visual presence and weight in this way, they begin to undermine the categorical distinctions they are also pointing towards, most particularly conventional distinctions between surface and depth, and appearance and reality. These are general distinctions that we hold dear where issues of knowledge, truth and revelation are concerned, including at a personal level. Take, for instance, the unethical comfort we may take from assertions that we are not, in fact, who or what we appear to be. That who we are should not be equated with how we show ourselves through our actions, over time, in the world.

A second complexity to which Hitsuda's work points has to do with the visual instabilities of surface and interface. When we attend to the surfaces of the Hitsuda image that is of particular interest to me, it is immediately obvious that they are intricately modulated and glowing, consisting of fold after fold of cloth, some like delicate ripples, others more angular, deep, dark and magnetically present, like great chasms. The latter, however, seem to hint less at a jagged passage through the work to a scene lying behind than to its own interior spaces. The image's overall composition offers an invitation to enter more fully into what the surface itself has to offer. Indeed, as these folds intersect with the three strong horizontals formed by those digitally layered flounces, the surface texture of the work seems to change from sleek and shiny to grid-like and orderly. As such, we may gradually become aware of certain tensions: the soft, billowing folds of the depicted surface as compared with the hardness, the geometry, of the physical work's edges. Here, arguably, there is a sense that 'the external form, the envelope, is secondary and derived'.[111] Likewise, referring again to Hitsuda's technique of digital assemblage – her collage aesthetic – there is also the difficulty of discerning where one surface may end and another begin. These instabilities relating to the edges and interconnections of surfaces are intensified by the layers of shine that are present in the work. Symbolically, as noted, they may refer to superficiality. But phenomenologically, by means of their mirroring capacities, they weave us – as viewers of the work – and thus also the worlds in which we are embedded, into the work's own fabric. As such, Hitsuda's image-making reminds us, as Alberti put it in *On Painting*, that:

> A surface is the outer part of a body which is recognized not by depth but by width and length, and by its properties. Some of these properties are so much part of the surface that they cannot be removed or parted

from it without the surface being changed. Others are ones which may present themselves to the eye in such a way that the surface appears to the beholder to have altered, when in fact the form of the surface remains unchanged. The permanent properties of surfaces are twofold. One of these we know from the outer edge in which the surface is enclosed. Some call this the horizon: we will use a metaphorical term from Latin and call it the brim, or the fringe . . . the other property . . . if I might put it this way, is like a skin stretched over the whole extent of the surface.[112]

He makes the additional point that the surface is also the site of inscription and meaning, indeed, he defines a sign (including the most fundamental, that is, non-divisible of signs, namely, the point) as 'anything which exists on a surface so that it is visible to the eye'.[113]

Although surface is all there is, and although, from a definitional point of view, as Alberti indicated, every surface has the permanent properties of 'edge' and 'skin', specific surfaces are also characterized by elements of impermanence. They erode; they shift, physically, perceptually and conceptually. What happens when we move from a consideration of one sense of surface to another, or when a sense of surface to which we have become accustomed seems to have disappeared? The instabilities of surface and interface testify to the fact that this is a lived realm which, like Hitsuda's curtain, has a sense of being unified and yet stitched together. It is like a flowing fabric that is nonetheless full of holes, or if not holes then chasms, in which we may become disorientated and unsure. What is being described, however, is not some deficiency of the visual that needs to be overcome. This is how the world of appearance is structured, although there are times when, due to one or other innovation, perceived holes, gaps or chasms may be reperceived as occupied.

In *The Voices of Silence* – referred to earlier in this book in a different context and for different reasons – Malraux made an observation of this kind. Malraux was writing at a historical moment when colour reproductions of artworks were beginning to become more readily available, and he was reflecting on the impact of photography on our definitions and understanding of art. Regarding colour photography, for instance, he stated that by these means certain art objects – such as stained glass windows – that were of primary importance for their colouration could now be made reproductively available in a way that reflected their fundamental visual character. This availability would in turn affect their status within debates about art; they could be described as being about to enter and inhabit the category of art in a way that had not previously been possible. Such enlargements of the artistic and art historical image-world he identified as a general legacy of the invention of photography. He also argued that by means of this technology new kinds of visual connection and thus communication were becoming

established between works from different times and places, and between works made from different media or for different purposes. More than that however, these technological advances were enriching and stabilizing the quality of art historical exploration qualitatively as well as quantitatively by operating as aids to memory. Here, Malraux's observations from the opening chapter, titled 'Museum Without Walls', are worth citing at some length. 'What (until 1900) had been seen by all those writers whose views on art still impress us as revealing and important, whom we take to be speaking of the same works as those we know, and referring to the same *data* as those available to us?' he asked.

> They had visited two or three galleries, and seen reproductions (photographs, prints or copies) of a handful of masterpieces of European art; most of their readers had seen even less. In the art knowledge of those days there was a pale of ambiguity, a sort of no man's land – due to the fact that the comparison of a picture in the Louvre with another in Madrid was of a present picture with a memory. Visual memory is far from being infallible, and often weeks had intervened between the inspections of the two canvases. From the seventeenth to the twentieth century, pictures, interpreted by engraving, had *become* engravings; they had kept their drawing but lost their colors, which were replaced by 'interpretation', their expression in black-and-white; also, while losing their dimensions, they acquired margins. The nineteenth-century photograph was merely a more faithful print, and the art lover of the time 'knew' pictures in the same manner as we now 'know' stained glass windows.[114]

Whether the texture of the visible – especially that relating to art – was in fact becoming more closely woven is open to debate. As noted, some would argue that the more data that is presented to sight by these means, the more bedazzled we become and the less well able to attend to the visible world. We might want to think, here, in terms of losses and gains, or in terms of distortions, compromises, variations and transformations all with their own particular kinds of richness. But the fact remains that, with or without us, the appearing world, the realm of surfaces, cannot but continue to unfold. Thus I end with Arendt: 'Could it not be that appearances are not there for the sake of the life process but, on the contrary, that the life process is there for the sake of appearances?' she asked.[115] 'Since we live in an *appearing* world, is it not much more plausible that the relevant and the meaningful in this world of ours should be located precisely on the surface?'[116]

FIGURE 4 *Carolyn Lefley,* Eva, 2005, *from the series* The Watchers. © *Carolyn Lefley. Reproduced with permission.*

FIGURE 5 *Carolyn Lefley,* Carolyn and Ralph, *2005, from the series* The Watchers.
© *Carolyn Lefley. Reproduced with permission.*

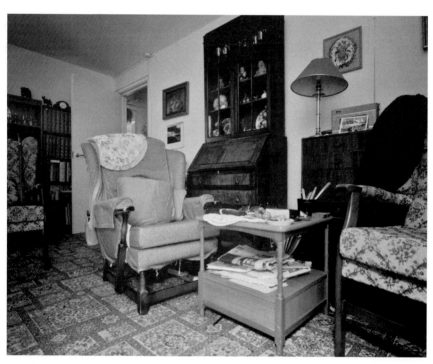

FIGURE 6 *Carolyn Lefley,* Ida, 2005, *from the series* The Watchers. © *Carolyn Lefley. Reproduced with permission.*

3

Image wars

The 'trap' of visibility

The image-world is full of wonders. But it is also rife with pressures and inequalities, many of which have been extensively investigated and critiqued by philosophers, critical theorists, artists, and others. Nonetheless, or so I am claiming, since this world as a whole is one from which we cannot and must not extricate ourselves – we too circulate within it as image – the challenge is to ascertain how to actively inhabit it, and inhabit it well. More than that, drawing on the phenomenological writing of Merleau-Ponty, I am making claims for an ethics originating in practices of self-showing which are of necessity deeply embedded in, and engaged with, this often problematic visual territory. Clearly, these are claims that must be tested.

A first objection to my argument is that the realm of the visual is irredeemably problematic. One of the most prevalent ways in which this idea has been formulated is through the well-rehearsed anti-ocular notion of visibility as a trap. This is a serious objection. We have all, surely, experienced such feelings of entrapment. For many, they form a more or less permanent psychological backdrop to our lives. And under pressure here are not only those who are, or feel, disprized at the level of image within dominant cultures or subcultures. Equally but differently pressurized are those who find themselves exalted within these contexts of evaluation and misevaluation. And intertwined in these experiences, of course, are further dimensions of visual entrapment: the complex structures of surveillance and reportage that have become infiltrated into our lives, partly without our conscious consent and in large part with it. For anti-ocular theorists, the most immediate ethical response to this general state of affairs is to expose

and critique the entrapments of the visible realm, so that their dangers might best be avoided. In this chapter, though, drawing on case studies where the designation of visibility as a trap is being propounded, I will argue that this designation is ultimately invalid; it can only be sustained, incompletely, in scenarios that ignore or deny that the roots of seeing and being seen are to be found within the more fundamental, and fundamentally open structures of self-showing. However – and this is an idea I will develop in the final chapter of this book – where conditions of self-showing *are* prioritized over those of seeing and being seen, visibility may be resignified not as a trap but as a gift. And by this I mean, essentially, a donation of oneself that comes without strings attached.

A second objection to the lived, ethical possibilities of self-showing that I am proposing follows on from the first, namely that the only viable route to freedom and agency lies in seeking, as far as possible, to operate in the world invisibly. This argument is based on a deeply embedded dualistic ontology, spanning religion, philosophy and the sciences that takes so-called eternal, invisible realities to have priority over impermanent visible ones. Here, invisibility is misleadingly defined as a characteristic of scenarios or entities in themselves, rather than as a description of that which is – temporarily or constitutionally – perceptually unavailable to us. A related factor where prioritizations of the invisible over the visible are at issue is an assumed binarism in which the visible and the invisible are not only opposed but also differently valued: the visible is disprized, and the invisible is prized. By way of example, within a theological context, according to such a logic a biblical definition of God as invisible might be prioritized over, and obscure, those places where God is implicitly or explicitly self-defined as image with all that this implies – the earliest instance of this occurs in the first chapter of Genesis, when God says 'Let us make man in our image, in our likeness.'[1] A strength of Merleau-Pontean phenomenology has been its capacity to show such binarisms to be invalid and to propose alternative ways of understanding and navigating the world of appearances. In addition, and this is an argument that I have already presented, we know, again from everyday experience, that a deeply problematic relationship exists between invisibility, dissimulation and unaccountability; it is within attempts to operate invisibility – attempts that ultimately always fail – that some of the most invidious attempts to control others are to be found. Can such a position, in favour of the invisible workings of power, really stand its ground against my claim regarding the ontological as well as existential priority of self-showing? This priority is expressed not only in our deep desires to self-show but also in the fact that we cannot but do so.

A third objection is broadly epistemological. It has to do with the purported problems of trying to discover or locate a foundation for knowledge and an ethical ground within a realm that is experienced as unstable and frequently deceptive. At issue on the one hand is the fact that what can be known, what shows itself, must do so by means of a process that is characterized by incompleteness: we see and think as situated beings. At issue on the other hand is the multidimensional character of self-showing; as argued earlier, self-showing entities might be described as always operating both as performers and as a type of stage on which other forces – some of which may be consciously known to us and others which may not be – perform, or show, themselves through us. This is an impure realm, then, in which self-showing may be problematically compromised. But these complexities are unavoidable – we are not merely intersubjective, but intercorporeal beings always already embedded in complicated communicative scenarios. Moreover, as I will show – it is another key theme of the book's final chapter – this reality provides the basis for exceptionally generous notions of identity, communication and community to emerge.

To partake in an ethics of self-showing then, is to enter into an entangled and highly charged territory made all the more troublesome because it is often not self-evident what should be interpreted as treacherous and what as justly appealing, beautiful and beneficial. We know, but often recognize too late, that the treacherous often presents itself either as deceptively attractive or, even more problematically, as innocuous. As was argued in *The Pupil of Pleasure*, it is in navigating this territory that our greatest struggles tend to reside. Not only the troublesome impact of the 'bad' but also that of the 'good' must be overcome. As I will show, to challenge that which has been designated good is especially difficult because it requires cherished, and thus well-defended material to be accessed and resignified. For all of these reasons, therefore, actively taking on the challenges of an ethics of self-showing means making a virtue of vulnerability – but without becoming a lasting casualty of it. Is this really possible? Most obviously, it invariably means offering ourselves to the prejudiced sight of others with the hope, but not the certainty, that its destructive powers will dissipate. It also means understanding how incorporated we already are not only within those detrimental ways of seeing but also within detrimental modes of showing, and the degrees to which, knowingly or not, we therefore also perpetuate them. At issue are the ways in which we too inflict those negative values on others. Our concerns with questions of seeing and being seen obscure those more fundamental spaces of self-showing, spaces that are also riddled with significant difficulty. At issue here, to repeat, are sight and self-showing that

may be operating at their most prosaic, that are riddled with assumptions, presumptions and judgements that have as yet been inadequately challenged, and perhaps never will be. To cite Kaja Silverman, it is to come face to face with the image-repertoire or cultural screen that is internalized in others and in ourselves, through which persons are 'socially ratified or negated as spectacle'.[2]

What then of this notion of visibility as a trap? By the time the *Phenomenology* was published in 1945, Merleau-Ponty's friend and colleague Jean-Paul Sartre, using the terminology of 'the look' (*le regard*, or *le regard absolu*) had already written extensively about one aspect of this visual encounter, namely, what was, in his view, the violent sense of exposure associated with being under observation by others. This issue was central to his seminal philosophical work, *Being and Nothingness*, where he wrote, for instance, that:

> If we start with the first revelation of the Other as a look, we must recognize that we experience our inapprehensible being-for-others in the form of a possession. I am possessed by the Other; the Other's look fashions my body in its nakedness, causes it to be born, sculptures it, produces it as it is, sees it as I shall never see it. The Other holds a secret – the secret of what I am. He makes me be and thereby he possesses me, and this possession is nothing other than the consciousness of possessing me.[3]

My position, if this is not already obvious, is that the idea of 'the first revelation of the Other as a look', possessive or otherwise, is misleading. The first revelation of the Other is, rather, as a self-showing. Indeed, to prioritize the realm of sight over self-showing leads to untold difficulties Take Sartre's 1938 novel *Nausea*, one of his best-known and most disturbing explorations of scopic 'possession' – which is at the same time a terrible estrangement. In the words of its protagonist Antoine Roquentin, a character Sartre later described as being, to some degree, autobiographical:[4]

> I don't know where to go . . . I don't need to turn around to know they are watching me through the windows: they are watching my back with surprise and disgust; they thought I was like them, that I was a man, and I deceived them. I suddenly lost the appearance of a man and they saw a crab running backwards out of this human room.[5]

For Sartre, it was impossible to live productively under the look of others. It was utterly debilitating and imprisoning. And, as suggested in *Nausea*, and other works – including his one-act play *Huis Clos* (or *No Exit*) to

which I will turn shortly – these are the oppressive regimes of visibility – or visuality – that dominate everyday life. Since Sartre was a philosopher of freedom, presumably his work will indicate how it might be possible for us to live with a sense of choice and agency within conditions such as these – conditions which presumably we are unable to change – after all, in one way or another, we all live among others who see us. If we accept Sartre's world view, we must ask whether it is possible to live within the conditions he describes without succumbing to them, without being victim to them and without inevitably perpetuating them ourselves. More than that, we must ask whether it is possible not only to survive but also to discover and come into our own precisely within the midst of these contexts.

Before pursuing these questions, though, a second, preliminary point is also worth making. Another reason for putting my argument for self-showing to the test is because the Merleau-Pontean valorizations of the visual on which I am drawing have been criticized (by Irigaray, for instance, and other feminist writers) as being a direct consequence of his own privileged status within the visual. For instance, in Helen Fielding's essay 'White Logic and the Constancy of Color' we read of Merleau-Ponty that 'despite or perhaps even because of his meticulous phenomenological descriptions, he himself could not see beyond the cultural level of a euro-centred heterosexual male perspective'.[6] What I see in his writing though – I will return to this point later – is a commitment to the visual that is grounded in an understanding of visual violence that is more, not less profound – and challenging – than is generally presented within anti-ocular discourse, particularly within what has broadly been referred to as identity politics. To begin with therefore, I will provide a setting for testing my claims further by engaging with those critiques of visuality that underlie identity politics, focusing on the particular problem of what Silverman has referred to as disprized bodies. My approach will be to turn to various worst-case scenarios as defined by those thinkers, contemporaneous to Merleau-Ponty – namely Sartre, Simone de Beauvoir and Frantz Fanon – whose work laid important conceptual foundations for much of the feminist and identity-based activist writing that was to become dominant from the mid-twentieth century onwards.

The terrors of Sartre's **le regard absolu**

Perhaps the best-known study of the notion of visibility as a trap – a trap that not only limits and encloses but is also wrought through with violence of the worst kind – is Foucault's *Discipline and Punish* of 1975, with its analyses of panopticism in its different manifestations. But it is to an earlier exploration of the horrors of visual entrapment that I want to turn: Sartre's

No Exit, just referred to, which has been translated into English variously as *In Camera*, *No Way Out*, *Vicious Circle* and *No Exit*. *No Exit* was written in 1944 and first performed at the Théâtre du Vieux-Colombier in Paris in May of that year, thus while the city was still under German occupation and surveillance. Set in the then-present, but in Sartre's vision of hell – that is, in the most extreme and inescapable of enclosures – it has frequently been described as an important popularization of his brand of existentialism and perhaps even as a test case for it. As already indicated, it is surely fair to say that if existentialism's rationale is valid – namely, its insistence on our being self-defined rather than defined by others, and on taking sole responsibility for that self-definition and the choices associated with it – it must be valid in all circumstances, even the most deprived and desperate.

The play is about three strangers, an unholy trinity, who are condemned to spend eternity exclusively in each other's company. Incarcerated in the enclosed space of a simulated bourgeois drawing-room that has been designed specifically with them in mind, each person is destined to simultaneously torment and be tormented by the other two. As will become apparent, the most overt way in which this torment is administered is through the operations of Sartre's look (or what theorists more commonly have called the Gaze) in its various manifestations, and through other extreme visual phenomena including the presence of unremitting light. Indeed, in this dialogue-intensive play, it is one or other oppressive form of visuality that is almost always either the topic of conversation, or its provocation.

Where the unfolding storyline is concerned, the first character to be ushered on stage by the play's anonymous valet is Joseph Garcin. Wishing to present himself in the best possible light, Garcin claims that he is a journalist and pacifist who was executed for refusing to fight. As the play progresses, and after much dissimulation, he finally admits to being a wife cheater and deserter. The issue that now consumes him – Sartre's hell is not a place of oblivion; quite the contrary – is whether or not he has been judged a coward by his compatriots and within the historical record. The two remaining characters are women, the sadistic Inéz and the spoiled, self-absorbed Estelle. Like Garcin, Estelle is reluctant to account for her presence in hell; only later does she tell the truth: she cheated on her aged, well to do husband, murdered the baby she had conceived by her lover, and caused her lover to shoot and kill himself. Inéz, by contrast, though a 'damned bitch'[7] – her own words – is at least honest. For instance, she is the only character in the play to consistently acknowledge the reality of their collective situation, and, albeit in an attempt to wound rather than to aid or save, tries to force the others to recognize it too. A lesbian, her crime was that she had seduced her cousin's wife and, with her lover, contributed

towards her cousin's death. Her lover, Florence, had finally killed herself and Inéz too, by allowing gas to leak into their bedroom while they slept. Each of *No Exit*'s characters, then, is markedly different. But what unites them here in hell is that they are doomed always to crave what they can never have: either to have their deceptive self-perceptions – or self-images – affirmed by the others or to have their desires met. Garcin needs but never receives affirmation that he is not in fact a coward. In lieu of this affirmation, he at least craves peace and quiet for reflection in order to try and resolve his inner conflicts. But this is something that the unbearable, loquacious proximity of Estelle and Inéz makes impossible. Inéz wants above all to love and be loved by Estelle but is constantly repudiated. Although her longing persists, she cannot help but unleash the cruelty that alienates her from the others. Nor is she able to conceal the cowardice – a trait she shares with Garcin – that underlies that cruelty. Estelle, in turn, craves the adoration of a 'real' man but must make do with Garcin, whom she relentlessly pursues despite his lack of credentials. Garcin does eventually succumb – to a degree – which is torture for Inéz, but he cannot truly reciprocate. It is not Estelle's self-serving pseudo affections that he wants. Rather, he needs approval from someone who is truthful – this is crucial – and who understands him, namely Inéz. But she despises him and dedicates herself instead to constantly deriding him and undermining the possibility of a liaison between Garcin and Estelle. Thus, on the one hand, she urges him to pursue the affair. On the other hand, she dissuades him from doing so, conjuring up a disconcerting scenario in which the cowardly Garcin tries to embrace Estelle, the baby-killer, in his manly – or not so manly – arms. Then she calls upon the 'crowd', that imputed mass of judging viewers whose good opinion Garcin, in particular, is so concerned to obtain. This is a crowd, described by Inéz as now having become compressed into her own being, that has definitely determined him to be a coward and will insist upon it for all eternity. I'll never let you go, she says.[8]

Garcin knows that this torment will be his fate. Indeed, when an opportunity for escape had unexpectedly presented itself a little earlier, he had not taken it. Unable to bear the presence of Inéz and Estelle a moment longer, Garcin had begun to beat violently on the room's locked door, demanding to be let out. Suddenly it had swung open. Immediately, Inéz had challenged him to leave but he was suspicious and hesitated. Why had the door opened? Ignoring Inéz's urgings, he refused to go. Estelle, too, had stood there, motionless. But then Inéz, laughing at the farcical situation in which they were all immersed, discovered that she was as reluctant as the others to step out into the unknown. The fact that each had been offered, and refused, a way out of the prison and an escape from the other two, only accentuated how

irrevocably tied to each other they had become. They were, as Inéz put it, "Inseparables".

Then, unexpectedly, Estelle sprang forward and, calling upon Garcin for help, tried to push Inéz outside. Inéz's cowardice rose to the surface in full force. She struggled, shouted and begged; she was terrified at the thought of what might lie beyond – until Garcin intervened and told Estelle to leave her alone. Yes, Inéz hated him, Garcin informed the dumbfounded Estelle, but it was precisely because of her that he was determined to stay exactly where he was. Inéz, too, was surprised. But, accepting this to be the case, she instructed Garcin to go ahead and close the door. Then Garcin addressed himself, illuminatingly, to Inéz. He explained that he needed her presence because she understood him; she understood what it is to be a coward and she knew what wickedness, shame and fear are. Inéz conceded and Garcin continued with his speech, talking as though the deepest recesses of her being had become transparent to him: he sees the sense of horror she has so often felt when she has looked into herself and counted the cost of evil; when Inéz describes Garcin as a coward, she knows from experience what this means.[9]

Inéz does indeed know, and admits it freely. But she uses this knowledge not to empathize with Garcin but to distress him all the more effectively. For Garcin – for all of them – their condition is one of fundamental but eternally fruitless dependency on one another for self-definition. It is in recognition of this that Garcin finally utters the phrase for which the play is most famous: '*l'enfer, c'est les autres*' (usually translated as 'hell is – other people').[10] The play seems to end with all three characters acknowledging this to be the case. Estelle laughs at the absurdity of this vicious circle, there is – so the script tells us – a long period of silence, and then there are Garcin's words, 'Well, well, let's get on with it.'[11]

In *No Exit*, the entrapments of visibility are not just foregrounded by the dialogue and emphasized by the visual exchanges that accompany these words. Invidious environmental factors also play their part. The first of these is apparent the moment that the play begins. It is embedded in the oppressive look of the drawing-room which is described as being in the Second Empire style. This was an eclectic style that became popular in the mid-nineteenth century during the reign of Napoleon III in which elements from preceding styles – including a preference for dark woods such as mahogany and ebony – were combined with newer materials such as papier-mâché, cast iron, mother-of-pearl and ivory inlay, gilt bronze and faux bamboo. Estelle looks at the sofas. 'They're so hideous', she cries. Indeed, they remind her of visits to a dull old aunt. Her house was full of precisely such horrors.[12] The focal point of the room, positioned on its mantelpiece is, in Garcin's words, 'a bronze

atrocity – a collector's item, by Barbedienne, he recalls. He understands why it is there; what its role will be'.[13] But it is not only the appearance of these furnishings that is troublesome. It is also their arrangement, or rather, their misalignment, and the fact that nothing can be moved or changed to produce compositions and correspondences that at least work tolerably well on their own terms. Garcin does, however, acknowledge the aptness of this situation. He is philosophical about it. What does it matter? In fact, he admits that in a way the situation suits him. It reflects the attitudes of his former life in which, he says, he had acquired the habit of living among furniture he did not relish and in positions that were false; in positions that were bogus. He had even come to like such inauthenticity.[14]

Aesthetics comes to the fore again at the play's near conclusion. Indeed, in Sartre's hell aesthetics – specifically the form of décor and furnishings – is always an underlying, and sometimes an overt and insistent source of torment. For Garcin it becomes apparent that, certainly for him, it will be by means of the bronze sculpture, that immovable, unspeaking object, that the look (or Gaze) will find its greatest consolation, and will exert its greatest destructive force. This terrible encroachment of inanimate objects was also, of course, a key theme in *Nausea*. In *No Exit*, then, Garcin bemoans the fact that in this place the oblivion of night will never come. He also bemoans the fact that here he will always be inescapably visible not only to the others but also in a strange and disturbing way to the inanimate objects surrounding him. Inéz – characteristically and with grim satisfaction – affirms that this is indeed the case and Garcin finds himself moving back towards that ornament. He touches it meditatively and when he speaks it is once again to stress its terrible significance for him. As he looks at this object he truly understands not only that he is in hell but also that, here, everything has been thought out in advance. 'They' – those who have incarcerated him – have anticipated all of his actions and reactions from the start; they knew, for instance, that he would be standing at the fireplace now, stroking that thing of bronze, with, he says, all of those eyes intent on him; devouring him. [15]

What this serves to emphasize is that for Sartre, as noted, the forceful, debilitating look of the Other can never be eradicated. Even in the absence of other people – an impossibility, of course, in Sartre's hell – that look would remain embedded in, and emanate from the object world. This issue, regarding the dysfunctional effects of aesthetics and of objects, including art objects, is important. Indeed, when an adaptation of *No Exit* was created for BBC television in 1964 – called *In Camera*, it was directed by Philip Saville and starred Harold Pinter in the role of Garcin – this was underlined and amplified. The set was reconceptualized so that it was no longer an ugly nineteenth-century

drawing-room but what looked like the interior of a modernist 'white cube' art gallery. More on the significance of this restaging later.

The second environmental factor in *No Exit* associated with 'visibility as a trap' has been mentioned already. It is the problem of unremitting illumination. The room, which has no windows, is flooded with an artificial light that can never be switched off. And so, here again, Sartre undermines conventional images of hell. Just as there are no instruments of torture – no bloodcurdling implements invented to haunt the imagination as well as wound the body[16] – so is there no darkness. Indeed, Garcin had quickly come to realize, from his interactions with the valet upon his first arrival, that there will also be no possibility of turning away from this light. Not only will the room's inhabitants be incapable of sleep, but they will also be denied the respite of blinking, or what Garcin refers to as 'four thousand little rests per hour'.[17] Interestingly, of course, although this constant illumination and this inability to close one's eyes may at first seem like an intensification of the visual, in fact it represents a diminishment of it: a pseudovisibility. As is well known, our physiological capacity to see, and to go on seeing, depends on, rather than is hindered by, darkness in its various forms. Garcin addresses the valet. Will he really have to live here with his eyes open all of the time? With broad daylight, as he puts it, in his eyes, and in his head? It is a horrible proposition, one that he can barely comprehend. The valet responds by querying his use of the word 'live'.[18]

In hell, then, there is nowhere to hide. On the contrary, it is a realm of hypervisibility. Indeed, the characters soon begin to describe each other as being naked; as 'time' goes on – there is of course no time as we know it – each is increasingly able to see right to the core of the others' beings. In hell therefore, as in heaven, illumination dominates and truth is revealed. There is even confession in Sartre's hell. But here, since there is no covering of grace, no forgiveness and no love, illumination and truth are unbearable and confession never brings relief.

Thirdly, there are no mirrors or other reflective surfaces in the room, save for the eyes of the others which cannot but distort. This lack – which further reduces the scope of the visible world – is a particular problem for Estelle who describes her life on earth as one spent encircled by mirrors from which she sought constant affirmation, not only as to her appearance but also her very being. How queer she now feels without them. Unable to see her reflection she wonders whether she truly exists. She pats herself to make sure she is there, but to no real avail.[19] In the context of *No Exit*, this is intended to signal Estelle's superficiality. Indeed, she is presented as someone who has no inner life. She describes all that occurs within a person's head as vague – it makes one want to fall asleep. Then she

recalls the six big mirrors in her old bedroom. 'There they are', she says.[20] At this point she has suddenly caught a glimpse of the world she has left behind, a capacity they all have, in snatches, early on, but which diminishes until there is no more to be seen. She can see the mirrors, she says, but they don't see her. She observes how they reflect the contents of the room – the carpet, the settee, the window – and she commiserates with their emptiness, their loneliness, without her. She had always depended so profoundly on their affirming presence nearby; when talking to people, for instance, she had always also watched herself doing so. It kept her alert.[21]

Of course, Estelle was, and still is, someone obsessed with maintaining and managing a certain image of herself, and the mirrors with which she surrounded herself in life were used in support of this aim. She did not, of course, therefore see herself as others saw her, but only as she wished to see herself. Nonetheless, in the context of my own argument, particularly as presented in the previous chapter, in an important sense Estelle is correct. Appearance and existence, appearance and reality, do go together. In the words of Merleau-Ponty, 'I must be the exterior that I present to others.'[22] And again: 'there is no inner man, man is in the world, and only in the world does he know himself'[23] – I will discuss the implications of this in more detail later. In any case, here in hell, Estelle especially needs to see her reflection. She has applied make-up – it is significant that cosmetics have been allowed to enter Sartre's hell – and she must ensure that it looks right. Then follows one of the play's most memorable scenes. Partly as a seductive ploy, Inéz offers to act as Estelle's mirror. Estelle complies, with reservations, which turn out to be justified – all three have already discussed the fact that their roles in hell are to torture and be tortured by the others, and this is exactly what will happen in the exchange between Inéz and Estelle. The sequence is worth describing at length.

It begins with Inéz inviting the reluctant Estelle to come and sit next to her on her sofa (Inéz, Estelle and Garcin have a sofa each). Estelle hesitates, gesturing towards Garcin, perhaps as a delaying tactic, perhaps out of self-consciousness. But Inéz is dismissive; he doesn't count, she says. Estelle then changes her tactics. She addresses the fact that this is bound to be an encounter that ends badly. They will hurt each other. It is inevitable. Inéz is dismissive of this too: if she must suffer, she says, she would prefer the lovely Estelle be the source of her pain. Come on, she says. She is persuasive and Estelle does indeed draw near.

Inéz's eyes are to function as the mirrors that Estelle craves. Inéz tells Estelle to gaze into them and to report what she sees. She sees herself, of course, but a version of herself so small that she is barely discernable.

Frustrating! But Inéz is, or pretends to be, reassuring: Estelle may not be able to see herself, but Inéz, by contrast, perceives every inch of her. She instructs Estelle to ask her questions and promises to be as candid as any looking-glass.

Estelle is embarrassed. She turns to Garcin, hoping for help, but Garcin ignores her. She has no option but to return to Inéz. Don't concern yourself with Garcin, says Inéz again; he doesn't count. So Estelle begins to ask her questions. Are her lips alright? Inéz indicates that her lipstick is smudged and, movement by movement, guides Estelle as she tries, blindly, to apply more. Then Inéz takes over and when Estelle tries to ascertain her appearance, Inéz confirms that her lips look quite good, better than before, more cruel – diabolical in fact. More frustration, and a good deal of anxiety, for Estelle. How unbearable! She will never now know for certain what she looks like. For surely Inéz's taste and her own are diametrically opposed? Inéz flirts and teases and reassures Estelle mercilessly, claiming to be much nicer than those mirrors upon which she had once depended. But Estelle feels terrorized and terrified: in her old looking-glass, she says, her reflection was like something she had tamed. But Inéz-as-mirror is lethal territory.[24]

Inéz's cruelty, as always, is intentional. She is exerting her power. Indeed, earlier, she had tortured Garcin in a not dissimilar way by drawing his attention to aspects of his visual being that he could neither see nor control. At the same time though, she was agitated by what she saw because – or so it seemed to her – Garcin's face was mirroring her own extreme anxiety. She had honed in on Garcin's mouth, which, she asserted, was twisting about in a grotesque manner. It was never still for a moment; she could not stand it. Garcin apologized, claiming unawareness, which further infuriated Inéz. And inevitably this caused his mouth to twitch even more. Inéz ranted about his impolite inability to keep his face in check. She reproached him for forgetting that he was not alone. He had no right, she said, to inflict the sight of his own fear on her.[25]

The fourth manifestation of visibility as a trap is linked to the broad fact that, apart from that moment when the hellish drawing-room's door suddenly opens, the space in which Garcin, Inéz and Estelle are trapped is becoming progressively more of a closed circuit. Physically and literally there is, from the beginning, the combined effect of that locked door, the lack of windows (thus no vantage points onto other spaces), and the presence of a bell, ostensibly for summoning the valet, that may or may not work. In addition, apart from the monstrous sculpture, there are no cultural objects in the room. While this lack could be interpreted to mean that there are no diversions or distractions in Sartre's hell, it could equally

be seen to imply that there are no provisions for imaginative, emotional and intellectual enlargement. Provocatively, there is a paper knife lying about (of the sort that would have been used, in the past, to cut the pages of new books) but there are no books – towards the end of the play, incidentally, Estelle uses the knife to try and 'kill' Inéz, in order to 'stop her watching'.[26] Finally, as noted, not only is intellectual reflection impossible here, all three characters realize that although, at first, they had all been able to access visions of the world and the people they had left behind, all connection with their past lives is rapidly fading. They can no longer see afar, spatially or temporally. A repeated idea is that they are fated to be eternally and fully in the moment, that is, to be fully present – something, presumably, they had avoided while alive. Inéz indicates as much when her own visual access to the earth ceases. She speaks in terms of now also having lost the alibis she once had. And this leaves her feeling empty. Now, the whole of who she is here, in this room.[27]

No Exit closes, as indicated, with Estelle's laughter at their absurd situation, with a long period of silence, and with Garcin's final words 'Well, well, let's get on with it.'[28] That is, it seems to end with the acceptance of an irresolvable conflict between two conditions – or perhaps, more accurately, two forces. On the one hand, the inhabitants of Sartre's hell are aware, as never before, of the indomitable power of the look as it operates through and against them. On the other hand, they are closer than ever before to the existentialist ideal of facing up to one's own life and taking responsibility for it. In hell, clearly, the battle with the look can never be won. What is less clear, however, is whether, for Sartre, this image-war between the look and free will can be won in real life.

On the one hand, given that *No Exit* is, precisely, a play that is set in hell, we might infer some kind of distinction between its treatment of this topic and real life. Indeed, Sartre himself insisted time and time again that this was the case. But on the other hand the play's hellish mise en scène – that garish, outmoded, but otherwise unremarkable bourgeois drawing-room – is, after all, a near replica of environments familiar not only to the characters in the play but also to its then-contemporary French audiences. More broadly, through the presentation of hell as a place of unremitting artificial light *No Exit* may also be alluding to Paris itself, Paris, which had been referred to as the City of Light (*La Ville-Lumière*) not only allegorically for its fame as a centre of knowledge and learning during the Enlightenment, but also literally due to the extensive systems of gas street lighting and other forms of illumination that had transformed the city from the early part of the nineteenth century. All of this suggests, disturbingly, that a clear line between life on earth and the hellish afterlife presented here may be difficult

to draw. Likewise, although we might argue that Sartre's presentation of the power of the look in *No Exit* is extreme there are times when our experience of the visual in real life seems to coincide with that closed system that Sartre has portrayed – take, for instance, the conditions in which the play was written and first performed, those of enemy occupation with its surveillance, privations and oppression.

Again – in order to emphasize the difference between the experiences described in *No Exit* and those in real life – we might want to insist that what Sartre has presented in the play is emphatically not visuality as it is actually experienced, but rather a phantasmic pseudovisuality. But what are we then to make of Sartre's extreme anti-ocularism in *Being and Nothingness*, which had been published a year earlier in 1943? There he had asserted, for instance, that 'I grasp the Other's look at the very center of my act as the solidification and alienation of my own possibilities.'[29] This suggests that there is no effective distinction between the conditions described in the play and the 'real life' problems his existentialism was seeking to address (in phenomenological terms this would certainly be taken to be the case). But in the words of Gail Weiss, if 'the look of the Other, as Sartre asserts, reveals no more and no less than "my transcendence transcended", then it is indeed difficult to see how the Other can be other than an obstacle to the exercise of my freedom'.[30] In other words, if in our earthly lives, as in Sartre's hell, visuality incarcerates us, then the ideals of existentialism – which were above all a quest for freedom within everyday life – are bound to fail. Only two options seem feasible in principle. Either, somehow, the visual must be evaded – a proposition that certain theorists have argued is our only viable way forward. Or – this is my argument – the dominance of the seeing/being-seen dyad must be broken, so that a new focus on phenomena, practices and the productive possibilities of coming-to-appearance may be brought into play. In Sartre's hell, neither of these is an option.

Within the context of putting pressure on my argument in favour of self-showing, I will consider the option favouring quests for invisibility in a moment. Before doing so, however, there is a further aspect of the ethos and motivations underlying Sartrean existentialism that is worth considering. For what are we to make of the fact that in *No Exit* it is Inéz, the most sadistic and possessive of the three characters, who is also the most consistent embodiment of the existentialist commitment of taking responsibility for the consequences of one's actions? Does this, perhaps unintentionally, suggest that the radical existential freedom and individualism that Sartre's existentialism proposes may likely be experienced by others as radical heartlessness or selfishness when it is actually lived out? That it would be experienced as a form of uncompromising *disregard* for others? If taken at face value, the philosophical novel written by Sartre's lifelong

partner Simone de Beauvoir, *L'Invitée*, seems to suggest as much. *L'Invitée* (translated into English as *She Came to Say*), was written in 1943, thus just a year earlier than *No Exit* and in the same year that Sartre published *Being and Nothingness*. Like several of de Beauvoir's other philosophical novels in which fictionalized accounts of her own life were used to interrogate not only her relations with others but also the philosophical principles and choices animating them, *She Came to Stay* was focused on the open relationship – the experiment in freedom – she and Sartre (Françoise and Pierre in the novel) were attempting to maintain. The ethical basis for this relation – as described in the novel – was that each partner was free to do as they wished, sexually, relationally and in any other way, as long as they were honest about it. Thus, their lives were to be lived in transparency not, as in *No Exit*, because each lived under the constant surveillance of the other but rather because they would always tell each other exactly what was taking place: the power of the word. In *She Came to Stay* however, this, arrangement falls apart as far as Françoise is concerned when they establish a ménage-a-trois with a younger woman, Xavière (Olga Kosakiewicz in real life, or a composite of women with whom Sartre and de Beauvoir were erotically involved) who refuses to play according to those pre-existing rules of full verbal disclosure. (As in *No Exit*, and indeed in the film *Sangam*, discussed earlier in *Showing Off*, we have here another dysfunctional threesome.) Merleau-Ponty reflected on de Beauvoir's novel, and on its central propositions and dilemmas, in 'Metaphysics and the Novel'. Published in March 1945 in the French literary journal *Les Cahiers du Sud*,[31] this essay was an exploration of the 'hybrid' literary forms 'having elements of the intimate diary, the philosophical treatise, and the dialogue'[32] that had been appearing since the end of the nineteenth century with the emergence of phenomenological and existential philosophy. In it he focused at length on *She Came to Stay* and given that it had met with considerable moral outrage when it was first published he used his essay as an opportunity to defend what he saw to be a powerful critical interrogation of the existential values of good and bad faith, and of true and false morality.

> The metaphysical drama which Pierre and Françoise had succeeded in forgetting by dint of generosity is abruptly revealed by the presence of Xavière. . . . They thought they had overcome jealousy by the omnipotence of language; but when Xavière is asked to verbalize her life, she replies, 'I don't have a public soul.'[33]

He continues:

> One should make no mistake about the fact that if the silence she demands is perhaps that of equivocations and ambiguous feelings, it may

also be that in which true commitment develops beyond all arguments and motives. 'Last night', she said to Pierre, with an almost painful sneer, 'you seemed to be living things for once, and not just talking about them'. Xavière challenges all the conventions by which Françoise and Pierre had thought to make their love invulnerable.[34]

In any case, returning to the story, Xavière's refusals – but, crucially, also Pierre's free choice to continue the relationship nonetheless – create a situation that Françoise is unable to tolerate. De Beauvoir's novelistic self is wounded, becomes ill, and finally murderous. Within the logic of existentialism, the fact that Françoise allows herself to be so fatally determined by the actions of others is an expression of bad faith. As with the slightly later *No Exit*, *She Came to Stay* is art, and de Beauvoir was no murderess in real life. Like Sartre, she was a passionate advocate of the existentialist ideals of good faith, freedom and responsibility for one's choices. Nonetheless, she reputedly wrote *She Came to Stay*'s ending as an act of revenge.

Pseudo-invisibilities

I can hear you say, 'What a horrible, irresponsible bastard!' And you're right. I leap to agree with you. I am one of the most irresponsible beings that ever lived. Irresponsibility is part of my invisibility; any way you face it, it is a denial.

RALPH ELLISON[35]

In *She Came to Stay*, as indicated, at the crucial moment of challenge Françoise retreats into illness before turning to murderous aggression. This retreat into illness is a retreat from the givens of her situation and from others – principally, but not exclusively, from Pierre and Xavière. By becoming ill and confined to her bed she literally takes herself out of circulation.[36] As we read, however, it becomes apparent that it is particularly at the specular level that this retreat is being enacted. For above all, Françoise wants to avoid being seen. She wants to retreat into invisibility – or, rather, she believes that illness is now the only way left open to her to regain the condition of invisibility that she had convinced herself was the foundation, and enabler, of her life. Indeed, it is evident from the first pages of *She Came to Stay* that, for Françoise, ultimate assurance and ultimate power reside in those who see but (believe they) are not themselves seen, and she considers herself to be such a person. As Merleau-Ponty puts it:

I remain the center of the world. I am that nimble being who moves about the world and animates it through and through. I cannot seriously mistake

myself for that appearance I offer to others. I have no body. 'Françoise smiled: she was not beautiful, yet she was very fond of her face; it always gave her a pleasant surprise when she caught a glimpse of it in a mirror. Most of the time she did not think she had one.'[37]

'Everything exists just for her', writes Merleau-Ponty.

Not that she uses people and things for her private satisfaction; quite the contrary, because she has no private life: all other people and the whole world coexist in her. 'Here I am, impersonal and free, right in the middle of the dance hall. I simultaneously contemplate all these lives, all these faces. And if I were to turn away from them, they would soon disintegrate like a forsaken landscape.[38]

But at a given moment, her relationships with Pierre and with Xavière, and the relationship of those two with each other, have suddenly become opaque. Metaphorically, their refusals to 'confess' have blinded her. Their non-compliance has turned her sense of herself upside down and inside out, from generous, disembodied viewer, to disprized object at the end of the gaze of those others. As Merleau-Ponty, again, put it, her illness, and then her recourse to violence were driven by the fact that 'Françoise wanted to shatter the image of herself she had seen in Xavière's eyes' and because '[a]s long as Xavière exists, Françoise cannot help being what Xavière thinks she is'.[39]

Françoise's attitudes and actions in *She Came to Stay* exemplify one of our most fundamental human responses to threat: flight. More specifically, the impulse to hide out in what we take to be the invisible, believing this invisibility to be at the very least protective, and at best both protective and empowering. Here, the underlying rationale is that power ultimately operates invisibly and that it is therefore from this position, or foundation, that those who feel disprized, or have been defined as such, should aim to establish their power base. Peggy Phelan makes a proposition of this kind in *Unmarked*, her seminal critique of the politics of visibility and of representation that had been central to classic twentieth-century identity politics from the 1960s to the late 1980s. Indeed, in this work Phelan too claimed visibility to be a trap: 'It summons surveillance and the law; it provokes voyeurism, fetishism, the colonialist/imperial appetite for possession.'[40] Therefore – this has to do with what she considered to be the flawed strategy lying at the centre of the politics of visibility – in order to 'counter the physiological and psychic impoverishment of the eye/I, visual representation makes ever more elaborate promises to deliver a satisfying and substantial real'.[41] But even if she is correct with respect to the error of falling for the false promises offered by representation – and I believe that she is – surely the attempt to establish a politics that eschews visibility is a false move. For, as de Beauvoir's Françoise

knew but nonetheless resisted, visibility and embodiment go together. You cannot have one, and not the other, which is why, in *She Came to Stay* she was trapped into trying to deny both: 'I cannot seriously mistake myself for that appearance I offer to others. I have no body.'[42] As I have already tried to argue – and was this not implied in *No Exit*? – there is no safe, secure and permanent realm of invisibility. It is a fantasy. Whatever goes into hiding must eventually reveal itself. Take another, much-discussed example from the realm of identity and post-identity politics – namely, the discussions of 'whiteness' that began to emerge during the 1990s (alongside a new focus on the theorization of masculinity). Here, much was made of the idea that 'whiteness' as an ideological force is difficult to identify and critique because it operates invisibly. But this is, again, a fantasy. As most of us know, it is experienced as invisible only by those who are defined, or define themselves, as white. Those who are not so defined can identify and critique it with ease. Which brings me to the issue of race. For here, if anywhere, we would expect to find the most fervent agreements that visibility is indeed a trap, and that not only power but also peace of mind are sourced within invisible realities. What we find instead are some of the most powerful presentations of invisibility as a spurious condition to be resisted or overcome at all costs.

Iconoclasm and race

In the well-known opening lines from the 'Prologue' to Ralph Ellison's *Invisible Man* of 1952 are the words spoken by Ellison's unnamed narrator:

> I am an invisible man. No, I am not a spook like those who haunted Edgar Allan Poe; nor am I one of your Hollywood-movie ectoplasms. I am a man of substance, of flesh and bone, fiber and liquids – and I might even be said to possess a mind. I am invisible, understand, simply because people refuse to see me. Like the bodiless heads you see sometimes in circus sideshows, it is as though I have been surrounded by mirrors of hard, distorting glass. When they approach me they see only my surroundings, themselves, or figments of their imagination – indeed, everything and anything except me.[43]

The location from which these words are spoken is a basement room on the outskirts of Harlem where this narrator has secreted himself, rent free – a basement, sealed off and forgotten during the nineteenth century, in a building 'rented strictly to whites'.[44] He had discovered it while on the run from one of the book's dominant characters, the black nationalist Ras the Destroyer (formerly known as Ras the Exhorter) and, like the drawing-room in *No Exit*,

it is a place of confinement that is also intensively illuminated. Although in hiding, Ellison's narrator has rigged his room with 1,369 light bulbs powered by siphoned-off electricity to make it brighter than 'the Empire State Building on a photographer's dream night'.[45]

Not only does Ellison's novel highlight one man's quest for a state of illumination, it has also been remarked that, from its opening lines onwards, it testifies to a fundamental understanding of self and world as image. As discussed, for some thinkers – Heidegger in his essay 'Age of the World Picture', Debord in his *Society of the Spectacle*, for instance – this definition of humankind was believed to be distinctively modern. For others it has always been foundational to human identity, self-knowledge and communication. In any case, since Ellison's narrator, as he put it, may indeed 'be said to possess a mind' he starts by analyzing his condition within the image-world. From this, it is clear that what he has suffered in terms of his existence as image is, in effect, a form of iconoclasm – an issue to which I will return. Also evident, given our earlier discussions of *No Exit*, is the dramatic contrast between the encounter with the mirror as it has just been presented here, and as it was described not only in *No Exit* by Estelle but also in *She Came to Stay* by Françoise. In the 'Prologue', having defined his situation, Ellison's narrator goes on to diagnose its causes:

> That invisibility to which I refer occurs because of a peculiar disposition of the eyes of those with whom I come in contact. A matter of the construction of their *inner* eyes, those eyes with which they look through their physical eyes upon reality.[46]

It is this disposition that Ellison's narrator is finally able to defy. Turning now to the book's 'Epilogue', where the narrator reflects back on the story he has told – that of a long journey towards individuation – we read as follows:

> So it is that now I denounce and defend . . . say no and say yes, say yes and say no. I denounce because though implicated and partially responsible, I have been hurt to the point of abysmal pain, hurt to the point of invisibility. And I defend because in spite of all I find that I love. . . . So I denounce and I defend and I hate and I love. . . . Thus, having tried to give pattern to the chaos which lives within the pattern of your certainties, I must come out. . . . I'm shaking off the old skin and I'll leave it here in the hole. I'm coming out, no less invisible without it, but coming out nevertheless.[47]

There is, here, a clarion call where the idea of stepping into the visible is concerned. This is significant. In the 'Prologue', by contrast, Ellison's narrator

had been explicit that a turning point in his life had come when he discovered how to take advantage of the invisibility that had been imposed upon him by racism, how to use it 'to carry on a fight against them without their realizing it'.[48] His fight against Monopolated Light & Power was precisely of this order. Thus, while the illuminated basement symbolized his desire for visibility, it is also true that it was due to his status as invisible that he discovered the means to create this private world of artificial radiance.

> I use their service and pay them nothing at all, and they don't know it. Oh, they suspect that power is being drained off, but they don't know where. All they know is that . . . a hell of a lot of free current is disappearing somewhere into the jungle of Harlem. The joke, of course, is that I don't live in Harlem but in a border area. Several years ago (before I discovered the advantages of being invisible) I went through the routine process of buying service and paying their outrageous rates. But no more. I gave up all that, along with my apartment, and my old way of life.[49]

Despite all of this, though – despite what we might define as the disadvantages of visibility when it is reduced to the condition being negatively perceived, or, as here, of not being perceived at all – *Invisible Man* ultimately presents the condition of visibility as paramount. Of utmost importance is being able to reveal and define yourself, no matter what. 'And I love light. . . . Light confirms my reality, gives birth to my form. . . . Without light I am not only invisible, but formless as well; and to be unaware of one's form is to live a death.'[50]

This coming out is crucial – Ellison's narrator implies that it is the inevitable movement of love; love always goes out; it extends beyond itself. Coming out into the visible is vital, even if it continues to be resisted externally by those others who are determined not to see. Indeed, it is only by coming into visibility that the lie regarding the visible can be seen to collapse – a point made by the social scientist and criminologist Majid Yar in his 2003 essay 'Panoptic Power and the Pathologisation of Vision: Critical Reflections on the Foucauldian Thesis'.[51] Here, referencing the work of activist groups operating under the collective title of 'Surveillance Camera Players', he wrote of practices in which there occurs 'an inversion of the economy of visual power as postulated by Foucault, such that *making oneself visible* subverts the effectiveness of the gaze'.[52] Likewise, at issue in Ellison's writing – in his 'I'm coming out, no less invisible without it, but coming out nonetheless' – it is self-showing that has been chosen, even if into an apparent perceptual vacuum. At issue, in any case, are an identity and a mode of interacting with others that have slowly been learning how to operate outside of the

oppressive logics of the seeing/being-seen dyad. Or, to use a different, but analogous set of references, Ellison's narrator has learned to find meaning for his life outside of that Hegelian model in which, as Yar and Simon Thompson have put it in their recent book, 'a subject's acquisition of self-consciousness necessarily requires the presence of another subject who recognizes the first'.[53] As they remind their readers, a 'politics of recognition' is being referenced here that has its roots in Hegel's *Phenomenology of Spirit* of 1807, specifically in the short section dealing with the dialectic of lordship and bondage (better known as the 'dialectic of master and slave'). This proposition regarding the acquisition of self-consciousness had gained a new currency in the first part of the twentieth century through Alexandre Kojève's lectures on Hegel's *Phenomenology* at the École Pratiques des Hautes Études during the 1930s (attended by Sartre and Merleau-Ponty, among others) and the 1947 publication, in French, of his *Introduction to the Reading of Hegel*. These ideas were influential on Sartre, who overtly explored them in his essay 'Anti-Semite and Jew', written in 1944, and published in two parts in 1945 and 1946. It was also precisely this struggle for recognition that was described in such detail in *No Exit*. Here, the enduring nature of this struggle was evident since it persisted even beyond death.

Returning to our main theme, there are many other examples to which I could turn in order to support the importance of laying claim to the visible despite its difficulties, and in order to emphasize the persistence of the visible itself in even the most aggressively anti-ocular conditions; examples, in other words, that affirm the ultimate impossibility of its erasure. Here, for instance, given my definition of Ellison's struggle as a struggle with iconoclasm, I cannot help but recall my feelings, many years ago in the Rijksmuseum in Amsterdam, when confronted with the powerful yet wounded visibility of an object that had undergone, but survived, iconoclastic attack during the sixteenth century: the Master of Alkmaar's *The Seven Works of Mercy* of 1504. Although restored in the 1970s, areas of damage were left visible on its seven thick, wooden panels, particularly on the face of Jesus who was repeatedly depicted in this work as one of a group of people in need of charity.[54] Another powerful reference may be found in recent work by the contemporary theorist Ariela Azoulay, particularly as explored in her groundbreaking book *The Civil Contract of Photography*. For in this book, which focuses on photographic situations in which, rather than being cast in a passive or objectified position, those who are being photographed claim agency – they are described as seizing the photo opportunity in order to present their positions and make claims about rights they wish to obtain. They are described as those who seize and project their visibility within that very condition – of being photographed – which has so persistently been

described by theorists as a terminal moment of capture and objectification. Her claim is made all the more valid since the photographed persons who are operating as the agents of photographic representation are those who are so routinely designated as victims: her thesis had been inspired by the actions of Palestinians being photographed by news crews and journalists, and by the manner in which she saw them using these opportunities as platforms from which to claim justice.

Hiding out within the visible

There is, however, another dimension of invisibility (or pseudo-invisibility) that I wish to discuss: that of hiding out *within* the visible. At issue here is still a struggle for recognition – my example comes from the realm of corporate branding – but the strategy adopted is one that places a flawed sense of confidence in the 'invisible' workings of power through masquerade, a form of masquerade, needless to say, that is of a completely different order to that carried out by Pushpamala, since its aim is not to enlighten by means of cultural critique but to persuade. It does so apparently altruistically though, by diverting attention away from 'self' (the company in question and its products), and onto others (the company's target audience).

My case study is the 2002 rebranding of Channel 5, the United Kingdom's fifth terrestrial broadcaster. Although there have been many rebrands since then, most recently in 2011, the 2002 rebrand represented the channel's first major image-rethink, and also its most radical, interesting, and as I will show, problematic one. Having launched in 1997, by 2002 it was in a degree of trouble. In its attempts to claim a significant audience share from its longer established rivals, BBC1, BBC2, ITV and Channel 4, it had adopted a lowbrow, sensationalist approach to its programming – including tasteless forms of reality television and soft porn – as if attempting to be the broadcast equivalent of such British tabloid newspapers as the *Sun* or the *Sunday Sport*. This negatively affected its public image in certain spheres – in 2000, for instance, provoked by the release of a nude game show called *Naked Jungle*, concerns about increasing tastelessness in British broadcasting, especially on this channel, were raised in the House of Commons, particularly by the then Culture Secretary Chris Smith. The channel was referred to as 'tacky' by the Independent Television Commission, which regulates commercial channels, and the British right leaning newspaper, the *Daily Mail*, branded the station 'Channel Filth'.[55] Nowadays, of course, not dissimilar programming is more or less mainstream across several of the United Kingdom's major networks.[56] As

well as the problem of negative press perhaps more significant for the channel itself was the fact that ratings were not as strong as they could have been. The 2002 rebrand sought to address this problem. Conceived by the London-based design group Spin, it saw the channel and its logo change to 'five', and it consisted of a sequence of disarmingly self-effacing and non-spectacular idents in both still and moving image formats conveying snippets of everyday life. Among them were sequences showing a woman in a bedroom trying on shoes, a man getting into a swimming pool, a man doing push-ups, two women embracing, a patch of grass and an image of a housing estate. In each case, the font accompanying these images, and the one through which the rebranded channel now communicated its on-screen announcements, was a simple, versatile sans serif. Clearly, this new font and the channel's new logo (consisting, ironically perhaps, of a four-letter word) seemed to be aiming at a kind of generic flexibility.[57] Likewise, the images were presumably intended to reference ordinary members of the British public (the channel's hoped for viewers) carrying out everyday activities – activities, notably, that emphatically did not involve television viewing. In fact, those featured were orientated away from the camera and the screen, as if unaware that their images were being filmed; their bodies rather than their faces were emphasized. To repeat, as with the contemporaneous *Economist* campaign discussed earlier in this book, here the point of focus was the intended consumer. But, in contrast to the *Economist*'s authoritarian, threatening and belittling tone, here the mode of address was apparently hands off, disinterested and non-manipulative. There was no immediate sense that an appeal was being made; rather lifestyle vignettes of selected, anonymous individuals were 'simply', quietly, and rather stylishly presented almost as if in passing. But despite taking this apparently other-orientated approach, the company nonetheless revealed itself – indeed, gave itself away – in this series of idents in various, arguably disadvantageous, ways.

For instance, although the broadcaster was hoping to increase its viewing figures, and although it was aiming at an image of greater sophistication, rather than use these vignettes to reflect the cultural diversity of the United Kingdom in the twenty-first century, each time the idents were aired what might be described as an outmoded, if not reactionary, monocultural photo-portrait of Britishness was conveyed. Surprisingly, if a sample of 68 moving image idents aired during 2002 and 2003 is studied, it becomes clear that everyone featured was white, or would be identified as white, with two exceptions: an ident with a black youth and a white youth playing a videogame, and one showing, from the back, a dark-haired, possibly Asian woman undressing.[58]

There was another area of compromise. As indicated earlier, the scenarios featured in the campaign purposely seemed to have nothing to do with television programming or television watching. When viewed on screen, there was often a distinct sense of disjunction between what we were given to see, and the programme information that was being conveyed by voiceover. But there was one ident that broke this mould and, in so doing, inadvertently proposed a set of unhelpful analogies between its own content and the purported ethos of the broadcaster. The ident in question was that of the woman, in her bedroom, trying on shoes and checking her appearance in an unseen mirror – unseen, since the camera would appear to have been set up more or less adjacent to it. As with the other idents featuring people, her face and blonde hair were only partially and fleetingly visible. Rather her legs and feet were the point of focus, seen against a backdrop consisting of a flounced diagonal of bed and a muddled swirl of shoes, varied in colour and style, which had been cast upon smaller swirls of textured, beige carpeting. Although ostensibly conceptually similar to the other idents – again a passing glimpse of an everyday moment of life – this ident differed from almost all the others in this campaign in a number of ways.

First, this was the only one in which the person featured was orientated towards the camera/screen (a close correlate would be the ident of the youths playing the videogame where again a screen was implied).

Secondly, due to its overt focus on self-staging and, as many theorists would argue, due to the culturally embedded scopic practices that are evoked by images of the female form, it broke out of the carefully staged unspectacular character of the other idents in this series.

Thirdly, it differed from the others (even that of the dark-haired woman undressing) because of its overt concern with image or appearance. Like the broadcaster, the woman was presented in the process of considering and producing a series of possible looks that were intended to achieve certain aims, specifically that of attracting favourable attention. Perhaps too the competitive aim of looking better than her peers.

There was, finally, also something else, suggested by the implied presence and placement of the camera, filming as if unobtrusively in a woman's bedroom: namely, the idea that at issue here might not only be a woman looking at herself in a mirror, but perhaps also a woman performing, in the privacy of her own bedroom, to a camera she has herself set up there: a webcam. In other words, the woman as broadcaster. On the one hand, this notion of the woman as broadcaster could be seen to reference the growing trend, during that period of image-viewers increasingly also becoming image-makers – as discussed in Chapter 1 – and the analogous trend within broadcasting towards user generated content and reality programming. On the other hand, though,

the implication of this bedroom-based ident is that less than respectable imagery is being broadcast. This is precisely the negative image that the channel's 2002 rebranding was intended to remedy.

War games

As long as our world views are governed by the restrictive logics of the seeing/being-seen dyad, stepping out into the visible means becoming involved in a losing battle – a point made with considerable intellectual and emotional force in another classic mid-twentieth century text: *Peau Noire, Masques Blanques* (*Black Skin, White Masks*). Written by the revolutionary psychiatrist and philosopher Frantz Fanon and published in France in 1952 – the same year as Ellison's *Invisible Man* – like de Beauvoir's *She Came to Stay* it was, again, a hybrid mode of expression as defined by Merleau-Ponty; it reads like a mix of biographical or semi-biographical novel, philosophical and psychological treatise, and manifesto. Its subject is, again, the alienating force of vision, and, as with the Ellison, questions of race are central; it is an impassioned account of how Fanon's black Antillean narrator, having first been overwhelmed by the destructive effects produced in him by the 'white' Gaze – my descriptor, not Fanon's – finds ways of locating, strategizing against and overcoming that Gaze.

Clearly, the issue on which *Black Skin, White Masks* is focused was then, and remains, a persistent global problem, despite having now been much analysed and theorized by scholars and activists alike. When the book was first published, though, it failed to attract significant attention. Only when the English translation appeared in 1967, six years after Fanon's death, did it begin to make its mark. It influenced the Civil Rights movement in the United States and, due to its non-assimilationist arguments – of which, more below – it also had an impact on the rise of Black Power. More broadly though, as Ziahuddin Sardar put it in his foreword to the 2008 English republication of *Black Skin, White Masks*, the book 'caught the imagination of all who argued and promoted the idea of black consciousness. It became the bible of radical students, in Paris and London, outraged at the exploitation of the Third World'[59] – and it should be noted, here, that during the 1950s and 1960s the designation 'Third World' referred not to the world's poorest countries, dependent upon the charitable support of the developed world, but to an emergent political alliance that was alternative to the First World (Europe and the United States) and the Second World (the Soviet Bloc). Furthermore, because *Black Skin, White Masks*, though non-assimilationist in its position, eschewed the reactionary politics of black supremacy – here it parted company with the Black Power stance – it

has also been important for the more recent emergence, and development, of post-identity politics. So much so that the theorist Teresa de Lauretis stated in her 2002 essay 'Difference Embodied: Reflections on *Black Skin, White Masks*', that Fanon had become for her and others 'the figure that more than any other animated cultural theory in the last decade of the twentieth century'.[60] This is because, according to de Lauretis, Fanon's work was ultimately centred not on questions of identity (understood as 'the assimilation of each individual to a social group, a class, a gender, a race, a nation – concepts that are themselves questionable'[61]), but rather on the psychoanalytically resonant notion of 'identification', which, as she puts it, 'carries an ontological and an epistemological valence, such that the question, Who or What am I? becomes a question of being and knowing, a question of desire'.[62]

As I see it, the model of being referred to here is powerful. Grounded as it is in the notion of 'identification', it again offers a logic alternative to that proposed by the politics of recognition. Nonetheless, at the beginning of the journey described in *Black Skin, White Masks*, it is the latter, destructive politics in which Fanon's narrator finds himself entrenched. In the book's fifth chapter, notably, Fanon describes the turmoil and profound sense of exile that are experienced by a black man – perhaps Fanon himself – who has newly arrived in France from the French colony of Martinique. Although this chapter was translated as 'The Fact of Blackness', its French title is '*L'expérience vécue du Noir*' or 'The Lived Experience of the Black [or Negro]' which more accurately conveys the existential and phenomenological character of Fanon's philosophical affiliations, particularly as they are expressed in this part of the book. The chapter begins, in any case, with the words '"Dirty nigger!" Or simply, "Look, a Negro!"' It continues:

> I came into the world imbued with the will to find a meaning in things, my spirit filled with the desire to attain to the source of the world, and then I found that I was an object in the midst of other objects.[63]

A little later, having expanded on the experience and effects of this objectification, he returns to those verbalizations, noting a transition from 'Look, a Negro!' to 'Mama, see the Negro. I'm frightened!'[64] – words that he hears one day while walking along a Paris street. His immediate response is one of bemusement: how ludicrous that his mere presence should provoke such fear. But he quickly understands that the child's cry is not just a specific and perhaps excusable expression of unfamiliarity or ignorance. Rather, it is an unguarded and spontaneous expression of a whole set of deeply embedded Eurocentric prejudices, even phobias – so deeply embedded that even this young child has absorbed and transmits them. 'I could no longer laugh', he

wrote, 'because I already knew that there were legends, stories, history, and above all historicity'.[65] The effect on him is devastating:

> On that day, completely dislocated, unable to be abroad with the other, the white man, who unmercifully imprisoned me, I took myself far off from my own presence, far indeed, and made myself an object. What else could it be for me but an amputation, an excision, a haemorrhage that spattered my whole body with black blood. But I did not want this revision, this thematisation. All I wanted was to be a man among other men. I wanted to come lithe and young into a world that was ours and to help to build it together.[66]

A few pages later, in a similar vein, we find the pronouncement: 'dissected under white eyes, the only real eyes, I am *fixed*'.[67] These, then, are the conditions in which he is immersed and with which, in one way or another, he will be in constant contention, a contention that is made all the more difficult because – apart from those specific, identifiable and, indeed, public verbalizations just described – the aggression at issue is generalized, and ultimately unlocalizable. Hence my use of the term 'white Gaze': 'I occupied space', wrote Fanon 'I moved toward the other . . . and the evanescent other, hostile but not opaque, transparent, not there, disappeared. Nausea . . .'[68]

Crucially, too, Fanon's narrator discovered that it was also in a temporal sense that this Gaze is generalized and dispersed. Although its destructive operations had only become apparent upon his arrival in France, it had had a much longer, hidden history where it had functioned, unnoticed and unchallenged, in an apparently benign, formative and thus much more destructive mode:

> The black schoolboy in the Antilles, who in his lessons is forever talking about 'our ancestors, the Gauls', identifies himself with the explorer, the bringer of civilization, the white man. . . . [T]he Antillean does not think of himself as a black man; he thinks of himself as an Antillean. The Negro lives in Africa. Subjectively, intellectually, the Antillean conducts himself like a white man. But he is a Negro. That he will learn once he goes to Europe; and when he hears Negroes mentioned he will recognize that the word includes himself as well as the Senegalese.[69]

In Martinique, too, the Negro was disprized by the white Gaze; the Negro was understood to be elsewhere, in those text books, and far off in Africa, having nothing to do with the Antillean. Thus it was only upon arrival in Europe that this designation was thrust upon him, and the Antillean became involved in a battle in which it was particularly his body and the colour of

its skin that were targeted. Making reference to Sartre's 'Anti-Semite and Jew', Fanon underscored the inescapability of this coming under attack by comparing the plight of the 'Black' man to that of the (European) Jew who looks white and therefore has the possibility of disguising his ethnicity. Fanon writes that whereas the Jew 'is disliked from the moment he is tracked down' in his own case 'everything takes on a *new* guise. I am given no chance. I am overdetermined from without. I am a slave not of the "idea" that others have of me but of my own appearance.'[70] As noted, one consequence of this for Fanon's narrator was that he took himself far off from his own presence and made himself an object. This was both a retreat into and a retreat away from the self, into a kind of non-position from which it was almost impossible to act, create or participate.

On the one hand, at issue was a diminishment of his being. In Fanon's words, he experienced his 'corporeal schema' as having 'crumbled'.[71] This schema was above all the being Fanon had previously felt and known himself to be, and which he wished to continue projecting into the world, not just psychically, but in actuality: the man who wanted to live 'among other men' and come 'lithe and young into a world that was ours and to help to build it together'. Referencing de Lauretis, this is a sense of self that is organized not around classical notions of identity but rather of identification.[72] It is above all the actional body – and here, vitally, we must remember that, as for Sartre and Merleau-Ponty, for Fanon too who we are is above all and intimately tied to what we do and how we do it. In any case, suddenly this corporeal schema was found to have been replaced 'by a racial epidermal schema',[73] that screen of 'blackness' to which all manner of negative, even frightening, connotations had already been attached, and through which he was generally seen (or, again, more precisely, *not* seen). Crucially, for Fanon, this racial epidermal schema is not a true, bodily or biological fact but a cultural, historical and linguistic phenomenon, and a product of discourse. It is also overdetermined, either demonized, as in Fanon's experience, or, in certain other contexts, idealized.

On the other hand, also at issue with the emergence of the corporeal and the racial epidermal schemata (the former only having become apparent at the moment of its eradication) was an unproductive doubling of the Antillean's being at the level of image. In fact, Fanon referred not just to a doubling but to a multiplication of his being: on the train he was given 'not one but two, three places'.[74] And he described himself as suddenly, seemingly, being made responsible 'at the same time for my body, for my race, for my ancestors'.[75] In any case, in his racialized being he was overburdened with 'an unfamiliar weight'.[76] In the words of de Lauretis, his was a 'body in excess' and as such

was bound to collapse.[77] All these determinations, however, he wished to resist. But how?

One aspect of the battle is defined, again in psychological terms, by Silverman, who has also reflected on *Black Skin, White Masks*. Using the term 'visual imago' for Fanon's racial epidermal schema, and 'the proprioceptive body' for his corporeal schema, she writes that:

> The struggle here is not to *close* the distance between visual imago and the proprioceptive body as in the classic account of identification, but to *maintain* it – to keep the screen of 'blackness' at a safe remove from the sensational ego, lest it assume precisely that quality of self-sameness which is synonymous with a coherent ego.[78]

The problem, however, is that if this task of keeping the corporeal schema and the racial epidermal schema apart is enacted from and prolongs the split position that it inaugurated in the first place, tremendous energy and persistence will be required to maintain it – energy and persistence that would be applied more productively in the pursuit of different, creative, that is, non-reactive, projects. The exertion involved in keeping opposing energies apart leaves little room for manoeuvre; a split position of this kind is no position at all. In *Black Skin, White Masks* Fanon seemed to suggest, on the one hand, that this impossible position was exactly the Negro's plight, indicating that while the image-war of keeping the corporeal schema and the epidermal schema apart was one that had to be waged, it could never be won. The Negro's condition, he wrote, is to be 'forever in combat with his own image'[79] – surely a worst-case scenario if ever there was one. But on the other hand, the broader project energizing Fanon's book was the determination to achieve disalienation. This required that two additional and differently positioned steps be taken within the image-world.

The second dimension of image-war to be undertaken is tied to one of the most important points that Fanon makes in *Black Skin, White Masks*, namely that the destructive relation between the white Gaze and the colonized subject is at root not an external but an internalized one. This is because, as already noted, the colonized subject, without being particularly aware of it, has been educated and socialized to identify himself with the white colonizer. (As I put it earlier, the operations of whiteness are invisible to those, as here, who consciously or unconsciously identify themselves as white.) To repeat, it is only upon arrival in Europe that Fanon's colonized Antillean understands that he has been sold a lie. Gradually he understands that it is not only the externally imposed, raced epidermal schema that is

problematic; the familiar, corporeal schema too has been long contaminated. The scenario is now much more complicated. At issue is no longer a battle waged between two, clearly identifiable schemata, one, the corporeal, taken to be benign, and the other, the epidermal, taken to be detrimental. He now understands that he is also the denigrated object of his own internalized Gaze. He is divided against himself, and it is a division that cannot be negotiated with and reconciled. Rather the internalized white Gaze must be ruthlessly eradicated for which an aggressive, revolutionary stance is required. The freedom that is sought in this regard cannot be given; it must be taken by force. In this regard, influenced in part by the teachings of the radical Catalan psychiatrist François Tosquelles, and particularly by the Négritude movement, Fanon cited the work of his friend, the Martiniquian poet and activist Aimé Césaire.[80] Here, while the Hegelian master/slave dialectic is clearly referenced, as I understand it, a dialectical process of negotiation is rejected.

> Then, once he had laid bare the white man in himself, he killed him: 'We broke down the doors. The master's room was wide open. The master's room was brilliantly lighted, and the master was there, quite calm . . . and we stopped. . . . He was the master. . . . I entered. "It is you", he said to me, quite calmly. . . . It was I. It was indeed I, I told him, the good slave, the faithful slave, the slavish slave, and suddenly his eyes were two frightened cockroaches on a rainy day . . . I struck, the blood flowed: That is the only *baptism* that I remember today'.[81]

Although expressed here in clearly articulated and starkly oppositional terms, this was of course no easy task because it was so profoundly personal. For at issue was the necessary expulsion of what was, in effect, a still-significant aspect of the colonized subject's own being around which fundamental aspects of his identity had been formed. However, the accomplishment of this non-negotiable act was crucial for Fanon and would be an insistent theme of the writing he produced first in France and then, from 1953 and until his deportation in 1957, in Algeria, where he had been appointed as a psychiatrist at the Blida-Joinville Psychiatric Hospital – in November 1954, Algeria had embarked on its bitter, and eventually successful, struggle for independence from French colonial rule; Fanon actively supported this quest having, in 1954, joined the Front de Libération Nationale.

A third dimension of the image-war outlined by Fanon occurs in the sixth chapter of *Black Skin, White Masks*. Here, Fanon is concerned about the cultural assumptions, narratives, histories and historicities, Eurocentric

in origin, that have deformed the perception (and self-perception) of the colonized black body. But at issue here is not only the important work of disidentification, as earlier. Also crucial are acts of personal and cultural reimaging and reimagining, and specifically the creation of new identifications that bypass the limitations of race. 'The *eye* is not merely a mirror, but a correcting mirror', he writes:

> The *eye* should make it possible for us to correct cultural errors. I do not say the *eyes*, I say the *eye*, and there is no mystery about what that eye refers to; not to the crevice in the skull but to that very uniform light that wells out of the reds of Van Gogh, that glides through a concerto of Tchaikovsky, that fastens itself desperately to Schiller's *Ode to Joy*, that allows itself to be conveyed by the worm-ridden bawling of Césaire.[82]

Here, Fanon makes use of visual terms and metaphors, notably 'the *eye*' which is not the organ with which we look at the world, but a 'very uniform light' that traverses and thus also unites in some inexplicable way various cultural objects – not only visual works, but also music and literature. This 'eye', then, seems to be a phenomenon that emanates from those works, that is felt, somehow, to look out at, and apprehend, us. This is comparable with what Merleau-Ponty, in his later writing, would describe as a kind of reversal that can occur in perception between seer and seen, in which, 'as so many painters have said . . . things look at them'.[83] But another way of thinking about this 'uniform light' that traverses a number of different cultural productions is from within the auspices of self-showing. In other words, it might be understood as analogous to style – style as an expressive correlate to the Gaze in the sense that although we can apprehend it, and recognize it, it is also in a sense unlocatable; it seems to reside in but also to unite entities that would otherwise be perceived as distinct. (Here, we might see analogies with Yar's assertions about the way in which strategies of '*making oneself visible*' may subvert 'the effectiveness of the gaze'.[84]) Yet another analogy, also on the side of coming-to-appearance, would be with the now much-discussed notion of affect, which has been defined as 'a turbulent background field of relative intensity, irreducible to and not containable by any single body or subject'.[85] Indeed, Fanon's intention was that this light would also well up and push its way through *Black Skin, White Masks*, making itself perceptible to his readers: 'This book, it is hoped, will be a mirror with a progressive infrastructure, in which it will be possible to discern the Negro on the road to disalienation.'[86] Certainly, this sense of the progressive and affective is to be felt, flowing powerfully alongside, but not the same as, that other,

important force within his writing: emotion – intensely human emotion of the kind that is more often left unexpressed, repressed, because the material it deals with seems unbearable. But unless it is borne, it cannot be transformed.

A productive violence

Earlier I referred to a criticism that has been levelled against Merleau-Ponty. Namely, that he foregrounded the visual positively in his philosophical writing because, as a privileged, white male, he had never been subjected personally to the destructive terrors of the Gaze; because he could not have known what it means to be disprized within the visible. I countered this by claiming that Merleau-Ponty's writing about the visual demonstrates that he knew its violences only too well, violences, though, that are significantly different in nature and effect to those associated with the Gaze. This is more than apparent when we read his own diagnosis of the workings of perception in the chapter of the *Phenomenology* titled 'Other Selves and the Human World'. In his words (already cited in the introduction to *Showing Off*):

> Perception . . . asserts more things than it grasps: when I say that I see the ash-tray over there, I suppose as completed an unfolding of experience which could go on *ad infinitum*, and I commit a whole perceptual future. Similarly, when I say that I know and like someone, I aim, beyond his qualities, at an inexhaustible ground which may one day shatter the image that I have formed of him. This is the price for there being things and 'other people' for us, not as the result of some illusion, but as the result of a violent act which is perception itself.[87]

Clearly, for Merleau-Ponty the violence in question is not fundamentally that of objectifying the other. Nor is it fundamentally a form of violence that is enacted upon the seer by the self-showing world. At issue instead (and this may sound a little odd at first) is a more fundamental form of violence that is internal to perception itself, a violence that perception, as a phenomenon, first and foremost enacts upon itself. For perception, as he describes it, has a doubled aspect: it makes certain assertions about the world while at the same time aiming at, and opening onto phenomena that may later shatter them. Perception, then, is an act that continually exceeds *and* undermines itself, and to perceive means becoming immersed within the (confident) 'makings' and (violent) 'undoings' of self-showing worlds.

If we can embrace this Merleau-Pontean understanding of the violence that is at the heart of perception and at the heart of the self-showing world, we will discover its power to reposition us in a qualitatively different, more expansive visual reality in which we are not fated to function either as the victims or the perpetrators of the Gaze. More than that, we will discover how to steer through that distinction I have been insisting on between self-showing and being seen, a distinction which must be kept open if we are to exist within the image-world creatively, as agents. This is what Fanon was aiming for in *Black Skin, White Masks*. In the final analysis, the evidence that disalienation has occurred, that colonized subjects have indeed entered into a successful combat with their own images, is that they have become reconciled to themselves in their bodily, and thus visible, beings. This is not easy, since, to quote Fanon, it is 'in his corporeality that the Negro is attacked. It is as a concrete personality that he is lynched. It is as an actual being that he is a threat.'[88] But such reconciliation is vital. Note the words with which Fanon closes *Black Skin, White Masks*: 'My final prayer: O my body, make of me always a man who questions!'[89] At issue is a prayer for the recovery of agency at an embodied level, and for the release of that other-orientated impulse to explore, that is at the root of all creative activity: of being able to come 'lithe and young' (as 'a man among other men') 'into a world that was ours and to help to build it together'.[90]

For Fanon then, to be in combat with the forces of alienation involves not just the mind, not just the visual imagination, but mind and imagination understood as irrevocably tied to the body in the specifics of its locatedness in the world. Likewise, properly reconciled subjects are not merely those from whom the internalized white Gaze has been eradicated. They have also discovered ways of *inhabiting* the world, of projecting themselves into it, that demonstrate that reductive identifications – in this case, of 'blackness' and 'whiteness' – and the myths attached to them, might as well be treated as redundant. In this way, they prove that there are indeed ways of being happily and adventurously otherwise. Here again, that notion of affect is crucial for the ways in which it flows along routes that bypass familiar designations such as race. In this regard, Fanon's model of disalienation indicates a final shift in trajectory beyond oppositional thinking and behaving. What has also been achieved, against the odds, is a non-paranoid relationship with the condition of being visible, a relationship that can be explored further by returning to the work of Merleau-Ponty.

As indicated earlier, Merleau-Ponty wrote in the 'Preface' to the *Phenomenology* that 'I must be the exterior that I present to others'. He added that 'the body of the other must be the other himself'.[91] In 'Metaphysics and the Novel', he wrote that 'Once we are aware of the

existence of others, we commit ourselves to being, among other things, what they think of us.'[92] For Merleau-Ponty, though, when gazes cross and perspectives are exchanged, these actions must, again, be understood as occurring within the broader context of that self-showing world described earlier as intrinsically organized around patterns of assertion, being shattered, and remaking. The vulnerability that is at issue can be taken on board as worthwhile once we realize that it is only within such structures that real encounters with others are ensured, and where provocations for change may be discovered.

> [T]he dialectic of the Ego and the Alter are possible only provided that . . . I discover by reflection not only my presence to myself, but also the possibility of an 'outside spectator'; that is, again, provided that at the very moment when I experience my existence – at the ultimate extremity of reflection – I fall short of the ultimate density which would place me outside time, and that I discover within myself a kind of internal weakness standing in the way of my being totally individualised; a weakness which exposes me to the gaze of others as a man among men or at least a consciousness among consciousnesses.[93]

Merleau-Ponty rearticulates this argument in *The Visible and the Invisible* as follows:

> Vision ceases to be solipsist only up close, when the other turns back upon me the luminous rays in which I had caught him, renders precise that corporeal adhesion of which I had a presentiment in the agile movements of his eyes, enlarges beyond measure that blind spot I divined at the center of my sovereign vision, and, invading my field through all its frontiers, attracts me into the prison I had prepared for him and, as long as he is there, *makes me incapable of solitude.*[94]

This passage is significant because it describes scenarios analogous to those that are usually theorized according to the logics of the Gaze – note Merleau-Ponty's references to notions of invasion and imprisonment. But here he has reconfigured these negative experiences and anxieties within a broader, profoundly challenging but also more embracing sense of the visual, a sense of the visual that anti-ocular theorists have tended to underplay. A challenging factor within situated perceptual scenarios of this kind is that the price of my being real is that I am always given to the Other in a deformed way. I am perceived in a manner that is not necessarily of my own choosing and I may be grievously misperceived. This would seem to be part of the deal. If this challenge is taken up though, and if, as I argued earlier, I am

able to distinguish my own acts of self-showing from those experiences of being seen, I will experience myself and others not only, or no longer, as the opponents or rivals we often seem to be but also as associates, *differently embedded* within this same world.

To repeat, for Merleau-Ponty, 'the violent act which is perception itself' is the necessary condition for creating genuine forms of community, not (as with the notion of the Gaze) the means whereby one person tries to assert his or her supremacy over others. This is emphasized in the chapter from the *Phenomenology* referred to earlier: 'Other Selves and the Human World'. Underlining his argument that this 'violent act' shatters solipsism, he writes that:

> In reality the other is not shut up inside my perspective of the world, because this perspective itself has no definite limits, because it slips into the other's and because both are brought together in the one single world in which we all participate as anonymous subjects of perception.[95]

It is also when we become immersed in this sense of the perceptual and the visual that we come face to face with the other's power to resist us by his or her refusal (or inability) to slip compliantly into the world that we have built for ourselves, and in which we have already assigned him or her a particular place, a particular role and a particular future.

It is, then, an unavoidable fact that the visual, in and of itself, is more intimately violent than we may like it to be. As such, it is hardly surprising that so many of our activities, including our cultural activities, seem designed to help us evade, ignore or domesticate this reality. Thus, an important question to ask of a work of art is what its role might be in this regard. This is also a question to be asked of the places where art is displayed. If we refer back to Sartre's hell as presented in *No Exit*, for instance, we will recall that one work of art, described as a 'bronze atrocity' was allowed in. Since Garcin described it as being by the French nineteenth-century metalworker and manufacturer Ferdinand Barbedienne, it may have been a miniaturized bronze replica of an antique statue housed in one or other European museum collection; Barbedienne's colleague Achille Collas had invented a machine for making these miniaturizations, and they went on to establish a successful business together. These were in fact high-quality works, but they were, nonetheless, literal and metaphorical examples of art being brought down to scale and domesticated. In 1964, when the play was restaged in the BBC's adaptation for television – as noted, it was called *In Camera*. It was directed by Philip Saville and starred Harold Pinter in the role of Garcin, Jane Arden as Inéz, Katherine Woodville as Estelle, and Jonathan Hansen as the valet – questions about taste in art, about the status of art and an implied

criticism of the art world itself, were given a strong visual emphasis. For here, the set had been changed from a Second Empire drawing-room to a room modelled according to the unembellished logic of the modernist 'white cube' gallery, and it contained a number of unappealing modernist paintings and sculptures.

Aesthetics: Domestication or danger?

Already in the early 1950's Malraux, in *The Voices of Silence*, had reflected on the emergence and implications of the modern art gallery, linking it, among other things, with what he described as 'a more and more intellectualized' approach to art that had been emerging since the mid-nineteenth century. He referred to the way in which the art museum both recontextualized and diminished the efficacy of individual works of art. The art museum, he wrote, 'imposed on the spectator a wholly new attitude towards the world of art. For they tended to estrange the works they bring together from their original functions and to transform even portraits into "pictures".'[96] Also worth citing is a somewhat later response to this state of affairs by the artist and writer Brian O'Doherty: his critique of 'white cube' gallery spaces originally published in the journal *Artforum* in 1976. Almost as though he were taking his cues from the staging of the BBC's *In Camera*, he wrote that here:

> The outside world must not come in, so windows are usually sealed off. Walls are painted white. The ceiling becomes the source of light. The wooden floor is polished so that you click along clinically. . . . The art is free, as the saying used to go, 'to take its own life'. . . . Modernism's transposition of perception from life to formal values is complete. This, of course, is one of modernism's fatal diseases. Unshadowed, white, clean, artificial – the space is devoted to the technology of aesthetics. Works of art are mounted, hung, scattered for study. Their ungrubby surfaces are untouched by time and its vicissitudes. Art exists in a kind of eternity of display.[97]

This eternity, he continues, 'gives the gallery a limbolike status; one has to have died already to be there. Indeed the presence of that odd piece of furniture, your own body, seems superfluous, an intrusion. The space offers the thought that while eyes and minds are welcome, space-occupying bodies are not'.[98]

On the one hand, we have here the sense of a space intended to nurture and promote art that is killing it instead, robbing it of excitement and

relevance by cutting art off from its sources and resources of meaning beyond the gallery walls. And on the other hand, there is the sense that the viewer is also poorly accommodated here; this is not a place where the involvements of living, human bodies are encouraged. And indeed, with the emergence of public museums in Europe and America during the late eighteenth and nineteenth centuries, the problem of bodies, hygiene and bodily comportment within these spaces was a matter of concern to museum curators. Very specific rules and expectations, including an often overly unnatural and constrained decorum, were imposed upon visitors. Since the 1990s, these conventions have been undergoing an increasingly wide-scale revision at an institutional level; as museum-goers we now often find ourselves being resocialized about how to behave in these spaces. Artists, and some theorists, have been rethinking such issues for much longer, with an explosion of non-traditional art forms (conceptual and minimalist art practices, site-specific art, land art, performance and installation art, and a wide variety of participatory art projects and events) occurring during the 1960s (when *In Camera* was also staged), all of which implicitly or explicitly incorporated elements of so-called institutional critique. All in all, though, frequently made analogies between museums and mausoleums tend to hold true.

More than ten years ago, I visited a two-work installation in a miniscule gallery in North London that I still recall vividly for the powerful and emotive way in which precisely these questions about the fate of art were explored. Maria von Köhler's one-person exhibition *Made in Taiwan* was held at the Kiosk Project in London in 2002 and consisted of two large-scale works, *Crash Barrier* and *Blazing Hero*. The Kiosk Project was an alternative art space, a narrow converted shop, just one room with a courtyard in the back. The room was set up according to the neutral model of the modernist white cube. *Crash Barrier*, the work that was displayed in Kiosk's interior gallery space, seemed to activate the workings and impact of the white cube in two ways. First, it honed in on that sense, described by O'Doherty, of the viewer's body positioned within these spaces as excessive, a kind of foreign body, and an object out of place. Von Köhler is a sculptor, whose work around that time was generally focused on the world of artificialia, including various man-made replicas such as trophies, monuments and toys. *Crash Barrier*, from 2002, was a greatly enlarged section of a Scalextric crash barrier. Measuring 2.1 × 6.5 metres, it was squeezed lengthwise onto the gallery floor, from front to back door, leaving barely enough room for the viewer, 'its exaggerated angle' as one commentator put it, forcing visitors 'down a specific path'.[99] In this way, the art-work also blocked access to the pristine gallery walls,

making them redundant. As such, the piece inevitably recalled the many other obstructions that are conventionally to be found in gallery spaces: the heavy braided cords and posts intended to mark a non-man's land between viewer and work, the borders painted or taped onto floors, the polite 'no touching' signs, and in several exhibition spaces the alarms that are triggered if you lean into the work too closely.

By provoking these traditional conventions about how to behave in, and move through, a gallery space, *Crash Barrier* draws them to our critical attention. More specifically, since the piece represents an object that is designed to warn and guard against physical threat, and since that threat is an apparently non-existent one (apart from the object itself there are only blank walls), it amplifies the habits of emotional constraint, reserve and dispassion that are generally associated with the appreciation of art. Indeed, it suggests that this is precisely where the danger lies. The danger is that there is no danger, no challenge: *Crash Barrier*, as I see it, despite its own sculptural coolness (its fluorescent orange warning markings do little to alarm, and despite its references to the world of mass-produced models and model making you cannot but help also recall large-scale, industrially produced minimalist floor pieces), is a provocation against the taming of art, art-viewing and aesthetics within modernity. In 1994, the Italian political and cultural theorist Giorgio Agamben had made an analogous point in the opening chapter of his book, *The Man Without Content*. In this chapter, titled 'The Most Uncanny Thing', he problematized the rise of 'aesthetics', associating it with a process 'through which the spectator insinuates himself into the concept of "art"'.[100] The ultimate effect of this process, he claimed, is that it robs art of its agency (specifically its capacity to invoke terror), thus domesticating it. 'Perhaps nothing is more urgent', he wrote,

> – if we really want to engage the problem of art in our time – than a *destruction* of aesthetics that would . . . allow us to bring into question the very meaning of aesthetics as the science of the work of art. The question, however, is whether the time is ripe for such a destruction, or whether instead the consequence of such an act would not be the loss of any possible horizon for the understanding of the work of art and the creation of an abyss in front of it that could only be crossed with a radical leap.[101]

His proposal was to reprioritize the maker over the viewer within the field of art, a shift of focus from 'the [Kantian] disinterested spectator to the interested artist'.[102] What concerned him was 'the idea that extreme

risk is implicit in the artist's activity'[103] and that this sense of risk should also attend the viewing of art, individually and collectively. The latter, to repeat, was an orientation that began to proliferate in the 1990s with an increase in alternative gallery spaces and participatory art initiatives, and it became increasingly institutionalized within mainstream exhibition spaces too.[104]

Agamben's theorizations of art attempted to reorient attention from the viewers of art back onto art makers. More precisely, he argued that in order to revive the efficacy of art those models of exploration and risk that are involved in art making must become paradigmatic for the viewer as well. Here, the artist is the primary agent. But in the second portion of von Köhler's *Made in Taiwan* installation, she seemed to be directing attention towards the unaided agency of the work itself. *Blazing Hero*, a large, rectangular work on display in the gallery's small, ramshackle courtyard, was, again, a piece of sculpture that referenced the world of model making. This time, it consisted of the massively enlarged but as yet unassembled components of a model soldier, whose head and torso, arms, legs, helmet, and rifle were still attached, in pieces, to their plastic frame. Leaning against the courtyard wall, as though the sculpture itself has also not yet been properly installed, it communicated a simultaneous sense of boundedness and containment, and of imminent resurrection. There was an extraordinary intimation of energy embodied in the work; it seemed on the point of bursting free and overwhelming the viewer. In this way, powerfully but simply, the work's own emerging, self-showing agency superseded that of the viewers who has come to look at it. As a viewer, I felt as though I was suddenly standing in front of a (wo)man-made entity that was uncannily dangerous.

An analogous sense of agency, I felt, pervaded a rather different, and certainly less physically confrontational work of art: Kwesi Owusu-Ankomah's *Movement 27* of 2003, which was acquired in 2007 by the newly remodelled and extended Detroit Institute of Arts. It is a large painting which shows a gridded sequence of signs, symbols and logos painted in black on a white, textured background. Several of the symbols belong to a 400-year-old Ghanaian visual language known as adinkra. Others are, or resemble, corporate logos and global product signage, while still others belong to an invented, private language. The symbols on the outer perimeters of the paintings are cut off, some only in part, and others almost entirely, as if the canvas is registering only a snapshot of a much larger field of signs. Within this ordered layout, though, there is an area of distortion, a ripple on this surface of signs, as if in water, which gradually resolves itself into the overlapping outlines of two running male figures, seen side on, that seem at once to be pushing through that world of symbols, emerging from it,

disturbing it, and at times becoming resubmerged into it. The two figures are themselves schematized from the sort of imagery we are used to from the media sports coverage of runners straining their bodies forwards as they approach the finishing line of a race.

Movement 27 is part of a larger, ongoing series of similarly composed paintings in which active, classically proportioned (black) male bodies are simultaneously shown and concealed. According to the artist, one intention here is to make historical references to the aspirations expressed in the pan-African manifesto of Ghana's first president Kwame Nkrumah who, like the black intellectuals Marcus Garvey and W. E. B. Du Bois before him, insisted on claiming and celebrating the achievements of black men and their contributions to world culture. As such, the paintings activate one sort of recurring but positive stereotype of black men in circulation in the contemporary image-world, that of the exceptional athlete. But this is only one reference among many others. More generally, the painting's overall visual language, with its figures at once emerging from and remerging into a screen of signs, engages with broader characteristics of the contemporary, globalized image-world and our engagement with it. Perhaps, most obviously, its intertwining of bodies and signs underlines the logics of the varied images according to which, in the words of Silverman, 'we see and are seen'.[105]

Silverman, writing in the 1990s, was particularly concerned with the powerful representational logic, beyond that of cinema and video, of still photography. Her argument, following Roland Barthes and Jacques Lacan, was that the still photograph, by transforming subjects into immobilized objects, positioned them, as it were, within the spectacle of death.[106] But, despite *Movement 27*'s clear referencing of the photographic still, specifically the arrested movement of the photo-finish, this objectification does not seem to be the governing logic of Ankomah's painting. On the contrary, as indicated in the work's title, a remarkable sense of movement remains uppermost, not only pushing forward in pursuit of a goal but also pulsating into our space: self-showing, again, breaking into and addressing the space of sight.

Also at play, however, are the logics of the symbol, sign, logo: alternate forms of the still image. On the one hand, then, it is the logo that functions as spectacle: logos face and show themselves from their most legible perspectives to the viewers of the painting. At first sight, it is their visibility rather than that of the appearing/disappearing persons also depicted that is more apparent. Certainly the texture of paint has literally given them a sense of relative consistency and permanence. In the painting, then, there is a displacement of subjectivity as it is normally understood. Rather,

the broader image-world, visibility itself, is foregrounded, with bodies represented as active folds within it. These bodies are like vectors that inevitably communicate (show off) but are not captured by, a wide range of visual and coded messages. On the other hand, therefore, whether corporate and conventional signs are at issue, or personal meanings (symbols of the artist's own devising), this is an image-world in which Ankomah's figures remain flexibly but purposefully embedded; a world that seems to promise abundant opportunities for ongoing fashioning and self-fashioning. This sense of irrevocable potential within the visual is strengthened by the fact that the artist has presented us with a painting that is emphatically handcrafted and unique. Not just an adoption and mixing of traditions, but active, physical invention and intervention within the visual.

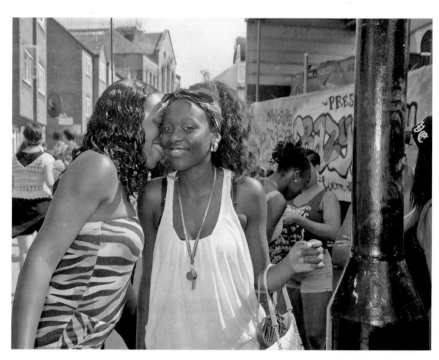

FIGURE 7 *Liz Johnson-Artur, 'Carnival' 2013, Black Balloon Archive. © Liz Johnson-Artur. Reproduced with permission. http://lizjohnson-artur.blogspot.co.uk*

4

Sacred conversations

Conversing against the grain

What forms might an active commitment to the self-showing world take? What kinds of orientation would be required and what might the possible costs and outcomes be, particularly where an ethics is concerned? Where, finally, might we find models, sources of inspiration, to assist us in this quest?

On Saturday 29 September 1990, the Spanish film director Víctor Erice – already acclaimed for such films as *The Spirit of the Beehive* (*El espíritu de la colmena*, 1973) and *The South* (*El Sur*, 1983) – started filming a long and unusually approached 'portrait' of his friend, the celebrated Spanish realist painter and sculptor Antonio López García. But if it was a portrait, it was also a self-portrait; it is clear from the opening credits that this film was jointly conceptualized. Here then, López is not only being put on show by means of the cinematic devices Erice has chosen to work with but also putting *himself* on show. Like Pushpamala N's Indian Lady, he is putting himself on stage.

When the film was released two years later though, in 1992, it was with the title *The Quince Tree Sun* (*El Sol del Membrillo*). This enlarged that initial definition of the film as portraiture and self-portraiture by referring us not to the artist directly but to the project that was his point of passionate focus during the period of filming. For the film records a three-month period in López's working life when he was attempting first to paint, and then to draw the small, heavily laden quince tree growing in the yard outside his studio. An especial incentive for him to do so came from the look of the tree itself, specifically the effects of golden morning light falling upon it. Immediately apparent therefore is the fact that *who* López is will be defined relationally in this film. Above all, in phenomenological terms, he will be defined by

what he *intends* towards and therefore also shows himself to. And by what intends towards and shows itself to him. Who López is, his significance, will be defined by the ways in which he inhabits, partakes in and opens up the appearing world, and vice versa. And of course the same can be said for Erice. Even though he is behind the camera, his values and concerns are made visible in the film. What this film offers therefore are complex, intertwining experiences of showing and self-showing that are activated and reflected upon by two men who may justly be called experts in this field. Hence my prolonged examination of this film in this chapter.

The experiences of showing and self-showing at issue in *The Quince Tree Sun* are by no means always unproblematic. For instance, accompanying the cinematic unfolding of López and Erice's engagements in and with the self-showing world is what Erice has called 'a confrontation – or relationship between the language of painting and that of film'.[1] This sense of a potentially uneasy interaction is important and one aspect of it quickly becomes apparent: Erice's camera seems to convey immediately, accurately and effortlessly precisely that encounter between illumination and materiality that is the ongoing, and elusive focus of López's three-month project. But I write 'seems to convey'. As it turns out, this assessment of the capacities of film – and of the photographic in general – to capture the visible world as it is, is one with which López would disagree. This becomes clear from a conversation in *The Quince Tree Sun* between the artist and Fan Xiao Ming, a visiting art historian from China.

'I've noticed that your method is quite different from the ones used by . . . other painters', his visitor remarks, via her interpreter.

'I see.'

'As far as I know a lot of painters feel more comfortable working from a photograph.'

'Well, the best part is being close to the tree', López responds. 'That is more important than the end result for me. A photograph doesn't give you that.'[2]

Here, an oppositional relationship is being set up between painting and photography. It is akin to the distinction Merleau-Ponty had made in 'Cezanne's Doubt' between 'the lived perspective' of painting and 'a geometric or a photographic one' – a distinction that has often recurred in artistic and theoretical debates around this topic.[3] Virilio's 'A Topographical Amnesia', referred to earlier, is a case in point. It was published in the late 1980s when considerable developments were taking place within image and communication cultures, and in it Virilio refers to Merleau-Ponty's thought and to some of Merleau-Ponty's own sources. In the

opening paragraph, for instance, Virilio cites Auguste Rodin's assertion that 'the visible world demands to be revealed by means other than the latent images of the phototype'.[4] Here, the phototype literally refers to a printing plate with a relief surface, produced by photographic means and used in the mechanical reproduction of images. But it has metaphorical resonances too. Virilio seems to be suggesting, via Rodin, that at issue is not just the increasingly dominant impact of actual photographs, or of paintings, graphics or virtual spaces modelled after the photographic. Also at issue are the ways in which our own capacities to visualize are largely and unconsciously modelled after this pervasive image-type. In 'Eye and Mind', Merleau-Ponty had also drawn on the insights of Rodin to argue in favour of the accurate inaccuracy of artistic depictions that are the product of hand and eye, as opposed to the existentially and phenomenologically inaccurate veracity of the camera.

Here though, it must be remembered that the photograph is not merely that which is 'taken' by the camera. It can be put on show only after having manipulated or processed in a darkroom of some kind. Today this 'darkroom' is likely to be within the electronic realms of the camera itself, or in a digital photo-editing package. In any case, during this process of being exposed, the photographic image might in fact be underexposed, overexposed or double exposed. It might be layered or filtered. It might be cropped, or enlarged, or have its hues rebalanced. The possibilities are multiple and inexhaustible, with hand and eye once again playing a major and often a prolonged role. Indeed, the techniques of the pioneering twentieth-century photographer Anselm Adams are paradigmatic in this respect. For him, work carried out in the darkroom was at least as important as that carried out with his camera in hand, if not more so: he referred to his photographic negative as 'the script' of which the photographic print was 'the performance'. As in the theatre, the same script might give rise to considerably different performances, and these differences are, of course, intriguing and often remarkable. Where *The Quince Tree Sun* is concerned, if the filming took around three months, the editing – the work in the 'darkroom' – took around a year.[5] What this reveals is that the photographic, too, is an open, reworkable structure where considerable, handcrafted choices may be made. But will this reworking enhance the individualized visual possibilities inherent to the image in question? Or (as with the colour guide instructions Magnum issues to its photographers, for instance) will it make the image accord with already prescribed aesthetic demands for the purposes of coercion, persuasion or reassurance?

Returning to the theme of veracity, the filmic revelations of *The Quince Tree Sun* also indicate that the relationships between painting, film and indeed photography are ones in which 'deceptive similarities' – to cite Caillois

again – as well as deceptive dissimilarities, need to be negotiated.[6] An area of 'deceptive similarity' where López's painting and the photographic are concerned, relates to the rhetorics of realism that are at issue in both, and the formative role that the action of light plays in each case. For it has been observed that López's work, though derived from emphatically non-photographic resources, tends to be described as having photographic qualities. According to William Dyckes, López's drawings and paintings may be mistaken for flashlighted photographs, and thus mistakenly associated with Photo-realism. But, he continues, a distinguishing characteristic of the Spanish realist tradition of which López is a leading proponent is that these painters do not work from photographs.[7] These artists were on a rather different trajectory. This was partly due to the relative cultural isolation of Spain during the middle of the twentieth century when, elsewhere, photo-realism was becoming a dominant painterly language – the Franco regime lasted from 1939 to 1975. And, according to Dyckes, it is partly due to the ongoing influence of Spain's long artistic tradition. A deleted scene from *The Quince Tree Sun*, incidentally, shows López and his painter friend Enrique Gran discussing Diego Velasquez's *Las Meninas*. To these factors, Dyckes adds a Spanish emphasis on craftsmanship and 'the revelation of the inherent emotional content' of a given scene.[8] 'The Spaniard would in fact reject the photograph for its extraordinary *lack* of information about light and spatial qualities', he writes.

> He is still, in a sense, in competition with the camera, and proud of the fact that he can get more into a drawing with his eye and hand than a machine can capture on film. His impulse is complex and out of phase with other movements. Closer counterparts might be artists like Andrew Wyeth and Edward Hopper, whose attention to atmosphere and the objects and sensations of everyday life are even more important to them than questions of visual fidelity or brushwork.[9]

According to Erice, another central aspect of the 'confrontation – or relationship' between painting and film-making is that the artist 'works only with the moment, but the movie camera can capture something the painter cannot: the movement of time'.[10] At issue, in other words, are the long-standing definitions of painting as a spatial medium and cinema as a temporal one. However, in *The Quince Tree Sun*, these traditionally opposed approaches to image-making are presented as closely aligned. A point of emphasis in the film is how remarkably skilled López is at creating paintings that do in fact seem to have movement, and certainly the passing of time, embedded into their surfaces. And here, in fact, Erice's comment about the artist working 'only with the moment' is key. López's painterly involvement

with the world produces a visual texture that is necessarily marked by gaps, juxtapositions, adjustments and layerings. Likewise – this is a point to which I will return – a defining feature of *The Quince Tree Sun* is the way in which, in the editing process, Erice uses layered fades, and repeated motifs (like images of the sky) that emulate the surfaces of López's paintings and, in this way, disrupt normal cinematic flow. As evidenced by Erice's other films, filmic engagements with the rhetorics of painting have been an ongoing concern.

Despite López's profound painterly attention and skill though, in *The Quince Tree Sun* he is presented – and presents himself – as eventually failing in the task he had set himself. Due to certain environmental conditions, in the end he is unable to depict the quality and effects of the light to which he has been drawn. This problem is discussed in a conversation that takes place about a month into the project, one of many to take place in proximity to the tree. López, his wife María Morena, his two daughters, and a young painter who lodges above the studio, Pépe Carretero, are drinking tea in the garden. Morena – who is also the film's executive producer – is cutting her husband's hair.

'So you've left the canvas, the painting?' one of the daughters remarks.

'I started drawing', López replies.

'When?'

'A couple of days ago'.

'Why did you stop painting? You didn't like it?' asks his other daughter.

'The weather was so rotten, so unsettled, so horrible', says López. 'I couldn't go on painting. I wanted to show the sun on the tree. But the light changed so often, I couldn't go on'.

'Will you be able to pick it up next year?' asks Carretero.

'No, no, no. You see, next year, the quinces, the leaves, will have changed.'

'So, that's it?'

'Yes, that's it.'

Later, he will have to give up on the drawing too. And so, in a conventional sense – again an analogy can be made with Pushpamala's *Indian Lady* – *The Quince Tree Sun* is a film in which nothing much happens and nothing much is achieved. Nonetheless – this is a third aspect of the 'confrontation – or relationship' at issue here – as is again clear from the opening credits ('a film inspired by a work by the painter Antonio López García'), and from Erice's approach to film-making, Erice makes important aspects of López's work

paradigmatic for his own. Not only editorially, in the ways just described, but also because, throughout the filming process, Erice consistently orientates his camera towards López as if the camera is an apprentice emulating a master, a master who has already apprenticed himself to a specific but constantly changing phenomenon: that light, on that tree. This in turn is linked to the film-maker's desire not to 'take' images but, like the painter, to create the conditions in which aspects of the appearing world can best reveal themselves. The idea here is that an image, above all, is something you attempt to discover and receive. As such, there is a profound openness and what we might call humility running through the image-world engagements of these artists. A reason for my interest in *The Quince Tree Sun* therefore, is for what it might reveal about a central claim I am trying to make in this book: that the proper site of generosity within the visual is on the side not of sight, but of showing and self-showing. Indeed, two interconnected aspects of the agency and generosity that are rooted in the appearing world are made manifest as López puts himself on show during those months of filming, presenting himself and allowing himself to be presented, explicitly, as a cinematic image – first painting and then drawing the tree – and as Erice's camera witnesses these processes and the encounters taking place in proximity to them. First, self-showing presents itself not as an enclosed or self-involved form of expression, but as a venturesome and invested activity that is always already directed towards other self-showings. Attention is focused on existences and meanings that both men want to make shareable – and thus open up to further exploration by others – through some kind of embodied response. Thus a case is made, quietly, and persuasively, for self-showing as profoundly thoughtful to the degree that it is also profoundly relational and therefore vulnerable to the involvements and actions of others: to commentary, to potential approbation, as well as to approval.

Secondly, self-showing as a shared, exploratory activity is therefore generative in a communicative and collective sense. As is the case with *The Quince Tree Sun*, on a number of diegetic and non-diegetic levels, over time, acts of self-showing draw together idiosyncratic, interested, questioning, communities that would not otherwise have gathered. In the process, certain accepted understandings and experiences of communication and the creation of community may be challenged. At a more personal level, the film may also ask us to consider what kinds of communities have been – what kinds of communities *are* – in the process of gathering around our own ongoing acts of showing and self-showing, and around our own active engagements with an understanding of self-as-image. What might be their characteristics, their possibilities as well as their possible risks to ourselves and others?

This brings me to a more finely tuned description of the central, ethical theme of this final portion of *Showing Off*. For, provoked by the delicate

yet profound outcomes of Erice's filmic reflections on López's painterly concerns and methods, my focus now is precisely on the capacities of specific creative practices to extend and diversify our understanding of the collective spaces and structures of appearance in which we play our part as visual, demonstrative, questioning and exploratory beings. I turn, in particular, to practices and models that tend to be underemphasized today, perhaps because they reveal as enterable and liveable predicaments that we might prefer to avoid under the assumption that they will involve too much personal risk. For as will become apparent, communication and community within the contexts of showing and self-showing emerge from the creation of profound bodily connections and commitments. In every instance, at issue, to some degree, are one or more bodies in jeopardy, bodies, though, that manifest themselves not as victims, but as agents for change. Here, too, as in other image-world examples that I have explored in this book, the apparently inconsequential, the fleeting, and, again, the idiosyncratic, repeatedly turn out to have extraordinary, often unspoken reach and consequence.

'Spaces of appearance', and the actions and relationships associated with them, immediately recall the work of Arendt. In *The Human Condition* she equates such spaces with the political and ethical dimensions of the 'polis'. This, she is quick to remind her readers, is not just a historically specific actuality, but a mode of speaking and acting collectively, and in public, that makes political participation possible. It is a condition we can choose to carry around with us, as it were, and make effective wherever we might happen to be.[11] Later, I will implicitly draw on this concept in order to try and articulate important aspects, and effects, of how both Erice and López make images.

As indicated by the title of this chapter, however, the particular model I want to bring into play in order to think about the sensitive, collective and exploratory ethics of showing and self-showing is that of the 'sacred conversation'. This may seem surprising, not only because of its religious connotations but also because nowadays the word 'conversation' evokes the idea of speech. By contrast, this book is especially concerned with the visual dimensions of life: with the image-world in which the self, too, is understood as image, and with the philosophical and ethical implications of this. But the sense of 'conversation' upon which I want to draw, as derived from its etymology, has its roots not in the idea of speech but in ideas of 'association', 'society' and 'intercourse'. In the thirteenth century, conversation meant 'custom' and 'manner of life', and in the fourteenth, it meant 'familiarity'.[12] When combined with the word 'sacred', further ethical implications come to the fore. As will become apparent, particularly significant are the visual or image-world dimensions of sacred conversation, and thus their particular relevance to the image-world issues we are called to grapple with today.

Intimacy

Within the biblical tradition, and in late medieval sources – for instance, in the vernacular literature and preaching of the mendicant monastic orders of the Franciscans and Dominicans established in the thirteenth century – the 'sacred conversation' signified a particular kind of community, that of the Kingdom of God, which was to be entered into not after physical death, but now. This was achieved not only by repenting for a life lived apart from God, not merely through mental assent to the teachings of Christ, but also by embodying, literally imaging, those teachings now, showing them to be true in action. This meant, in effect, embarking on the most radical of lived experiments in which, according to the Rule of Saint Francis, for instance, every worldly affiliation, dependency and security was renounced.[13] It began with giving everything you owned to the poor and living, calmly and happily, without possessions.[14] Crucially, this was not to be understood as a condition of *not* having, but one in which earthly riches had been, and were being exchanged for heavenly ones which were perceived to be of greater worth. Relinquishment was not about loss, but about making space for the practical revelation and provisions of the Kingdom of God. As such, poverty of this kind was equated with freedom. The lifestyle that emanated from all of this was not one of withdrawal from the world, however. Rather, it was intensely active and outward in orientation. For the Franciscans, who were an uncloistered order and were often to be found in the newly expanding, poverty ridden cities, it included working in the world and serving others without financial recompense. And it meant living a celibate life, thus renouncing the existential and psychological security of having natural heirs. In other words, and without wishing to invalidate the more usual forms of family life, living in the Kingdom of Heaven while still on earth meant focusing on the creation of an unbounded, worldwide spiritual family with affiliations beyond the biological. But it was above all a community in search of the most profound intimacy of spirit, soul and body with Christ himself. This was to be obtained by imitating, as closely as possible, the life that Christ had demonstrated and proclaimed: 'Nothing, then, must keep us back, nothing separate us from him, nothing come between us and him.'[15] According to tradition, Francis's imitation of Christ was so profound, and was divinely acknowledged as such, that mystically he received the wounds of the crucified Christ, the stigmata, in his own hands, feet and side. For this reason he came to be known as an *alter Christus* or 'another Christ'. Again, the visual and physical dimensions of this intimacy are important.

It was, in any case, through devoted imitation of Christ (not just pointing to him, which is an external relationship, but seeking to become inhabited by him) that the triumvirate of truth, goodness and beauty could be released, tangibly and visibly, from the Kingdom of God into the otherwise

'man'-centred, power-hungry kingdoms of this world, superseding and transforming them. This triumvirate could be understood as the divinely attuned workings of spirit, soul and body or, using a somewhat different vocabulary and set of distinctions, as the divinely inspired workings of the (embodied) intellect, will and imagination.

Furthermore, and in order to continually achieve and safeguard this intimacy and efficacy, the Franciscan community recognized the need for guidance and correction. Admonition and self-admonition were deemed crucial, and were therefore catered for, built in, expected and welcomed. Nonetheless, the degree to which this was maintained over time must be called into question, for there would be a dark and disturbing capacity associated with the radicalism of this community. During the various religious Inquisitions, the Catholic Church – deemed by some critics to be as corrupt and power hungry as any worldly institution – relied particularly on Dominicans and Franciscans to act as inquisitors; as is well known, and although the aims and practices associated with the Inquisition were complex, torture and execution were used to try and quell heresy. Here then, is a troubling irreconcilability. Presumably – since a central tenet of Christ's teaching was not to kill, but to love one's enemies – a shift must have occurred, an implied loss of the vital, receptive self-criticality and grace that had been advocated, in the case of the Franciscans, by the order's founder. Why did that loss and subsequent shift in orientation occur? Perhaps it was due to the abandonment of that exploratory orientation described earlier as central to self-showing properly understood, in which a certain self-regulating openness and existential uncertainty must remain in play. In any case, a prioritization of self-showing had given way to acts of non-reciprocal seeing – and judging. And, according to the philosopher and theologian Paul Tillich, when openness and uncertainty are relinquished, persons and communities inevitably resort to a fanatical self-assertiveness. This self-assertiveness 'shows the anxiety which it was supposed to conquer, by attacking with disproportionate violence those who disagree and who demonstrate by their disagreement elements in the spiritual life of the fanatic which he must suppress in himself'.[16] Given that fanaticism of that kind is just one of the many forms of rigidity that have always plagued cultural, social, political and personal life – this suggests that we seem to be predisposed towards such rigidities – the creation of visual and material structures intended to release us from their hold would seem crucial.

This brings me to my next point, and to an image-type that was created to do just this. For, finally, and significantly, 'sacred conversation' is a term that came to have distinct pictorial connotations: it refers to certain Western religious paintings that probably arose in response to Franciscan, and

Benedictine, influence, and were later referred to by art historians as *sacra conversazioni*. These are devotional works, created mainly between the fourteenth and sixteenth centuries in Italy, in which saints – usually martyrs – from different times and places are depicted in a unified pictorial space. As time went on, these spaces became increasingly cohesive in a perspectival sense. Usually the saints are gathered around a seated Virgin and Child. Pictured in each case, therefore, are an association, society and mode of intercourse that could never literally or directly have arisen within physical space and historical time. Not only are these communities understood as spiritually available to anyone wishing to participate in them, they are also presented as accessible, uniquely and profoundly, in the material space of painting. Significantly, too – hence their particular relevance in the context of this chapter – these paintings usually depict silent communion in which connections are established by means of glances and gestures arranged so as to convey flows and intersections of sympathy. In the words of the scholar Rona Goffen, in most sacred conversations the 'bond among the figures is not aural, but established by purely visual and psychological means, by their common spatial and emotional environment, by light, color, scale, by gesture and glance'.[17] As such, these compositions, these communities, established in mutual self-showing, emphasize our embodied ways of being in the world: they emphasize *how* we are and *what* we do. In so doing they also counterfact what I have been arguing are our more usual ways of navigating the visual, namely, by trying to hide within, or from it. These are habits – referencing the biblical tradition that provides the background to these works – that were first instituted, and then institutionalized, after the 'Fall of Man' as recorded in the book of Genesis.[18] In fact, this account from Genesis is of great interest since it presents a model in which self-showing – Adam and Eve showing themselves to God in their fallen state, albeit incompletely, given their fig leaf coverings – is equated with the start of a possible journey (since it must be willingly taken up) from separation to reconciliation, and from deception into truth. Within the biblical account of this journey, self-showing means opening oneself up to critique and accountability but in a broader context that is imbued with divine love.

The *sacra conversazioni* – these images of divinely inspired visual and gestural self-showing one to another – also had other, more specific aims that are worth reflecting on because they provide further concrete examples of an ethics of showing and self-showing in action. Perhaps the most important practical aim – practical because engagement with these works was intended to have an everyday, earthly impact – was to encourage physical and psychological intimacy between the worshippers viewing the work, and the depicted sacred community of which those worshippers longed to be a part. This was why illusionism and attempts to portray the

Madonna, Christ Child and saints in as lifelike a manner as possible were so crucial; in this way, artists hoped to convey a sense of the 'real presence of the divine figures'.[19] In addition, these works were usually positioned within architectural spaces so as to suggest a spatial continuity between actual and depicted worlds. In the service of intimacy, another aim was to encourage worshippers to emulate the holy lives of those depicted, not necessarily literally but qualitatively in terms of allowing the life of Christ to unfold in their lives too, in an individualized way, there to flourish in whatever way it chose to do so. And this individualized focus was crucial, discouraging competitiveness and encouraging differences to coexist. Otherwise, as is indicated at an etymological level, emulation easily slips either into enmity – to emulate another can also mean to rival him or her – or it slips into conformity. Since the impulse to emulate someone or something is intrinsic to the relational structure of being, this issue also connects with questions, raised earlier, about how we might best exercise awareness and choice regarding the diverse models or exemplars that may be showing themselves in and through us. What have we chosen, what are we choosing, to be visually imprinted by? The sacred conversation offers a specific exemplar which may, or may not, be taken up. And this brings me to a further observation about the importance of emulation as an individualized practice, namely, that it enacts and makes shareable a particular way of being without necessarily or inevitably imposing it on others.

Finally, these devotional – and motivational – works had a mediating role with respect to worshippers obtaining salvation and divine blessing. In other words, they provoked worshippers to request that the Virgin, infant Christ and saints intercede to God for them. Goffen indicates that this Catholic emphasis on saintly mediation between man and God was not peculiar to the Franciscan tradition but 'seems to have intensified from the beginning of the thirteenth century onwards', as witnessed by such hagiographies as the *Golden Legend* from about 1260 and the Franciscan *Fioretti* (or, *Little Flowers of Saint Francis*) from 1390.

One way of thinking about the intended mediatory character of the sacred conversation is in terms of its capacity to forge a divinely connected community in which spiritual growth is recognized as something that can never be achieved in isolation. However, this is again potentially dangerous territory, often difficult to navigate. In the Catholic Church, the mediation of the Virgin, the saints and indeed the Church itself was often presented not as an *aid* to achieving salvation from Christ alone, but as the means, even the guarantor, of achieving that salvation. The focus was no longer on Christ, and as a consequence error, manipulation and the abuse of power became inevitable. As is well known, during the sixteenth century, institutionalized practices of this kind would be challenged as unscriptural, most notably by

Martin Luther. It should be admitted, though, that there would be negative consequences connected with the reformist view too, because it meant that now the scriptural emphasis on the individualized but nonetheless communal and interdependent basis of holy living could be more easily undermined or ignored. Finally too, adding to the complexities around this issue of mediation, Tillich has also associated it with more generalized religious and cultural anxieties that were becoming rampant. '[T]oward the end of the Middle Ages', he wrote, 'the anxiety of guilt and condemnation was decisive. If one period deserves the name of the "age of anxiety" it is the pre-Reformation and Reformation'.[20]

Referencing a type of then-contemporary imagery very different to that of the sacred conversation and the lived practices they inspired and supported, he continued:

> The anxiety of condemnation symbolized as the 'wrath of God' and intensified by the imagery of hell and purgatory drove people of the late Middle Ages to try various means of assuaging their anxiety: pilgrimages to holy places, if possible to Rome; ascetic exercises, sometimes of an extreme character; devotion to relics, often brought together in mass collections; acceptance of ecclesiastical punishments and the desire for indulgences; exaggerated participation in masses and penance; increase in prayers and alms. In short they asked ceaselessly: How can I appease the wrath of God, how can I attain divine mercy, the forgiveness of sin?[21]

Later, Tillich explored the sociological cause of this anxiety. He identified what he described as 'the dissolution of the protective unity of the religiously guided medieval culture' which, among the new, educated and independently minded middle classes, led to a condition of 'hidden or open conflict with the Church', whose authority they at once acknowledged and resisted.[22] To this he added other factors relating to intensifications of political power vested in 'the princes and their bureaucratic-military administration, which eliminated the independence of those lower in the feudal system', the impact of mass disempowerment associated with state absolutism, and of various 'economic catastrophes connected with early capitalism, such as the importation of gold from the New World, expropriation of peasants, and so on'.[23] 'In all these often-described changes', he writes,

> it is the conflict between the appearance of independent tendencies in all groups of society, on the one hand, and the rise of an absolutist concentration of power on the other, that is largely responsible for the predominance of the anxiety of guilt.[24]

'The irrational, commanding, absolute God of nominalism and the Reformation', he adds, is partly shaped by the social, political, and spiritual absolutism of the period'.[25]

But such guilt, and desire for appeasement and control through superstition are far removed from the sense of gentle and loving affinity with the divine, and with the whole created order, at the heart of Francis of Assisi's teaching. And they are utterly at odds with the ethos of peaceful intimacy embedded in the contemporaneous visual tradition of the sacred conversation. Hence, arguably, the cultural or counter-cultural significance of these paintings, since intimacy and condemnation cannot coexist. The *sacra conversazioni* offer radically alternative existential models. Take, for instance, Pietro Lorenzetti's fresco *Madonna and Child with Saints Francis and John the Evangelist* in the south transept of the San Francesco Lower Church in Assisi. Here, surrounded by rich earthy colours and illuminated by golden light, are the Virgin and Child, centrally placed. The church's patron saint, Francis, is portrayed in profile on the left, showing them his wounds while St John stands on the right-hand side of the image. He too is visible from the side, and holds the epistle he has written. According to Goffen, this work, dating from around 1326 to 1330, may be one of the earliest *sacre conversazioni*. Not only does it display the characteristics just discussed – intimacy, including intimacy through emulation, and mediation – this image, and ones like it, also broke with the earlier visual tradition of depicting sacred figures separately, each in clearly defined spaces that were distinguished from each other by pillars or other real or depicted architectural features.[26] Here, and in the sacred conversation tradition as a whole, as well as portraying a shared space, there is a new fluidity of movement and interaction. In the Lorenzetti, this fluidity may at first seem somewhat localized: engagement seems to flow mainly between the Virgin and Child, and St Francis. But equally intense, though less immediately obvious visual and bodily connections also exist between those three figures and St John on the right. It is true that St John's role in the picture would seem to be that of a demonstrator who points away from himself towards those others.[27] But it is also the case that this disciple of Christ, reputedly the person emotionally closest to the adult Christ, is shown to closely resemble the infant in terms of look and colouring. In addition, there is an almost exact parity between the position and pose of John's left hand, with which he carries the gospel that he has written, and the left hand of Mary, with which she carries Christ, the living Word. These factors underline the intimacy that is at issue. They demonstrate the degree to which, John, like Francis, having given himself to Christ, embodies and shows off Christ in his own being. As such, this painting and works like it, convey a state of profound renovation. In the words of St Paul to the believers in Colossae (now a site

near the town of Honaz in present-day Turkey), 'you have taken off your old self with its practices and have put on the new self, which is being renewed in knowledge *in the image* of its Creator'. [28] As discussed earlier, this is an individuated and personal renewal. Not only that, again as claimed by Paul, such embodied revelations of the life of Christ enable new forms of community to arise in which 'there is no Greek or Jew, circumcised or uncircumcised, barbarian, Scythian, slave or free, *but Christ is all, and is in all*'.[29] Finally, then, returning to the rhetorics of intimacy and connection in Lorenzetti's painting, and back, specifically, to the depiction of St Francis, it is likely that the position of his lower right arm and hand, now almost entirely obscured due to damage sustained by the work but apparently resting on the balustrade, would have intensified the painting's overall sense of gestural flow.

The Lorenzetti also demonstrates a play with time, and thus also with life and death, that is additional to the general anachronicity of all sacred conversation gatherings. As noted, St Francis is marked with the stigmata. One of these is clearly visible on his left hand, which he has placed over his heart. Not only is this wounded hand clearly on show, but Mary also gestures towards it with her right thumb. In this way, both Mary and Francis, and indirectly John too, indicate to the child, and thus also to the viewers of the work, the kind of death this infant will undergo as a man. This is underlined by the inclusion of a crucifixion scene in the painting's central panel directly beneath the Virgin and Child. Indeed, in all sacred conversations, references to suffering, death and resurrection are evident. As per iconographic tradition, the saints assembled in these works are identified by attributes that testify to the singularity of their devotional lives, and often to their form of martyrdom. Thus, sacred conversations refer us to the often extreme implications of dedication. But they do so in a remarkably matter-of-fact way. These factors are interwoven into, and are an inextricable part of a whole that remains calm, gracious and beautiful. This costly reality is subtly present even in a significantly later, more naturalistic sacred conversation, Titian's *Madonna and Child with Saints Luke and Catherine of Alexandria*. This is again a painting with four figures. A seated Madonna and Child are on the right in front of a backdrop of draped cloth. They face St Catherine, also seated, and St Luke, who stands behind Catherine holding his epistle. Behind both saints is a delicate landscape that recedes into the far distance. St Catherine, incidentally, is a patron saint of scholars, preachers and unmarried women, among others. As noted in the *Catholic Encyclopedia*, due to her legendary eloquence and persuasiveness as a defender of the faith, her intercession would be 'implored by theologians, apologists, pulpit orators and philosophers. Before studying, writing or preaching, they besought her to illumine their minds, guide their pens, and impart eloquence to their

words.'[30] Painted in around 1560, reputedly for Titian's friends, the Dondi dell'Orologio family of Padua, the painting has circulated through just a few private collections, including, from the late 1930s, that of Baron Desborough and his wife, Ettie, who was famed as a society hostess. Her regular guests included noted political and cultural luminaries of the day from King Edward VII and Vita Sackville-West to Henry Irving, H. G. Wells, Edith Wharton and Oscar Wilde. In 2011, the painting was auctioned at Sotheby's in New York for $16.9 million, a record-breaking price for a Titian.[31]

In this large yet visually intimate work – an intimacy that is intensified by the strong, inward leaning movements of all four figures – an emotive but also profoundly everyday and human connection is shown to be evolving between Saint Catherine and the infant Christ. Here, symbolic reference to Catherine's martyrdom is minimized, namely the spiked wheel on which she was placed, part of which is visible in the lower part of the painting. In fact, according to legend, the wheel broke miraculously and failed to kill her, and she met her death by decapitation, which may explain why the child reaches so tenderly towards her face. But in this painting too, an important observation may be being made about devotional suffering. Not only has it been willingly undergone (the martyr is no victim), but it has also now been overcome and effectively forgotten, even if it has also been defining in its effects. Indeed, here, Catherine literally uses her instrument of torture as a kind of prop, a source of fortuitous support against which she rests.

Finally, almost diametrically opposed to the Titian in terms of emotional atmosphere, but still firmly within the sacred conversation tradition – indeed, all the more intriguing for it – is Giovanni Bellini's *San Zaccaria Altarpiece*. Painted in 1505, thus more than half a century before the Titian, and almost two centuries after the Lorenzetti, it shows the Virgin and Child, accompanied by a small, seated angel playing a violin or viola, surrounded by four saints. On the painting's left are St Peter, orientated forwards towards the viewer, and St Catherine of Alexandria facing the Madonna and Child. On the painting's right, mirroring Catherine, is St Lucy, who was martyred during the Diocletian persecutions of 304 CE in Syracuse, and St Jerome, the scholar who, also in the fourth century, translated the Bible into Latin. Like Peter, he faces forwards, his head buried in the large open Bible he is holding. In this painting, there are visual passages of profound correlation and connection, as with the overlapping bodies of the saints on the left and right. But these figures are also pictured within an atmosphere suffused by an individualized sense of quietude. They are shown to be participating in this shared world in their own distinct ways, as if each is singularly caught up in the angelic music that permeates the space – this, then, is a sacred conversation in which sound plays a part; sound, though, and not speech: indeed, according to Josef Pieper, a Catholic philosopher, music, or music of this kind, makes possible

'a listening silence' through which connection with God is enabled. In this painting, in any case, there is a sense of the characters being together yet apart. The point I want to make, in other words, is that here we are clearly presented with a community that is emphatically grounded in heterogeneity; the figures are established in, and show themselves through what sets them apart. But these are ideographic structures that are powerfully communicative nonetheless. Indeed, this sense of heterogeneous connection is intensified by Bellini's complex use and distribution of colour – the flows and folds of blue, for instance, that move from the Virgin's cloak, diagonally down through the strip of upturned lining of Catherine's overgarment, and down still further to the lower portion of Peter's tunic. Thus the compositional significance of this image, as I see it, is that it emphasizes and alerts us to a vision of differentiated yet harmonious communication and community that is central to the sacred conversation tradition as a whole. As it turns out, this is a vision of community that would later, consistently, reveal itself in the writing of Merleau-Ponty. For here I cannot but think of Merleau-Ponty's powerful statement about true communication and community being grounded in a divergent yet cohesive notion of universality – universality being a concept he insists on retaining – to which we are grafted by that 'which is most our own'.[32] Indeed, Merleau-Ponty could almost have been looking at the Bellini when, in his essay 'Metaphysics and the Novel', he wrote that communication

> exists *between* the moments of my personal time, as between my time and that of other people, and in spite of the rivalry between them. It exists, that is, if I will it, if I do not shrink from it out of bad faith, if I plunge into the time which both separates and unites us, as the Christian plunges into God.[33]

This Merleau-Pontean understanding of communication – which, to repeat, finds an analogue in the sacred conversation – offers no easy guarantees. And is as rare today, in practical terms, as it is crucial. To support his claims, he also argues that these qualities of openness and of the ideographic have a universal application to language in all of its sensual and intellectual manifestations, including the verbal. In this regard, Gary Brent Madison, when discussing what he calls Merleau-Ponty's non-foundationalist, or postfoundationalist understanding of communication and universality, has cited Merleau-Ponty's claim that

> Language leads us to a thought which is no longer ours alone, to a thought which is presumptively universal, though this is never the universality of a pure concept which would be identical for every mind. It is rather the call [*appel*, appeal] which a situated thought addresses to other

thoughts, equally situated, and each one responds to the call with its own resources.[34]

Madison makes the additional point that Merleau-Ponty's conceptions of language and communication accord with his conception of rationality. By 'reason', Madison reiterates, Merleau-Ponty

> did not understand some sort of metaphysical 'faculty' by means of which we are able to form epistemologically correct 'representations' of the 'objective' world. Approaching the issue in a thoroughly postfoundationalist way, Merleau-Ponty viewed reason or rationality as essentially an appeal to the other, a dialogical attempt to arrive at a mutual understanding.[35]

Likewise, Kerry Whiteside in *Merleau-Ponty and the Foundation of an Existential Politics* of 1988 has written that for Merleau-Ponty: 'Reason is the outcome, not the presupposition, of the discursive processes that are binding together ever larger segments of mankind.'[36] This is also a mode of relating that derives its critical power from embedded rather than supposedly external, oppositional perspectives. Thus, in comparison to more polemical approaches to critical interaction – like those practised by Sartre, arguably, which would so profoundly influence the development of twentieth-century and contemporary forms of protest culture – Merleau-Ponty's modes of critical address are more measured but also more ambiguous, and thus less easily accounted for in established linguistic terms. Hence my recourse, here, to visual-artistic models. To that of the sacred conversation to begin with, and to others. In a moment, I will return to *The Quince Tree Sun*, which I will examine at length. Later, I will turn to another biblically inspired model: the 'Northern Renaissance' scenes of crucifixion by Rogier van der Weyden that portray, assembled beneath, around and on the cross, complex redemptive communities from which there is much to learn. My penultimate study – Moufida Tlatli remarkable film, *The Silences of the Palace* of 1994 – brings us back, perhaps, to more familiar territory. Set in Tunisia, it intersects and compares a woman's search for personal freedom with a political struggle for national liberation. Here, crucially, the woman is not best interpreted as a straightforward symbolic representation of the nation, nor is her personal transformation best understood as a metaphor for political change within Tunisia, as has often been the case in 'third cinema' film-making.[37] Rather, her experience and actions offer a model for change of a different kind. For uniting this work and the van der Weyden crucifixions in particular are the difficult but decisive virtues of showing up in sites of suffering, and of making apparent the forms of agency that are released in so doing.

The slow science of bodily donation

The Quince Tree Sun is a long, unhurried film. Its genre is difficult to define. Certainly, it is factual. It records a period in the unfolding life of a real person, López, and shows aspects of his actual practice. But it is clear that considerable staging, restaging and re-enactment are also involved. Analogously, although the film displays considerable attention to detail and process with the camera acting not only as a witness but also as an investigator of the events unfolding before it, much is left unsaid. The film does not make use of the usual documentary device of extra-diegetic narration to contextualize or explain what it shows, although narration *is* used poetically towards the end of the film. So the kinds of questions a documentary would normally be expected to address are left unanswered. Apart from what we can glean from the film's opening and closing credits, everything we learn arises from within the visual contexts, actions and conversations that have been recorded. The only sources of additional information are on-screen titles that label sequential portions of the film with the appropriate day and date. In addition, a conceit of *The Quince Tree Sun* is that those filmed never overtly acknowledge the presence of this camera; they never speak to camera, or look straight at it.[38] But by means of a carefully orchestrated poetics of cinematic gesture, our attention *is* drawn to the active role that the camera plays in the film – as it focuses in to scrutinize López's actions, as it occasionally drifts over the garden wall to survey the surrounding area, or as it slows or ceases its movement to create scenes that resemble still imagery. As already indicated, also key are the ways in which its movements are intervened with in the editing process. All of these factors give the film a reflexive quality that is taken up, and taken further by its viewers. More than that, the visual, spatial and temporal poetics of the film convey a growing sense of the camera as an entity that 'wishes' to move beyond its usual parameters by emulating the capabilities of the painter. This 'desire' – analogous to that described earlier with respect to the viewer–participants of sacred conversations – is presented in explicit terms in an unexpected and surreal dream sequence that is inserted just before the very end of the film, and which I will discuss shortly.

The Quince Tree Sun begins, in any case, with the camera planted in the middle of a residential street recording López, who approaches holding a small case, and carrying what look like lengths of wood and a roll of canvas under his arm. The sequence is labelled 'Madrid, Autumn 1990; Saturday September 29th'. López unlocks a solid, wooden gate in a wall to his right and enters a yard, where – or so it seems to the viewer – the camera is again awaiting his arrival. López greets Emilio, his dog, and moves towards the house where his studio, that of his wife, and that of Carretero are located. A wheelbarrow, building materials and rubble, surround the doorway and

it is apparent that renovations are in progress. Indeed, throughout the film López's painterly work will be compared with this other form of labour. As López crosses the threshold, diegetic sounds – local traffic and the whistle of a passing train – provide further impressions of the surrounding environment. Later on, the diegetic sound which accompanies almost all of the film will include López humming and singing distractedly as he paints, the classical music and news bulletins that are broadcast over the radio that stands on the ground next to his easel, and of course, the banging and clanging of the building work.

The film cuts to López's studio, which is a large, relatively bare room. Mainly in shadow, a long, rectangular stripe of strong light intersects the floor. As *The Quince Tree Sun*'s opening scenes continue – as the film goes through the conventions of setting itself up – the artist becomes immersed in his own preparations. He works slowly and systematically; indeed a notable feature of López's character as it is presented in the film is that he devotes the same quality of attentive patience to everything he does. Erice's film-making adjusts to the artist's pace; the film conveys – in fact intensifies – the sense of duration that is involved as the artist methodically sweeps his studio and prepares his canvas, by means of a layered cinematic language of juxtaposed, slow fades. These seem at once to compress time and to create breathing space. This is the first of many such sequences to appear in the film.

On day two, a Sunday, the preparatory work begins outside in the yard where, yet again, Erice's camera is already positioned. As the painter opens the studio door we hear the ringing of church bells. First, the artist simply approaches the tree that will be the focus of his artistic attention. As he leans in to look at its fruit and foliage the camera leans in with him. Then, again presented through a sequence of fades, López constructs his working space. First, he brings out a ladder, climbs it, and from there hammers two long stakes into the ground in front of the tree and somewhat to the left and right of it. He stretches a length of twine between the stakes and suspends a small pendulum from it, to create a plumb-line aligned with the tree's slender trunk. He brings out and positions a large easel. Then follows the prepared canvas, and an old chair on which his painting equipment is laid out. Using a spade, López then clears a patch of ground in front of the easel into which he hammers two metal markers: these will indicate where he must position his feet each time he paints. Finally, standing in the place he has designated for himself, he carefully and precisely marks the canvas with a centrally placed vertical line. Still only diegetic sounds are heard.

The next shot is something of a surprise: there is a sudden cut from a close-up of the canvas to a close-up and then a pan of López as he moves steadily around the walls of his courtyard marking them with broken horizontal lines of white paint. Squeezed straight from the tube, presumably these lines

will correspond with the horizontal line he then proceeds to mark onto the canvas. Finally, all is in place and fresh pigment is laid out on a palette much encrusted with layers of old, dried paint – this is a beautiful sequence again consisting of fades, creating the illusion that the colours López will use have appeared before us magically, cluster by cluster. All of this preparation now having been completed, as viewers we think that López will surely now put paint on canvas. But no! His loaded brush reaches out in quite another direction; his first painted mark is a small, white line on one of the quince tree's leaves, followed by further marks placed on its trunk. Only then, at last, does he start work on the painting itself. Already, 15 minutes of wordless footage have gone by.

Having made just a few, faint guiding marks, López's technique is to draw with his loaded paint brush directly onto the canvas. Using carefully mixed hues, he starts more or less centrally and then allows the image to evolve organically, but with exquisite accuracy, mark by mark. The intensity is palpable as he continually looks back and forth between tree and canvas, and the painted surface grows rather quickly. As is the case with all who are skilled at what they do, watching López at work is exhilarating. We are being given a step-by-step guide to his process, and yet The scene fades to white.

If López's painterly communications with the tree are of ongoing concern in *The Quince Tree Sun*, also key are the ways in which these communications are opened up to others. Earlier, I wrote that communities – of which we may, or may not be consciously aware – always gather around specific acts of showing and self-showing. In *The Quince Tree Sun* this reality is made explicit. These gatherings, which take place in the yard, and particularly around the tree and the canvas, may involve family, friends, other visitors or the three Polish builders who are carrying out the renovations. We see these builders arriving on site on the third day, Monday, 1 October:

'Better move these bags', says one.

'If we don't finish soon, we'll lose shares', says another, upon entering the house.

'Either they bring sand or we'll be doing nothing.'

Some of the conversations taking place in the presence of the tree occur when the artist is present. The first of these is between López and Morena. From this, we gain additional insight about the practical setting up of this project, namely, that López was conscious right from the beginning that probable, uncontrollable difficulties with the weather might impede his progress. Indeed, Morena suggests that by choosing the quince tree as the subject for this film he may have set himself up to fail. Following directly after the first of the film's many slow portrayals of ominous sky, López exclaims

that 'It's gone. . . . A little while ago, the sun came out over there. But it went and hid behind those clouds.'

'It's not a good day, is it?' his wife remarks.

'You can't imagine how pretty it was', he responds. 'The golden fruits . . . Really pretty.'

'Yes, I see. The season isn't going to help you much.'

'I'm going to try it anyway. I think I have to paint the sun . . .'

'How long will it last?'

'That's the worst part, very little. Maybe a couple of hours in the morning. I mean, for the kind of light I want.'

Morena's pessimism is warranted. The very next day it begins to rain hard. Determined to continue with his work, López enlists the builders to help him cover the tree, his easel and other implements – his temporary studio – with a large, polythene covered canopy. Over the next days, López continues to paint in variable weather conditions – periods of sunshine interspersed with relentless, torrential rain. It is during this period that a visit by Gran is recorded, the first of two. This visit is presented in the format of a set of extended sequences in which they talk about a variety of topics while López continues to paint. They discuss the progress López is making with the painting; the early years when they met as students at the Escuela de Bellas Artes in Madrid, and Gran, in particular, talks about the urgency he feels, now that he is aging, to work without ceasing.[39] They also discuss an iconic painting, Michelangelo's *The Last Judgement* of 1541, a large reproduction of which hangs in López's studio – to this I will return. By 24 October, however, the weather has deteriorated to such a degree that López gives up with his current project; the unfinished painting, nonetheless, is exquisite. Then, helped by his wife, he prepares a new canvas, and two days later he starts to draw. By now, though, not only does he have bad weather to contend with, but the fruit is also growing ripe and heavy. Since the tree's branches are becoming increasingly weighed down, López now finds himself continually having to recalibrate the grid-work of white lines he had originally applied to the tree as part of his overall system of reference points. As the days pass, processes of constant readjustment create what begins to look like an indecipherable maze. As he tells Fan Xiao Ming, whose visit takes place during this period, since beginning the earlier painting process the elements he is recording have dropped by 5 centimetres. López works on the drawing for a further month and a half but by 10 November much of the fruit has fallen, and some of it is rotting. So López stops, and clears the yard. But the film itself is not yet over. For at this point a gradual transition begins towards the dream sequence

referred to earlier. This dream, which is narrated by López, was a second decisive source of inspiration for making the film.

This transitional sequence begins with López preparing to pose for his wife. This scene is accompanied by an atmospheric soundtrack composed by Pascal Gaigne which ceases when Morena enters the room. Some time ago, evidently, she had begun a large portrait in which López lies on a bed, fully clothed – he even wears an overcoat. As soon as López is positioned and Morena begins to paint, López suggests she might be wise to abandon the painting and start afresh. She insists that she wants to persist a bit longer. He then continues to interrupt her. He reminisces; he suggests they take a holiday; he seems to be making it difficult for her to work. While he lies there, holding a photograph in one hand, and turning a small, faceted crystal in the other so that the light refracts off its many surfaces, Gaigne's soundtrack returns and a surreal mood descends. As the music intensifies, and then suddenly ceases in favour of diegetic sound once again, López falls asleep. The crystal falls onto the floor and rolls away, and Morena is forced to stop working. She switches off the light and leaves the room. The camera leaves with her, now shifting to portrayals of outdoor scenes of the city at night. These include views of Madrid's communications tower in the distance, and layered views of, and through, the windows of the surrounding apartments, revealing rooms inhabited by television screens and television watchers illuminated by that strange blue light that television casts around itself – these are by now familiar scenes, similar to those that Erice has used regularly throughout the film as forms of what we might call cinematic punctuation. Suddenly, though, these scenes are interrupted by the whirring of a film camera, and we are back in the yard where López had spent those months painting and drawing. First we see what looks almost like a still image: the silhouettes of a film camera and of the quince tree, almost touching each other, thrown against one of the garden walls. The image has an archaic appearance like that of an antique photographic print or plate. We then see the camera itself, operated by a timer, standing precisely where the painter had once stood – López's markers have remained in the ground – while a spotlight sheds bright light on a pile of rotten quinces lying at the base of the tree. Akin to those rooms in the surrounding apartments, but differently hued, the garden too is bathed in a strange, artificial light. The musical composition begins again, and provides a haunting backdrop to scenes of López's darkened studio and the paintings and sculptures that are stored there, shots of the full moon, shots of López sleeping and close-ups of rotting fruit. Finally, layered over all of this, we hear López recalling his dream: 'I'm in Tomelloso', he says.[40]

Across the square I see trees that had never been there before. I recognise the dark leaves. My parents and I are beneath the trees along with some

people I can't seem to place. I can hear our voices. We chat peacefully. Our feet sink in the muddy ground. All around us, on the branches, the ever softer, wrinkled fruit hangs. Dark spots slowly cover the skin. In the still air, I feel their flesh rotting. From where I stand, I can't tell if the others can see it too. Nobody seems to notice that the quinces are rotting under a light I can't really describe. Clear, yet dark, it changes all into metal and dust. It isn't the night light. Neither is it that of twilight. Nor of dawn.

The next, and final portion of the *The Quince Tree Sun*, filmed some months later, begins with the sound of birdsong, and a view of a blackened, decomposing quince. The word 'Primavera' (Spring) appears. The camera pans up the quince tree; we see that its form has evolved, and that it is laden with budlike new fruit. In the background – and this, for me, is especially poignant – we hear López humming, a signal that he is again at work somewhere in the yard, drawing or painting.

Painting as following, showing and sharing

One description of López's painterly project as depicted in *The Quince Tree Sun*, with its involved preparatory and referential mark-making processes, is as a failed *rationalist* attempt at mastering a shifting natural and visual environment. 'All this careful groundwork serves to delineate and frame the tree, to ready it for perspectival treatment', wrote Terry Berne in his review of the film.

> These preliminaries also alert us that the painting will be executed within an explicit conceptual frameworkWe are made immediately aware that this is going to be a rationalist enterprise, based on empiricist precepts, and partaking as much of science as of any presupposed notions of artistic intuition suggested by the romantic image of an artist poised before a tree. The line between nature and culture could not be drawn more heavily.[41]

Berne went on to write that *Dream of Light* (the title under which the American version of the film was released)

> is fundamentally a tale about the impossibility of representing nature through art, at least when nature is approached from the analytic perspective which has reigned in much of Western art since the Renaissance. It subtly reveals the lacunae that lie hidden at the base of empiricism.[42]

My own response is different. Yes, Berne's observation about the film's revelations of those lacunae 'that lie hidden at the base of empiricism' is astute. But although these lacunae, which are also fundamental to the structure of the visible world, may threaten the coherence of certain empirical projects, there is no sense in *The Quince Tree Sun* that they are problematic for López. On the contrary, as I will show, they are his entry points into alternative visual-material models of coherence in which incompleteness is accommodated, even welcomed, and to which his approach to painting is especially well attuned.

As such, López's project does not seem to me to be a rationalist enterprise. Nor is it a failed one. On the whole, his process is responsive. As he told Fan Xiao Ming, 'I correct. I follow the tree; I'm always in parallel with the development of the tree.' This is not to say that struggle is never in evidence. The painter's project is a quest, with all the challenges that this implies. And there are comical episodes towards the end of the drawing process where López has definitely abandoned his commitment to following the development of the tree. The fruit has dropped yet lower and is now about to fall. And so, rather than yet again adjust his reference points and alter his drawing, he asks Carretero, and, a few days later Gran – on his second visit – to assist him by using a stick to raise the leaves that are now obscuring the fruit he is trying to portray. But in *The Quince Tree Sun* such behaviour is an exception. It is true that Erice, in interview, has spoken of López's endeavours as a struggle against time, and that he also used a rhetoric of failure: 'Time is present in every work of artistic creation', he said, 'because mankind seeks permanence. The struggle to remain in the midst of what is transitory is an expression of the tragic condition of existence. So Antonio López's attempt to halt the tree's natural cycle and capture forever a moment in its life is doomed to failure.'[43] But in the film itself López appears to be fundamentally at ease as he engages with the challenges raised by the passing of time. Except for those comical interludes just referred to, far from being in combat with nature and with time, his general concern is indeed to adjust his own mark making to accord with the tree's unfolding qualities. A conversation that occurs in an earlier part of the film makes this evident. It takes place during Gran's first visit on 10 September. Having admired the tree, they are discussing the painting.

'What about the size?' asks López.

'Fine', Gran replies.

'Mari says I needed a bigger canvas. What do you think?'

'It looks alright to me. It could have been bigger. Still I think that those shapes over here are fine for the fullness of the quinces.'

'Yesterday . . .', López stops, then asks, 'Wouldn't you lower the tree . . .?'

'You mean [it's a matter of] space?' asks Gran;

'. . . and some is missing up here', continues López. Their voices overlap.

'You can always add in the upper area', Gran suggests.

'No, no, no'.

'You want to lower it all?'

'Yeah. I want to lower the whole thing, I mean, the fruits, the leaves. Look, I've made some marks over here. I want to lower the horizon down to here. To lower it all . . . some six centimetres. Wouldn't it be better? Stand back a little.

'It isn't the first time we've discussed it.'

'Yeah, but . . '.

'How much lower?'

López talks of feeling that he hasn't given the image enough space to breathe.

'Alright, lower it', says Gran. 'But I can't help it, I feel it's cruel after all that work.'

López shakes his head.

'But nothing is lost. It remains underneath.'

According to several commentators, it is due to this technique of continual readjustment that López's oeuvre as a whole includes not only work that has been created over a very long period of time but also many unfinished pieces. 'He produces little work and finishes less – his obsessive need to revise has slowed his production into something like reverse gear – yet his fame has grown steadily within and beyond Spain.'[44] What this underlines is the nature of López's commitment not to retreat from the difficulties of the self-showing world but to stay with them, preferring states of painterly incompletion, if necessary, and the likely requirement of repeated returns to the same scene, to an invented sense of accomplishment. As such, if we return to López's working methods, including that prolonged and assiduous process of setting up – the hanging of the plumb-line and pendulum, the mark-making on the tree and on the walls, and his placement of stakes in the ground to mark where he must stand each time he paints – isn't it more accurate to say that far from trying to dominate a situation that is marked by change, he is constructing a finely tuned infrastructure into which he must enter and in which he must remain, adjusting it as necessary, if he is to forge a sufficiently sensitive relationship with the tree he wishes to paint? But if López's self-positioning and precision

do not primarily imply a drive towards control of the kind indicated by Berne, they do demonstrate remarkable self-control, literal self-restraint or self-limitation, as if by keeping variability on his part to a minimum, the richness of his subject-matter will best be able to show itself. More broadly, the infrastructure that López has created – he describes it in the film as being organized around two 'centres of vision', one within the heart of the tree, the other within the heart of the paper he is working on – enables him to keep pressing into what some would describe as the endemic 'weaknesses' of the visible world (its ambiguous, shifting and partial aspects), others as its threatening character (since so much of what shows itself does so in ways that we may not anticipate, and cannot control), and still others (López included, surely?) as its open and evolving character, and its wondrousness, since these are phenomena that take us to the very edge of our known capacities. For López, then, don't painting and drawing the tree comprise a sort of bowing down before nature, adjusting to it, getting aligned with it, expressing a profound sense of relationship with an aspect of the world he cares about? Taking such a view, two important issues with respect to self-showing are amplified.

First, since López is an artist, the task he has set himself is not only that of seeing and being with some aspect of the world but also of making his experiences – or the fact of his experiences – shareable in visual-material form. At issue is partaking in and showing off the self-showing of the tree with as much accuracy and responsiveness as possible. It is for this reason that his practice as a painter has the broader capacity to illuminate what is also a central theme of this book but one that is easy to ignore, evade, abuse or obscure: the priority of self-showing over sight. In Chapter 2 of *Showing Off*, 'Appearance is everything', I referred to perception as an act of entering a universe of beings which *display themselves*. Painters such as López understand that they are always already part of this self-showing world; that they are mapped into it. Conversely, they understand that for something to show itself, that 'something' must necessarily do so from the basis of its intertwinedness with other things, including beings who see. In so doing, they also draw attention to those relations and those beings. To see is to be inhabited by the self-showing world, and it is also to be exposed, or put on show, by it. Painters, artists, bring the self-showing foundations of sight to the fore in a literal, graspable way. In addition – and this is perhaps most emphatically the case in the context of a realist practice – despite his commitment to following the ways in which the appearing world presents itself, López's realist paintings are recognizably by *him*, and not by another. As such, they magnify the fact that seeing is a mode of self-showing, and of transforming. It is expressive, and it *stylizes*.

Secondly, as well as amplifying often overlooked aspects of the relationship between seeing and self-showing, López's work and his working methods

also draw our attention to a distinction that I am concerned to tease out in this book: the gap that must be recognized and maintained between conditions of being seen (where agency is primarily on the side of the one who sees) and those of self-showing (where agency is on the side of the appearing world). López's modes of responsiveness affirm that although in everyday life we often allow experiences of self-showing and being seen to collapse into one another, in actuality they never coincide. As already argued, self-showing is the prior condition from which being seen, as well as seeing derive. The prolonged, nuanced and intricate nature of López's working methods may be described as holding open this gap between self-showing on the one hand, and seeing and being seen on the other, and in so doing makes the agency of the human and non-human self-showing world explicit and undeniable.

Psychologists Nicholas Wade and Michael Swanston have written that 'the goal of perception is to achieve an internal representation that matches the dimensions of external space'.[45] Likewise, prosaic interpretations of realist image-making traditions may take what we see on canvas as an externalization of that goal. And to repeat an earlier point, some might equate such practices with an attempt at control and closure – this is how representation is generally and negatively understood within art historical and theoretical discourse; the receptiveness of such activity is missed. But control and closure are not the painter's aim. Indeed, here value may be gained from turning again to the writing of Merleau-Ponty in order to discover different formulations for describing the working processes of an artist such as López. One such formulation is that of attempting to make correspondences within the self-showing world.[46] This is illuminating. It is a dynamic notion that accords with the equally dynamic texture of the visible world and without wishing to contain it. It also suggests a sense of the choreographic, drawing our attention of the gestural character of the appearing world. And it implies an attempt at communication, or 'conversation', within the present rather than – as tends to be associated with the term representation – the substitutionary retrieval of some lost object. This making of correspondences, finally, takes all activities within the visual, including seeing and 'representing', to be matters of attunement. As such, they are also approaches to knowledge that are grounded in forms of being-with that are always to some degree at odds with each other, thus in need of negotiation or mediation. Merleau-Ponty's writing is apt. As against those rhetorics expressed above of control on the one hand, and failure on the other, he understands that it is precisely the always open and incomplete texture of the self-showing world that attracts and challenges the painter. 'The eye sees the world, sees what inadequacies [*manques*] keep the world from being a painting', he wrote in 'Eye and Mind',

> sees what keeps a painting from being itself, sees – on the palette – the colors awaited by the painting, and sees, once it is done, the painting that

answers to all these inadequacies just as it sees the paintings of others as other answers to other inadequacies.

It is no more possible to make a restrictive inventory of the visible than it is to catalogue the possible usages of a language or even its vocabulary and devices.[47]

When interviewed, López expressed his artistic experiences and aims in similar terms:

[Y]ou can't predict what's going to happen as you continue adding elements, but at a certain moment something begins to happen; the pictorial nucleus begins to grow and you work until the whole surface has an expressive intensity equivalent to what you have before you, converted into pictorial reality. The process is neither defined nor clear; it is a very open interpretation, a confrontation with reality, like a mirror, where there are no limits except your capacity for effort and your personal limitations. For years I haven't striven towards that aim which is called finishing the picture.[48]

Merleau-Ponty, in any case, went on to describe painting as an activity that 'celebrates no other enigma but that of visibility' and stated that 'the painter's world is a visible world: a world almost demented because it is complete when it is yet only partial'.[49] It is this fabric of incompleteness that provokes ongoing artistic exploration – in 'Image wars' I referred to this in terms of a productive violence that is integral to vision and the visible. But to navigate this territory, to experience it not as intimidating but as appealing, requires forms of responsive self-discipline and heightened awareness akin to those exemplified by López in *The Quince Tree Sun*. 'The painter lives in fascination', wrote Merleau-Ponty.

The actions most proper to him – those gestures, those paths which he alone can trace and which will be revelations to others (because the others do not lack what he lacks or in the same way) – to him they seem to emanate from the things themselves, like the patterns of the constellations.[50]

Of particular note here is Merleau-Ponty's use of embodied, situated, yet expansive terms – actions, gestures, paths and tracings. And this brings me to a second way of describing López's painterly process as demonstrated in *The Quince Tree Sun*, one in which the notion of making correspondences is transferred into, and explored from, a more emphatically somatic point of view. I am thinking, specifically, of Merleau-Ponty's definition, in 'Eye and

Mind', of painting as a process in which painters 'lend' or 'donate' their bodies to the world, enabling a deeply felt experience of communicative exchange to take place. In fact, Merleau-Ponty insists that it is indeed only 'by lending his body to the world that the artist changes the world into paintings'.[51] In the context of 'Eye and Mind', Merleau-Ponty was presenting a counter-argument to a dominant conception of vision as an 'operation of thought'.[52] He defined it instead as an operation of 'the working, actual body', which is 'an intertwining of vision and movement'.[53] The world towards which this body is directed therefore, is not some rationalist construct, some ideation or idealization. Rather this body is directed towards, and navigates, what he described as two intertwining or overlapping maps of the 'I can' in which – much as López had said of his project – two centres may be found, one in the visible world (for López, the tree) and the other in our motor projects (for López, his drawing – in both senses of the word – of the tree). It is clear that several agencies, human and non-human, are at work here. Where those non-human agencies are concerned, it is also, finally, from this lived experience of bodily donation that we are able to understand and accept that the scope of the self-showing world expands far beyond our own aspirations and intentions. For in the words of Kaja Silverman:

> It is . . . not the perceiving subject but rather the perceptual object which plays the initiating role in this scopic transaction When we look at other creatures and things . . . it is also in response to their very precise solicitations to us to do so.[54]

It is important, though, that the nature of these non-human agencies are not misunderstood. They are neither rooted in vitalism, nor taken to be an effect of anthropomorphic projection. Instead, Silverman argues that these relationship are corporeal, formal or compositional, and gestural.

Also important is the fact that the exchanges at issue here are between maps of the 'I can' that overlap but do not coincide. Thus, to become immersed in these exchanges is also to become aware of the spaces – the communicative spaces – between them. It involves encounters with what Merleau-Ponty referred to as 'other inadequacies'. As I will show, because of López's patient, prolonged and generous donations of himself to the self-showing world, these are precisely the structures and exchanges that become visibly and materially mapped into his paintings and drawings. It is part of his style. But before discussing this further, a comment and a question.

As I have presented it here, to self-show is to give oneself. More than that, it is to relinquish control to the agency of 'another' in the knowledge that this act of donation can never wholly be received by that other, and

may not be reciprocated. At worst – we saw this earlier with Ellison's invisible man – it may be disavowed or rejected. In other words, to donate oneself is always, in the first instance, to put oneself at some risk. Which is why it is here, on the side of self-showing – within, and in spite of this broader atmosphere of risk that surrounds it – that the particular quality of generosity within the visual that I am interested in is to be found. I take this generosity to be foundational to all other genuinely ethical actions, including those open and generous modes of *seeing* that, as I've argued, are generally prioritized within provisual ethical arguments. As already discussed, it is only in exchanges where a fundamental gap between self-showing and being seen is kept open, and where primary ethical worth is located in the former (in self-showing), that these risks can be embraced. It is within this ground of generosity, I would argue, that Merleau-Ponty's 'I can' is fundamentally rooted – 'I can give myself, and I can do so on these terms.'

López, Erice and the reinvigoration of the image-world

In *The Quince Tree Sun* variations of the risks and possibilities associated with self-showing are seen to occur around, and in relation to López's practice. As already indicated, Erice's orientation towards López's practice is above all one of emulation. But this does not prevent the film from also calling into question the broader existential and ethical value of López's artistic goals of being-with. In other words, the film does not always fully or uncritically receive or accept what López is offering. For instance, although the people around him – including his family – express admiration for the tree and for his work, a shared response to his working methods is some degree of bemusement. On the first day of painting, at lunchtime, after López and Morena have been seen leaving the premises, two of the builders look at the painting which López has left on its easel in the yard:

> 'He probably started it this morning.'
> 'How about those marks on the leaves?'
> 'Weird, isn't it? Can't make anything out.'

And later, at the drawing stage, we witness a discussion that takes place in López's absence. Two of his friends, smartly dressed for some social event, are standing in the yard, looking at the tree. Since the camera is positioned at something of a remove, it is difficult to be sure who says what, but their exchange again focuses on what seems to them to be the oddness

of López's methods. Here too those methods are understood in broadly rationalist terms.

'He's so orderly . . .'.

'Look, this is where he stands. . . . His point of view doesn't change . . .'.

'I'm really astounded. I couldn't see from so close up', the first speaker remarks, and then adds, illuminatingly,

'Perhaps I'm more the spectator than the actor . . .'.

'I've always wondered about that obsession with physical space, about square inches . . '.

Some of the film's visual juxtapositions also seem, implicitly, to be questioning the value of López's long, slow quest of 'being-with'. Most obviously, his work, with its uncertain outcomes, is juxtaposed with that of the builders with its more defined objectives and deadlines. There is also the inevitable suggestion, when López's working life and situation are contrasted with those of the builders, that López's activities might be regarded as elitist, privileged and non-urgent. Yes, there are analogies between the two kinds of labour at issue – like the builders, López is presented as a labourer, who starts work early and works hard. Despite his fame, there is nothing ostentatious about his working conditions, appearance or lifestyle. But the differences between the painter and builders in terms of economic advantage are nonetheless clear. The builders are economic migrants for whom, among other things, financial considerations, and the implications of working to an agreed schedule are matters of crucial importance; López, though, appears to have unlimited time and resources to spend on his quest, a perception that is intensified in the film by the fact all that he seems to do, during the period of time portrayed, is paint and draw the quince tree. The film also seems to raise subtle questions about his relationship to the world at large. It is true that the artist's working space – the yard – cannot properly be described as cut-off from external reality. Not only is it a place that receives many visitors, but it is also more than evident, when the camera pulls back from its focus on the details of the artist's activities, that the yard is open in the sense of being overlooked, on all sides, by the surrounding apartment blocks that populate the apparently run-down part of the city in which López's studio is located. As such, it is no Platonic cave. Nonetheless, it is also true that whereas Erice's camera regularly cuts or drifts away in order to consider those other spaces – it enters the artist's house to examine what is taking place there, and frequently rises over the walls of the yard to view the surrounding neighbourhood and broader cityscape – López himself is

shown to be focused almost entirely on the tree, as if relatively oblivious to his surroundings. Oblivious also, it seems, to the larger world as it is conveyed to him through the regular news bulletins – reporting political crises and the attempts at their resolution, war (the Gulf War), terrorism, accidents and injury – that are transmitted over the radio playing by his side while he paints. Finally it could also be argued, probably unfairly, that the scene near the end of the film, in which López's wife tries in vain to progress with her portrait of him, casts doubt on the transferability of being-with from tree to person. Might his many verbal interruptions, and the fact that he then falls asleep, be understood as evasive, an avoidance of self-showing within a human context that we might take to be more challenging than his engagements with the non-human world?

Nonetheless, to return to our earlier theme, if *The Quince Tree Sun* raises such questions at an implicit level, explicitly it sets out not only to portray but also to emulate López's practice. Indeed, as was apparent from an interview with Erice published in *Sight and Sound* in 1993, Erice's approach to making this film was interconnected with a broader agenda: his belief that contemporary cinema must be reinvigorated as a phenomenon and as a practice by immersing itself into painterly modes of image-making, such as those in which López is skilled.

A first aspect of Erice's agenda for cinema was apparent the moment the *Sight and Sound* interview began. The opening question was about the present and future possibilities for cinema as a communicative medium: 'As cinema reaches its hundredth anniversary', he was asked, 'what do you think there is left to say?'[55] Erice immediately responded by challenging the questioner's assumption that film-making is fundamentally an attempt at speech. Later on in the same dialogue Erice would state explicitly: 'Generally I don't like cinema in which the message is very obvious, so I'd prefer to call it showing or suggesting a particular interpretation'.[56] In *The Quince Tree Sun*, as already indicated, this emphasis on showing rather than saying was underlined, negatively if you like, by the film's avoidance of the usual explanatory modes of documentary film-making. And it was underlined positively by the way in which a sense of the demonstrative was conveyed through the camera's exploratory filmic gestures as it honed in on the spaces and sensibilities associated with López's practice. Also by those visual rhetorics of layering and juxtaposition referred to earlier associated with the film's editorial processes, which also gave it a reflexive texture.

The importance for Erice of non-didactic forms of demonstration is that they intervene in non-authoritarian ways in a wider communication culture he describes as having become overwhelmingly dictatorial, primarily due to the pervasiveness of television (and here we need to bear in mind that this conversation took place just before the turn of the twenty-first century, that

is, before the internet and mobile technologies had taken the cultural hold they have now). In the interview, he referred to television's 'authoritarian language that seeks a hidden means of persuading the consciousness'.[57] Erice, by contrast, is interested in creating exploratory environments and provoking exploratory attitudes: 'the language of cinema – or at least the cinema I like – communicates on an emotional level and obliges people to look within themselves, but without the idea of a rigid or direct discourse'.[58] 'I think all the films I have made have a common characteristic', he said. They 'describe a journey of discovery, a spiritual journey. At the outset there is a consciousness that is beginning to discover things and at the end of the journey that consciousness has understood something. But', he continued – and this is crucial – 'that formative process involves pain. Knowledge is like a wound; consciousness is formed through the wound.'[59]

A third, related point that Erice made about the contemporary image-world has to do with what he called the 'existing inflation of the image'. Here, he also referenced claims made by Wim Wenders about 'the pollution of the image' and stated that 'one of the great problems we have as film-makers today is how to give authenticity, truth, to the mass-produced image'. Again, Erice identified television as the main culprit: 'Television daily projects thousands of images into homes throughout the world – a flood that has brought about a hypertrophy of the image.'[60] Therefore, he argued:

> We are forced to search constantly to regain a vision of the real image for cinema, and in this I find the relationship with painting very interesting because the painter was the first creator of images in our civilisation. For me, the painter is a primitive artist: painting is a language from the dawn and cinema a language from the twilight of our civilisation.[61]

As noted earlier, scenes of glowing televisions and of television watching, visible day and night through the windows of the apartments surrounding López's yard, are repeatedly used by Erice to punctuate The Quince Tree Sun, and provide a further context against which López's painterly activities are juxtaposed. Throughout the film, the luminous blue light that television casts into the environment, and which is especially visible at night, is contrasted with the qualities and effects of golden sunlight that have been the objects of López's search.

At first sight, Erice's statements about the future of cinema and of the contemporary image-world in general, could be interpreted as problematically idealizing of painting and damning where mass-produced images are concerned, these being contrasted, seemingly negatively, with the handmade originals of painting. But – and here our earlier discussions of the photographic in relation to López's practice should also be recalled – I think

that Erice is searching for a more complex relationship between the two. For if Erice's statement is restaged in the light of his cinematic emulation of López's practice, his search must have to do with discovering individuated modes of self-showing within which mass-produced imagery, including film, may become immersed and flourish. This is what I think Erice is getting at when he refers to that search for 'the real image for cinema'. Why is this important? Because, as I have argued throughout this book, it is at those points of greatest individuation where self-showing is concerned that the greatest possibilities for genuine, that is, heterogeneous communication also arise. These possibilities remain obscure to those who participate in the image-world, fundamentally, at the levels of 'saying', 'meaning' or explaining but bypass what is in fact much more crucial: attentiveness to the specifics of how that world – in which they are also intertwined – is coming to appearance here, and now. López and Erice, by contrast, are interested in how these intertwinings may be drawn out and amplified. For Erice, presumably, a key question is how that slow science of bodily donation that is at the heart of López's work as a painter might also become embedded within practices of mass communication. Which leads me to look more closely at some of the specifics of López's painterly self-showing, and to some of the specific ways in which Erice emulates these in *The Quince Tree Sun*.

I have already referred several times to the gestural character and role of the camera itself in this film. I have also commented on the way in which a cinematic emulation of the painter is made a literal part of the film during the dream sequence. But two other characteristics of *The Quince Tree Sun* are noteworthy. The first of these I have already alluded to several times. It has to do with its compositional aspects, specifically those created in the editing suite, which Erice uses to punctuate the film: to slow it down, to alter its rhythm, its pace, and to make yet more complex the film's gestural life, already evidenced by the varieties of camera movement conveyed. In this way, the passing of time is both emphasized, and interrupted. Sometimes, by the use of repetition and those layered fades, time is conveyed variously as dense or textured, ordinary and recurrent, or multiplicitous and rearrangeable. These repeated motifs, in which the same scenes or the same things are shown in ways that emphasize their shifts in nature or appearance, include those short sequences already referenced: the camera's 'wanderings' through the house; its shots of the surrounding area, several taken at night after López's work is done, revealing the rooms of neighbouring apartments illuminated by the blue lights of television, its panoramic views of the city with Madrid's illuminated communications tower taking a central place; images of the sky, often with clouds obscuring the sun. Also notable are the sequences of fades that are regularly inserted to document the day-to-day progress of López's

work between filming: these works-in-progress are shown disconnected from lived space, floating against a fathomless, black background.

As noted, these effects emulate the ways in which López, as a painter, creates complex textures of time's passing, both through over-painting, and by the presence of incomplete, still-schematic passages. In this way, Erice creates a cinematic fabric that likewise contains gaps and insufficiencies. All of these factors punctuate and indeed poeticize the film, providing breathing space and time for reflection. And so it is that I find myself suddenly reflecting back on Erice's comments about the journey he wants to convey in his own films, and which he described as a formative process involving pain in which knowledge is 'like a wound' and 'consciousness is formed through the wound'. For it is by reflecting on the metaphorical aspects of these engagements with time that a broader analogy with everyday life emerges. This is the fact that life does not merely flow like an unfolding, linear narrative (the general, biographical account we might give of our lives with its perceived failures and accomplishments, highs and lows). Countless tributaries are also generated based on how, at this or that given moment, aspects of our lives have entered into, and been taken up by others, whether positively or negatively (here is the wound). Of most of these we will be unaware, but they live on. With awareness, if such awareness ever arrives, will come further wounds in response to the ways in which we may have wounded others.

This brings me to the second broad aspect of the film that I want to reflect on: its exploratory character with respect to the everyday objects and scenes that exist alongside us but with which we normally engage in habituated ways – the same realm towards which mass culture is generally directed. By giving himself to this realm artistically, Erice, like López, is able to discover within it the appearance of qualities that might conventionally be defined as 'transcendent'. With respect to *The Quince Tree Sun*, for instance, Philip Strick has written, evocatively, of the way in which the artist's work 'gradually and uncontrollably becomes the margin to an altogether different memoir'.[62] Within this context, significant is the way in which both painter and film-maker engage broadly with the rhetorics and metaphysics of the Western still life tradition. Indeed, one commentator, Linda C. Ehrlich, has specifically referenced the Spanish Baroque tradition of the bodegón, which combined scenes of everyday life with strong elements of still life[63] – paradigmatic paintings of this kind include works by Diego Velásquez, Francisco de Zurbarán and Juan Sánchez Cotán.

Not surprisingly, given these traditions, a crucial aspect of López's and Erice's engagements with the self-showing of things is their sensitivity to the role that light plays within these processes. So much so that the world of light, rather than the world of things, has been described as López's primary

subject. Emphatically at issue here are the wonders of natural light as it penetrates the everyday environment, illuminating it and beautifying it, while also drawing attention to its particularities. Dyckes has said that for López it is the 'quality of light that dictates' how things will be shown and drawn.[64]

Crucially though, since engagement with the movements of natural, ever shifting light requires repeated returns and redonations of the painter's body to the appearing world, López's involvement is finely tuned and prolonged. As is the case with the Madrid Realists more generally, López's quests to adjust to the patterns, rhythms and gestures of the appearing world, produce what Dyckes has called a 'deep penetration of subjects and environment, a real knowledge' such that the portrayal of specific things has universal resonance.[65] As Dyckes puts it, following, he says, Ortega's description of the young Velasquez, these contemporary Realist artists are portraitists of places and things who 'try to transcribe the individuality of each object'.[66] This individuality, this 'essence' is elusive, however, but not unattainable. As López has put it, 'The work is able to contain certain things without those things being explicit – they permeate.'[67] And again: 'Real forms get to the point where they contain the unreal, within the objects or the light.' He added that 'the same thing happens in life'.[68] Crucially, as insisted upon earlier, the discovery of what we might call this other, self-showing light, has a sense of agency associated with it. As already indicated, at issue is not some kind of anthropomorphism, which is an act of mental or imaginative projection, but rather a testimony to the uniquely sensitive and receptive modes of investigation of which the body – or what Merleau-Ponty called the body-subject or embodied mind – is capable. It is through such revelations that the body learns; it is by taking things on, and living them, that the body tests them out. In López's paintings, and in Erice's films, to repeat, these processes of embodied discovery, and the revelation of this second kind of light, are made shareable through specifically visual languages – by showing.

Despite their capacities to present disclosures of this kind, realist art practices are frequently dismissed within broader debates about the contemporary – and, particularly, the political – efficacy of art. Indeed, a year after the release of *The Quince Tree Sun*, López was involved in a controversy that touched on these matters. The trigger was what López saw to be an inadequate representation of Spanish Realist art in the Museo Nacional Centro de Arte Reina Sofía, for which, over the past two years, López had been preparing a major retrospective. He felt that this lack was due to the misperception that realist art lacks relevance. And this, he argued, was a case of 'rather severe shortsightedness. . . . We are making a commentary about this century in a vernacular that was not possible in other centuries.'[69] To underline his criticism, he cancelled his retrospective. He did later relent, and the show opened in May 1993. But in the meantime, the controversy had

continued. As reported by George Stolz in his article 'Clash of the Titans', Antoni Tàpies, the 'godfather of all contemporary Spanish abstract art' joined the debate by publicly disparaging the 'realist vision' of painters such as López. In *ABC*, a Spanish daily newspaper, he described this vision as 'facile' and 'pleasing to the nouveau riche and uninformed'.[70] 'Our idea of reality is a bit different from that of our grandparents', he continued. 'Realism today has no reason for existence'.[71] On another occasion, in an unspecified telephone interview he reputedly spoke of the need for 'committees' to keep watch over the 'expiration dates' of art works. López retorted that 'Tàpies's attitude is that of a dogmatic man. I don't agree with looking at the world that way. Liberty, not only in art but in life itself, is the basis of every achievement of the twentieth century.'[72] López went on to have a blockbuster exhibition. In 2011, he had further retrospective at the Museo Thyssen-Bornemisza in Madrid and today he is the best-selling living Spanish artist.

There is, however, what I take to be a largely unacknowledged but profound politics associated with the work of López and painters like him. This could be described in a number of ways. As an intimate politics perhaps – rather than a practice marked by overt critique, opposition or agitation – in which what López referred to as 'a commentary about this century' is produced from a position of profound connection with specific aspects of the everyday world as they unfold in space and time. I would like to think of it as a two-staged politics of figuring out where and how life is being manifested within a given context, and of following its trajectories. The layers of mark making and encrustations of time in López's large topographical paintings – works such as *View of Madrid from Torres Blancas* (1974–82) and *Lucio's Balcony* (1962–90) – seem to confer a kind of (secular) benediction onto the city itself.

In *The Quince Tree Sun*, Erice repeatedly emulates this kind of engagement when his camera records similarly composed views of the city, and produces slow pans of the local environment surrounding López's studio: the run-down or areas of waste ground, the noisy railway station, the apartment blocks and houses with their television-watching inhabitants, and – a particular point of focus – a broken down concrete hut marked with graffiti showing a hypodermic needle and the words 'La Chispa de la Muerte' or 'The Spark of Death'. These are what Dyckes described as the displaced regions on the edges of the prosperous city that the Madrid realists consistently portray. In addition, by revealing that López himself works in the midst of one such place, the film conveys a powerful sense of possibility: the possibility – more properly, the reality – that even here forms of engagement with the world are being practised that enhance rather than destroy life. At issue, again, are those alternate sources of light that are discoverable only when the showing and self-showing world is attended

to. Nonetheless, in *The Quince Tree Sun* the ongoing political potential of such artistic involvements is understated. In a more recent work, though, the political and ethical scope of his realist practice is explicit. I am referring to López's sculptural installation, *Night and Day*, which consists of two large-scale bronze heads of his baby granddaughter, Carmen, one showing her with her eyes closed, asleep, the other showing her with her eyes open, awake. This installation has been seen in several locations, but most enduringly in the Atocha train station in Madrid, where it commemorates the victims of the terrorist train bombings that took place in 2004. Here then, is a piece of mass communication created by López and positioned in a site of trauma. But it is mass communication of the most delicate and individuated kind. Not only is life emphasized, it is emphasized not by means of an abstract or idealist symbolic language, but by sharing that which is most intimate, precious and personal to the artist: the modulations of a loved infant's face. This is, therefore, also an extraordinarily generous act of showing and self-showing that circulates life-giving associations into, and through what had become a corrupted space. And in this sense, it also exerted an extraordinary authority, an authority associated with Merleau-Ponty's conception of the 'I can' that is activated when artistic vision and movement are intertwined: an 'I can' of freely expressed donation and relinquishment. 'Yes, I can give of myself, even here, and even now, within this, the worst of contexts.'

To conclude, then, by taking this stand, by searching for the life within a given situation, by staying with it, and by following its movements and amplifying them, the working methods of artists such as López and Erice provide alternatives to two common tendencies. The first is to try to change situations before having truly entered into and examined them, that is, before having let them reveal themselves as fully as possible. The second – which occurs within attempts at correction – has to do with focusing on and trying to remedy what is wrong within a situation (the movements of death) rather than magnifying what is alive, as if forgetting where the real potency lies. I think that the same simple, life-orientated sensibility characterizes the very end of Erice's film where, as noted, spring has returned to the courtyard, and we hear López humming softly in the background. What this final sequence brings is a sense of ethical commitment to the everyday world that is informed less by the application of agreed rules and regulations, and more by the connective sensibilities provoked by myth, especially myths of death and resurrection. In Erice's film, López's tree is a humble counterpart to other, great, mythic trees. On the one hand, Yggdrasil, the great world tree of Norse mythology, the ash tree that was thought to overshadow the whole world binding together earth, heaven and hell with its roots and branches. On the other hand, the biblical 'tree' of crucifixion. Here, it is a small quince tree that stands at the centre

of the world, demonstrating – to repeat – the humble character of ultimate agency. For as Erice put it, again in that interview for *Sight and Sound*, with that ending he wanted to show 'the generosity of this fragile tree that every year, *in silence*, produces fruits which serve as food for people'. He added: 'When an audience sees the film and follows the path we have walked, they make the process which has been ours their own. Everyone has the capacity to create and recreate within them.'[73]

Stripped

In *Black Skin, White Masks*, Fanon described the brutalizing sense of being stripped under the power of the Gaze. But there is also a different, empowering aspect to being stripped. It occurs in connection with those journeys of discovery described by Erice in which knowledge is experienced as a wound and where consciousness is formed through the wound. This 'wound' of coming to knowledge and consciousness – whether at an individual or collective level – may also be described as occurring when the gap that exists between being seen and self-showing is revealed and when it becomes a place of accountability and therefore also of agency. While art has a general facility to draw us into this gap, some works of art explicitly activate it.

In 2011, I visited the 'Signature Art Prize' exhibition at the Singapore Art Museum. On show was work by 11 finalists selected from nominated artists from the Asia–Pacific region, including Australia and New Zealand. The works nominated, and those eventually displayed, were remarkably diverse in terms of how they were made, their appearance, materiality and subject-matter. In one way or another, most of the artists were participants in the international art world (perhaps through aspects of their training, or in terms of their exhibition profile), but in this exhibition internationalism was not centred in any obvious way on or around those Western concerns or perspectives that still so commonly pervade contemporary debates about art and culture. Other transcultural circuits were in play. The Grand Prize was awarded to the Filipino artist Rodel Tapaya, for a large painting, *Baston ni Kabunian, Bilang Pero di Mabilang* (*Cane of Kabunian, Numbered but Cannot Be Counted*) from 2010, in which various Filipino mythological sources were montaged using a strongly coloured, folkish visual language. If viewed with eyes searching for analogies with Western visual conventions, superficial links (or deceptive similarities) might be forged with aspects of surrealism, or with an older trajectory traced back to the Early Netherlandish work of Hieronymus Bosch. But this would be to miss the particular ways in which, as the artist's nominator stated, a 'distinctly global outlook' – specifically a concern with ecological issues – was

being addressed by forms of knowledge and sense making that were firmly rooted in the local.[74] In my case, though, it was an installation by the Chinese artist Yang Xinguang that was to impact me most powerfully. *Thin*, dating from 2009, consisted of a vertical arrangement of tree branches, discards from the 'brutal' pruning of fruit trees that takes place each winter in northern China. Rather than having been immediately repurposed for the creation of something new or beautiful, these branches had been viciously hacked even further by the artist, evoking what he described as 'a state of being invaded and attacked'.[75] The bark had all but been removed, and in some places the branches – which were displayed in a row, supported by a section of gallery wall – were so fragile that they seemed about to break. As weak but upright beings, and as objects which, through the artist's process of hacking, had taken on the texture and shape of bones, they were images of a double rejection, importing the realities of sacrifice, devastation and abuse into the privileged space of the art gallery. And yet, as they stood there, displaying their terrible wounds, they seemed also to be presenting themselves as if newly individualized, expressive and resilient, as if in a strange state of grace. This returns me to *The Quince Tree Sun*, and to a particular portion of it, where an analogous territory is unexpectedly opened up. It occurs towards the end of Gran's first visit. Following another of those repeated sequences focused on the sky, in which the sun is becoming obscured by cloud, López and Erice are shown having entered the studio. Gran has paused in front of the reproduction of *The Last Judgement* referred to earlier, and López joins him. After a discussion of Michelangelo's likely age when he created it (he completed the painting, says López, when he was about 67 or 68; as noted, it dates from 1541), López comments on this work understood as a self-portrait:

'Isn't it rather macabre to paint himself as Saint Bartholomew?'

'It's something I've known for a while', says Gran. 'I didn't believe it at first. But the resemblance is really incredible.'

'They discovered it last century', says López.

'No one knew it. . . . Where is he?'

'Here', says López, pointing at Saint Bartholomew's attribute, the appalling flayed skin with hideous, masklike face – here is the self-portrait – that Bartholomew is dangling over an expanse of empty space as if it is a discard about to be dropped.

'Yes, that's right.'

'Rather awful.'

'On the original you can see it's him. . . . In a way it's a negative self-criticism', responds Gran.

'What do you mean?' asks López.

'Well, you know, he called himself "a poor madman"'.

'No, he wasn't mad.'

'He said he was.'

'But he had a terrible outlook on life. To create a God who threatens . . . not only the damned but also the innocent. They all look kind of intimidated by their God.'

'They certainly do. Here's God. The innocent are here', says Gran pointing to figures to the left of Christ. 'The damned are here.'

'No, those are the souls who go to heaven. They rise from the earth. These go up, and these go down to Hell.'

'The resurrection, isn't it? The descent into hell.'

'Would you like to be in that Paradise?' asks López, amused.

'I've never believed in it', replies Gran. 'No, I wouldn't like it, fawning all over God. I don't believe in that. Besides, he's a human God, isn't he? God must be brought to man somehow, that's why God became a man.'

'Such a different God from the Greek ones. Just look at her over there, so very full of light', says López, referring to a large plaster cast of Aphrodite that is also in the studio.

'Yes', says Gran. 'She embodies a healthy spirit and soul. And physical prime. While here, all these strong men are scabby.'

'Sorrowful.'

'Guilty. Michelangelo looks tremendously sorrowful. They look guilty. It was another world, another thought, another time. So much worse. I mean, Phidias can be seen as a religious artist but you don't notice it. All you see is joy and beings in their prime. And they're powerful' (Gran is again speaking of the figures in Michelangelo's painting), 'muscle everywhere, but they're so . . '.

'As if they denied life.'

López and Gran interpret Michelangelo's *Last Judgement* as a presentation of crippling apprehension. This is congruent with Tillich's descriptions, referred to earlier, of Western works of art produced during this period in which a wrathful God and the problems of anxiety and guilt were recurrent themes. Tillich reflected on the various culturally and historically specific factors that probably informed these attitudes. Here, though, the biblical reference points for the painting, the parables associated with the Last Judgement, are additional causes for concern not only because they describe the day and the hour of this Judgement as unknown, thus likely

to catch many unawares, but also because these accounts highlight crucial differences between divine and human value systems. In the parable of 'The Sheep and the Goats' in the Gospel of Matthew, for instance, those identified by Christ as 'blessed' (the sheep) and who, in Michelangelo's painting are seen rising to be with Christ, express surprise at having been chosen, as do the 'damned' (the goats) at having been rejected. Why? Because both groups had failed to realize that what counted for Christ was not religiosity. Crucial instead was whether they had allowed the self-showing of Christ's goodness to reveal itself through them towards others in practical ways. And, inversely, whether they had consistently recognized, honoured and served Christ as he revealed himself in the lives of others, even the lowliest and most troubled. In Christ's words: 'I tell you the truth, whatever you did for one of the least of these brothers of mine, you did for me.'[76] This is again a reason why, both within the Catholic and Protestant traditions, worshippers sought practices or constructed doctrines (such as the Calvinist doctrine of predestination) that they hoped would ensure a safe eternal destiny.

López and Gran point out that in Michelangelo's painting, the blessed look just as tormented and guilt-ridden as the damned. And indeed, drawing again on the writing of Tillich, we might argue that here pathological anxiety has been depicted in which, even in the presence of grace, grace can neither be perceived, nor received, nor conveyed. According to Tillich, pathological anxiety is anxiety that a person has not been able to take upon him or herself and overcome. As such, it 'produces images having no basis in reality'.[77] Arguably such anxiety is expressed in a particularly heightened way in Michelangelo's self-portrait. As the scholar Sarah Rolfe Prodan has reminded her readers, this gruesome self-representation may not necessarily have been autobiographical in intent. Its primary aim may have been 'the articulation of a topos, the journey of everyman as sinner as it was understood during Michelangelo's time'.[78] Or, as pointed out earlier, the artist may have been personifying the fact that during this period the Catholic Church, as the purported instrument through which the faithful were to obtain the salvation of Christ, was in reformation and (early) counter-reformation turmoil. Turmoil certainly pervades every portion of the painting. We cannot be certain of the intentions that informed the details of Michelangelo's painting and the self-portrait contained within it. Nonetheless, we *can* discuss it purely at the level of image. As such, we can ask whether what we are being given to see, terrible as it is, really is – as López and Gran would have it – *entirely* an expression of guilt, and a denial of life. It is true that Michelangelo has portrayed himself as a flayed skin that looks as though it might be dropped at any moment and descend towards hell. The spectre of this fate seems imprinted on its sagging face. But in the final analysis, by depicting himself

as the flayed skin of St Bartholomew, he has positioned himself, albeit precariously, among the blessed. Therefore, might it not be more accurate to say that one of the things that we are presented with in this painting – again purely at the level of image and appearance – is an honest and courageous expression of existential fears that few of us would dare to face? For, like it or not, however we might choose to *conceptualize* 'heaven' and 'hell' and our relationship to them, they are phenomena that we all continually experience and contribute to in everyday life.

At the level of image, to repeat, Michelangelo has implicated himself into a publicly available rendering of a terrifyingly uncertain spiritual journey. Indeed, Prodan's research is suggestive on this point. In an essay written in 2009, she examined the significance of the fact that in *The Last Judgement* Michelangelo mixed together biblical and mythological themes. In particular, instead of picturing Satan presiding over hell and judging the damned, he replaced Satan with the classical figures of Minos, shown at the lower right of the painting entwined by a huge serpent. A little higher up, he depicted Charon, the boatman of classical myth, who ferries the dead across the river Acheron. Prodan argues that in so doing, Michelangelo was in dialogue with Dante's *Divine Comedy* (c.1308–20) and with the literary scholar Cristoforo Landino's psychologically inflected commentary on Dante's work, with which Michelangelo was familiar. From this basis she argues that *The Last Judgement* might best be interpreted as picturing a specific psychological state in which, following Landino, Minos stands for the biting attacks of a bad conscience, and Charon for a free will that chooses misdirection. As Prodan has pointed out, the poems that Michelangelo was writing prior to, and during the fulfilment of this commission for the Sistine Chapel, refer in the first person to someone who is struggling with the horror of feeling damned, and the despair of believing he is unable to move beyond this to receive grace. For those preferring a personal interpretation of these poems, the impact of his homosexuality in this regard is sometimes taken to have been at issue. In a poem probably written between 1528 and 1530, for instance, he wrote that:

> Now that time is changing and sloughing off my hide, / death and my soul are still battling, / one against the other, for my final state. / And if I'm not mistaken / (God grant that I may be), / I see, Lord, my eternal penalty / for having, though free, poorly grasped or practised the truth, / and I don't know what I can hope for.[79]

As noted, it is unclear how best to interpret Michelangelo's portrayal of himself within the context of the painting. But by this act of painterly self-showing – there was, after all, no requirement that he include himself

within this scenario – he portrayed himself as subject to judgement – by the viewers of the work as well as by God – and uncertain as to his final fate. Within a biblical context the ultimate outcome of judgement for a believer would not be condemnation but salvation. But given the 'macabre' sensibility that is pictured here, salvation has not yet become a spiritual and thus a psychological reality. When compared with the *sacre conversazioni* paintings from the same period, the differences in terms of orientation and energy between Michelangelo's image and those others are startling: horror, dread and turmoil in comparison to peace, joy and connection, even in the presence of suffering. But what Michelangelo may be presenting, here, is a stage on a journey towards salvation in which intense obstacles still need to be overcome. In this regard, perhaps we might interpret the painting, among other things, as a visual-material prayer, even an appeal for the mediating help of Saint Bartholomew with whom Michelangelo had so intimately associated himself. More than that, by showing himself not as one of the damned, already en route to hell but as that sloughed skin – also described in his poem – suspended in an intermediate space, can we not find here the very slightest public demonstration of hope against all odds? Or, more radically, might we interpret this as imaging a potential relinquishment: the risk of letting go of the tormented 'old self with its practices', the 'Old Adam', referred to earlier, without quite knowing what new and surprising – even apparently impossible – identity in Christ will reveal itself? (I am intrigued by the way in which Michelangelo has embedded this uncertain sense of potential action – physically and visually – into Bartholomew's extraordinary contrapuntally turning body.) In any case, Michelangelo-as-image must without doubt be described as 'showing off' in a place of pain in which, nonetheless, all manner of possibilities are about to unfold. And this is a theme with which I would like to continue. In order to do so I will remain, for now, within the field of Christian iconography; it is within the Christian tradition that an ethics associated with actively encountering and overcoming suffering has been extensively developed. To this end, I shift to another set of images: Netherlandish crucifixion scenes dating from the thirteenth to the sixteenth centuries, thus once again from the same period that produced the sacred conversations discussed earlier.

Showing up in sites of suffering

Like the sacred conversations, these crucifixions were influenced in large part by the writings of St Francis of Assisi and, before him, St Bernard of Clairvaux (1090–1153) and marked a transition away from an emphasis, in earlier devotional works, on images of Christ Triumphant. Here, instead, his humanity and suffering were foregrounded with the intention of encouraging

an intimate and more emotional piety. So these are images of suffering, and in this sense difficult. But the sensibility portrayed here again bears little resemblance to the torment pervading Michelangelo's painting.

As I enter into the visual and emotional territory of these crucifixions, my interest, as noted, is in pursuing further the idea of an ethics rooted in a determination to stand and show oneself even in a place of pain. However, my focus will not be on the figure of Christ, but on Mary who, in works by such artists as Jan van der Weyden (1400–64) and Jacob Cornelisz van Oostsanen, is shown standing, and often appearing to swoon, at the base of the cross.[80] My aim in so doing is to treat the figure of Mary as paradigmatic. I will regard her devoted demonstrations of intimacy with the crucified Christ at Calvary in general terms, as models of risky but willing inhabitation of the visual. I am interested in how this risky inhabitation, and its outcomes and effects, are theorized within these works, and the degree to which Mary, as she is presented here, might serve as a model for the ethics, and indeed the politics, of self-showing that I am proposing in this book.

Medieval mediations on the Passion had already described at length Mary's encounter with her Son as he carried the Cross. But from the second half of the twelfth century she was regularly included in images of the crucifixion. This was because the notion of *compassio Mariae*, which emphasized Mary's compassion and participation in Christ's suffering, had become an important religious theme.[81] From the thirteenth century, as with images of the crucified Christ from this period, the humanity, and thus the vulnerability of Mary had become a recurrent subject. She began to be shown fainting at the foot of the cross, sometimes with a sword piercing her breast, as had been prophesized by Simeon – described by the gospel writer Luke as a righteous and devout man – on the occasion of the infant Jesus's presentation, or dedication, at the temple.

An important extra-biblical literary source for depictions of Mary's co-suffering with Christ at the foot of the cross was a thirteenth-century poem, the 'Stabat Mater'. Most scholars believe that the author of this devotional hymn was a Franciscan monk called Jacapone da Todi, who died in 1306. Written in Latin, it became popular in the church, and has been set to music by various composers, most famously perhaps by Giovanni Battista Pergolesi in the early eighteenth century. The first few lines of the hymn translate as follows:

At the Cross her station keeping, / Stood the mournful mother weeping / Close to Jesus at the last. / Through her soul, of joy bereaved / Bowed with anguish, deeply grieved / Now at length the sword has passed. / O, that blessed one, grief-laden / Blessed Mother, blessed Maiden / Mother of the

all-holy One. / O that silent, ceaseless mourning, / O those dim eyes, never turning / From that wondrous, suffering Son.[82]

The hymn celebrates Mary's refusal to turn away from the self-showing of Christ who, in the eyes of the onlooking world, had become shameful and despicable. Here I refer to the self-showing of Christ in order to emphasize his agency; in the biblical account, at root, crucifixion was not inflicted on, but chosen by him. Particularly striking, is the way in which the poem emphasizes not only the corporeal nature of Mary's remaining with Christ but also the specifically *visual* aspects of her being-present with him – her devoted and courageous looking and her self-showing. It is as if her staying-with and continuing-to-perceive him, enables the pattern of Christ's being to become imprinted into her own. At issue therefore is the foundation for an ethics that is not primarily rooted in intellectual assent, or an act of will, but in a fundamental knowing *with the body*: an incorporated ethics, moreover, of showing up and standing out in a place of pain. This is again an expression of that Merleau-Pontean 'I can', as I interpreted it earlier.

The bodily nature of Mary's identification with Christ figured even more powerfully in visual form, that is, in paintings from the late medieval and early Renaissance periods, particularly in those by van der Weyden. In such works as the *Deposition* from about 1435, now in the Prado, Madrid, the *Crucifixion Triptych*, from about 1445, now in the Kunsthistorische Museum, Vienna, the central panel of the remarkable altarpiece *Triptych of the Sacraments* of 1445–50, now in the Koninklijk Museum voor Schone Kunsten, Antwerp, and the *Crucifixion with the Virgin and Saint John the Evangelist Mourning*, from about 1460, now in the Philadelphia Museum of Art, Mary is depicted as a collapsed or falling figure. Often she is shown supported by Christ's disciple, John – the same John the Evangelist whom we saw represented in the Lorenzetti. The bowed and anguished soul, described poetically in the 'Stabat Mater', is here and now made manifest in the depiction of her bowed and anguished body. In *The Deposition* of 1435, this profound bodily identification with Christ is perhaps most clearly articulated: here we find the dead Christ's form as he is being lifted down from the cross repeated in that of his fainting mother. Mary too is like a bloodless corpse, and the artist has placed her lifeless arm and that of Christ in such close proximity that they almost unite.

Some commentators have taken a rather different view of Mary's act of fainting before the cross, seeing it as an expression of her *self*-absorption, that is, her closedness to everything other than her own pain. However, given the theological orientations of the period, it is probably more appropriate to regard this behaviour as expressive of her radical, bodily openness to

her son. Mary does not draw away from his pain, but enters into it. She incorporates it.

Radical openness, then, is one of Mary's key qualities. Indeed, in the language of critical theorist and psychoanalyst Julia Kristeva, she may be described in this regard as an 'open system'. John Lechte explains this idea as follows:

> Kristeva proposes that the [human] subject be understood as an 'open system'. This means that rather than thinking of the outside world of the other as a threat, we should see it as a stimulus to 'change and adaptation'. Trauma, crisis and perturbation similarly should be seen as the sources of an 'event' in the life of a subject, something which broadens horizons, and not something to be denied or resisted with a resultant atrophying of psychic space. To the extent that the crisis is absorbed into the psychical structure, the latter becomes increasingly more complex and supple, increasingly more capable of love. The greater the capacity for love, the less the other becomes a threat and becomes, in his or her very individuality, a participant in an identity as 'a work in progress' central to 'the amorous state'.[83]

This description seems perfectly to accord with the orientation of Mary towards the traumatic fact of her son's death.

One of the important aspects of Mary's radical identification with Christ's sufferings is that it is an identification that leads to transformation. Of course, a sense of transformation is intrinsic to the notion just described of Mary as an 'open system'. However, for certain commentators a more radical sense of transformation may be at issue in works of this kind, one that involves not just Mary herself but the whole of humanity. These commentators argue that the imagery of Mary's Swoon (her collapse before the cross), refers neither to a swoon of self-absorbed evasion, nor only to a swoon of compassion and identification but also to a swoon of maternal labour. Drawing on theological debates from this period about the so-called Doctrine of Mary's Swoon, and connecting the posture of Mary in these crucifixions with those found in older, classical representations of women giving birth, they argue that Mary's spiritual role, here at the foot of the cross, is that of painfully, agonizingly, giving birth to the New Humanity that her son's death is at that moment bringing into being. Christ is the New Adam. Mary is the New Eve, the mother of a redeemed, transformed human community. In *The Deposition*, in fact, the fainting Mary's right hand almost brushes against a skull that is lying on the ground in the lower left side of the painting, a symbolic representation, precisely, of the Old Adam. More than that, Mary's body seems to create a bridge between the Old Adam and the New. A radical view (one still much

debated within Catholic circles), and one that was being debated when van der Weyden was active, was the notion that Mary's role at Calvary was that of a co-redeemer with Christ.[84]

In these works a third quality vital to community is also depicted: relinquishment or leave-taking. The proposition at issue here is that Mary was able to identify so profoundly with Christ on the cross, to stay when, according to the biblical accounts, others ran away, precisely because she had learned again and again in the course of her relationship with Jesus, to let him go. Indeed, it is surely not insignificant that where Mary's dealings with the growing and adult Christ are recorded in the gospels the issue is always the same. Jesus repeatedly asserts his separateness from her while nonetheless also demonstrating his commitment to her. 'Didn't you know I had to be in my Father's house?' he is recorded as saying to his parents when, as a boy, he had alarmed his parents – who had already set off to their home town of Nazareth – by remaining behind in the temple in Jerusalem to discourse with the teachers there. But afterwards, so we are told, 'he went down to Nazareth with them and was obedient to them'.[85] And years later, at the marriage feast of Cana when Mary approaches Jesus because the wine has run out, he rebukes her for involving him, but he performs the miracle of turning water into wine anyway.

At issue, then, in the example of Mary's motherhood of Christ, is an understanding of intimacy based on having learned how not to possess, control or manipulate him. This is a point that Kristeva has also made in her writing: there is a requirement of separation for the formation of love. An analogous recognition of the paradox of proximity and distance as a requirement for genuine forms of community to emerge was taken up by Merleau-Ponty. This was most overt in his reference, cited earlier, to our need, as communicators, to become immersed in an experience of time 'which both separates and unites us, as the Christian plunges into God'.[86] Merleau-Ponty's text – 'Metaphysics and the Novel' – continued with further observations about the nature of human interrelatedness and belonging which again accord remarkably with the nature of Mary's devotion to Christ in these paintings. First, there is again the notion of the ethical as an embodied position, which operates at a much deeper level than that of external rule-following. His point is not that such rule-following is invalid, but that it is an insufficient starting point for the formation of communities of belonging. He is interested in the discovery, and creation, of more profound bonds. Associated with this, crucially – and here again a brand of humility and acceptance is required – is a particular attitude towards the self: our belonging to others requires, in the first instance, that we willingly take on or plunge into who we are – who we happen to be, may not entirely want to be, and cannot but be. True morality, writes Merleau-Ponty, is 'actively being what we are by chance, of establishing that communication with others and

with ourselves for which our temporal structure gives us the opportunity and of which our liberty is only the rough outline'.[87]

And now, a final point. So far I have considered van der Weyden's crucifixion scenes from the perspective of personal devotion and its effects, focusing on the model provided by Mary. But his paintings are also of interest for the ways in which they reference then-contemporary places and methods of worship. The spatiality of the *Deposition*, for instance, clearly indicates that the drama depicted is sited within the shallow space of a gold-painted niche. In other words, it duplicates the architecture and spatiality of the many carved altarpieces that were produced in the Netherlands during the fifteenth century, comprising painted figures arranged in wooden boxes. The painting is, in this sense, an image of an image found in a church, and as such it not only brings Christ's sacrifice into the then-present, but also inevitably provokes reflection upon the forms and processes of public devotion. This characteristic is present in other paintings by the artist. In his *Crucifixion* of around 1460, housed in the monastery of San Lorenzo, El Escorial, Spain, the drama is again located within a shallow architectural space. It is also set against the gridded backdrop of an unfolded red cloth, like the cloths against which crucifixes in churches were often displayed. The figures of Mary and St John standing beneath the cross appear almost as if sculpted from stone or marble. In the central panel of the earlier *Triptych of the Sacraments*, contemporary modes of devotion are even more overtly referenced, and in a way that also forges a direct connection between the body of the crucified Christ, and the body of the believing viewer of the work. In the foreground the historical crucifixion is alluded to, and we see Mary figuring once again as a fainting or collapsing form. But what is actually depicted is not the cross at Calvary but a large crucifix, located in a church in which a Low (or daily) Mass of Holy Communion is being performed. This is visible in the painting's background. Indeed, the falling body of Mary is vertically aligned with the figure of a priest who stands before an altar and is in the process of elevating the host. According to Catholic tradition, this raising up of the host, or 'monstrance', is intended to affirm the real rather than merely symbolic presence of Christ. And so, returning to the cross in the foreground, although on the one hand it is just an object, a crucifix, on the other hand it is much more than that: it relates to a sacrament through which the broken body of the historical Christ crucified is taken to be actually present. During Holy Communion it is this 'real' body that will be consumed and thus incorporated into the bodies of individual believers, making them one *with* Christ in his death and resurrection, and one *in* Christ. Here again, Mary presents a model for this profoundly internalized connectivity. Indeed, in this regard, the art historian Amy Neff provides a further interpretation of Mary's swooning presence in this painting. 'Mary's Swoon', she writes, 'gives birth to the eternal Church, which is renewed, reborn, daily in its sacraments'.[88]

This painting brings the body of the believer into play in another way too. For like all paintings it communicates richly not only at the level of meaning but also sensually. It communicates as powerfully through its form, its colours, its materiality, and its internal rhythm or beat, as it does through its overt subject-matter. And interestingly, many of the crucifixion scenes from this period, including the van der Weydens, emanate tremendous pulse and energy on a formal and aesthetic level. This is true also of the poem, 'Stabat Mater', in both its Latin and its English versions – something that Pergolesi, for instance, picked up on when he set it to music in the eighteenth century: he maintained, even enhanced, the profound and pleasurable mixing of sorrow and joy that was already present in the text, and is also present visually and compositionally, in these paintings. Such works, then, would seem to call us as viewers simultaneously into death and into life, or into what the writer and philosopher Hélène Cixous, in a somewhat different context, has called a 'difficult joy'.

> All authors and all readers have experienced being wounded by the coming of the text, being wounded by wonder because the joy that a text inflicts *hurts*. Why does it hurt? When it comes to us, first of all it tears the night and the lie in which we usually live; it hurts to see the truth but it is of course a joy.[89]

Significantly, visual works, such as these crucifixions, in which a necessary relationship is proposed between vulnerability and community, have not survived much into the modern age. Rather, they seem to have been increasingly suppressed within mainstream Western cultures from the sixteenth century onwards. For instance, where visual references to the crucifixion are concerned, a significant shift – which began to emerge in the sixteenth century in response to the iconoclasm of the Reformation – was the *empty* cross of Protestantism, a cross from which the body of Christ has been evacuated, and the narrative of Christ somehow stripped, defleshed, emptied of pain as well as passion. In one sense, therefore, the models of community that I have been discussing insert themselves rather uneasily into our world, in which individualist pleasures (rather than individuation) and self-sufficiency (rather than vulnerability) tend to be applauded.

In the image-world – 'woman' as hinge

'"Woman" as hinge'. In the first place, I am coining this phrase poetically, as a figuration of all of those occasions in which the realms of self-showing are prioritized over the domain of seeing and being seen such that new

experiences of connection and community are made possible. In the video by Pushpamala N. discussed in the introduction and first chapter of *Showing Off*, her Indian Lady repeatedly lays claim to the visible despite her less than confident and less than prestigious position within it. *Sangam*'s Radha and Fanon's and Ellison's narrators turn around their own fate by resignifying themselves within the image-world – of note is their final refusal to define themselves as a product either of the external or the internalized Gaze. López and Erice, using paint on the one hand, and camera on the other, donate themselves, time, and time again, to the movements of the self-showing world of which they are a part. They allow that self-showing world to extend their vision and capacities into unexplored territories. Mary, in those crucifixion scenes, disregards shame and embraces pain, moving beyond them in order to show up at the side of her son who is being executed.

So '"woman" as hinge' is not necessarily or wholly a biological entity, and in no respect does 'she' symbolize the gendered, passive counterpoint to supposed male agency. Nonetheless, I have used a gendered term purposely in order to evoke associations with those who, conventionally, and for one reason or another, are disprized or ignored. But while we might expect this 'woman' to turn away from the visible with its difficulties, she turns towards it. Disregarding the fact that, like Ellison's invisible man, certain kinds of recognition and acknowledgement may continue to evade her, she is, and stands for, a generative form of agency and an orientation that extends expressive possibilities outwards. In this regard, then, she personifies the 'I can' discussed earlier. More specifically, she opens up this map of the 'I can' to others, just as, according to Virilio, the person of Mary (named Mediator) is 'the initial map of the Infant-God's 'I can'.[90] She is vulnerable and capable; at issue in her outwardness is not an oppressive sense of mastery. Instead, she facilitates potential.

In the second place I am also using this expression – and here it is the notion of 'hinge' that is significant – to convey the centred flexibility that characterizes those who define themselves according to the sensibilities of self-showing rather than allowing themselves to be pulled into the fight-or-flight mentality that erupts when the logics of seeing and being seen dominate. '"Woman" as hinge' keeps the often hard to discover, and difficult to enact distinction between showing off and being seen in play.

And finally, I am using this expression as a homage to Merleau-Ponty; I am referencing a specific Merleau-Pontean source, found, obscurely, in one of the schematic Working Notes published at the end of *The Visible and the Invisible*. Before turning to it though – this will be *Showing Off*'s concluding discussion – I want to consider one more filmic exploration of the subtle ethical potency of self-showing within conditions that are again less than hospitable. What this discussion will also do, I hope, is strengthen an understanding of

the agency associated with self-showing as having to do neither with an act of solicitation – to solicit means to ask for or demand something, and has etymological associations with agitation and anxiety – nor with an attempt at seduction which, to recall Mulvey, stops the action.

The film in question is *The Silences of the Palace* of 1994, written, directed and edited by the renowned film-maker Moufida Tlatli. Set in Tunisia in the post-independence period of the mid-1960s, it is a narrative of recollection, told through a series of flashbacks. Alia is a professional singer. She is unhappy, apparently unwell and insecure. As she put it herself at the end of the film, 'I could never express myself; my songs were stillborn.'[91]

When the film opens, the camera is focused on her face. She is on stage, singing at a traditional engagement party that is being held at a hotel – but how different her energy is to that of Pushpamala's performer in *Indian Lady*. We watch her eyes as they scan the room. No-one is paying attention to her. She and her songs are a mere backdrop to those other lives. We watch her struggle to overcome a sense of hopelessness as she closes her eyes and begins to sing with intensity, as if to and for herself, but she cannot conceal her dispiritedness. This is only one aspect of her felt relationship with the image-world however; another soon becomes apparent.

Alia leaves the hotel. Lotfi, the man she lives with but is not married to, is waiting to drive her home. Once there, we learn almost immediately from their unfolding conversation that he is placing her under pressure to undergo another unwanted abortion. Not only does she again feel that she is going to lose a part of herself, but she also feels that she is drowning in an atmosphere of condemnation.

'I'm scared.'

'What of?'

'Of the neighbours. They stare. They stare at me all the time. Every eye accuses me as if they could read my thoughts.'

'You're imagining it. They know nothing about you. . . . It's a difficult period.'

Listening and watching, we realize that this is a conversation that has probably been repeated many times with the same outcome: Alia relents, saying that she will have the procedure. More broadly, her life itself seems fated to continue in what is, from her perspective, its failed and futureless existence. But this state of affairs is interrupted when she suddenly finds herself returning to the unhomely home from which she had fled ten years previously: the palace of the Bey in Tunis. This was the residence of the Tunisian rulers under the French during the colonial period where Alia had

spent the first 16 years of her life as the illegitimate daughter of the beautiful Khedija, a household servant, now dead. Her return had been provoked by news of a second death, that of Sid Ali, one of the princes, and the man she had grown up believing *might* be her father. The secrecy that had always surrounded her paternity – and would continue to do so – is one of the silences referred to in the film's title. The crisis of identity and belonging that this had cast over her past, present and projected future is a central issue to which the film repeatedly returns.

The Silences of the Palace addresses this crisis of identity and belonging by asking questions about the nature of servitude and about the means whereby liberation and individuation may be gained. These questions are examined on at least three registers. Of first and most immediate concern are Alia's personal experiences: among other things, psychological servitude to the past, and to the designations and judgements of others in the present, keep her imprisoned. Secondly, at issue are the interlocking layers of literal servitude, including sexual servitude, that defined the everyday experiences of the women living in the palace. The 'silences' of the palace underline that these were tormenting conditions about which the women were neither allowed, nor able to speak, even to each other. They were conditions that Alia's mother was desperate to try and protect her daughter from. Thirdly, there is the issue of political liberation. As noted, the struggle for Tunisian independence creates a backdrop to the unfolding domestic drama that Tlatli has foregrounded. These three narratives overlap, and often intersect, but their relationship is not necessarily one of direct analogy. In any case, it is Alia's story that takes centre stage. The film's conclusion, regarding the attainment of freedom at a personal level at least, is that this is possible but only, once again, by being willing to stand in a place of pain in a way that enables certain life-giving possibilities to emerge. Alia's reappearance in the now dilapidated spaces of the palace forces her to recall the life she had tried to forget. This remembering is provoked by her direct, physical interaction with places and objects. Often it is as though those memories are being awakened not only in her but also within the spaces she is revisiting where they have also lain dormant. In a sense, both Alia and the spaces of the palace combine to form a kind of darkroom – I am referencing my earlier comments about the photographic – in which unexposed negatives are actively being developed.

To begin with, Alia recalls memories of singing and laugher, but tension escalates as she remembers reaching puberty and embarking on a process of trying not only to discover the identity of her father but also to understand her mother's role in the palace beyond that of a domestic servant. With her best friend Sarra she secretly watches her mother dance for the royal family and their friends at a party – Sarra is the legitimate daughter of Sid Ali's brother,

born just minutes before Alia herself; their friendship is a marker of Alia's ambivalent position within the palace hierarchies. Time and again, alone, she follows and watches as her mother and other female servants attend to the princes, privately and sexually, in their chambers. The realities she discovers are complex. It is clear, for instance, that her mother and Sid Ali love each other. But then, one day, when she is resting in her room, Alia witnesses her mother being raped in their own quarters by Sarra's father – who had also begun to show an unhealthy interest in Alia herself. This rape would lead to a pregnancy which her mother would try to abort, and from which she would later die. Alia becomes ill, traumatized at having witnessed the rape, and presumably projecting into this abuse her own future prospects. She does gradually recover – or appears to – in large part because her greatest desire is fulfilled: her mother, aware of her love of music, gives her a lute of her own. Soon Sid Ali becomes aware of Alia's skills as a singer and a musician, and she too begins to perform at family events. Also during this period, news about the country's political struggles penetrates steadily into every part of palace life and tension mounts. Khalti Hadda, an elderly servant and mother-figure to both Khedija and Alia, has been persuaded to assist in the struggles by allowing a young revolutionary, Lotfi (later Alia's Lotfi) – also tutor to the children – to hide in her apartment. The film now gradually approaches its various points of climax, the culmination of which is the evening of Sarra's engagement party. Alia is present both as Sarra's friend and in order to perform for the guests, which she does with the greatest sense of enjoyment and freedom we have yet witnessed from her. Lotfi, with whom she has become increasingly close, looks on. And then, suddenly, Alia disrupts the private happiness that the family has somehow managed to maintain in the midst of national turmoil, by starting to sing a different, nationalistic song. The musicians stop playing, but she continues unaccompanied, and one by one the guests stand up in disgust and leave. At the same time, behind the scenes, Khedija becomes unwell. She has begun to haemorrhage – the attempted abortion is now killing her – and while Alia is singing her song of protest, Khedija dies. When Alia reaches her side, it is too late. That night, also the night in which Tunisian independence is achieved, Alia leaves the palace.

At the beginning of this chapter of *Showing Off*, when I introduced *The Quince Tree Sun*, I defined identity in phenomenological terms. Here, what counts is what we *intend* towards and therefore show ourselves to. Also what we sense intends towards and shows itself to us, and through us. At the beginning of *Silences of the Palace*, it is clear that for the adult Alia these intentional relationships in and with the world have lost what positive force they might have had, and become deadly. Her image-world, and her sense of herself as image, have been so colonized and repressed by trauma that she is unable to give herself to the actualities of all that is unfolding for her. When

she returns to the palace and finally faces those repressed memories her intentional world is reconfigured towards life.

Significantly, in the film, the process by which Alia's agency is gradually released is investigated and amplified by means of the agency of Tlatli's camera, a camera she has described in interview as 'somewhat sly and hidden. It's there and it can capture small details about something one is trying to say, so in a sense it can be an instrument of poetry.'[92] Indeed, like *Sangam*, *The Silences of the Palace* is a melodrama, but one that uses the poetic and emotional conventions associated with this genre to make inroads into the traumatic, unarticulated territories of fear, abuse, loss and death just described. In an interview with Tlatli, Laura Mulvey referred to the director's capacity, in this film, to decipher long-repressed material. But this deciphering is of a specific kind: since the palace's silences remain unbroken, it is achieved by means of the visual as a route to truth, and, as noted, with the camera as that instrument of poetry. In Tlatli's words:

> For me, the women's silence is a silence through the inability to speak. Their mouths are closed. Human beings want to speak, to express themselves. If the mouth is closed then the eyes speak. I wanted to make their eyes speak – and say a great deal. All the women are within the tradition of taboo, of silence, but the power of their look is extraordinary. They have had to get used to expressing themselves through their eyes.[93]

Indeed, the film unleashes the power of the poetic – an art form that Tlatli describes as particularly significant in Arabic culture – in order to find ways of showing the unspeakable. And in this sense there is a definite relationship with Erice whose work, especially and overtly his 1973 film *The Spirit of the Beehive*, was markedly

> of the generation who had lived through the Civil War. And civil war is the most terrible experience a community can have because brother is set against brother. In a civil war everyone is defeated – there are no real victors. What characterises those people in my memory of my childhood is that they were in general very silent, introspective people. They didn't want to speak because they had lived through something so horrific. We children experienced it as a form of absence: we sensed that deep down they were far away. And perhaps that is why there was a lack of communication.[94]

The compulsion to show what cannot be said is a shared characteristic of Tlatli's and Erice's film-making. In Erice's words, 'Prose always recounts things in a direct way, whereas poetry expresses the ideas of the world in a

totally indirect way, and more powerfully perhaps, because it speaks to the unconscious.'[95] Tlatli would agree. As she has put it:

> Poetry is made up of a superimposition of images on words. Perhaps this culture of the indirect has advantages over a culture valuing simple and direct expression. Here everything is a little bit devious, a bit unformulated This is why the camera is so amazing. It's in complete harmony with this rather repressed language.[96]

Both film-makers have different cinematic means of achieving their goals, however. In *The Silences of the Palace*, as in *The Quince Tree Sun*, the camera again plays an active role. In some cases, as noted, it operates in a way that is 'somewhat hidden and sly' – as it accompanies the young Alia, for instance, in her secretive pursuits of her mother through the corridors and curtained doorways of the upper regions of the palace. But above all, Tlatli's camera has a connective role. A significant feature of Tlatli's cinematic style is a predominance of long, slow tracking shots. Visually, aesthetically and emotionally these shots are like gestures of acceptance analogous to those discussed earlier with respect to the sacred conversations. In other words, here, in a story whose vital source, or centre, cannot be accessed, the camera mediates and heals by embracing that which is unresolved and fragmented. It is thus able to achieve, visually and gesturally, what cannot be accounted for coherently in narrative terms.

The connective force of Tlatli's camera is powerfully in evidence in two very different portions of the film. The first occurs early on and, according to Tlatli, stands in a synecdochical relationship to the film as a whole: she has described it as containing 'the whole story of the palace' and as 'showing everything'.[97] The sequence begins at the wrought iron palace gates behind which Alia and Sarra are portrayed as confined. While relaxing in the garden and in an atmosphere of apparent playfulness, both girls run up to and grasp the gate, which is in the process of closing. Unusually, the camera is positioned on the outside looking in, and records their faces pressed against the gate's filigreed bars. Then a call is heard, and Sarra and Alia turn and walk swiftly to the gazebo where Sarra's music lesson is in progress. As Sarra plays the lute under the guidance of her tutor, Alia looks on with a mix of pleasure and longing, taking everything in. Then a second voice is heard, calling Sarra. A professional photographer has set up his camera and tripod and is ready to take a formal group portrait of the family. Both girls respond to the call and, hurrying in the direction of the formal gathering, take their place in the group. Despite their actual differences in status within the household, they behave as though they are one person, bonded to and in tune with each other. But the photographer, whose literal and metaphorical role

is to represent and affirm normativity and the status quo, immediately ascertains that Alia does not belong and tells her – in French – to step aside. Embarrassed Alia does so and goes to join the servants who are standing in a cluster nearby.

The camera in the meantime has been following all of these transitions in what is essentially a single, prolonged tracking shot, interspersed with a minimum of cuts to show, where necessary, an emotional response in close-up. As such, when the formal photograph is being set up and taken, there is an overt sense of one kind of spatiality (that generated by Tlatli's camera) suddenly being juxtaposed with another. The event of the formal photograph has produced a kind of stiff artificiality and a classification of individuals into two distinct groups (masters and servants) – a sharply demarcated scenario in which the undecidability of Alia's position becomes painfully more-than-obvious. For Alia, even the sound-world, with the sudden intrusion of French, a language she does not understand, pushes her away, alienating and humiliating her as much as the photographer's act of excluding her from the still camera's frame. Once the photograph has been taken, the family group disperses as if this scenario of unambiguous divisiveness can be only superficially and temporarily sustained. This dispersion coincides with a further call: Sid Ali wants Alia to be photographed with him and Sarra as if they are all, now, on an equal footing. To repeat, though, particularly significant in this entire, evolving scene is the contrast between the segmented and divisive 'looking' of the still camera as it captures a formal scenario that it has been called upon to both to produce and prolong, and the flowing, cinematic observations of Tlatli's camera, which refuse to divide and rule. As Alia is ejected from the formal scene, Tlatli's camera holds on to her; it seems to attend to her, going where she goes, gathering together her shifting emotions as she faces rejection and then accepts the informal acknowledgement of posing with Sid Ali and Sarra. Indeed, in contrast to the still camera's single frame picturing, Tlatli's movie camera functions in an accumulative mode. Its long – sometimes very long – tracking shots, shots which will have taken much planning and precision to choreograph, enable a host of contradictions to be taken into account and shown together as part of the same fundamental reality. When interviewed, and in the context of a discussion of editing, Tlatli elaborated on this cinematic preference, favouring it for the way in which it also *slows everything down*. This is in contrast to what she describes as a Western propensity for accelerated cutting and thus for fast-moving shots, scenes and sequences. Indeed, she spoke in terms of her desire to adjust the pace of the film to that of:

> the bodies of women who move, and work, with all the time in the world I couldn't allow myself to show them in an 'efficient' montage, which would be false, because the content and the form would not

correspond. I had to show them in their own rhythm, in their own way of living and breathing. I had to show the slowness of their lives through my use of the camera.[98]

Tlatli's cinematic slowing down of things, of course, forces a particular quality of attentiveness. It allows detail and nuance to emerge. Most significantly, to repeat, it allows a host of complexities, ambiguities, tensions and possibilities to be held together within a single take, within a single, extended cinematic gaze. There is an emphasis on making or remaking connections in which there is room for incompatibility and the coexistence of differences. And here, a second sequence is worth considering. It comes much later in the film. At this stage of the narrative, Alia's mother can hide no longer from the fear that she is pregnant. She enters the kitchen with Khalti Hadda who offers to help her:

'No, leave me alone', she screams.

The scream is shattering. The others, who have been working quietly in the kitchen, turn around. Alia, who unbeknownst to her mother was also approaching the kitchen at that moment, flinches with shock.

'Let me go. I hate myself. Everything disgusts me; I hate my body.'

Khedija wraps her arms around herself. She weeps, as does Alia, who is still secreted near to the kitchen's entrance. Then a terrible silence descends and Tlatli's camera embarks upon an extraordinary, slowly moving tracking shot that takes in the reactions of the other women. To begin with, the camera avoids their faces, as if honouring their privacy – Khedija's scream of anguish was also theirs. Instead, we see their hands at work, hands which had at first been pictured as swift and efficient, but which now appear to be moving in agonizing slow motion. Again, the camera is not merely recording a scene, but holding, even embracing it.

A second characteristic of Tlatli's cinematography is also significant. The camera's positioning in and movement through space ensures that, like the women living in the palace, we, as viewers, remain immersed or encased within the scenarios being portrayed. We too are on the inside, and this is something we experience viscerally. There are no establishing shots. The camera never looks down upon the palace from above, or from far enough away so that we see it in its entirety and locate its edges. It is as if the palace has no edges. It is endlessly labyrinthine. Even its gardens are in this sense 'inside', and any desires we might have to get out of this image-world are

thwarted, as they are for Alia and the other women. In the film as a whole, therefore, and in our position of immersion, we are denied the privileged perspective that is so often on offer to cinema audiences. We never know more, or see differently, than do the characters themselves. Like the women, we are cut off from non-immediate, non-domestic concerns. Thus, it is only gradually that we learn of the political situation framing this story and begin to consider whether, and to what degree, this story of an individual struggle for liberty is also metaphorical of political struggle. As noted, the day on which Alia escaped from the palace – also the day of her mother's death – coincided with the day when the nation's political independence was gained, but we already know that Alia only went on to exchange one sense of imprisonment for another.

In any case, it is, I think, within the context of this cinematic insistence upon remaining inside, that a formulation concerning the nature and location of freedom may be found. For if the focus is upon the inside, and on detail, this is because the solution, if there is one, must also be found on the inside and in the details. It cannot be imported from without. Indeed, in a sense, there is no 'without' and there is no place of escape. Having made this point, though, Tlatli's camera also shows us that (like the surface as discussed in 'Appearance is everything'), the inside, when it reveals itself on its own terms, is more expansive and replete with possibilities than we might at first suppose. And so we see that Tlatli's insider approach also challenges the oppositional, externally oriented models for change that generally undergird political and other forms of revolution, suggesting that however, and wherever we might try to apply them, they will prove inadequate. As such, her approach provides an implicit critique of those Third Cinema conventions in which the revolutionary potential of film had been associated with a notion of the camera as a weapon – as a 'gun', as expressed in the writing of the Argentine directors Fernando Solanas and Octavio Getino.[99] Indeed, *The Silences of the Palace* posits that wherever else we may take 'the enemy' to be, our most difficult to identify foes – and therefore also our deadliest – are located in the territories we designate, precisely, as within. As discussed in 'Image wars', this is analogous with the difficult discoveries that Fanon's narrator made in *Black Skin, White Masks*. The end result of such an understanding is an approach to life, and to the narration of life, that is at once uncompromising and compassionate.

Indeed, the non-oppositional position that Tlatli adopts, as she attempts to unravel the conditions and character of oppression, makes for complex and often contradictory portrayals of character. No-one is presented wholly as victim or oppressor. Thus issues of internal ambivalence, guilt, innocence, complicity, rebellion, and so on are opened up. This instability of character

is played out in the film in a variety of ways, but particularly, perhaps, through the portrayal of Sid Ali. Within the scene described earlier, when the formal and informal photographic group portraits are being taken, his very real affection and sympathy for Alia seem to be emphasized. But later in the film, his equally real, but more or less hidden, predatory position within this narrative of servitude and exploitation becomes apparent. Suddenly we are made powerfully aware of one of the hardest facts that I think the film communicates, that is, the way in which the lovers of women (Sid Ali in the case of Alia's mother; Lotfi in the case of Alia) and their de facto predators or destroyers can intersect in one body. This understanding, however – since it is revealed to Alia and to the viewer, only gradually, gently, and with a compassion that is also directed towards the men at the heart of this story – is not intended to produce paranoia. Instead it breaks the silence of complicity and shows Alia, in any case, that it is possible for her to resolve the conflict and oppression in which she has been embedded. At issue is the revelation of new configurations of response and action, and new forms of human perception, that have already been prefigured by Tlatli's camera. These are logics, therefore, analogous to those generated by Caillois's diagonal sciences discussed earlier, whose purpose was to enable lines of communication between existences that were seen to coexist but not to communicate.[100]

And so Tlatli's film ends with Alia, quiet and thoughtful, walking through the garden towards those same wrought iron gates, and pausing finally to crouch beside the gazebo where she had joined Sarra in her music lesson all those years ago. In voiceover (there have been moments of voiceover throughout the film) she speaks to her mother, whose funeral, we learned earlier, she had failed to attend.

> I thought that Lotfi would save me. I have not been saved. Like you, I've suffered, I've sweated. Like you, I've lived in sin. My life has been a series of abortions. I could never express myself. My songs were stillborn. And even the child inside me Lotfi wants me to abort.

But, she continues: 'This child . . . I feel it has taken root in me. I feel it bringing me back to life. Bringing me back to you. I hope it will be a girl. I'll call her Khedija.' We know that when she leaves the palace this time, she will, in fact, be leaving it for the first time. We know that for Alia a new gateway has opened of which *she* is the hinge. This brings me finally to that working note written by Merleau-Ponty.

Taken as a whole, the note bears a thought-provoking relationship to the broad subject-matter of *The Silences of the Palace*. It too concerns our engagements with material and meanings which, for whatever reason, are not immediately or consciously available to us. It attempts to understand the

mechanisms whereby, suddenly, so it seems, we may either grasp those meanings holistically, and all at once, in a way that is difficult to explain, or find ourselves responding to them without being aware that we have apprehended anything at all. The first example that Merleau-Ponty provides is very ordinary: that of being linguistically unskilled, in a foreign country, and at first not understanding what is being said to us:

> The taxi driver at Manchester, saying to me (I understood only a few seconds later so briskly were the words 'struck off'): I will ask the police where *Brixton Avenue* is – Likewise, in the tobacco shop, the woman's phrase: *Shall I wrap them together?* which I understood only after a few seconds and *all at once* – cf. recognizing someone from a description or the event from a schematic prevision.[101]

Then, drawing on the holistic logics of gestalt theory – which had been important for his thought throughout his career – he argues that the individual signs (here, words spoken in a foreign language) become understandable once the gestalt is perceived, and he reflects on the non-linear temporalities at issue here. The question is though: how is this meaning transmitted? His speculation: it is given and received unconsciously. He writes – again schematically – that 'there is a *germination* of what *will have been* understood', and, of the unconscious, that it 'functions as a pivot, an existential, and in this sense, is and is not perceived'. He continues, evocatively: 'For one perceives only figures upon levels – And one perceives them only by relation to the level, which therefore is unperceived. – The perception of the level: always between the objects.'[102] This territory therefore accords with that region not of sight, but of coming to appearance, that López, for instance, had described when he spoke of his works being realms of permeation which 'contain certain things without those things being explicit',[103] and again when he referred to that moment when 'real forms get to the point where they contain the unreal, within the objects or the light'.[104]

Merleau-Ponty also turns to a second example. I am particularly interested in it for what it tells us about the relationship between seeing, being seen and self-showing. Again, it consists of a short sequence of words, easily overlooked, lying quietly within those constructions of dashes, ellipses and still-schematic sentences that characterize the working notes. Referring to a woman 'in the street feeling that they are looking at her breast, and checking her clothing',[105] he again raises questions about the type of perception that is occurring here, and how it is operating.

> Here the impression of telepathy, of the occult = vivacity in reading the look of the other in a flash – Should we say *reading*? It is on the contrary

by means of this phenomenon that one comprehends reading – To be sure, if a woman of good faith who closes her coat (or the contrary), were questioned, she would not *know* what she has just done. She would not know it in the language of conventional thought, but she would know it as one knows the repressed, that is, not as a figure on a ground, but as ground. A detail perception: a wave that runs on in the field of the *In der Welt Sein*[.][106]

Knowing the repressed – as was the case with Alia, we apprehend more than we may be willing to admit. But, Merleau-Ponty insists, perception is not just, or primarily, something we do, something we control. It is also something that happens in and around us, and in which we participate. 'I do not perceive any more than I speak – Perception has me as has language.'[107] It is something that happens alongside us; perception is installed in that fundamental realm of self-showing that is bursting with life and with possibility, and into which, like the salvation of the Christians, we have the invitation, the choice, to enter, participate, plunge – or not. And preferably to plunge since such commitments to self-showing are not for the faint hearted.

And then there is the observation of the greatest interest to me because overtly at issue is that crucial sense of gap or distinction between being seen and self-showing that is central to my own argument. For when Merleau-Ponty writes of this woman who feels 'that they are looking at her breast, and checking her clothing' he adds that 'Her corporeal schema is for itself – for the other – It is the hinge of the for itself and the for the other.'[108]

This is a powerful image, and I have already referred to some of its varied connotations. What is especially significant though is the way in which it not only recalls, but also contrasts with our discussions, in 'Image wars', of Fanon's narrator embroiled in that battle with his own image, described as attempting to maintain a vital gap between his corporeal and his epidermal schemata. To begin with, he found himself to be torn down the middle; a split subject, in a position from which creative forms of agency in the world are overwhelmingly difficult to perform. This condition has been differently theorized by others, as 'double consciousness' by W. E. B. Du Bois, for instance. As discussed, Fanon's project of disalienation then sought to take his subject beyond that point of apparently irresolvable conflict. In Merleau-Ponty's example, gender, not race, is the point of focus but his woman is confronted with a situation analogous to that of Fanon's protagonist. But, as described by Merleau-Ponty – and here I am also playing a little with his thought; somewhat recontextualizing it – in fact she is very differently positioned within that gap between being seen (the 'for the other') and self-showing (the 'for itself'). First, she is not in that terrible condition of strain that

is brought about by trying to hold apart two powerful forces that are seeking to unite. Rather, her 'schema', as hinge, is centred, stable *and* flexible. As such, despite the sense of discomfort that is also at issue, her configuration within the realm of visibility is one of peace – peace, that is, in the sense of *shalom*, which is an active and generative term. This is crucial since it enables that receptiveness and alertness that is foundational to individuated action (rather than reaction) – to taking that plunge – to clear and courageous thinking, and to creativity; where the latter is concerned, the conventional, romantic equation of creativity with disorder and an often destructive and self-destructive wildness is something of a false image.

'Woman', then, as hinge. A metaphor, and a forceful one, and one, surely, that is worth enacting. It conveys cohesion and strength, but is a spine of being that is also yielding and mobile. It is also an actuality, a mode of lived agency is which the challenges – but above all the delights – of showing and self-showing, and of self-as-image, may be taken up and given away. What doors into what rooms – what *darkrooms* even – and into what ventures and adventures might be opened up as a result? Doors, perhaps, that we *thought* we did not know were there, but whose presence we had sensed all along?

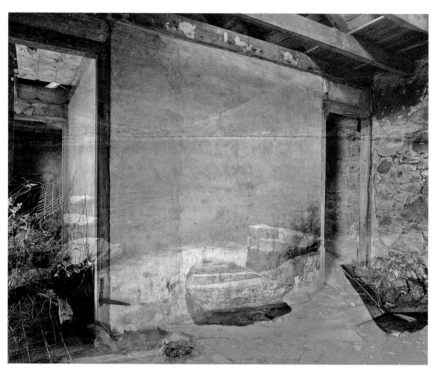

FIGURE 8 *Carolyn Lefley, 'Realm #6, Llyn Cwm Llwch' from the series* Realm, *2009–12. © Carolyn Lefley. Reproduced with permission.*

Notes

Introduction

1 See 'List of Major Financial Centres in Asia', *World City Information* (19 January 2012). www.city-infos.com/list-of-major-financial-centres-in-asia (Accessed 24 October 2013).

2 Cinema came early to India. On 7 July 1896, for instance, representatives of the Lumière Brothers held a film screening at Mumbai (Bombay)'s Watson's Hotel. On 13 May 1913, Dadasaheb Phalke, hailed as the 'father' of India cinema, released his silent film *Raja Harishchandra*. According to film historians, although this was not the first film to be made in India, it was regarded as inaugural to the creation of the Indian Film Industry because of Phalke's advocacy of the nationalistic philosophy of *swadeshi*, a political movement in British India that encouraged Indians to take charge of their own economy by focusing on domestic production and boycotting foreign, especially British, goods as a step toward home rule.

3 Later in *Showing Off*, I will draw on phenomenological arguments that take self-showing to be a fundamental characteristic of the non-human world too.

4 Donald Hoffman, *Visual Intelligence: How We Create What We See* (New York and London: W. W. Norton, 1998), 13. This characteristic of the visual has also been much discussed in the fields of art history and cultural theory. Most famously, perhaps, by Roland Barthes who wrote of the need, where precise communication is required, for visual imagery to be carefully anchored by captions or other verbal formations.

5 Ibid., 14 and 15.

6 Particular sources of inspiration are Hannah Arendt's discussions of appearance in 'Appearance', the first section of *The Life of the Mind: Thinking* [1971] (London: Secker and Warburg, 1978).

7 Hal Foster, *The First Pop Age* (Princeton and Oxford: Princeton University Press, 2012), 8–9.

8 Ibid., 8.

9 Jean Baudrillard, 'Transsexuality', *The Transparency of Evil: Essays on Extreme Phenomena*, trans. James Benedict (London: Verso, 1993), 20–5, 23.

10 Maurice Merleau-Ponty, 'Eye and Mind', in James M. Edie (ed.), *The Primacy of Perception* (Evanston: Northwestern University Press, 1964),

159–90, 168. The first insertion in square brackets is my own, the second is present in the original.

11 Paul Virilio, 'A Topographical Amnesia' [1988], *The Vision Machine* (Bloomington, IN: Indiana University Press, 1994), 1–18, 14.

12 Ibid., 14.

13 Ibid.

14 Ibid.

15 Nicholas Mirzoeff, 'Introduction', *The Visual Culture Reader* (3rd edition) (London and New York: Routledge, 2012), xxx.

16 Ibid., xxxi.

17 Ibid., xxx. The words in square brackets are my own insertions and are not in the original.

18 Ibid., xxxiii.

19 Ibid.

20 Peggy Phelan, *Unmarked: The Politics of Performance* (London and New York: Routledge, 1993). See, for instance, 1–2.

21 See, for instance, Iris Murdoch, *The Sovereignty of Good* [1970] (London and New York: Ark, 1989); Lawrence A. Blum, *Moral Perception and Particularity* (Cambridge: Cambridge University Press, 1994); Kaja Silverman, *The Threshold of the Visible World* (London and New York: Routledge, 1996); Edward S. Casey, *The World at a Glance* (Bloomington, IN: Indiana University Press, 2007); Jacques Rancière, *The Emancipated Spectator* (London: Verso, 2009), and his lecture/essay of the same title, first delivered in Frankfurt in 2004.

22 Blum, *Moral Perception and Particularity*, 30. He is making particular reference to essays published in Murdoch's *The Sovereignty of Good*.

23 He cites as contemporary exceptions Martha Nussbaum, Charles Larmore, Nancy Sherman and John Kekes.

24 Blum, *Moral Perception and Particularity*, 30.

25 Kaja Silverman wrote powerfully about the challenges facing such bodies in *The Threshold of the Visible World*.

26 Maurice Merleau-Ponty, *Phenomenology of Perception*, trans. Colin Smith (London and New York: Routledge, 1962), 68 (emphasis in the original).

27 Kaja Silverman, *World Spectators* (Stanford: Stanford University Press, 2000), 130.

28 Ibid.

29 Jean-Luc Marion, *Being Given: Toward a Phenomenology of Givenness* (Stanford: Stanford University Press, 2002).

30 By way of brief biographical introduction, Maurice Merleau-Ponty, who was born on 14 March 1908, in Rochefort-sur-Mer, France, studied philosophy at the École Normale Supérieure. He first worked as a philosophy teacher in grammar schools in Beauvais, Chartres and Paris. In 1945, he was granted his doctorate on the basis of two dissertations

La Structure du Comportement (*The Structure of Behavior*) of 1942 and his *Phénoménologie de la Perception* (*Phenomenology of Perception*) of 1945. Merleau-Ponty's academic career began with an appointment as a professor at the University of Lyons. In 1949 he was appointed to teach psychology and pedagogy at the Sorbonne in Paris, and in 1952 he was awarded Chair of Philosophy at the Collège de France where he remained until his sudden death on 3 May 1961. Throughout his career, beginning with his collaborations with Jean-Paul Sartre, Simone de Beauvoir, and others – more on this in a later chapter – he was also committed to applying his phenomenological perspectives to wide-ranging contemporary concerns in such areas as the arts, culture, economics, history and politics.

31 Merleau-Ponty, *Phenomenology of Perception*, 361.

32 See Jorella Andrews, 'Vision, Violence and the Other: A Merleau-Pontean Ethics', in Gail Weiss and Dorothea Olkowski (eds), *Feminist Interpretations of Merleau-Ponty* (University Park, PA: Pennsylvania State University Press, 2006), 167–82.

33 Maurice Merleau-Ponty, 'In Praise of Philosophy', in *In Praise of Philosophy and Other Essays* (Evanston: Northwestern University Press, 1963), 3–76, 4–5 (emphasis in the original).

34 Ibid., 5.

35 Maurice Merleau-Ponty, 'The Primacy of Perception and Its Philosophical Consequences', in James M. Edie (ed.), *The Primacy of Perception* (Evanston: Northwestern University Press, 1964), 12–42, 15–16.

36 Merleau-Ponty, 'Eye and Mind', 167.

37 Ibid.

38 Ibid., 169.

39 Ibid., 168.

40 Maurice Merleau-Ponty, *The Visible and the Invisible*, trans. A. Lingis (Evanston: Northwestern University Press, 1968), 133.

41 René Magritte, 'Letter to Alphonse de Waelhens (28 April 1962)', in Galen A. Johnson and Michael Bradley Smith (eds), *The Merleau-Ponty Aesthetics Reader: Philosophy and Painting* (Evanston: Northwestern University Press, 1993), 336.

42 Merleau-Ponty, 'Eye and Mind', 168.

43 Maurice Merleau-Ponty, 'Indirect Language and the Voices of Silence', *Signs* (Evanston: Northwestern University Press, 1964), 39–83, 68.

44 André Malraux's *The Voices of Silence* (*Les Voix du Silence*) was a one-volume revised version of his three-volume work, *The Psychology of Art*, which had been published between 1947 and 1949. Malraux would later become France's first Minister of Cultural Affairs (1959–69).

45 Merleau-Ponty, 'Indirect Language and the Voices of Silence', 47.

46 Ibid. The insertion is square brackets is my own, and is not in the original.

47 Ibid., 52.

Chapter 1

1 Alasdair MacIntyre, *After Virtue: A Study in Moral Theory* [1981] (London: Duckworth, 2002), 213.

2 Ibid., 216.

3 Ibid., 213.

4 Ibid., 216.

5 Ibid., 213. MacIntyre's focus on narrative came at a time when post-modern and post-structuralist theorists were challenging certain accepted ideas about the role of narrative and metanarrative in maintaining the flow of power and knowledge along established routes. In the introduction to *After Virtue*, titled 'A Disquieting Suggestion', MacIntyre writes that his thesis entails that we live in a culture in which 'the language and the appearances of morality persist even though the integral substance of morality has to a large degree been fragmented and then in part destroyed' (ibid., 5). He also issues a challenge to analytical philosophy, existentialism and phenomenology (the latter being a challenge I would want to question), claiming that none is able to discern this state of disorder, since their resources do not enable them to access the past. As he puts it, their techniques are 'essentially descriptive and descriptive of the language of the present at that'. Where phenomenology is concerned, he writes, 'all the structures of intentionality would be what they are now' (ibid., 2).

6 Pushpamala N. and Clare Arni, *The Ethnographic Series. Native Women of South India: Manners and Customs*, 2000–4, 45 sepia-toned silver gelatin prints. Accessible online at www.saatchi-gallery.co.uk/artists/artpages/pushpamala_n_installation1.htm

7 It is also worth bearing in mind that, at a broader metaphorical level, a dominant trope within the history of art, and one much used in nationalist, colonial and post-colonial visual discourse, involves the representation of woman as a symbol for place, for a particular nation or region. The classical Western figure of Europa would be one such example. *Indian Lady*'s juxtaposition of woman and location also seems to evoke this convention. As discussed in the previous chapter, here again we see how notions of the individual and particular, and the collective intertwine.

8 See, for instance, www.city-infos.com/list-of-major-financial-centres-in-asia and 'Mumbai's Population' (2012), *India Online Pages*, www.indiaonlinepages.com/population/mumbai-population.html. Both accessed 23 October 2013.

9 Marta Jakimowicz, 'The Self versus Self-Images and the Cliché', in *Pushpamala N: Indian Lady* (BP Contemporary Art of India Series, Volume 19) (New York: Bose Pacia, 2004), n.p.

10 Carl Haub and O. P. Sharma, 'India's Population Reality: Reconciling Change and Tradition', *Population Bulletin*, 61.3 (September 2006), 10. This is also the figure recorded in *India Online Pages*, www.indiaonlinepages.com/population/slum-population-in-india.html

11 See, Carl Haub and O. P. Sharma, 'What Is Poverty, Really? The Case of India', Population Reference Bureau (January 2010). Available online at www.prb.org/Articles/2010/indiapoverty.aspx (Accessed 31 January 2012). There they report that, while it is very difficult to be accurate, according to the World Bank, in 2009, 41.6 per cent of India's population was living below the poverty line at $1.25 per day, and 75.6 per cent below the poverty line at $2 per day.

12 See Derek Bose, 'Introduction', *Brand Bollywood: A New Global Entertainment Order* (New Delhi, Thousand Oaks and London: Sage Publications, 2006), for more on this.

13 Ibid., 11.

14 Rajesh Devraj with Edo Bouman, *The Art of Bollywood*, Paul Duncan (ed.) (Hong Kong, Köln and London: Taschen, 2010), 7.

15 Ravi Vasudevan, *The Melodramatic Public: Film Form and Spectatorship in Indian Cinema* (New York: Palgrave Macmillan, 2011), 35.

16 Bose, 'Introduction', 22.

17 Pushpamala N., 'National and Global: N Rajyalakshmi, Chief Reporter of the *Ideal Times*, Bangalore, interviews the artist Pushpamala N about her views on internationalism', in *Pushpamala N: Indian Lady* (BP Contemporary Art of India Series, Volume 19) (New York: Bose Pacia, 2004), n. p.

18 Ibid. The video's aesthetic is also reminiscent of the bazaar-based photographic studios that have remained popular in India since the earliest days of photography.

19 Devraj and Bouman, *The Art of Bollywood*, 9.

20 Vasudevan, *The Melodramatic Public*, 28.

21 M. Madhava Prasad, 'The Last Remake of Indian Modernity', in *Pushpamala N: Indian Lady* (BP Contemporary Art of India Series, Volume 19) (New York: Bose Pacia, 2004), n.p.

22 As has been much discussed by film theorists, from the late nineteenth century onwards, in many locations around the globe, film as a new form of entertainment developed alongside and in conversation with new forms of metropolitan modernity.

23 Devraj and Bouman, *The Art of Bollywood*, 128.

24 Ibid., 125. See also Sharmistha Gooptu's earlier article 'Bollywood's Foreign Affairs' in *Verve Online*, 15.4 (April 2007). www.verveonline.com/48/life/bollywood.shtml (Accessed 30 January 2012).

25 Prasad, 'The Last Remake of Indian Modernity', n.p.

26 Jakimowicz, 'The Self versus Self-Images', n.p. In this regard, see also Luce Irigaray, *This Sex Which Is Not One*, trans. Catherine Porter and Carolyn Burke (Ithaca: Cornell University Press, 1985), 133–4:

> The belief that it is necessary to *become* a woman, a 'normal' one at that, whereas a man is a man from the outset. [. . .] a woman has to become a normal woman, that is, has to enter the *masquerade of femininity* [. . .], [has to enter] into a system of values that is not hers, and in which she

can 'appear' and circulate only when enveloped in the needs/desires/ fantasies of others, namely men.

27 Walter Lippmann, *Public Opinion* [1922] (New Brunswick, NJ: Transaction Publishers, 1991), 96.

28 Ibid., 98.

29 Ibid., 98–9.

30 Vijay Mishra, *Bollywood Cinema: Temples of Desire* (New York and London: Routledge, 2002), 5.

31 Ibid., 4.

32 Ibid., 100.

33 All quotations from *Sangam* are transcribed from the film's subtitled translations into English.

34 Weblog entry: 'Sangam, Raj Kapoor's Murky Waters', 2 January 2009. http://letstalkaboutbollywood.over-blog.org/article-26350946.html (Accessed 30 January 2012).

35 During January 2012, for instance, protests were in force in the United States concerning the government's attempt to pass the Stop Online Piracy Act (SOPA). As I understand it, the main objection was not so much to the issue of IP protection that the act was devised to protect, but to its provision that websites contravening the act could be unilaterally closed down, this being regarded by protesters as an unconstitutional breach of freedom of speech.

36 I will return to this point in the third chapter of this book, 'Image wars', when I discuss the 2002–3 rebranding of the UK broadcaster currently known as Channel 5.

37 Editorial: 'Originality in Art', The *New York Times*, 24 July 1881. Available online at http://query.nytimes.com/gst/abstract.html?res=F00C1EFD385A11 738DDDAD0A94DF405B8184F0D3

38 Ibid.

39 Carey Young, *Colour Guide*, 2004, translucent vinyl film applied to window, framed email printout on paper. Commissioned by Index, Stockholm. Available to view online at www.careyyoung.com/past/colourguide.html (Accessed 28 January 2012).

40 'Painting by Numbers: The Search for a People's Art, Interview with Alex Melamid', *The Nation* (14 March 1994): 334–48. See http://awp.diaart.org/ km/nation.html (Accessed 31 January 2012).

41 Ibid.

42 Ibid.

43 Vitaly Komar and Alex Melamid, 'The Most Wanted Paintings on the Web'. Available online at http://awp.diaart.org/km/painting.html (Accessed 31 January 2012).

44 Melamid interview, *The Nation*.

45 Michael Govan, 'Director's Introduction to The Most Wanted Paintings on the Web', Dia Center for the Arts. http://awp.diaart.org/km/intro.html (Accessed 31 January 2012).

46 'The Economist – How to Build a Brand on Outdoor' (an advertising story published by D&AD (British Design and Art Directors)) in association with Royal Mail, 4 October 2006. Available online at http://fideliuganda. com/analysis/bestpractisearticle/itemId/i65767739/index.html (Accessed 23 October 2013).

47 There have been some deviations from this, such as the *Economist*'s 'Smarties' poster, a Silver Award Winner at D&AD in 2001.

48 Isaiah 60.1–5a, *The Holy Bible*, New International Version (Reference Edition with Concordance and Maps) [1973] (London, Sydney, Auckland, Toronto: Hodder and Stoughton, 1984), 682.

49 See www.economistgroup.com/what_we_do/our_brands/the_Economist_ brand_family/the_Economist.html (Accessed 30 January 2012).

50 James Wilson 'championed free trade, internationalism, and minimum interference by government' stating that 'we seriously believe that (free) trade, free intercourse, will do more than any other visible agent to extend civilization and morality throughout the world – yes, to extinguish slavery itself [. . .].' Available online at www.economist.com/ help/about-us (Accessed 30 January 2012). For more information see Ruth Dudley Edwards's history of the *Economist* titled *The Pursuit of Reason: The Economist 1843–1993* (Boston: Harvard Business Review Press, 1995).

51 'The *Economist* is different from other publications because it has no by-lines. It is written anonymously because it is a paper whose collective voice and personality matter more than the identities of individual journalists. This ensures a continuity of tradition and consistency of view which few other publications can match.' www.economistgroup.com/what_ we_do/editorial_philosophy.html (Accessed 6 January 2009).

52 See www.economistgroup.com/what_we_do/editorial_philosophy.html (Accessed 30 January 2012).

53 See 'The Economist: About Us'. Available online at www.economist.com/ help/about-us (Accessed 31 January 2012).

54 Camiel van Winkel, *The Regime of Visibility/Het primaat van de zichtbaarheid* (Rotterdam: NAi Publishers, 2005), 15.

55 Ibid.

56 See 'World Internet Usage and Population Statistics: 30 June 2012', *Internet World Stats: Usage and Population Statistics*. Available online at www.internetworldstats.com/stats.htm. Copyright © 2001–13, Miniwatts Marketing Group. All rights reserved worldwide (Accessed 23 October 2013).

57 Alfredo Jaar in conversation with Wolfgang Brückle and Rachel Mader, 'Die Mise-en-scène ist fundamental', *Camera Austria*, 86 (2004). Available online at www.camera-austria.at/zeitschrift.php?id=1086622067&mainsub=beitra g&bid=-186214297 (Accessed 30 January 2012).

58 Documentation of the project is available at http://universes-in-universe.de/ car/documenta/11/frid/e-jaar-2.htm (Accessed 22 January 2012).

59 Jaar with Brückle and Mader, 'Die Mise-en-scène ist fundamental'.

60 Ibid.

61 Jacques Rancière, *The Politics of Aesthetics: The Distribution of the Sensible* (London and New York: Continuum International Publishing Group, 2006).

62 J. J. Charlesworth, Jacques Rancière (Interview), *Art Review*, 40 (April 2010): 72–5, 73.

63 Ibid., 75.

64 *Broadcast*. Curated by Irene Hofmann and co-organized by iCI, New York, and the Contemporary Museum, Baltimore. MOCAD (Museum of Contemporary Art, Detroit), 12 September–28 December 2008. Available online at www.mocadetroit.org/exhibitions/broadcast.html (Accessed 3 February 2012).

65 Marshall McLuhan, *Understanding Media: The Extensions of Man* [1964] (Cambridge, MA: MIT Press, 1994), 5.

66 See again Virilio, 'A Topographical Amnesia', 1–18, 4–5.

Chapter 2

1 Merleau-Ponty, *Phenomenology of Perception*, 68 (emphasis in the original).

2 Luce Irigaray, 'Interview', in Marie-Françoise Hans and Gilles Lapouge (eds), *Les femmes, la pornographie et l'érotisme* (Paris: Éditions du Seuil, 1978), 43–58, 50.

3 Jacques Lacan, *The Four Fundamental Concepts of Psycho-Analysis* (Harmondsworth: Penguin Books 1977), 84. One of several definitions of the Gaze.

4 Irigaray, 'Interview', 50.

5 Laura Mulvey, 'Visual Pleasure and Narrative Cinema', *Screen* 16.3 (Autumn 1975), 6–18.

6 Or original error, being based on certain false premises.

7 Wolfgang Welsch, 'On the Way to an Auditive Culture?' *Undoing Aesthetics* (London, Thousand Oaks and New Delhi: Sage Publications, 1997), 150–67, 154–5. Originally published in German in 1993. At the start of this essay, he wrote that, compared to the person who sees, 'the person who hears is also the better person – one, that is, able to enter into something different and to respect instead of merely dominating it'. Moreover, he insists: 'A continued existence of the human species and planet earth is to be hoped for only if our culture in future takes hearing as its basic model, since in technicized modernity the old dominance of vision is driving us unavoidably towards a catastrophe, from which only hearing's receptive, communicative, semiotic relationship to the world is able to keep us' (ibid., 150).

8 Ibid., 155.

9 Merleau-Ponty, Working Note, dated 2 May 1959, *The Visible and the Invisible*, trans. A. Lingis (Evanston: Northwestern University Press,

1968), 189. The actual text reads: ' – To have a body is to be looked at (it is not only that), it is to be *visible*' (emphasis in the original).

10 Merleau-Ponty, *Phenomenology of Perception*, 57.

11 Maurice Merleau-Ponty, 'The Intertwining – The Chiasm', *The Visible and the Invisible*, trans. A. Lingis (Evanston: Northwestern University Press, 1968), 130.

12 Merleau-Ponty, *Phenomenology of Perception*, xxi.

13 Ibid., xx–xxi.

14 Ibid., xxi.

15 Jean-Paul Sartre, 'Merleau-Ponty', [1964], *Situations*, trans. Benita Eisler (New York: George Braziller, 1965), 322.

16 Merleau-Ponty, 'Indirect Language and the Voices of Silence', 45.

17 Martin Jay makes this point in *Downcast Eyes: The Denigration of Vision in Twentieth-Century French Thought* (Berkeley, Los Angeles and London: University of California Press, 1994).

18 Merleau-Ponty, *Phenomenology of Perception*, 52.

19 Ibid., 67.

20 Ibid. 67–8.

21 Ibid., 68 (emphasis in the original).

22 Wolfgang Welsch, 'Aesthetics Beyond Aesthetics: For a New Form to the Discipline', in *Undoing Aesthetics* (London, Thousand Oaks and New Delhi: Sage Publications, 1997), 78–102, 87.

23 Maurice Merleau-Ponty, 'Cézanne's Doubt', *Sense of Non-Sense* (Evanston: Northwestern University Press, 1964), 9–25, 16.

24 Ibid., 16.

25 Ibid., 12.

26 Ibid.

27 Ibid.

28 John Locke, *An Essay Concerning Human Understanding* (London: Penguin Books, 1997).

29 Merleau-Ponty, 'Cézanne's Doubt', 13 and 14.

30 Merleau-Ponty, 'Eye and Mind', 159–90, 180.

31 Ibid.

32 Merleau-Ponty, 'Cézanne's Doubt', 14.

33 Merleau-Ponty, *Phenomenology of Perception*, 68.

34 Leon Battista Alberti, *On Painting and Sculpture*, trans. Cecil Grayson (London: Phaidon Press, 1972), 37 (Book 1:1).

35 This sensibility permeates the whole of *On Painting*, but see in particular Alberti's discussions at the beginning of Book 1 of *On Painting*, and in Book 3. For instance: 'The fundamental principle will be that all the steps of learning should be sought from Nature [. . .]' (ibid., 97, paragraphs 55 and 56).

36 Merleau-Ponty, *Phenomenology of Perception*, 68.

37 Paul Cézanne, *Mont Sainte-Victoire*, 1885–7, oil on canvas, 67 × 92 cm (26.4 × 36.2 in), Courtauld Institute of Art, London.

38 See, for instance, www.courtauld.ac.uk/gallery/collections/paintings/imppostimp/Cézanne_montagne.shtml (Accessed 13 May 2012).

39 Maurice Merleau-Ponty, 'Cézanne's Doubt', 16.

40 Maurice Merleau-Ponty, 'The Primacy of Perception and Its Philosophical Consequences', *The Primacy of Perception* (Evanston: Northwestern University Press, 1964), 12–42, 15–16.

41 Merleau-Ponty, *Phenomenology of Perception*, 68.

42 Alberti, *On Painting and Sculpture*, 87.

43 Paul Moorhouse (ed.), *Anthony Caro* (exhibition catalogue) (London: Tate Publishing, 2005), 7 (Exhibition dates: 26 January to 17 April 2005).

44 Ibid., 38.

45 Ibid.

46 Alex Potts, *The Sculptural Imagination: Figurative, Modernist, Minimalist* (New Haven and London: Yale University Press, 2000), 184–5.

47 Ibid., 185.

48 Moorhouse, *Anthony Caro*, 112. Unpublished typescript of lecture by Caro (Townsend lecture) from 1982.

49 The composition of the first *Les Temps Modernes* editorial board in October 1945 was Raymond Aron, Simone de Beauvoir, Michel Leiris, Merleau-Ponty (politique), Albert Ollivier, Jean Paulhan and Jean-Paul Sartre (director). Howard Davies, 'Appendix 1', *Sartre and 'Les Temps Modernes'* (Cambridge and London: Cambridge University Press, 1987), 215. In his 'Introduction', Davies notes that 'The origins of *Les Temps Modernes* can be traced to the short-lived Resistance group Socialisme et Liberté, founded by Sartre after his release from prisoner-of-war camp in 1941' and of which he, de Beauvoir, Jacques-Laurent Post, Merleau-Ponty and Pouillon were members.

50 Merleau-Ponty, 'The War Has Taken Place', *Sense and Non-Sense* (Evanston: Northwestern University Press, 1964), 139–52, 139.

51 Ibid., 139.

52 Ibid.

53 Hubert L. Dreyfus and Patricia Allen Dreyfus, 'Translators' Introduction', in Maurice Merleau-Ponty, *Sense and Non-Sense* (Evanston: Northwestern University Press, 1964), xxiii–xxiv.

54 Ibid., xxiii.

55 Ibid.

56 Ibid., xxiii–xxiv. The words in square brackets are not in the original text.

57 Merleau-Ponty, *Phenomenology of Perception*, xvi.

58 Ibid., xvi.

59 Ibid., xvi–xvii.

60 Ibid., xxi.

61 Ibid., xxi.

62 See 'Editorial Note', Merleau-Ponty, *The Visible and the Invisible*, xxxiv.

63 Ibid., 28.

64 Ibid., 40–1.

65 I am citing an account of the history of visuality found in Wolfgang Welsch, 'Aesthetics Beyond Aesthetics', *Action, Criticism and Theory for Music Education*, 2.2 (November 2002). http://act.maydaygroup.org/articles/Welsch2_2English.pdf (Accessed 12 June 2008).

66 See, for instance, research carried out in the United States by Gary L. Wells et al. in 1998 which showed that 'among 100 people who were convicted prior to the advent of DNA testing, approximately 75% were victims of mistaken eye-witness identification' (Gary L. Wells, Mark Small, Steven Penrod, Roy S. Malpass, Solomon M. Fulero and C. A. E. Brimacombe, 'Eyewitness Identification Procedures. Recommendations for Lineups and Photospreads', *Law and Human Behavior*, 22.6 (1998), 603–45). Cited in Gorazd Mesko, Milan Pagon and Bojan Dobovsek (eds), *Policing in Central and Eastern Europe: Dilemmas of Contemporary Criminal Justice*, Faculty of Criminal Justice, University of Maribor, Slovenia, Document 208001, December 2004. www.ncjrs.gov/pdffiles1/nij/Mesko/208001.pdf

67 See, for instance, Igor Areh and Peter Umek, 'Personal Characteristics and Validity of Eye-witness Testimony', in Gorazd Mesko, Milan Pagon and Bojan Dobovsek (eds), *Policing in Central and Eastern Europe: Dilemmas of Contemporary Criminal Justice*, Faculty of Criminal Justice, University of Maribor, Slovenia, Document 208001, December 2004. www.ncjrs.gov/pdffiles1/nij/Mesko/208001.pdf

68 A second edition, from which I am citing here, was published in 1777, namely, Courtney Melmoth, *The Pupil of Pleasure* (London: G. Robinson, and J. Bew in Pater Noster Row, 1777).

69 The *Spectator*, which started as a daily, one-page newspaper, was published by Richard Steele and Joseph Addison, who also published the *Tatler*. The first edition was published on 1 March 1711, and the paper continued until 6 December 1712. It was then started up again, without Steele, in 1714. Due to its availability in coffee-houses, it was widely read although its official circulation was only 3,000. It is still published today.

70 Joseph Addison, 'Uses of *The Spectator*', *Spectator*, 10 (12 March 1711). Edited by J. H. Fowler in the twentieth century and available online at www.ourcivilisation.com/smartboard/shop/fowlerjh/indexe.htm

71 James Boswell, *Boswell's Life of Johnson: Including Their Tour to the Hebrides. By J. W. Croker* (Oxford: Oxford University, 1851), 87.

72 Virginia Woolf, 'Lord Chesterfield's Letters to His Son', *The Common Reader: Second Series* (London: Hogarth Press, 1974), 86–92, 88.

73 Ibid., 91.

74 Ibid., 89.

75 Ibid. A little further on she writes that: 'It may be that the art of pleasing has some connection with the art of writing. To be polite, considerate, controlled, to sink one's egotism, to conceal rather than to obtrude one's personality, may profit the writer even as they profit the man of fashion' (ibid., 90).

76 Melmoth, *The Pupil of Pleasure*, Vol. 2, 133.

77 Ibid., 189.

78 Ibid., Vol. 1, 9.

79 Ibid., 198.

80 Ibid., 81.

81 Ibid., 90–1.

82 Ibid., 103.

83 Ibid., 115.

84 Ibid., 67.

85 Ibid., 94.

86 Ibid., 36.

87 Ibid., 75.

88 Ibid., 75–6.

89 Ibid., 117–18.

90 Ibid., 226.

91 The Ordinary was the name given to a public dining-room.

92 Melmoth, *The Pupil of Pleasure*, Vol. 1, 119–20 and 122.

93 Ibid., Vol. 2, 96.

94 Ibid., 14–15.

95 Ibid.,104.

96 Ibid., 104–6.

97 Ibid., 107.

98 Ibid., 106.

99 Ibid., 47.

100 Hannah Arendt, *The Life of the Mind: Thinking* (London: Secker and Warburg, 1978), 26. Here, Arendt is referencing Merleau-Ponty, *The Visible and the Invisible*, 40–1.

101 Ibid., 38.

102 Merleau-Ponty, *The Visible and the Invisible*, 8.

103 See Roger Caillois, *The Mask of Medusa*, trans. George Ordish (London: Victor Gollancz, 1964), 13.

104 Ibid., 13–14.

105 Ibid., 14.

106 Ibid. See also his 'Mimicry and Legendary Psychasthenia', *October*, 31 (Winter 1984), 17–32.

107 Caillois, *The Mask of Medusa*, 9.

108 Ibid., 9–10.

109 Ibid., 10.

110 Pliny the Elder, *Natural History: A Selection*, ed. John F. Healy (London: Penguin Books, 1991), 330.

111 Merleau-Ponty, 'Eye and Mind', 180.

112 Alberti, *On Painting and Sculpture*, 37 and 39.

113 Ibid., 37.

114 André Malraux, 'Museum Without Walls', in Stuart Gilbert (trans.), *The Voices of Silence* [1951] (Princeton, NJ: Princeton University Press, 1978), 13–46, 15–16.

115 Arendt, *The Life of the Mind*, 27.

116 Ibid.

Chapter 3

1 Genesis 1.26, *The Holy Bible*, 2.

2 Silverman, *Threshold of the Visible World*, 133.

3 Jean-Paul Sartre, *Being and Nothingness: An Essay on Phenomenological Ontology* (London and New York: Routledge, 1991), 364.

4 Dermot Moran, 'Introduction' to *Phenomenology* (London and New York: Routledge, 2000), 367.

5 Jean-Paul Sartre, *Nausea*, trans. Lloyd Alexander (New York: New Directions Publishing Corporation, 1964), 124.

6 Helen Fielding, 'White Logic and the Constancy of Color', in Dorothea Olkowski and Gail Weiss (eds), *Feminist Interpretations of Merleau-Ponty* (University Park, PA: Pennsylvania State University Press, 2006), 71–89, 80.

7 Jean-Paul Sartre, 'No Exit', in Stuart Gilbert (trans.), *No Exit, and Three Other Plays* (*Dirty Hands*, *The Flies*, *The Respectful Prostitute*) (New York: Vintage Books, 1946), 1–47, 26.

8 Ibid., 46.

9 Ibid., 43.

10 Ibid., 47.

11 Ibid.

12 Ibid., 10.

13 Ibid., 4–5.

14 Ibid., 3.

15 Ibid., 46.

16 Ibid., 4.

17 Ibid., 5.

18 Ibid., 6–7.

19 Ibid., 19.

20 Ibid., 19–20.

21 Ibid., 20.

22 Merleau-Ponty, 'Preface', *Phenomenology of Perception*, xii.

23 Ibid., xi.

24 Sartre, 'No Exit', 20–1.

25 Ibid., 9–10.

26 Ibid., 47.

27 Ibid., 30.

28 Ibid., 47.

29 Sartre, *Being and Nothingness*, 263.

30 Gail Weiss, 'Simone de Beauvoir: An Existential Phenomenological Ethics', in John J. Drummond and Lester E. Embree (eds), *Phenomenological Approaches to Moral Philosophy: A Handbook* (Dordrecht: Kluwer Academic Publishers, 2002), 107–18, 113.

31 Founded by Jean Ballard in 1925 and published until 1966, *Les Cahiers du Sud* published surrealist writers like René Crevel, Paul Éluard and Benjamin Péret, and ex-surrealists like Antonin Artaud and Robert Desnos. Henri Michaux, Michel Leiris, Pierre Reverdy, Simone Weil, Marguerite Yourcenar, Walter Benjamin and Paul Valéry were also among those published in the journal.

32 Merleau-Ponty, 'Metaphysics and the Novel', *Sense of Non-Sense* (Evanston: Northwestern University Press, 1964), 27.

33 Ibid., 32.

34 Ibid.

35 Ralph Ellison, 'Prologue', *Invisible Man* (New York: Random House, 1952), 11.

36 As Merleau-Ponty points out, she does so because, for the first time, she has been forced to confront the fact that she really is embodied, and she does not like it. Interestingly, and by way of contrast, in de Beauvoir's influential philosophical work, *The Second Sex* (1949) she argues that there is in fact a crucial way in which any woman who wants to be free must take herself out of circulation at the level of embodiment. That is, she must disavow, or rather transcend, the givens of her biologically conferred destiny to reproduce.

37 Merleau-Ponty, 'Metaphysics and the Novel', 29.

38 Ibid., 29–30.

39 Ibid., 37.

40 Phelan, *Unmarked: The Politics of Performance*, 6.

41 Ibid., 15.

42 Cited in Merleau-Ponty, 'Metaphysics and the Novel', 29.

43 Ellison, 'Prologue', 3.

44 Ibid., 5.

45 Ibid.

46 Ibid., 3 (emphasis in the original).

47 Ibid., 437, 438 and 439.

48 Ibid., 4.

49 Ibid., 4–5.

50 Ibid., 5–6.

51 Majid Yar, 'Panoptic Power and the Pathologisation of Vision: Critical Reflections on the Foucauldian Thesis', *Surveillance & Society*, 1.3 (2003), 254–71.

52 Ibid., 266.

53 Majid Yar and Simon Thompson, *The Politics of Misrecognition: Rethinking Political and International Theory* (Farnham, Surrey, and Burlington, VT: Ashgate Publishing, 2011), 4.

54 The Master of Alkmaar, *The Seven Works of Mercy*, 1504, Oil on panel, 101 × 54 cm (outer panels); 101 × 56 cm (others), Rijksmuseum, Amsterdam.

55 Jonathan Duffy, 'Channel 5's Naked Ambition', *BBC News Online* website (14 June 2000). http://news.bbc.co.uk/1/hi/entertainment/789384.stm (Accessed 24 September 2013).

56 See, for instance, *How to Look Good Naked*, *Desperate Virgins* and *Embarrassing Illnesses*, to mention only three, which are aired on Channel 4 (a channel that has such values as innovation and experimentation as part of its brand identity). Channel 4 was, of course, for many years the broadcaster of the reality show *Big Brother*, now a Channel 5 programme.

57 As a variation on this four-letter-word theme, on 23 January 2006, five (as it was then still called) launched new idents in which the channel's logo – five – was replaced with other four-letter words suggestive of emotion or energy, such as 'love', 'hope', 'rush' and 'live'.

58 These may be viewed on YouTube: www.youtube.com/watch?v=VNfX_hDai84 (Accessed 24 September 2013).

59 Ziauddin Sardar, 'Foreword to the 2008 Edition', in Frantz Fanon, *Black Skin, White Masks* [1952] (London: Pluto Press, 1986), x.

60 Teresa de Lauretis, 'Difference Embodied: Reflections on Black Skin, White Masks', *Parallax*, 8.2 (2002), 54–68, 54.

61 Ibid.

62 Ibid.

63 Fanon, *Black Skin, White Masks*, 109.

64 Ibid., 112.

65 Ibid.

66 Ibid., 112–13.

67 Ibid., 116.

68 Ibid., 112.

69 Ibid., 147–8.

70 Ibid., 116 (emphasis in the original).

71 Ibid., 112.

72 de Lauretis, 'Difference Embodied', 54.

73 Fanon, *Black Skin, White Masks*, 112.

74 Ibid.

75 Ibid., 112.

76 Ibid., 110.

77 See de Lauretis, 'Difference Embodied', 58.

78 Silverman, *Threshold of the Visible World*, 28.

79 Fanon, *Black Skin, White Masks*, 194.

80 Aimé Césaire, 'Et les chiens se taisaient/And the dogs were silent', in *Les Armes Micaculeuses* (Paris: Gallimard, 1946).

81 Fanon, *Black Skin, White Masks*, 198 (ellipses and emphasis in the original).

82 Ibid., 202 (emphases in the original).

83 Merleau-Ponty, 'Eye and Mind', 159–90, 167.

84 Yar and Thompson, *The Politics of Misrecognition*, 266.

85 See Sean Carter and Derek McCormack (after Brian Massumi) in 'Affectivity and Geopolitical Images', in Fraser McDonald, Rachel Hughes and Klaus Dodds (eds), *Observant States: Geopolitics and Visual Culture* (London: I.B. Tauris, 2010), 107. My thanks to Mafalda Dâmaso for alerting me to this well-worded definition.

86 Fanon, *Black Skin, White Masks*, 184.

87 Merleau-Ponty, *Phenomenology of Perception*, 361.

88 Fanon, *Black Skin, White Masks*, 163.

89 Ibid., 232.

90 Ibid., 112–13.

91 Both quotes are from Merleau-Ponty, *Phenomenology of Perception*, xii.

92 Merleau-Ponty, 'Metaphysics and the Novel', 37.

93 Merleau-Ponty, *Phenomenology of Perception*, xii–xiii.

94 Merleau-Ponty, *The Visible and the Invisible*, 78 (emphasis mine).

95 Merleau-Ponty, *Phenomenology of Perception*, 353.

96 André Malraux, *The Voices of Silence* (New York: Doubleday and Company, 1953), 14.

97 Brian O'Doherty, 'Notes on the Gallery Space', *Inside the White Cube: The Ideology of the Gallery Space* (Santa Monica and San Francisco: Lapis Press, 1986), 15. Originally published in *Artforum* in 1976.

98 Ibid., 15.

99 Soraya Rodriguez, 'Maria von Köhler', *re-title.com: International Contemporary Art* (2004). www.re-title.com/artists/Maria-vonKohler.asp

100 Giorgio Agamben, *The Man Without Content* (Stanford, CA: Stanford University Press, 1994), 5.

101 Ibid., 6.

102 Ibid., 2.

103 Ibid.

104 See Nicolas Bourriaud, *Relational Aesthetics*, trans. Simon Pleasance and Fronza Woods with Mathieu Copeland (Dijon: Les presses du réel, 2004).

105 Silverman, *Threshold of the Visible World*, 195. As she put it, since the publication of Debord's *Society of the Spectacle* in 1967: '[I]t has become fashionable to claim that we are more dependent on the image than were the subjects of previous historical periods.' She continues with respect to Debord and 'one of the many points in his text where he imputes to our predecessors an existential immediacy that we ourselves lack', that this formulation is:

> predicated on a radical misrecognition of what is historically variable about the field of vision. There can never have been a moment when specularity was not at least in part constitutive of human subjectivity. Lacan speaks as much for our medieval or Renaissance counterparts as for us when he remarks, 'We are beings who are looked at, in the spectacle of the world.' And ever since the inception of cave drawing, it has been via images that we see and are seen. What is specific to our epoch is not the specular foundation of subjectivity and the world, but rather the terms of that foundation – the logic of the images through which we figure objects and are in turn figured, and the value conferred upon those images through the larger organization of the visual field. It seems to me that three technologies play a preeminent role in both of these respects, all of which depend centrally on the camera: still photography, cinema and video. Perhaps, surprisingly, it is the first of these technologies, rather than the second or third, that has the greatest import for how we experience our specularity. (Ibid.)

Here she is citing Debord's *Society of the Spectacle*, trans. Fredy Perlman (London: Practical Paradise Publications, 1977), 1, and Jacques Lacan, *Four Fundamental Principles of Psychoanalysis*, trans. Alan Sheridan (New York: Norton, 1978), 75.

106 Silverman, *Threshold of the Visible World*, 199.

Chapter 4

1 Rikki Morgan, 'Víctor Erice: Painting the Sun', *Sight and Sound*, 3.4 (March 1993), 26–9, 27.

2 All quotations from *The Quince Tree Sun* are transcribed from the film's subtitled translations into English.

3 Maurice Merleau-Ponty, 'Cézanne's Doubt', *Sense and Non-Sense* (Evanston: Northwestern University Press, 1964), 9–25, 14.

4 Virilio, 'A Topographical Amnesia', 1–18, 1.

5 See Erice in interview (TVE2's programme Versión Española, transmitted on 16 November 1999); however, Linda C. Ehrlich writes that 'Erice called the editing process "eight months of reflection, following the eight weeks of active filming," which resulted in three hours of useable footage.' Linda C. Ehrlich, 'Interior Gardens: Dream of Light and the Bodegón Tradition', in Linda C. Ehrlich (ed.), *An Open Window: The Cinema of Víctor Erice* (Filmmakers Series, No. 72) (Lanham, MD, and London: Scarecrow Press, 2000), 192–205, 193. This essay was first published in *Cinema Journal*, 34.2 (Winter 1995), 22–36.

6 Caillois, *The Mask of Medusa*, 9.

7 See William Dyckes, 'The New Spanish Realists', *Art International*, 17.7 (September 1973), 29–33.

8 Ibid., 29.

9 Ibid., 29–30.

10 Morgan, 'Víctor Erice: Painting the Sun', 27.

11 'The polis, properly speaking, is not the city-state in its physical location; it is the organization of the people as it arises out of acting and speaking together, and its true space lies between people living together for this purpose, no matter where they happen to be.' Hannah Arendt, *The Human Condition* (Chicago: University of Chicago Press, 1958), 198.

12 See Rona Goffen, 'Nostra Conversatio in Caelis Est: Observations on the Sacra Conversazione in the Trecento', *The Art Bulletin*, 61.2 (June 1979), 198–222, 199, footnote 11.

13 Francis of Assisi (1181–1226) was canonized in 1228, a year after his death.

14 See Heading VI of the 'Medieval Sourcebook: The Rule of the Franciscan Order' of 1223, available on Fordham University's *Internet Medieval Sourcebook*, www.fordham.edu/halsall/source/stfran-rule.html (Accessed 23 October 2013).

15 A prayer included in Chapter 23 of the Rule of 1221. Referred to in Andrew T. McCarthy, *Francis of Assisi as Artist of the Spiritual Life: An Object Relations Theory Perspective* (Lanham, Boulder, New York, Toronto, Plymouth, UK: University Press of America, 2010), 186.

16 Paul Tillich, *The Courage to Be* [1952] (London and Glasgow: Collins (The Fontana Library), 1973), 57.

17 Goffen, 'Nostra Conversatio in Caelis Est', 201.

18 Genesis 3. As in, for instance, *The Holy Bible*, 5–6.

19 Goffen, 'Nostra Conversatio in Caelis Est', 206.

20 Tillich, *The Courage to Be*, 65.

21 Ibid.

22 Ibid., 66.

23 Ibid., 67.

24 Ibid.

25 Ibid.

26 Goffen, 'Nostra Conversatio in Caelis Est', 206.

27 See, for instance, the chapter 'The Gesture of Demonstration', in Claude Gandelman's *Reading Pictures, Viewing Texts* (Bloomington, IN: Indiana University Press, 1991).

28 Colossians 3.9b–10. *The Holy Bible*, 1077 (emphasis mine).

29 Colossians 3.11. Ibid., 1077 (emphasis mine).

30 www.newadvent.org/cathen/03445a.htm (Accessed 24 August 2013).

31 Titian, *Madonna and Child with Saints Luke and Catherine of Alexandria*, ca. 1560, Oil on canvas, 127.8 × 169.7 cm. Private Collection.

32 Merleau-Ponty, 'Indirect Language and the Voices of Silence', 52.

33 Merleau-Ponty, 'Metaphysics and the Novel', 26–40, 40 (emphasis in the original). For a recent photographic reflection on the Bellini see Thomas Struth's *San Zaccaria, Venice*, 1995, housed in the Metropolitan Museum of Art in New York City. This is a chromogenic print measuring 181.9 × 230.5 cm and was gifted to the museum by the Howard Gilman Foundation in 1996.

34 See Gary Brent Madison, 'The Ethics and Politics of the Flesh', in Gary B. Madison and Marty Fairbarn (eds), *The Ethics of Postmodernity: Current Trends in Continental Thought* (Evanston: Northwestern University Press, 1999), 180.

35 Ibid.

36 Kerry Whiteside in *Merleau-Ponty and the Foundation of an Existential Politics* (Princeton, NJ: Princeton University Press, 1988), 99.

37 See the writing of Fernando Solanas and Octavio Getino, members of the Grupo Cine Liberación, in 'Towards a Third Cinema' published in 1969 in the journal *Tricontinental* by the OSPAAAL (Organization of Solidarity with the People of Asia, Africa and Latin America). This manifesto was published in English in *Afterimage*, 3 (Summer 1971), 16–30 and reprinted in *Cineaste*, 4.3 (Winter 1971), 1–10. A version is available online at http://documentaryisneverneutral.com/words/camasgun.html. Here they write, for instance, that:

> The anti-imperialist struggle of the peoples of the Third World and of their equivalents inside the imperialist countries constitutes today the axis of the world revolution. Third cinema is, in our opinion, the cinema that recognises in that struggle the most gigantic cultural, scientific, and artistic manifestation of our time, the great possibility of constructing a liberated personality with each people as the starting point – in a word, the decolonisation of culture.

38 In interview (again, TVE2's programme 'Versión Española', transmitted on 16 November 1999), López talked about the extreme intrusiveness of the cameras, and of the filming process, and of the difficulties for the family of having to re-enact their own lives, the conversations they might have, and so on. He described the process, in fact, as violent. Only when he was working, he said, was he able to forget that filming was taking place. Apart from a very slight stiltedness, a slight self-consciousness, in some of the conversations – not on the part of López, but of some family members – none of this stress is evident in the film itself.

39 Witnessing Gran expressing these concerns in the film is poignant since he was to die prematurely in 1999, in a fire in this studio.

40 Tomelloso, a municipality in the region of Ciudad Real, Spain, is where López was born on 6 January 1936.

41 Terry Berne, 'Chronicle of an Unfinished Painting', *Art in America*, 88.10 (October 2000), 93 and 95, 93.

42 Ibid., 95. The words in square brackets are my own explanatory addition.

43 Morgan, 'Víctor Erice: Painting the Sun', 27–8.

44 George Stolz, 'Clash of the Titans', *Art News*, 92 (September 1993), 70–1, 71.

45 Nicholas J. Wade and Michael T. Swanston, 'Preface to the Third Edition', *Visual Perception: An Introduction* (London and New York: Psychology Press, 2013), xiii.

46 See, for instance, Merleau-Ponty, 'Eye and Mind', 159–90, 164.

47 Ibid., 165.

48 Michael Brenson, 'Except from "Interview with Antonio López García" Conducted by Michael Brenson', in Linda C. Ehrlich (ed.), *An Open Window: The Cinema of Víctor Erice* (Filmmakers Series, No. 72) (Lanham, MD, and London: Scarecrow Press, 2000), 212.

49 Merleau-Ponty, 'Eye and Mind', 166.

50 Ibid., 167.

51 Ibid., 162.

52 Ibid.

53 Ibid.

54 Silverman, *World Spectators*, 129.

55 Morgan, 'Víctor Erice: Painting the Sun', 27.

56 Ibid.

57 Ibid.

58 Ibid.

59 Ibid.

60 Ibid.

61 Ibid.

62 Philip Strick, 'El Sol de Membrillo' [The Quince Tree Sun], *Sight and Sound*, 3.4 (March 1993), 59–60, 60.

63 See Ehrlich, 'Interior Gardens'.

64 Dyckes, 'The New Spanish Realists', 31.

65 Ibid.

66 Ibid.

67 Stolz, 'Clash of the Titans', 71.

68 Ibid.

69 Ibid., 70.

70 Ibid.

71 Ibid.

72 Ibid.

73 Morgan, 'Víctor Erice: Painting the Sun', 28.

74 See Ramon E. S. Lerma, 'Nominator Statement: Rodel Tapaya', *Signature Art Prize 2011* (Asia Pacific Breweries Foundation) (Singapore: Singapore Art Museum, 2011), 50.

75 Yang Xinguang, 'Artist's Statement: Yang Xinguang', *Signature Art Prize 2011* (Asia Pacific Breweries Foundation) (Singapore: Singapore Art Museum, 2011), 52.

76 Matthew 25.40, *The Holy Bible*, 904 (emphasis mine).

77 Tillich, *The Courage to Be*, 78–9.

78 Sarah Rolfe Prodan, 'Michelangelo Reading Landino? The "Devil" in Michelangelo's "Last Judgement"', *Quaderni d'italianistica*, 30.2 (2009), 19–38, 32, footnote 25.

79 Cited in ibid., 32. This poem by Michelangelo is listed as Poem 51 in James M. Saslow, *The Poetry of Michelangelo: An Annotated Translation by James M. Saslow* (New Haven and London: Yale University Press, 1993), 136. Saslow remarks that this *Canzone* is dated 1528–30, and is to be found on 'a sheet of drawings of Hercules and Antaeus and other subjects' (ibid., 136).

80 Jacob Cornelisz van Oostsanen was active in Amsterdam during the late fifteenth and early sixteenth centuries.

81 Gertrud Schiller, *Iconography of Christian Art*, Vols 1 and 2 (1968), trans. Janet Seligman (London: Lund Humphries, 1972), Vol. 2, 78.

82 The entire poem, in Latin, and as translated into English by Edward Caswall (1814–78), is available online at http://en.wikisource.org/wiki/Stabat_Mater

83 John Lechte, 'Art, Love and Melancholy in the Work of Julia Kristeva', in *Abjection, Melancholia and Love: The Work of Julia Kristeva* (London and New York: Routledge, 1990), 24–41, 32–3.

84 Lorne Campbell, *Van der Weyden* (London: Oresko Books, 1979), 7.

85 See Luke 2.41–52, *The Holy Bible*, 934.

86 Merleau-Ponty, 'Metaphysics and the Novel', 40.

87 Ibid.

88 Amy Neff, 'The Pain of *Compassio*: Mary's Labour at the Foot of the Cross', *Art Bulletin*, 80 (1998), 254–73, 265.

89 Hélène Cixous, 'Difficult Joys', in Helen Wilcox, Keith McWatters, Ann Thompson and Linda R. Williams (eds), *The Body and the Text: Hélène Cixous, Reading and Teaching* (New York: St Martin's Press, 1990), 5–30, 25.

90 Virilio, 'A Topographical Amnesia', 7.

91 All quotations from *The Silences of the Palace* are transcribed from the film's subtitled translations into English.

92 Laura Mulvey, 'Moving Bodies' [an interview with Moufida Tlatli], *Sight and Sound*, 3 (March 1995), 8–20, 18.

93 Ibid., 20.

94 Morgan, 'Víctor Erice: Painting the Sun', 27.

95 Ibid.

96 Mulvey, 'Moving Bodies', 18.

97 Ibid., 20.

98 Ibid., 18–19.

99 See again Solanas and Getino, 'Towards a Third Cinema'.

100 See Caillois, *The Mask of Medusa*, 13.

101 Merleau-Ponty, *The Visible and the Invisible*, 189.

102 Ibid.

103 Stolz, 'Clash of the Titans', 71.

104 Ibid.

105 Merleau-Ponty, *The Visible and the Invisible*, 189.

106 Ibid., 189–90.

107 Ibid., 190.

108 Ibid., 189.

Bibliography

Agamben, Giorgio. *The Man Without Content*. Stanford, CA: Stanford University Press, 1994.

Alberti, Leon Battista. *On Painting and Sculpture*, trans. Cecil Grayson. London: Phaidon Press, 1972.

Andrews, Jorella. 'Vision, Violence and the Other: A Merleau-Pontean Ethics'. In *Feminist Interpretations of Merleau-Ponty*. Edited by Gail Weiss and Dorothea Olkowski, 167–82. University Park, PA: Pennsylvania State University Press, 2006.

Anon. 'Sangam, Raj Kapoor's Murky Waters'. Weblog entry, 2 January 2009. http://letstalkaboutbollywood.over-blog.org/article-26350946.html

Areh, Igor and Peter Umek. 'Personal Characteristics and Validity of Eye-witness Testimony'. In *Policing in Central and Eastern Europe: Dilemmas of Contemporary Criminal Justice*. Edited by Gorazd Mesko, Milan Pagon and Bojan Dobovsek. Slovenia: Faculty of Criminal Justice, University of Maribor. Document 208001, December 2004. www.ncjrs.gov/pdffiles1/nij/Mesko/208001.pdf

Arendt, Hannah. *The Human Condition*. Chicago: University of Chicago Press, 1958.

—. *The Life of the Mind: Thinking*. London: Secker and Warburg, 1978.

Baudrillard, Jean. 'Transsexuality'. In *The Transparency of Evil: Essays on Extreme Phenomena*. Translated by James Benedict, 20–5. London: Verso, 1993.

Berne, Terry. 'Chronicle of an Unfinished Painting', *Art in America*, 88.10 (October 2000): 93 and 95.

Blum, Lawrence A. *Moral Perception and Particularity*. Cambridge: Cambridge University Press, 1994.

Bose, Derek. *Brand Bollywood: A New Global Entertainment Order*. New Delhi, Thousand Oaks and London: Sage Publications, 2006.

Boswell, James. *Boswell's Life of Johnson: Including Their Tour to the Hebrides. By J. W. Croker*. Oxford: Oxford University, 1851.

Bourriaud, Nicolas. *Relational Aesthetics*. Translated by Simon Pleasance and Fronza Woods with Mathieu Copeland. Dijon: Les presses du réel, 2004.

Brenson, Michael. 'Except from "Interview with Antonio López García" Conducted by Michael Brenson'. In *An Open Window: The Cinema of Víctor Erice*. Filmmakers Series, No. 72. Edited by Linda C. Ehrlich, 211–18. Lanham, MD, and London: Scarecrow Press, 2000.

Broadcast. Curated by Irene Hofmann and co-organized by iCI, New York, and the Contemporary Museum, Baltimore. MOCAD (Museum of Contemporary Art, Detroit), 12 September–28 December 2008. www.mocadetroit.org/exhibitions/broadcast.html

Buonarroti, Michelangelo. 'Poem 51'. In *The Poetry of Michelangelo: An Annotated Translation by James M. Saslow*. Edited by James M. Saslow, 136. New Haven and London: Yale University Press, 1993.

Caillois, Roger. *The Mask of Medusa*. Translated by George Ordish. London: Victor Gollancz, 1964.

—. 'Mimicry and Legendary Psychasthenia', *October* 31 (Winter 1984): 17–32.

Campbell, Lorne. *Van der Weyden*. London: Oresko Books, 1979.

Carter, Sean and Derek McCormack. 'Affectivity and Geopolitical Images'. In *Observant States: Geopolitics and Visual Culture*. Edited by Fraser McDonald, Rachel Hughes and Klaus Dodds. London: I.B. Tauris, 2010.

Casey, Edward S. *The World at a Glance*. Bloomington, IN: Indiana University Press, 2007.

Césaire, Aimé. 'Et les chiens se taisaient' ['And the dogs were silent']. In *Les Armes Micaculeuses*. Paris: Gallimard, 1946.

Charlesworth, J. J. 'Jacques Rancière' (Interview). *Art Review*, 40 (April 2010): 72–5.

Cixous, Hélène. 'Difficult Joys'. In *The Body and the Text: Hélène Cixous, Reading and Teaching*. Edited by Helen Wilcox, Keith McWatters, Ann Thompson and Linda R. Williams, 5–30. New York: St Martin's Press, 1990.

D&AD. 'The Economist – How to Build a Brand on Outdoor' (an advertising story). D&AD (British Design and Art Directors) in association with Royal Mail (4 October 2006). http://fideliuganda.com/analysis/bestpractisearticle/itemId/i65767739/index.html

da Todi, Jacopone, *Stabat Mater*. Translated by Edward Caswall. http://en.wikisource.org/wiki/Stabat_Mater

Davies, Howard. 'Appendix 1'. In *Sartre and 'Les Temps Modernes'*. Cambridge and London: Cambridge University Press, 1987.

de Beauvoir, Simone. *The Second Sex* [1949]. Translated by H. M. Parshley. New York: Penguin, 1972.

de Lauretis, Teresa. 'Difference Embodied: Reflections on Black Skin, White Masks', *Parallax*, 8.2 (2002): 54–68.

Debord, Guy. *Society of the Spectacle*. Translated by Fredy Perlman. London: Practical Paradise Publications, 1977.

Devraj, Rajesh with Edo Bouman. *The Art of Bollywood*. Edited by Paul Duncan. Hong Kong, Köln and London: Taschen, 2010.

Dreyfus, Hubert L. and Patricia Allen Dreyfus. 'Translators' Introduction'. In *Sense and Non-Sense*. Edited by Maurice Merleau-Ponty, ix–xxvii. Evanston: Northwestern University Press, 1964.

Duffy, Jonathan. 'Channel 5's Naked Ambition'. *BBC News Online* (14 June 2000). http://news.bbc.co.uk/1/hi/entertainment/789384.stm

Dyckes, William. 'The New Spanish Realists', *Art International*, 17.7 (September 1973): 29–33.

Economist website. 'The Economist: About Us'. www.economist.com/help/about-us

—. 'The Economist Brand Family'. www.economistgroup.com/what_we_do/our_brands/the_Economist_brand_family/the_Economist.html

—. 'The Economist: Editorial Philosophy'. www.economistgroup.com/what_we_do/editorial_philosophy.html

Editorial: 'Originality in Art', The *New York Times*, 24 July 1881. Accessible online at http://query.nytimes.com/gst/abstract.html?res=F00C1EFD385A117 38DDDAD0A94DF405B8184F0D3

Edwards, Ruth Dudley. *The Pursuit of Reason: The Economist 1843–1993*. Boston: Harvard Business Review Press, 1995.

Ehrlich, Linda C. 'Interior Gardens: Dream of Light and the Bodegón Tradition'. In *An Open Window: The Cinema of Víctor Erice* (Filmmakers Series, No. 72). Edited by Linda C. Ehrlich, 192–205. Lanham, MD, and London: Scarecrow Press, 2000.

Ellison, Ralph. *Invisible Man*. New York: Random House, 1952.

Fanon, Frantz. *Black Skin, White Masks* [1952]. New York: Grove Press, 1967.

Fielding, Helen. 'White Logic and the Constancy of Color'. In *Feminist Interpretations of Merleau-Ponty*. Edited by Dorothea Olkowski and Gail Weiss, 71–89. University Park, PA: Pennsylvania State University Press, 2006.

Foster, Hal. *The First Pop Age*. Princeton and Oxford: Princeton University Press, 2012.

Gandelman, Claude. *Reading Pictures, Viewing Texts*. Bloomington, IN: Indiana University Press, 1991.

Goffen, Rona. 'Nostra Conversatio in Caelis Est: Observations on the Sacra Conversazione in the Trecento', *The Art Bulletin*, 61.2 (June 1979): 198–222.

Gooptu, Sharmistha. 'Bollywood's Foreign Affairs', *Verve Online*, 15.4 (April 2007). www.verveonline.com/48/life/bollywood.shtml

Govan, Michael. 'Director's Introduction to the Most Wanted Paintings on the Web'. Dia Center for the Arts. http://awp.diaart.org/km/intro.html

Haub, Carl and O. P. Sharma. 'India's Population Reality: Reconciling Change and Tradition'. *Population Bulletin*, 61.3 (September 2006).

—. 'What Is Poverty, Really? The Case of India', *Population Reference Bureau*, January 2010. www.prb.org/Articles/2010/indiapoverty.aspx

Hoffman, Donald. *Visual Intelligence: How We Create What We See*. New York and London: W. W. Norton, 1998.

The Holy Bible, New International Version (Reference Edition with Concordance and Maps). London, Sydney, Auckland and Toronto: Hodder and Stoughton, 1984.

Irigaray, Luce. Interview in *Les femmes, la pornographie et l'érotisme*. Edited by Marie-Françoise Hans and Gilles Lapouge, 43–58. Paris: Éditions du Seuil, 1978.

—. *This Sex Which Is Not One*. Translated by Catherine Porter and Carolyn Burke. Ithaca: Cornell University Press, 1985.

Jaar, Alfredo. 'Alfredo Jaar in Conversation with Wolfgang Brückle and Rachel Mader: "Die Mise-en-scène ist fundamental"'. *Camera Austria*, 86 (2004). www.camera-austria.at/zeitschrift.php?id=1086622067&mainsub=beitrag&b id=-186214297

Jakimowicz, Marta. 'The Self versus Self-Images and the Cliché'. In *Pushpamala N: Indian Lady* (BP Contemporary Art of India Series, Volume 19). New York: Bose Pacia, 2004.

Jay, Martin. *Downcast Eyes: The Denigration of Vision in Twentieth-Century French Thought*. Berkeley, Los Angeles and London: University of California Press, 1994.

Komar, Vitaly and Alex Melamid. 'The Most Wanted Paintings on the Web'.
 http://awp.diaart.org/km/painting.html
Lacan, Jacques. *The Four Fundamental Concepts of Psycho-Analysis*.
 Harmondsworth: Penguin Books 1977.
—. *Four Fundamental Principles of Psychoanalysis*. Translated by Alan Sheridan.
 New York: Norton, 1978.
Lechte, John. 'Art, Love and Melancholy in the Work of Julia Kristeva'. In
 Abjection, Melancholia and Love: The Work of Julia Kristeva. Edited by John
 Fletcher and Andre Benjamin, 24–41. London and New York: Routledge,
 1990.
Lerma, Ramon E. S. 'Nominator Statement: Rodel Tapaya'. *Signature Art Prize
 2011* (Asia Pacific Breweries Foundation). Singapore: Singapore Art Museum,
 2011.
Lippmann, Walter. *Public Opinion*. New Brunswick, NJ: Transaction Publishers,
 1991.
'List of Major Financial Centres in Asia', *World City Information* (19 January
 2012). www.city-infos.com/list-of-major-financial-centres-in-asia
Locke, John. *An Essay Concerning Human Understanding*. London: Penguin
 Books, 1997.
McCarthy, Andrew T. *Francis of Assisi as Artist of the Spiritual Life: An Object
 Relations Theory Perspective*. Lanham, Boulder, New York, Toronto,
 Plymouth, UK: University Press of America, 2010.
MacIntyre, Alasdair. *After Virtue: A Study in Moral Theory*. London: Duckworth,
 2002.
McLuhan, Marshall. *Understanding Media: The Extensions of Man*. Cambridge,
 MA: MIT Press, 1994.
Madison, Gary Brent. 'The Ethics and Politics of the Flesh'. In *The Ethics of
 Postmodernity: Current Trends in Continental Thought*. Edited by Gary B.
 Madison and Marty Fairbarn. Evanston: Northwestern University Press,
 1999.
Magritte, René. 'Letter to Alphonse de Waelhens, 28 April 1962'. In *The
 Merleau-Ponty Aesthetics Reader: Philosophy and Painting*. Edited by Galen
 A. Johnson and Michael Bradley Smith. Evanston: Northwestern University
 Press, 1993.
Malraux, André. 'Museum Without Walls'. In *The Voices of Silence*. Translated
 by Stuart Gilbert, 13–46. Princeton, NJ: Princeton University Press, 1978.
Marion, Jean-Luc. *Being Given: Toward a Phenomenology of Givenness*.
 Stanford: Stanford University Press, 2002.
'Medieval Sourcebook: The Rule of the Franciscan Order' [1223]. Fordham
 University, *Internet Medieval Sourcebook*. www.fordham.edu/halsall/source/
 stfran-rule.html
Melamid, Alex. 'Painting by Numbers: The Search for a People's Art, Interview
 with Alex Melamid', *The Nation* (14 March 1994): 334–48. http://awp.diaart.
 org/km/nation.html
Melmoth, Courtney. *The Pupil of Pleasure*. London: G. Robinson, and J. Bew in
 Pater Noster Row, 1777.
Merleau-Ponty, Maurice. 'Cézanne's Doubt'. In *Sense of Non-Sense*, 9–25.
 Evanston: Northwestern University Press, 1964.
—. 'Eye and Mind'. In *The Primacy of Perception*, 159–90. Evanston:
 Northwestern University Press, 1964.

—. 'Indirect Language and the Voices of Silence'. *Signs*, 39–83. Evanston: Northwestern University Press, 1964.

—. 'In Praise of Philosophy' In *In Praise of Philosophy and Other Essays*, 3–76. Evanston: Northwestern University Press, 1963.

—. 'Metaphysics and the Novel'. In *Sense and Non-Sense*, 26–40. Evanston: Northwestern University Press, 1964.

—. *Phenomenology of Perception*. Translated by Colin Smith. London and New York: Routledge, 1962.

—. 'The Primacy of Perception and Its Philosophical Consequences'. In *The Primacy of Perception*. Edited by James M. Edie, 12–42. Evanston: Northwestern University Press, 1964.

—. *The Visible and the Invisible*. Translated by Alphonso Lingis. Evanston: Northwestern University Press, 1968.

—. 'The War Has Taken Place'. In *Sense and Non-Sense*, 139–52. Evanston: Northwestern University Press, 1964.

Mesko, Gorazd, Milan Pagon and Bojan Dobovsek (eds). *Policing in Central and Eastern Europe: Dilemmas of Contemporary Criminal Justice*. Faculty of Criminal Justice, University of Maribor, Slovenia, Document 208001, December 2004. www.ncjrs.gov/pdffiles1/nij/Mesko/208001.pdf

Mirzoeff, Nicholas. *The Visual Culture Reader* (3rd edition). London and New York: Routledge, 2012.

Mishra, Vijay. *Bollywood Cinema: Temples of Desire*. New York and London: Routledge, 2002.

Moorhouse, Paul (ed.). *Anthony Caro* (exhibition catalogue). London: Tate Publishing, 2005.

Moran, Dermot. *Introduction to Phenomenology*. London and New York: Routledge, 2000.

Morgan, Rikki. 'Víctor Erice: Painting the Sun', *Sight and Sound*, 3/4 (March 1993): 26–9.

Mulvey, Laura. 'Moving Bodies' (an interview with Moufida Tlatli), *Sight and Sound*, 3 (March 1995): 8–20.

—. 'Visual Pleasure and Narrative Cinema', *Screen*, 16.3 (Autumn 1975): 6–18.

Murdoch, Iris. *The Sovereignty of Good* [1970]. London and New York: Ark, 1989.

Neff, Amy. 'The Pain of *Compassio*: Mary's Labour at the Foot of the Cross', *Art Bulletin*, 80 (1998): 254–73.

O'Doherty, Brian. 'Notes on the Gallery Space'. In *Inside the White Cube: The Ideology of the Gallery Space*. Santa Monica and San Francisco: Lapis Press, 1986.

Phelan, Peggy. *Unmarked: The Politics of Performance*. London and New York: Routledge, 1993.

Pliny the Elder. *Natural History: A Selection*. Edited by John F. Healy. London: Penguin Books, 1991.

'Population of India: Mumbai's Population'. *India Online Pages*, 2012. www.indiaonlinepages.com/population/mumbai-population.html

Potts, Alex. *The Sculptural Imagination: Figurative, Modernist, Minimalist*. New Haven and London: Yale University Press, 2000.

Prasad, M. Madhava. 'The Last Remake of Indian Modernity'. In *Pushpamala N: Indian Lady* (BP Contemporary Art of India Series, Volume 19). New York: Bose Pacia, 2004.

Prodan, Sarah Rolfe. 'Michelangelo Reading Landino? The "Devil" in Michelangelo's "Last Judgement"', *Quaderni d'italianistica*, 30.2 (2009): 19–38.

Pushpamala, N. 'National and Global: N Rajyalakshmi, Chief Reporter of the *Ideal Times*, Bangalore, Interviews the Artist Pushpamala N about Her Views on Internationalism'. In *Pushpamala N: Indian Lady* (BP Contemporary Art of India Series, Volume 19). New York: Bose Pacia, 2004.

Rancière, Jacques. *The Emancipated Spectator*. London: Verso, 2009.

—. *The Politics of Aesthetics: The Distribution of the Sensible*. London and New York: Continuum International Publishing Group, 2006.

Rodriguez, Soraya. 'Maria von Köhler'. *re-title.com: International Contemporary Art*, 2004. www.re-title.com/artists/Maria-vonKohler.asp

Sardar, Ziauddin. 'Foreword to the 2008 Edition'. In *Black Skin, White Masks*. Edited by Frantz Fanon. London: Pluto Press, 1986.

Sartre, Jean-Paul. *Being and Nothingness: An Essay on Phenomenological Ontology*. London and New York: Routledge, 1991.

—. 'Merleau-Ponty' [1964]. In *Situations*. Translated by Benita Eisler, 225–326. New York: George Braziller, 1965.

—. *Nausea*. Translated by Lloyd Alexander, 124. New York: New Directions Publishing Corporation, 1964.

—. 'No Exit'. In *No Exit, and Three Other Plays* (*Dirty Hands*, *The Flies*, *The Respectful Prostitute*). Translated by Stuart Gilbert, 1–47. New York: Vintage Books, 1946.

Saslow, James M. *The Poetry of Michelangelo: An Annotated Translation by James M. Saslow*. New Haven and London: Yale University Press, 1993.

Schiller, Gertrud. *Iconography of Christian Art*, Vols I and II. Translated by Janet Seligman. London: Lund Humphries, 1972.

Signature Art Prize 2011 (Asia Pacific Breweries Foundation). Singapore: Singapore Art Museum, 2011.

Silverman, Kaja. *The Threshold of the Visible World*. London and New York: Routledge, 1996.

—. *World Spectators*. Stanford: Stanford University Press, 2000.

Solanas, Fernando and Octavio Getino. 'Towards a Third Cinema', *Afterimage*, 3 (Summer 1971): 16–30.

—. 'Towards a Third Cinema', *Cineaste*, 4.3 (Winter 1971): 1–10. http://documentaryisneverneutral.com/words/camasgun.html

Stanhope, Philip Dormer. *Lord Chesterfield's Advice to His Son, on Men and Manners: Or, a New System of Education: … The Whole Arranged on a Plan Entirely New*. London: G. Robinson, 1785.

Steele, Richard and Joseph Addison. *The Spectator*. London, 1711–12 and 1714–Present.

Stolz, George. 'Clash of the Titans', *Art News*, 92 (September 1993): 70–1.

Strick, Philip. 'El Sol de Membrillo' [The Quince Tree Sun]', *Sight and Sound*, 3/4 (March 1993): 59–60.

Tillich, Paul. *The Courage to Be*. London and Glasgow: Collins (The Fontana Library), 1973.

van Winkel, Camiel. *The Regime of Visibility*. Rotterdam: NAi Publishers, 2005.

Vasudevan, Ravi. *The Melodramatic Public: Film Form and Spectatorship in Indian Cinema*. New York: Palgrave Macmillan, 2011.

Virilio, Paul. 'A Topographical Amnesia'. *The Vision Machine*, 1–18. Bloomington, IN: Indiana University Press, 1994.

Wade, Nicholas J. and Michael T. Swanston. *Visual Perception: An Introduction*. London and New York: Psychology Press, 2013.

Weiss, Gail. 'Simone de Beauvoir: An Existential Phenomenological Ethics'. In *Phenomenological Approaches to Moral Philosophy: A Handbook*. Edited by John J. Drummond and Lester E. Embree. Dordrecht: Kluwer Academic Publishers, 2002.

Wells, Gary L., Mark Small, Steven Penrod, Roy S. Malpass, Solomon M. Fulero and C. A. E. Brimacombe (eds). 'Eyewitness Identification Procedures: Recommendations for Lineups and Photospreads', *Law and Human Behavior*, 22.6 (1998): 603–45.

Welsch Wolfgang. 'Aesthetics Beyond Aesthetics', *Action, Criticism and Theory for Music Education*, 2.2 (November 2002). http://act.maydaygroup.org/articles/Welsch2_2English.pdf (Accessed 12 June 2008).

—. 'Aesthetics Beyond Aesthetics: For a New Form to the Discipline'. In *Undoing Aesthetics*, 78–102. London, New Delhi, Thousand Oaks and New Delhi: Sage Publications, 1997.

—. 'On the Way to an Auditive Culture?' In *Undoing Aesthetics*, 150–67. London, New Delhi, Thousand Oaks and New Delhi: Sage Publications, 1997.

Whiteside, Kerry. *Merleau-Ponty and the Foundation of an Existential Politics*. Princeton, NJ: Princeton University Press, 1988.

Woolf, Virginia. 'Lord Chesterfield's Letters to His Son'. In *The Common Reader: Second Series*, 86–92. London: Hogarth Press, 1974.

'World Internet Usage and Population Statistics: 30 June 2012'. *Internet World Stats: Usage and Population Statistics*. www.internetworldstats.com/stats.htm. Copyright © 2001–13, Miniwatts Marketing Group. All rights reserved worldwide.

Yar, Majid. 'Panoptic Power and the Pathologisation of Vision: Critical Reflections on the Foucauldian Thesis', *Surveillance & Society*, 1/3 (2003): 254–71.

Yar, Majid and Simon Thompson. *The Politics of Misrecognition: Rethinking Political and International Theory*. Farnham, Surrey, and Burlington, VT: Ashgate Publishing, 2011.

Index